Nikon®
D7500™

by Julie Adair King

Nikon® D7500™ For Dummies®

Published by: **John Wiley & Sons, Inc.,** 111 River Street, Hoboken, NJ 07030-5774, www.wiley.com

Copyright © 2018 by John Wiley & Sons, Inc., Hoboken, New Jersey

Published simultaneously in Canada

For general information on our other products and services, please contact our Customer Care Department within the U.S. at 877-762-2974, outside the U.S. at 317-572-3993, or fax 317-572-4002. For technical support, please visit https://hub.wiley.com/community/support/dummies.

Wiley publishes in a variety of print and electronic formats and by print-on-demand. Some material included with standard print versions of this book may not be included in e-books or in print-on-demand. If this book refers to media such as a CD or DVD that is not included in the version you purchased, you may download this material at http://booksupport.wiley.com. For more information about Wiley products, visit www.wiley.com.

Library of Congress Control Number: 2017953579

ISBN 978-1-119-44832-7 (pbk); ISBN 978-1-119-44806-8 (ebk); ISBN 978-1-119-44808-2 (ebk);

Manufactured in the United States of America

10 9 8 7 6 5 4 3 2 1

Table of Contents

Where to Go from Here

To wrap up this preamble, I want to stress that if you initially think that digital photography is too confusing or too technical for you, you're in very good company. *Everyone* finds this stuff mind-boggling at first. So take it slowly, experimenting with just one or two new camera settings or techniques at first. Then, every time you go on a photo outing, make it a point to add one or two more shooting skills to your repertoire.

I know that it's hard to believe when you're just starting out, but it really won't be long before everything starts to come together. With some time, patience, and practice, you'll soon wield your camera like a pro, dialing in the necessary settings to capture your creative vision almost instinctively.

So without further ado, I invite you to grab your camera, a cup of whatever it is you prefer to sip while you read, and start exploring the rest of this book. Your D7500 is the perfect partner for your photographic journey, and I'm grateful for the opportunity to act as your tour guide.

1

Fast Track to Super Snaps

IN THIS CHAPTER

» Preparing the camera for its first outing

» Getting acquainted with the touchscreen and other camera features

» Viewing and adjusting camera settings

» Setting a few basic preferences

» Taking a picture in Auto mode

Chapter **1**

First Steps, First Shots

Shooting for the first time with a camera as sophisticated as the Nikon D7500 can produce a blend of excitement and anxiety. On one hand, you can't wait to start using your new equipment, but on the other, you're a little intimidated by all its buttons, dials, and menu options.

Fear not: This chapter provides information to help you get comfortable with your D7500. The first section walks you through initial camera setup; following that, you can discover how to view and adjust picture settings and get my take on additional setup options. At the end of the chapter, I explain how to take pictures using Auto mode, which offers point-and-shoot simplicity until you're ready for more advanced options.

Preparing the Camera for Use

After unpacking your camera, you have to assemble a few parts. In addition to the camera body and the supplied battery (charge it before the first use), you need a

lens and a memory card. Later sections in this chapter provide details about lenses and memory cards, but here's what you need to know up front:

>> **Lens:** You can mount a wide range of lenses on your D7500, but some lenses aren't compatible with all camera features. Your camera manual lists all the lens types that can be mounted on the camera and explains what features are supported with each type.

>> **SD (Secure Digital) memory card:** Your camera accepts only this type of card. Most SD cards carry the designation SDHC (for *High Capacity*) or SDXC (for *eXtended Capacity*), depending on how many gigabytes (GB) of data they hold. SDHC cards hold from 4GB to 32GB of data; SDXC cards have capacities greater than 32GB.

With camera, lens, battery, and memory card within reach, take these steps:

1. **Make sure that the camera is turned off.**

2. **Install the battery into the compartment on the bottom of the camera.**

3. **Attach a lens.**

 First, remove the caps that cover the front of the camera and the back of the lens. Then align the *mounting index* (white dot) on the lens with the one on the camera body, as shown in Figure 1-1. After placing the lens on the camera mount, rotate the lens toward the shutter-button side of the camera. You should feel a solid click as the lens locks into place.

4. **Insert a memory card.**

 Open the card-slot cover on the right side of the camera and orient the card as shown in Figure 1-2 (the label faces the back of the camera). Push the card gently into the slot and close the cover. The memory-card access light, labeled in the figure, illuminates briefly to let you know that the camera recognizes the card.

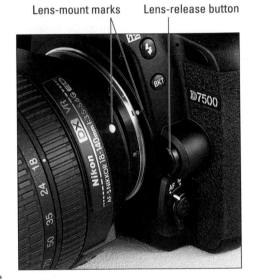

Lens-mount marks Lens-release button

FIGURE 1-1:
Align the white dot on the lens with the one on the camera body.

5. **Turn on the camera.**

6. **Set the language, time zone, and date.**

When you power up the camera for the first time, you can't do anything until you take this step.

TIP

The easiest option is to use the touchscreen. To select an option, just tap it as you do on any touchscreen device. If you see an OK symbol in the lower-right corner of the screen, tap it to finalize your selection and return to the previous screen. To exit without making changes, tap the exit arrow in the upper-right corner of the screen.

You also can use the Multi Selector and OK button, labeled in Figure 1-2, to navigate menus. Press the edges of the Multi Selector up, down, right, or left to highlight an option; press OK to select it. You can find more details about selecting menu options later in this chapter.

Multi Selector

OK button

Memory-card access light

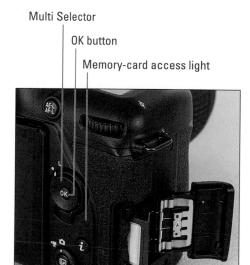

FIGURE 1-2:
Insert the memory card with the label facing the back of the camera.

7. **Adjust the viewfinder to your eyesight.**

WARNING

This step is critical; if you don't set the viewfinder to your eyesight, subjects that appear out of focus in the viewfinder might actually be in focus, and vice versa. If you wear glasses while shooting, adjust the viewfinder with your glasses on.

After taking off the lens cap and making sure that the camera is turned on, look through the viewfinder and press the shutter button halfway. In dim lighting, the flash may pop up. Ignore it for now and concentrate on the row

Rotate dial to adjust viewfinder

FIGURE 1-3:
Rotate this dial to set the viewfinder focus for your eyesight.

of data that appears at the bottom of the viewfinder screen. Rotate the dial labeled in Figure 1-3, officially known as the *diopter adjustment dial,* until the data appears sharpest. The markings in the center of the viewfinder, which

relate to autofocusing, also become more or less sharp. Ignore the scene you see through the lens; that won't change because you're not actually focusing the camera.

When you finish, press down on the flash unit to close it if necessary.

8. **Adjust the monitor position as desired.**

You can lift the monitor up and away from the back of the camera and then tilt it up or down to view the screen at different angles, as shown in Figure 1-4. To return the monitor to its original position, gently push it inward toward the back of the camera.

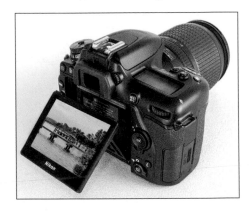

9. **If you prefer to use the monitor instead of the viewfinder to compose your photos, switch to Live View mode.**

FIGURE 1-4:
You can tilt the monitor up to view the screen from a variety of angles.

Live View enables you to compose photos using the monitor rather than by looking through the viewfinder. You must use Live View to record movies. To shift to Live View for still photography, rotate the Live View switch to the still-camera icon, as shown in Figure 1-5. Then press the LV button in the center of the switch. The viewfinder goes dark, and the live preview appears on the monitor, as shown in the figure.

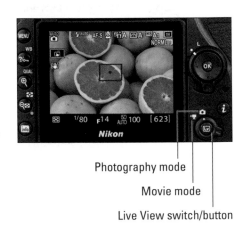

Photography mode

Movie mode

Live View switch/button

To set the camera to Movie mode, rotate the Live View switch to the movie-camera symbol and then press the LV button. You can then start and stop recording by pressing the red button on top of the camera.

FIGURE 1-5:
Press the LV button to toggle Live View on and off.

To return to viewfinder shooting, press the LV button again.

That's all there is to it — the camera is now ready to go.

REMEMBER

Checking Out External Controls

Scattered across your camera's exterior are numerous features that you use to change picture-taking settings, review your photos, and perform various other operations. In later chapters, I detail all these controls; this section provides just a basic "what's this thing do?" guide.

REMEMBER

In upcoming figures, some buttons bear multiple labels to indicate that they play different roles depending on whether the camera is in shooting or playback mode. As Nikon does in the camera's user manual, I refer to the button by the name that relates to the function that I'm currently discussing. To avoid any confusion, though, a picture of the button appears in the margin or is labeled in a nearby figure.

Back-of-the-body controls

Starting in the upper-left corner and working clockwise around the camera back, you find these controls, shown in Figure 1-6:

>> **Playback button:** Press this button to switch the camera to picture review mode; press it again to return to shooting. Chapter 9 details picture playback.

>> **Delete button:** Sporting a trash can icon, the universal symbol for delete, this button enables you to erase pictures. Chapter 10 has specifics.

>> **Eye sensor:** This window senses when you put your eye to the viewfinder and, in response, turns off the monitor to save battery power. Not working? Open the Setup menu and make sure that the Info Display Auto Off option is set to On. If the option is enabled, you may need to press your eye closer to the viewfinder. Also, when you wear glasses, sometimes the sensor can't detect your eye. You do have the option of pressing the Info button to turn the monitor on and off instead of relying on the eye sensor.

>> **Diopter adjustment control:** Rotate this dial to adjust the viewfinder focus to your eyesight; see the preceding section for details.

>> **AE-L/AF-L button:** When taking pictures in some exposure modes, you can lock focus and exposure settings by holding down this button. Chapter 4 explains.

>> **Main command dial:** You use this dial to adjust a variety of settings, often in combination with pressing a camera button.

>> **Multi Selector/OK button:** This dual-natured control plays a role in many camera functions. You press the outer edges of the Multi Selector left, right, up, or down to navigate camera menus and access certain options. At the center of the control is the OK button, which you press to finalize a menu selection or other adjustment.

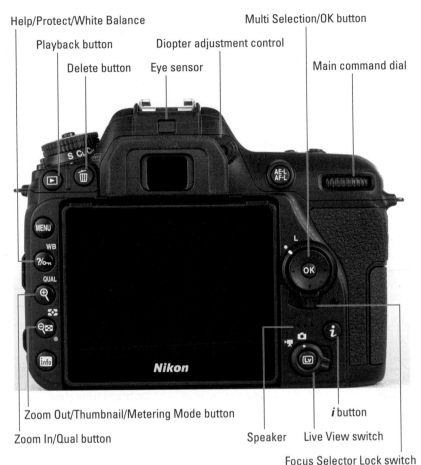

Help/Protect/White Balance
Playback button
Delete button Eye sensor
Diopter adjustment control
Multi Selection/OK button
Main command dial

Zoom Out/Thumbnail/Metering Mode button
Zoom In/Qual button
Speaker Live View switch
i button
Focus Selector Lock switch

FIGURE 1-6:
Here's a look
at the backside
controls.

>> **Focus Selector Lock switch:** Just beneath the Multi Selector, this switch relates to autofocusing. When the switch is set to the position shown in Figure 1-6, you can use the Multi Selector to specify which focus point that you want to use. Setting the switch to the L (locked) position prevents you from choosing a different point. See Chapter 5 for details.

>> **Memory-card access light:** When you insert a memory card, this light located above the *i* button flashes briefly to indicate that the card is installed. After you take a picture, the light appears until the camera finishes recording the picture or movie file to the memory card. Be careful not to turn off the camera before the light goes off; doing so can ruin the file.

>> *i* **button:** Pressing this button displays a special menu that gives you quick access to a handful of settings. The upcoming section "Navigating Menus" explains.

>> **Live View switch:** Rotate the Live View switch to the camera symbol to use Live View for still photography; move the switch to the movie-camera symbol for movie recording. Either way, press the LV button at the center of the switch to actually turn on Live View; press it again to exit Live View.

>> **Speaker:** When you play movies that contain an audio track, the sound comes wafting through these holes.

>> **Info button:** During viewfinder photography, press this button to display the Information screen, which provides an overview of your current camera settings. In Live View mode, pressing the button changes the type of data that appears over the live preview. See "Checking Out the Displays," later in this chapter, for details.

>> **Zoom Out/Thumbnails/Metering Mode:** In playback mode, pressing the button enables you to display multiple image thumbnails on the screen and to reduce the magnification of the current photo. In Live View mode, the button reduces the magnification of the live preview.

During viewfinder photography, this button provides access to the Metering mode, which determines which part of the frame the autoexposure system uses to calculate exposure. Chapter 4 has details.

QUAL

>> **Zoom In/Qual (Quality):** In playback mode, pressing the button magnifies the image and also reduces the number of thumbnails displayed at a time. Note the plus sign in the middle of the magnifying glass — plus for zoom in.

In picture-taking mode, pressing the button gives you fast access to the Image Quality and Image Size options, both of which you can explore in Chapter 2. However, this function works only for viewfinder photography; in Live View mode, pressing the button magnifies the display so that you can check focus closely.

WB

>> **Help/Protect/White Balance (WB) button:** This button serves three purposes:

- *Help:* When you see a question mark symbol in the lower-left corner of a screen, press this button to display information about the active option.

- *Protect:* In playback mode, pressing the button gives the photo or movie protected status, locking the file so that you can't accidentally erase it. (The key symbol on the button represents the lock function.) Note, though, that protection applies only to normal file-deletion options, described in Chapter 10. If you format the memory card, both locked and unlocked files are erased.

- *White Balance control:* During shooting, the button's main function is to access white balance options, a color-related topic you can explore in Chapter 6.

>> **Menu button:** Press this button to access camera menus. The section "Navigating Menus," later in this chapter, explains how to use the menu system.

Topside controls

Your virtual tour begins with the bird's-eye view shown in Figure 1-7. There are a number of features of note here:

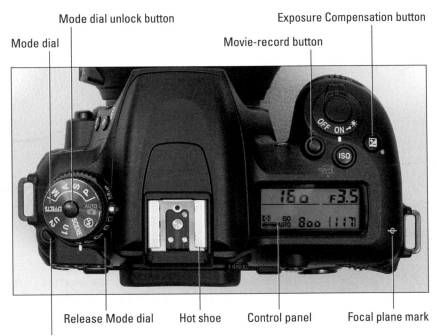

Mode dial unlock button

Exposure Compensation button

Mode dial

Movie-record button

Release Mode dial Hot shoe Control panel Focal plane mark

Release Mode dial unlock button

FIGURE 1-7:
Press and hold the Mode dial's unlock button before rotating the dial.

>> **On/Off switch and shutter button:** Okay, I'm pretty sure you already figured out this combo button. But you may not be aware that if you rotate the switch past the On position to the light bulb symbol, a backlight illuminates the Control panel, covered next.

>> **Control panel:** You can view many picture-taking settings on this LCD panel. The section "Checking Out the Displays" has more information about the Control panel and other data screens.

>> **Exposure Compensation button:** This button relates to an exposure correction detailed in Chapter 4. Press the button while rotating the Main command dial to set the amount of Exposure Compensation.

>> **ISO button:** Press this button to access ISO settings, which determine the camera's sensitivity to light. Chapter 4 explains.

>> **Movie-record button:** After setting the camera to movie mode, press this button to start and stop recording. (Engage movie mode by setting the Live View switch to the movie camera icon and then pressing the LV button.)

>> **Mode dial:** Use this dial to select an *exposure mode,* which determines how much control you have over exposure and other camera features. See Chapter 2 for an introduction to each mode.

REMEMBER

Before you can rotate the dial, you must press and hold the Mode dial unlock button, labeled in Figure 1-7.

>> **Release Mode dial:** You use this dial, set directly under the Mode dial, to switch from normal shooting, where you take one picture with each press of the shutter button, to one of the camera's other Release modes, including Self-Timer mode. As with the Mode dial, you must press the dial's unlock button, labeled in Figure 1-7, to change the Release mode setting. A letter representing the selected mode appears at the bottom of the dial. For example, in the figure, the S (Single Frame) mode is selected. See Chapter 2 for a look at all your options.

>> **Hot shoe:** A *hot shoe* is a connection for attaching an external flash head such as a Nikon Speedlight. See Chapter 3 for information about a few flash features that work only with this type of flash.

TIP

>> **Focal plane mark:** Should you need to know the exact distance between your subject and the camera, the focal plane indicator labeled in Figure 1-7 is key. This mark indicates the plane at which light coming through the lens is focused onto the image sensor. Basing your measurement on this mark produces a more accurate camera-to-subject distance than using the end of the lens or some other external point on the camera body as your reference point.

Front-right controls

Figure 1-8 offers a look at the front-right side of the camera, which sports the following features:

>> **Sub-command dial:** This dial is the counterpart to the Main command dial on the back of the camera. As with the Main command dial, you rotate this one to select certain settings, usually in conjunction with pressing a camera button.

>> **AF-assist/Self-timer/Red-eye reduction lamp:** In dim lighting, a beam of light shoots out from this lamp to help the camera's autofocus system find its target. The lamp also lights before the shutter is released in Self-Timer mode and before the flash fires in Red-Eye Reduction flash mode.

» **Function (Fn) buttons:** The Fn1 and Fn2 buttons are customizable buttons that you can set up to access certain features that don't already have their own buttons.

Fn1

- *Fn1:* By default, pressing the Fn1 button during viewfinder shooting adds *virtual horizon* markings along the bottom and right side of the viewfinder framing area. Check out the upcoming section "Viewfinder display" for information on how to interpret the markings. Press the button again to turn the virtual horizon off.

Fn2

- *Fn2:* For viewfinder and Live View photography, pressing Fn2 accesses the Image Area setting, which determines whether the camera records your picture using the entire image sensor or a smaller area at the center of the sensor. For details on the Image Area setting, see Chapter 2.

To find out how to assign other functions to the buttons, check out Chapter 11.

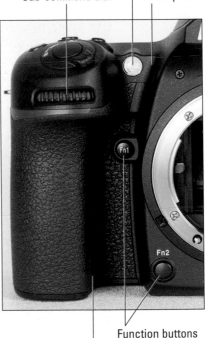

AF-assist/Self-timer/Red-eye reduction lamp

Sub-command dial Microphone

Function buttons

AC-adapter connection cover

FIGURE 1-8:
You get two Function buttons that can be set to perform a variety of operations.

» **Microphone:** Your camera has a built-in stereo microphone for recording movie audio. Two openings lead to the mic; one in the spot labeled in Figure 1-8 and the other on the opposite side of the camera.

» **AC-adapter connection cover:** Lift up this rubber flap to find the connection for the optional AC power adapter. The camera manual provides specifics on running the camera on AC power.

Left-front features

The front-left side of the camera, shown in Figure 1-9, sports these features:

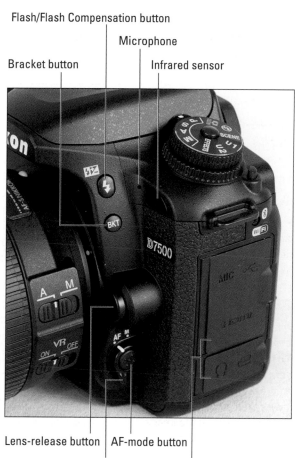

Flash/Flash Compensation button

Bracket button

Microphone

Infrared sensor

FIGURE 1-9:
Press the Flash
button to use
the built-in
flash in P, S, A,
or M mode.

Lens-release button | AF-mode button

Focus-mode selector Connection port covers

>> **Flash/Flash Compensation button:** Pressing this button pops up the camera's built-in flash (except in automatic shooting modes, in which the camera decides whether the flash is needed). Depending on your exposure mode, you may be able to adjust the Flash mode (normal, red-eye reduction, and so on) by holding the button down while rotating the Main command dial and change the flash power by rotating the Sub-command dial (the dial on the front of the camera).

>> **BKT (Bracket) button:** Press this button to access settings related to automatic *bracketing,* a feature that simplifies the job of recording the same subject using different settings for each shot. You can bracket exposure, flash power, white balance, and Active D-Lighting. Chapter 4 details exposure, flash, and Active D-Lighting bracketing; Chapter 6 discusses white balance bracketing.

>> **Lens-release button:** Press this button to disengage the lens from the camera body so you can remove the lens.

- **Focus-mode selector:** This switch sets the camera to manual (M) or autofocusing (AF). Chapter 5 gives you the lowdown on focusing.

- **AF-mode button:** This button accesses two autofocusing options. While pressing the button, rotate the Main command dial to adjust the Focus mode and rotate the Sub-command dial to adjust the AF-area mode. Chapter 5 explains these settings.

- **Infrared sensor:** If you own the optional ML-L3 wireless remote control unit, aim its transmitter at this spot. See Chapter 2 for more information about using a remote control to trigger the camera's shutter release.

- **Connection port covers:** Lift open these two doors to connect various devices to the camera; see the next section for specifics.

Hidden connections

You can connect a variety of accessories by plugging them into the openings hidden under the two doors on the left side of the camera. Figure 1-10 offers a look at what's behind each door.

The top panel has a jack for connecting an external microphone, a port for connecting a USB cable (for image download to your computer), and an HDMI-out port, for connecting your camera to a TV.

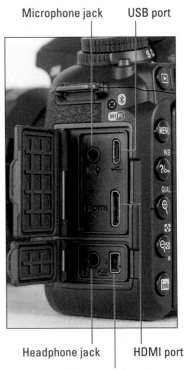

Under the lower door, you find a headphone jack and accessory terminal, where you can attach devices such as the Nikon GP-1/GP-1A GPS (Global Positioning System) unit; the ML-L3, WR-1, and WR-R10/WR-T10 wireless remote controllers; and the MC-DC2 wired remote control. I don't cover these devices, so refer to the device instruction manuals to find out more.

TECHNICAL STUFF

In case you're wondering, the two symbols above the top door have no function other than to remind you of two built-in wireless connection technologies: Bluetooth and Wi-Fi. The appendix of this book explains how to use those features.

FIGURE 1-10:
You can connect a variety of devices, including an external microphone and headphone, to the camera.

On the bottom of the camera, you find the battery chamber and a socket that enables you to mount the camera on a tripod that uses a ¼-inch screw.

Using the Touchscreen

If you've used a smartphone, tablet, or other touchscreen device, working with the camera's touchscreen will feel familiar. Just as with those devices, you communicate with the camera by tapping the screen or by dragging one or two fingers across the screen. For example, you can tap a menu option to select it. And during picture playback, you can magnify a photo by placing your thumb and forefinger in the center of the screen and then dragging outward — a maneuver Nikon refers to as a *stretch.* Dragging inward from the edges of the screen — *pinching* — reduces the image magnification.

TIP

By default, the touchscreen is enabled for both shooting and playback. But you can disable it entirely or use it just for playback if you wish. The following steps walk you through the process of adjusting this option and give you some practice in using the touchscreen:

1. **Press the Menu button to display the camera menus.**

Sadly, there's no touchscreen control that takes you to the menus.

2. **Tap the Setup menu icon, labeled in the left screen in Figure 1-11.**

The options on that menu appear to the right of the icons.

Setup menu icon Scroll bar Exit arrow

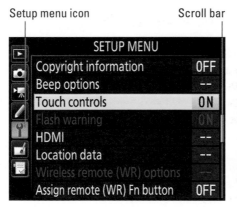 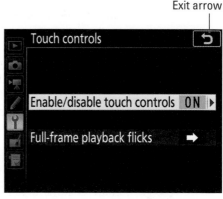

FIGURE 1-11:
Enable or disable the touchscreen via this Setup menu option.

3. **Drag the scrollbar, labeled in Figure 1-11, to scroll the menu display until you see the Touch Controls option.**

4. **Tap Touch Controls to display the screen shown on the right in Figure 1-11.**

5. **Set your touchscreen preferences.**

First, tap Enable/Disable Touch Controls to display these choices:

- *Enable:* All touchscreen functions on (the default setting).

- *Playback only:* The touchscreen works only when the camera is in playback mode. This setting avoids the possibility that an errant tap during shooting adjusts a picture-taking option that you didn't mean to change. But it also prevents you from using the touchscreen to change shooting settings that you *do* want to adjust. Instructions in this book assume that you stick with the Enable setting, but in most cases, you can change settings via other means if you prefer not to use the touchscreen.

- *Disable:* All touchscreen functions are turned off. To restore touchscreen function, you must use the Multi Selector and OK button to select Enable or Playback Only. (See the next section for more help with navigating menus.)

Tap your choice to return to the Touch Controls screen. Or, to exit without making any changes, tap the exit arrow in the top-right corner of the screen, labeled on the right in Figure 1-11.

The Full-frame Playback Flicks setting on the Touch Controls screen determines which direction you flick to see photos in the order you took them. At the default setting, a right-to-left flick scrolls from photo 1 to photo 2, and a flick in the other direction takes you back to picture 1. Choose left-to-right to reverse things. Again, tap your choice or tap the exit arrow to leave the settings screen without making any changes.

6. **Tap the exit arrow to return to the Setup menu.**

Some final tips about the touchscreen:

>> **A white border around a symbol indicates that tapping the symbol performs a function.** For example, a border appears around the exit arrow in the second screen in Figure 1-11.

>> **During Live View shooting, you can tap the screen to set focus and take a picture.** The last section of this chapter tells you more about this feature, known as the Touch Shutter. You also can tell the camera to set focus only when you tap or to disable both tap-to-focus and tap-to-shoot.

WARNING

>> **Don't apply a screen protector.** Applying a screen protector can actually damage the monitor and make it less responsive to your touch.

Navigating Menus

REMEMBER

Although you can change some settings by using camera buttons or by tapping touchscreen symbols, other options are accessible only via the menus.

To display the menus, press the Menu button. You see a screen similar to the one shown in Figure 1-12. The icons along the left side of the screen represent the menus. To the right of the icons are options associated with the current menu. Table 1-1 offers a quick guide to the menus.

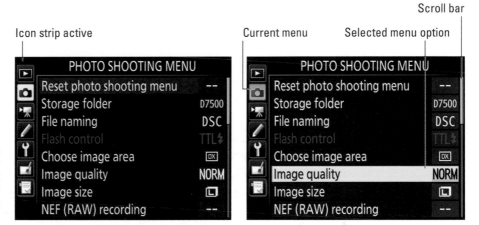

FIGURE 1-12:
The scroll bar indicates that the menu is a multi-page affair.

Here's how to work your way though the menu maze:

>> **Select a different menu.** Your fastest option is to tap the menu's icon. But you also can press the Multi Selector left to activate the icon strip, press up or down to select the icon that represents the menu you want to view, and then press right to access that menu's options.

>> **Select and adjust a menu option.** Again, you can take advantage of the touchscreen or use the Multi Selector:

- *Touchscreen:* If you see a scroll bar on the right side of the window, as in Figure 1-12, drag up or down to scroll to the next page of menu options. Tap the option you want to adjust. Settings available for the selected item then appear; tap the setting you want to use. Or, to exit without making any changes, tap the exit arrow in the upper-right corner of the screen.

- *Multi Selector/OK button:* Press the Multi Selector up or down to scroll the menu until the option you want to change is highlighted. Press OK to display the available settings. Repeat the old up-and-down scroll routine until the choice you prefer is highlighted. Then press OK.

TABLE 1-1 **D7500 Menus**

Symbol	Open This Menu ...	To Access These Functions
▶	Playback	Viewing, deleting, and protecting pictures
📷	Photo Shooting	Basic photography settings
🎬	Movie Shooting	Options related to movie recording
✏	Custom Setting	Advanced photography options and some basic camera operations
🔧	Setup	Additional basic camera operations
🖌	Retouch	Photo and movie editing options
🗒 🗐	My Menu/Recent Settings	Your custom menu or a menu listing the 20 most recently used menu options

REMEMBER

In some cases, a right-pointing triangle appears next to a menu item. That's your cue to tap that triangle or to press the Multi Selector right to display a submenu.

During shooting, items that are dimmed in a menu aren't available in the current exposure mode. For access to all settings, set the Mode dial to P, S, A, or M. When you open the Retouch and Playback menus, the camera dims options that can't be used with the currently selected photo.

» **Select items from the Custom Setting menu.** Displaying the Custom Setting menu, represented by the Pencil icon, takes you to a screen that contains submenus that carry the labels A through G, as shown in Figure 1-13. Each submenu holds clusters of options related to a specific aspect of the camera's operation. To get to those options, tap the submenu name or highlight it with the Multi Selector and press OK.

In the Nikon manual, instructions reference the Custom Setting menu items by a menu letter and number. For example, "Custom Setting a1" refers to the first option on the a (Autofocus) submenu. I try to be more specific, so I use the actual setting names. (Really, we all have enough numbers to remember, don't you think?)

FIGURE 1-13: The Custom Setting menu contains seven submenus of advanced options.

TIP

After you jump to the first submenu, you can simply scroll up and down the list to view options from other submenus. You don't have to keep going back to the initial menu screen and selecting a submenu.

» **Create a custom menu or view your 20 most recently adjusted menu items:** The seventh menu is actually two menus that share an apartment: Recent Settings and My Menu, both shown in Figure 1-14. Each menu contains a Choose Tab option as the last item on the menu; select this option to shift between the two menus.

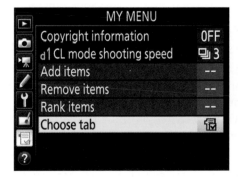

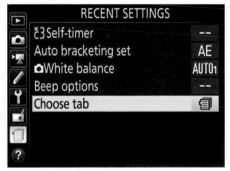

FIGURE 1-14: My Menu enables you to design a custom menu; Recent Settings offers quick access to the last 20 menu options you selected.

Here's what the two menus offer:

- *My Menu:* From this screen, you can create a custom menu that contains your favorite options. Chapter 11 details the steps.

- *Recent Settings:* This screen lists the 20 menu items you ordered most recently. The idea is to save you the time of wading through all the other menus to look for these options.

- To remove an item from the Recent Settings menu, use the Multi Selector to highlight the item and press the Delete button. Press Delete again to confirm your decision. (If you tap the item in the menu, you pull up that item's options screen.)

Checking Out the Displays

Your camera offers several displays to help you keep track of critical shooting settings and other information. The next sections introduce you to each display.

A word of reassurance before you move on: Don't freak out if what you see on your displays doesn't match what's shown here or if you don't have a clue what the symbols and values in the displays mean. The data changes depending on the current camera settings, and most of the data that's displayed relates to features covered later in the book.

For now, just familiarize yourself with the elements labeled in the figures, especially the ones that indicate the battery status and the shots-remaining value — how many more photos your memory card can hold. On the latter point, note that if the card can hold more than 999 photos, the shots-remaining value is followed by the letter *K*, which is the universal symbol for 1,000. So a shots-remaining value of 1.0K means that you can store 1,000 more pictures. The number is rounded down to the nearest hundred. During movie shooting, the display instead reveals how many minutes of video you can record.

REMEMBER

Also know that the camera preserves battery power by automatically turning off the displays after a period of inactivity. Bring the displays back to life by pressing the shutter button halfway and releasing it. In some cases, you can use other techniques, which I spell out in the section discussing each display.

Control panel (top LCD display)

Control panel is the official name of the display on top of the camera, shown in Figure 1-15. The symbol that represents a full battery is labeled in the figure, as is the shots-remaining value.

TIP

As noted earlier, rotating the On/Off switch to the light bulb position temporarily adds a backlight to make the panel easier to read in the dark. The light turns off automatically a few seconds after you release the switch. If you regularly need the backlight, you can set the camera to turn it on any time the exposure meters are activated: Open the Custom Setting menu, choose Shooting/Display, and set the LCD Illumination option to On. Of course, this option adds to battery consumption.

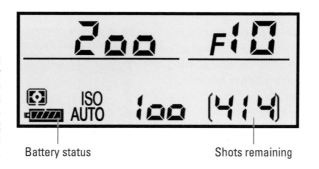

FIGURE 1-15:
You can quickly
confirm the
battery status
and shots-
remaining
value in the
Control panel.

Battery status Shots remaining

Note that even when the camera is turned off, the shots-remaining value remains visible in the Control panel unless you remove the camera battery.

Information display

Shown in Figure 1-16, the Information display appears on the monitor during viewfinder photography — that is, when Live View is not engaged.

By default, the screen appears when you turn on the camera and when you press the shutter button halfway. It turns off automatically when you put your eye to the viewfinder, thanks to the eye sensor located above the viewfinder. You also can press the Info button to toggle the display on and off.

You can customize a few aspects of the display through the following Setup menu options:

Battery status

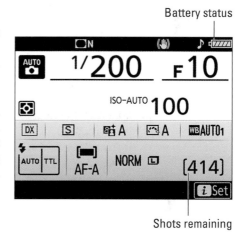

Shots remaining

FIGURE 1-16:
The Information display provides a larger and more complete view of camera settings than the Control panel.

>> **Change the color scheme.** By default, the camera tries to make the data easier to read by automatically shifting from black text on a light background to light text on a black background, depending on the ambient light. If you prefer one style over the other, scroll to the second page of the Setup menu and choose Information Display, as shown in Figure 1-17. On the next screen, select Manual, and then choose either Dark on Light or Light on Dark. In this book, I show the Dark on Light display because it reproduces better in print. To go back to the default setup, change the Information Display setting to Auto.

» Limit the on/off function to the Info button: By default, you actually can press a number of buttons other than the Info button to turn the Information display on. You can press the *i* button, for example, and other buttons related to adjusting shooting settings. If you want to rely solely on the Info button to turn on the display, choose the Auto Info Display option, found just below the Information Display option on the Setup menu, and change the setting to Off. But here's a tip: Even if you select this setting, you can press the *i* button to get to the Information display: Press once to bring up the *i*-button menu, explained a few sections from here. Press the button a second time to exit that menu and view the Information display.

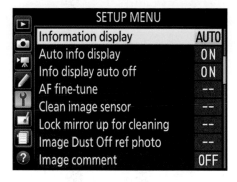

FIGURE 1-17:
Scroll to the second page of the Setup menu to access options that customize the Information display.

» Disable the eye sensor: If for some reason you want the Information display to remain on even when you're looking through the viewfinder, you can make it so. Travel one more step down the Setup menu and change the Info Display Auto Off option to Off.

If you're thinking, "Gee, Nikon might have made some effort to make the names of these three settings a little less similar," I'm in complete agreement. Fortunately, help screens are available to remind you which option does what. Just press the Help button to view information about the currently selected option. (The question mark in the lower-left corner of the menu screen indicates that help is available.)

» Display a virtual horizon on the monitor. Scroll back to the first page of the Setup menu, shown in Figure 1-18, and choose Virtual Horizon to display an electronic level, as shown on the right side of the figure. This feature is useful when you use a tripod and need to make sure that the camera is level. A green line like the one shown in the figure indicates the level position. Tap the exit arrow in the upper-right corner to return to the menu screens.

Viewfinder display

You can see limited shooting data at the bottom of the viewfinder, as shown in Figure 1-19. Again, ignore everything for now but the battery information and shots–remaining value, labeled on the left in the figure. The latter works the same way as in the other displays, but the battery–status symbol does not: When the

battery is running low on power, the almost-empty symbol shown in the figure appears. But the icon *only* shows up to alert you that the battery will soon need charging. When the battery is full, no icon appears.

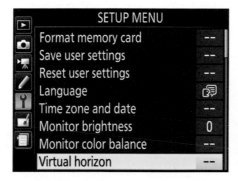
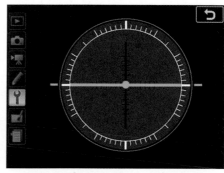

FIGURE 1-18: Choose this Setup menu option to display an electronic level on the monitor.

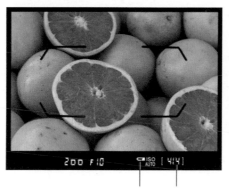
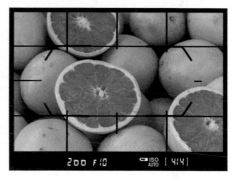

FIGURE 1-19: Along with the shots-remaining value, the viewfinder displays a low-battery warning (left); you also can add an alignment grid (right).

Low-battery warning Shots remaining

When it's important to align objects in your shot precisely, you may want to display a grid in the viewfinder, as shown on the right in Figure 1-19. Turn the grid on and off through the Viewfinder Grid Display option, found in the Shooting/Display section of the Custom Settings menu.

Additionally, you can display a viewfinder version of the virtual horizon feature. Instead of the graphic you can display on the monitor (refer to Figure 1-18) you see *pitch* and *roll* bars, which indicate alignment with respect to a horizontal and vertical axis. To see what I'm talking about, find the Fn1 button on the front of the camera. With your finger on the button, look through the viewfinder, holding the camera in the normal horizontal position. Press and hold the Fn1 button, and bars appear along the bottom and the right side of the viewfinder framing area. As you tilt the camera this way and that, the number of notches on the bar changes to show you the *pitch* (alignment to horizontal axis) and *roll* (alignment to vertical axis). When you see just a single notch at the center of each bar, you've hit the mark.

If you rotate the camera to a vertical orientation, the bars at the top of the frame indicate pitch; the bars on the right, roll.

Live View display

During Live View photography and movie recording, settings appear on the live preview, as shown in Figure 1-20. The left screen shows the default display for photography; the right screen, for movie recording. In both cases, this display is officially called *Information On*.

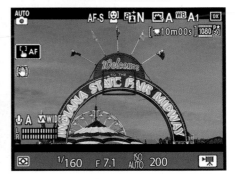

FIGURE 1-20:
These screens show the default display for Live View photography (left) and movie recording (right).

 By pressing the Info button, you can cycle from the Information On display to the Information Off display, shown in the upper-left screen in Figure 1-21. Keep pressing the button to cycle through the remaining display styles, also shown in the figure. Note, though, that the Histogram display is available only during movie recording. (A *histogram* is a chart that indicates exposure information; Chapter 9 explains how to read a histogram.)

 Regardless of which display you prefer, note the following Live View tips and precautions:

WARNING

>> **Cover the viewfinder to prevent light from seeping into the camera and affecting exposure.** Nikon provides the DK-5 eyepiece cap just for this purpose; dig around in the camera box if you haven't already discovered the cap. To use the cap, first slide the rubber eyecup that surrounds the view-finder up and out of the groove that holds it in place. Then slide the eyepiece cap down into the groove. (Orient the cover so that the Nikon label faces the viewfinder.)

Information Off

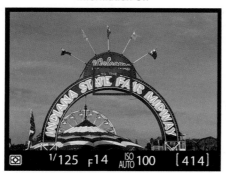

Framing Guides

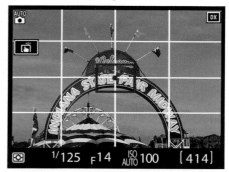

Histogram (Movie mode only)

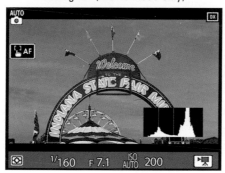

Virtual Horizon

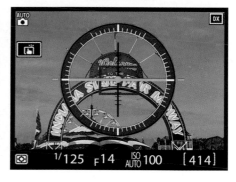

FIGURE 1-21:
Press the Info button to cycle through the available Live View and Movie mode display styles.

>> **In Live View mode, the monitor turns off by default after 10 minutes of inactivity.** When monitor shutdown is 30 seconds away, a countdown timer appears in the upper-left corner of the screen. To adjust the shutdown timing, open the Custom Setting menu, choose Timers/AE Lock, choose Monitor Off Delay, and select Live View.

>> **Using Live View for an extended period can harm your pictures and the camera.** In Live View mode, the camera heats up more than usual, and that extra heat can create the proper electronic conditions for *noise*, a defect that gives your pictures a speckled look. More importantly, the increased temperatures can damage the camera. For that reason, Live View is automatically disabled if the camera detects a critical heat level.

>> **Aiming the lens at the sun or another bright light can damage the camera.** Of course, you can cause problems by doing this even during viewfinder shooting, but the possibilities increase when you use Live View. You can harm not only the camera's internal components but also the monitor (not to mention your eyes).

REMEMBER

>> **Some lights interfere with the Live View display.** The operating frequency of some types of lights, including fluorescent and mercury-vapor lamps, can cause the monitor to flicker or exhibit odd color banding during Live View shooting and movie recording. Changing the Flicker Reduction option on the Movie Shooting menu may resolve this issue. At the default setting, Auto, the camera gauges the light and chooses the right setting for you. But you also can choose from two specific frequencies: 50 Hz and 60 Hz. (In the United States and Canada, the standard frequency is 60 Hz; in Europe, it's 50 Hz.)

This Flicker Reduction setting, by the way, is a different animal than the one on the Photo Shooting menu, which is designed to address exposure problems related to certain types of artificial lighting. See Chapter 4 for help with that Flicker Reduction option.

Saving Time with the i-Button Menu

Pressing the *i* button, labeled in Figure 1-22, displays a limited menu, henceforth known as the *i*-button menu. The idea is to give you a faster way to access these options than going through the regular menu system.

Which options appear depends on whether you're using the viewfinder, shooting stills in Live View mode, recording movies, or viewing pictures in playback mode. Figure 1-22 shows the *i*-button menu that appears during viewfinder photography when you shoot in the P, S, A, or M exposure modes. As is the case with regular menus, dimmed options are unavailable, either because they conflict with a current shooting setting or, during playback mode, don't work with the type of picture or movie file you're viewing.

i button

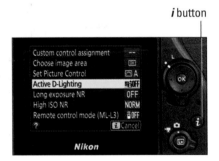

FIGURE 1-22:
During viewfinder shooting, press the *i* button to display this mini-menu of settings.

During viewfinder photography and picture playback, select menu items as you normally would: Tap the item or use the Multi Selector to highlight it and then press the OK button.

In Live View or Movie mode, the *i*-button menu appears as shown in Figure 1-23. The icons that run down the right side of the screen represent the various menu options, which vary depending on whether you're shooting photographs or recording movies. The name of the currently selected option

appears at the top of the screen; in Figure 1-23, the Active D-Lighting option is selected, for example. Again, just tap an option or highlight it and press OK to display the available settings for that option. Remember that the scroll bar on the right side of the screen indicates that the menu has a second page. Drag down on the scroll bar or press the Multi Selector down to display that page.

Exit the *i*-button menu by pressing the *i* button or tapping Cancel (lower-right corner of the touchscreen.)

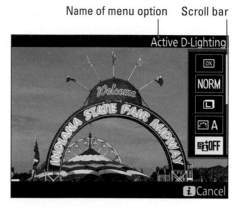

Name of menu option Scroll bar

FIGURE 1-23:
In Live View or Movie mode, the *i*-button menu takes on this appearance.

Familiarizing Yourself with the Lens

Because I don't know which lens you're using, I can't give you full instructions on its operation. But the following basics apply to most Nikon lenses as well as to many third-party lenses. (You should explore the lens manual for specifics, of course.)

>> **Setting the focusing method (Auto or Manual):** Assuming that your lens offers autofocusing as well as manual focusing, it has a switch that you use to choose between the two options. On the 18–140mm kit lens shown in Figure 1-24, choose M for Manual focus and A for Autofocus.

You also need to check the Focus-mode selector switch on the camera itself. This switch is also labeled in Figure 1-24. For autofocusing, move the switch to the AF position; for manual focusing, the M position.

REMEMBER

By pressing the AF-mode button in the center of the Focus-mode selector, you access two settings that control autofocusing behavior, a topic I save for Chapter 5.

>> **Focusing:** Use these techniques to set focus:

• *Autofocusing:* Press and hold the shutter button halfway down. During Live View shooting, you also can tap the screen to focus, but if the Touch Shutter is enabled, as it is by default, the camera takes a picture immediately after you lift your finger.

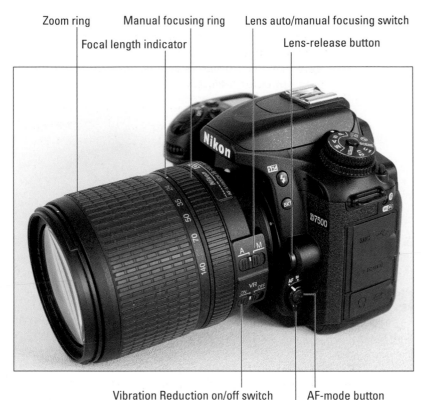

Zoom ring Manual focusing ring Lens auto/manual focusing switch

Focal length indicator Lens-release button

Vibration Reduction on/off switch AF-mode button

Focus-mode selector

FIGURE 1-24:
Set the focus
mode both on
the camera
body and
the lens.

- *Manual focusing:* Rotate the focusing ring on the lens barrel. The position of the focusing ring varies depending on the lens; I labeled the one found on the 18–140mm kit lens in Figure 1-24.

>> **Zooming:** If you bought a zoom lens, it has a movable *zoom ring* that you adjust to change the focal length of the lens. Figure 1-24 shows the location of the zoom ring on the 18–140mm lens. To zoom in or out, rotate the ring. Some lenses instead require a push/pull zoom action.

TIP

You can determine the current focal length of the lens by looking at the number that's aligned with the white dot labeled *focal-length indicator* in Figure 1-24. (If you're new to the term focal length, the nearby sidebar "Focal length and the crop factor," explains the subject.)

>> **Enabling Vibration Reduction:** Many Nikon lenses offer *Vibration Reduction,* which compensates for small amounts of camera shake that can occur when you handhold the camera. Camera movement during the exposure can produce blurry images, so turning on Vibration Reduction can help you get sharper handheld shots. When you use a tripod, however, turn the feature off

so that the camera doesn't try to compensate for movement that isn't occurring. Turn Vibration Reduction on or off via the VR switch (refer to Figure 1-24). The available settings vary depending on the lens, so again, see the lens manual for details.

When Vibration Reduction is enabled, the image in the viewfinder may appear blurry immediately after you take the picture. That's a normal result of the Vibration Reduction system and doesn't affect your photo.

TIP

In Movie mode, you also can enable Electronic VR from the Movie Shooting menu. This feature complements camera-shake compensation offered by your lens with a digital version built into the camera

FOCAL LENGTH AND THE CROP FACTOR

The angle of view that a lens can capture is determined by its *focal length*, or in the case of a zoom lens, the range of focal lengths it offers. Focal length is measured in millimeters. The shorter the focal length, the wider the angle of view. As focal length increases, the angle of view narrows, and the subject occupies more of the frame.

Generally speaking, lenses with focal lengths shorter than 35mm are considered *wide angle lenses* and lenses with focal lengths greater than 80mm are considered *telephoto* lenses. Anything in the middle is a "normal" lens, suitable for shooting scenes that don't require either a wide or narrow angle of view.

Note, however, that the focal lengths stated in this book and elsewhere are *35mm equivalent focal lengths.* Here's the deal: When you put a standard lens on most dSLR cameras, including the D7500, the available frame area is reduced, as if you took a picture on a camera that uses 35mm film negatives and cropped it. This *crop factor* varies depending on the camera, which is why the photo industry adopted the 35mm-equivalent measuring stick as a standard.

With the D7500, the crop factor is roughly 1.5x. When shopping for a lens, remember this crop factor to make sure that you get the focal length designed for the type of pictures you want to take. Just multiply the lens focal length by 1.5 to determine the actual angle of view.

Not sure which focal length to choose? Nikon offers a Lens Simulator tool that shows exactly how different focal length lenses capture the same scene. To find it, enter the term *Nikon Lens Simulator* in your browser's search engine. Be sure to set the simulator's Camera Body option to DX; that's the name Nikon uses for the size of sensor used in your camera.

>> **Removing a lens:** After turning off the camera, press the lens-release button (refer to Figure 1-24), and turn the lens toward that button until it detaches from the lens mount. Put the rear protective cap onto the back of the lens and, if you aren't putting another lens on the camera, cover the lens mount with its cap, too.

WARNING

Always switch lenses in a clean environment to reduce the risk of getting dust, dirt, and other contaminants inside the camera or lens. Changing lenses on a sandy beach, for example, isn't a good idea. For added safety, tilt the front of the camera body slightly down when performing this maneuver; doing so helps prevent any flotsam in the air from being drawn into the camera by gravity.

Working with Memory Cards

As the medium that stores your picture files, the memory card is a critical component of your camera. See the steps at the start of this chapter for help installing a card; follow these tips for buying and maintaining cards:

>> **Buying SD cards:** Again, you can use regular SD cards, which offer less than 4GB of storage space; SDHC cards (4GB–32GB); and SDXC cards (more than 32GB). Aside from card capacity, the other specification to note is *SD speed class,* which indicates how quickly data can be moved to and from the card (the *read/write speed*).

Card speed is indicated in several ways. The most common spec is SD Speed Class, which rates cards with a number between 2 and 10, with 10 being the fastest. Most cards also carry another designation, UHS-1, -2, or -3; UHS (Ultra High Speed) refers to a new technology designed to boost data transmission speeds above the normal Speed Class 10 rate. The number 1, 2, or 3 inside a little U symbol tells you the UHS rating; UHS-3 is fastest.

Some cards also are rated in terms of how they perform when used to record video — specifically, how many frames per second the card can handle. As with the traditional Speed Class rating and UHS rating, a higher video-speed number indicates a faster card.

>> **Formatting a card:** The first time you use a new memory card or insert a card that's been used in other devices, you need to *format* it to prepare it to record your pictures. You also need to format the card if you see the blinking letters *FOR* in the viewfinder or if the monitor displays a message requesting formatting.

WARNING

Formatting erases everything on your memory card. So before you format a card, be sure that you've copied any data on it to your computer. After doing so, get the formatting job done by selecting Format Memory Card, which is the first option on the Setup menu.

You also can use this formatting shortcut: Press the Delete and ISO buttons simultaneously until the word Format blinks on the monitor. To proceed, press both buttons again. The word Format appears in red next to each button to remind you of this option.

>> **Removing a card:** After the memory card access light turns off, indicating the camera has finished recording your most recent photo, turn off the camera. Open the memory card door, push down on the card slightly, and then let go. The card pops halfway out of the slot, enabling you to grab it by the tail and remove it.

REMEMBER

If you turn on the camera when no card is installed, the symbol [-E-] blinks in the lower-right corner of the viewfinder. A message on the monitor also nudges you to insert a memory card. If you have a card in the camera and you get these messages, try taking out the card and reinserting it.

>> **Handling cards:** Don't touch the gold contacts on the back of the card. (See the right card in Figure 1-25.) When cards aren't in use, store them in the protective cases they came in or in a memory card wallet. Keep cards away from extreme heat and cold as well.

Lock switch Don't touch!

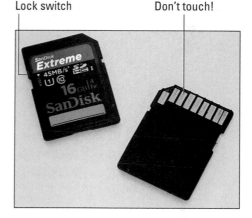

>> **Locking cards:** The tiny switch on the side of the card, labeled *Lock switch* in Figure 1-25, enables you to lock your card, which prevents any data from being erased or recorded to the card. If you insert a locked card into the camera, a message on the monitor alerts you, and the symbol Cd blinks in the viewfinder.

FIGURE 1-25:
Avoid touching the gold contacts on the card.

>> **Using Eye-Fi memory cards:** Your camera works with *Eye-Fi memory cards,* which are special cards that enable you to transmit your files wirelessly to your computer. I don't cover these cards in this book because they're more expensive than regular cards.

Taking a Few Final Setup Steps

Your camera offers scads of options for customizing its performance, some of which I discuss earlier in this chapter. Later chapters explain settings related to actual picture-taking, such as those that affect flash behavior and autofocusing, and Chapter 11 talks about some options that are better left at their default settings until

you're fully familiar with your camera. That leaves just the following options that I recommend you consider at the get-go. All these options live on the Setup menu.

The menu is a multiple-page affair. Drag on the touchscreen scrollbar or use the Multi Selector to move from page to page and check the status of the following settings:

>> **Monitor Brightness:** This option, highlighted in Figure 1-26, makes the display brighter or darker. But if you take this step, what you see on the monitor may not be an accurate rendition of the picture exposure. I recommend that you keep the brightness at the default setting (0).

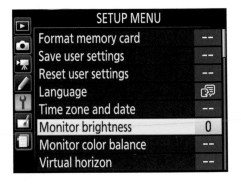

>> **Monitor Color Balance:** With this option, you can recalibrate the monitor if you think the screen is displaying colors incorrectly. I don't advise taking this step until you take the camera to a Nikon expert to

FIGURE 1-26:
Visit the Setup menu to customize the camera's basic operations.

make sure that it's your monitor, and not your picture or movie color settings, to blame. Also be sure to calibrate your computer monitor so that *it* displays pictures on a neutral canvas. Do an online search for *monitor calibration tools* for tips on taking that step.

>> **Clean Image Sensor:** Your camera has an internal cleaning system designed to keep a filter that's fitted onto the image sensor free of dust and other debris, which can show up as small spots in your photos. To run the cleaner, choose this option and then select Clean Now. Set the camera on a flat surface for best results. If you perform the cleaning sequence multiple times in a row, the camera may shut down briefly to give its circuitry a rest.

By default, your camera also cleans the sensor every time you turn the camera on and off. Adjust this setting through the second option on the main Clean Image Sensor screen, Clean at Startup/Shutdown.

>> **Lock Mirror Up for Cleaning:** This menu option moves the camera's internal mirror so that you can access the image sensor for manual cleaning. I don't recommend that you tackle this job yourself because you can easily damage the camera if you don't know what you're doing. If you *are* comfortable with the process, be sure that the camera battery is charged; the menu option disappears when the battery is low.

>> **Beep Options:** By default, your camera beeps after certain operations, such as after it sets focus when you shoot in autofocus mode. When the touchscreen is

enabled, you also hear a little "boop" every time you tap a screen item. If you need the camera to shut up, silence it via the Beep Options menu item.

To silence just touchscreen sounds, choose Beep On/Off option and then select Off (Touch Controls Only). Choose Off instead to disable the beep for all operations. You also can adjust the loudness and tone of the beep through the Volume and Pitch options.

>> **Location Data:** If you purchase the optional Nikon GPS unit, this item enables you to embed data related to the camera location into the file data for each file. This book doesn't cover this accessory, but the camera manual provides help to get you started.

When your camera is connected to a smartphone or other smart device, you can embed that device's location data. See the appendix for a getting-started guide to using this and other wireless features.

>> **Airplane Mode:** Again, I cover wireless functions in the appendix, but take a moment now to check the Airplane Mode option, found on the third page of the Setup menu. Like the Airplane Mode on a smartphone or tablet, this setting shuts down the camera's wireless transmissions, which your flight crew will politely ask you to do before takeoff. Even when you're not in an environment that prohibits wireless signals, enabling Airplane Mode saves battery power, so I recommend changing this setting from the default, Off, to On until you're ready to use the wireless functions.

TIP

An airplane symbol appears in the upper-left corner of the Information display and in the lower-right corner of the Live View screen when Airplane Mode is on. (In Live View mode, the symbol appears only in the default display style; press the Info button to change the style.)

>> **Conformity Marking:** I bring this one up just so that you know you can ignore it: When you select the option, you see logos indicating the camera conforms with certain camera-industry standards. More symbols appear in the area behind the monitor; to see them, tilt the monitor up and out from the camera back.

>> **Battery Info:** Select this option to display the detailed battery information shown in Figure 1-27. The Charge data shows you the current power remaining as a percentage value, and the No. of Shots value tells you how many times you've pressed and released the shutter button since the last time you charged the battery. The final readout, Battery Age, lets you know how much more life you can expect

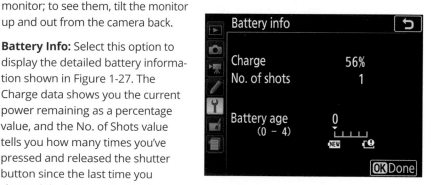

FIGURE 1-27:
Choose Battery Info from the Setup menu for details about battery life.

out of the battery before it can no longer be recharged. When the display moves toward the right end of the little meter, it's time to buy a new battery. (If you attach the optional battery pack, see its user manual to find out how to interpret the data that's reported on this menu screen.)

>> **Slot Empty Release Lock:** This option determines whether the shutter release is disabled when no memory card is in the camera. At the default setting, OK, you can take a temporary picture, which appears in the monitor with the word *Demo* but isn't recorded anywhere. (The feature is provided mainly for use in camera stores, enabling salespeople to demonstrate the camera without having to keep a memory card installed.)

WARNING

I suggest that you change the setting to Release Locked. It's too easy to miss that *Demo* message and think you've recorded a picture when you really haven't.

>> **Firmware Version:** Select this option to view which version of the camera *firmware,* or internal software, your camera runs. You see the firmware items C and L. At the time this book was written, C was version 1.00; L was 2.016.

Keeping your camera firmware up to date is important, so visit the Nikon website (www.nikon.com) regularly to find out whether your camera sports the latest version. You can find detailed instructions at the site on how to download and install any firmware updates.

Restoring Default Settings

If you want to return your camera to its original, out-of-the-box state, the camera manual contains a complete list of most of the default settings. Look on the pages that introduce each of the menus.

You can also partially restore default settings by taking these steps:

>> **Reset the Photo Shooting, Movie Shooting, and Custom Setting menus:** At the top of each of these menus, you find an option that resets all the menu's functions. Well, almost all functions: Resetting the Photo Shooting menu does not affect the Storage Folder option, which is a concern only if you create custom folders, as outlined in Chapter 11.

>> **Restore critical picture-taking settings *without* affecting all options on the Custom Setting menu:** Use the two-button reset method: Press and hold the Exposure Compensation button (top of camera) and the Metering Mode button (lower-left corner of camera back) simultaneously for longer than 2 seconds. The little green dots near these two buttons are a reminder of this function. See the camera manual for a list of which settings are restored.

Shooting Pictures in Auto Mode

Your camera is loaded with features for the advanced photographer, enabling you to exert precise control over options such as f-stop, shutter speed, ISO, flash power, and much more. But you don't have to wait until you master those topics to take great pictures, because your camera also offers point-and-shoot simplicity through its Auto exposure mode.

The next two sections walk you through the process of taking a picture in Auto mode, starting with normal (viewfinder) photography and then moving on to Live View photography. Both sets of steps assume that you're using the default picture settings. For information on how to restore the defaults, see the preceding section.

Viewfinder photography in Auto mode

When using the viewfinder, follow these steps to take a picture:

1. Set the Mode dial to Auto.

I labeled the setting in Figure 1-28. Remember to press and hold the Mode dial unlock button before rotating the dial.

2. Set the Release mode to S by pressing the Release Mode unlock button while rotating the Release Mode dial.

I labeled these elements in Figure 1-28. The *S* setting represents Single Frame Release mode, which captures one photo each time you press the shutter button.

3. Set the focus-method switches on the camera and lens to the autofocus position.

See Figure 1-24 for a reminder of where to find these switches.

4. Looking through the viewfinder, compose the shot so that your subject is within the autofocus brackets, labeled in Figure 1-29.

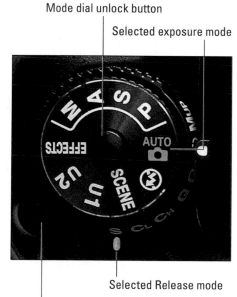

Mode dial unlock button

Selected exposure mode

Selected Release mode

Release Mode dial unlock button

FIGURE 1-28:
Press the unlock buttons before rotating the Mode and Release Mode dials.

5. **Press and hold the shutter button halfway down.**

The camera chooses exposure settings based on the available light, raising the flash automatically if the ambient light is insufficient. At the same time, the autofocus system starts to do its thing. The AF-assist lamp on the front of the camera may shoot out a beam of light to help the camera find a focusing target.

6. **Check the focus indicators.**

One or more rectangles, representing focus points, briefly flash red in the viewfinder to show you where the camera is trying to set focus.

When the camera establishes focus, a single black focus point appears, as shown in Figure 1-30. At the bottom of the viewfinder, the focus indicator, labeled in the figure appears.

REMEMBER

If the subject isn't moving, focus remains locked as long as you hold the shutter button halfway down. But if the camera detects subject motion, it adjusts focus as needed up to the time you press the button fully to record the picture. As your subject moves, keep it within the autofocus brackets to ensure correct focusing.

7. **Press the shutter button the rest of the way to record the image.**

While the camera sends the image data to the memory card, the memory card access lamp lights. Don't turn off the camera or remove the memory card while the lamp is lit or else you may damage both camera and card.

Autofocus brackets

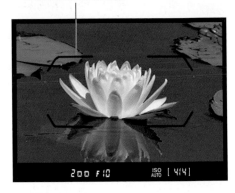

FIGURE 1-29:
Position your subject within the area surrounded by the autofocus brackets.

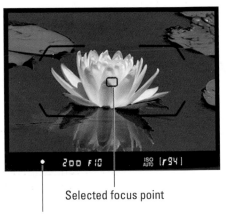

Selected focus point

Focus indicator

FIGURE 1-30:
The focus indicator lights when the camera establishes focus.

REMEMBER

WHAT DOES [R94] IN THE DISPLAYS MEAN?

In the viewfinder, the value in brackets at the right end of the display normally indicates the number of additional pictures that can fit on your memory card. This same value appears in the lower-right corner of the Control panel, Information display, and Live View display. When you press the shutter button halfway to initiate exposure metering and autofocusing, the value changes to show you how many pictures can fit in the camera's *memory buffer,* which is a temporary storage tank where the camera stores picture data until it has time to record that data to the memory card. For example, [*r94*] tells you that the buffer can hold 94 pictures. This system exists so that you can take a continuous series of pictures without waiting between shots until each image is written to the card. When the buffer is full, you can't take another picture until the camera catches up with its recording work.

TIP

Live View photography in Auto mode

For still photography, I don't use Live View often, for these reasons:

» **When you shoot outdoors in bright light, the Live View display washes out, making it difficult to get a good look at your subject.** Of course, the adjustable monitor enables you to reposition the screen to get the best possible view. Even so, don't expect to see things quite as clearly as you can through the viewfinder.

» **If you handhold the camera, you face an increased risk that camera shake will blur the image.** Any movement of the camera during the exposure can blur your photo. This is true for viewfinder photography, too, but when you use the viewfinder, you can brace the camera against your face. With Live View, you have to hold the camera out in front of you, making it more difficult to keep the camera steady during the shot. Long story short: Use a tripod for best Live View results.

» **Because the monitor remains on during shooting, the camera battery drains faster.** That means you have to stop shooting and recharge the battery more often than when using the viewfinder.

I do find Live View helpful for shooting still-life photos indoors, though. Being able to see the scene on the monitor saves me from having to repeatedly check the viewfinder while I'm arranging objects in the scene. Additionally, the tilting monitor can make shooting from certain angles easier, indoors or out. For example, if you're in a crowd and can't get a clear shot from eye level, you can raise the camera to shoot over the heads of people in front of you, angling the monitor so that you can see the subject.

Okay, enough preamble: Here are the steps to take a Live View picture in Auto mode using autofocusing and the default picture settings:

1. **Set the Mode dial to Auto and set the Release mode dial to S.**

Refer to Figure 1-28 to see the dials — don't forget to hold down the associated unlock button while rotating either dial.

2. **Set the lens and camera to autofocusing.**

See the section "Familiarizing Yourself with the Lens" if you need help with this step.

3. **Set the Live View switch to the Still Photo position, as shown in Figure 1-31, and then press the LV button to engage Live View.**

The viewfinder goes dark, and the scene in front of the lens appears on the monitor, along with some shooting data.

Press the Info button to cycle through the available Live View displays.

4. **Compose your shot.**

5. **Check the position of the focusing frame. If necessary, adjust the frame so that it's over your subject.**

The focus frame that appears depends on your subject:

- *Portraits:* By default, the camera uses an autofocusing option called Face Priority AF-area mode. If it detects a face, it displays a yellow focus box over it. In a group portrait, you may see several boxes, as shown on the left in Figure 1-33. The box that includes the interior corner marks indicates the face that will be used to set the focusing distance. To use a different face as the focus point, use the Multi Selector to move the focus box over it.

Focus-selector lock switch

Live View switch/button

FIGURE 1-31:
Set the Live View switch to the still-camera position and then press the LV button to turn on the Live View display.

- *Other subjects:* If the camera can't detect a face, it switches to Wide Area AF-area mode, with the focus area indicated by a red box in the center of the screen, as shown on the right in Figure 1-32. Again, use the Multi Selector to move the focus box over your subject. For example, in the figure, I moved the focus box over the center of the rose. Press the OK button to move the focus box quickly back to the center of the frame.

You also can set a focus point by tapping your subject on the screen, but avoid that option for now: By default, the Touch Shutter feature is enabled, so the camera immediately takes the picture after you tap. See the list at the end of this section for details.

Face-priority frame Selected face Wide-area focus frame

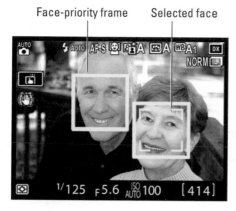 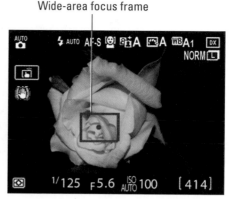

FIGURE 1-32:
If the camera recognizes faces, you see yellow focus frames over each face (left); otherwise, a single red focus frame appears (right).

WARNING

If nothing happens when you try to move the focus frame, check the position of the Focus-selector lock switch, labeled in Figure 1-31. If the white bar is aligned with the L, the focus frame is locked at the center of the frame. Move the switch so that the marker aligns with the white dot, as shown in the figure.

6. Press the shutter button halfway to set focus and initiate exposure metering.

When focus is set, the focus box turns green, as shown in Figure 1-33. In dim lighting, the built-in flash may pop up.

By default, the camera locks focus when you press the shutter button halfway, even if the subject is moving. To find out how to change this autofocusing behavior so that the camera tracks a moving subject, see the Chapter 5 section related to the Autofocus mode setting.

REMEMBER

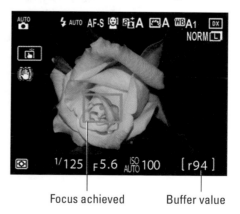

Focus achieved Buffer value

FIGURE 1-33:
The focus frame turns green when focus is achieved.

7. Press the shutter button all the way down to record the picture.

Now for the promised explanation of the Touch Shutter feature. During Live View still photography, this feature enables you to tap your subject on the monitor to set focus. When you lift your finger, the camera releases the shutter to take the picture. If you prefer, you can set the Touch Shutter to set focus only or to abandon both its focusing and shutter-release functions. To change the setting, tap the Touch Shutter symbol, labeled in Figure 1-34. Each time you tap the symbol, a text label identifying the current setting appears. For still photography, you can choose from three settings:

>> **Touch Shutter/AF: On:** The camera sets focus on the spot you tap and then releases the shutter to take the picture.

>> **Touch AF: On:** Your tap sets focus only. The camera does set focus again when you press the shutter button to take the picture, but it bases focus on the spot you tapped. In other words, for Live View still photography in Auto mode, this Touch Shutter option is there simply to make it easier to move the focus frame over your subject.

>> **Touch Shutter/AF Off:** Disables both tap-to-focus and tap-to-snap. You then use the Multi Selector to position the focus frame and press the shutter button halfway to set focus.

Touch focus only

Touch focus and touch shutter disabled

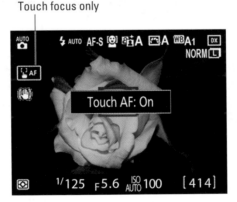 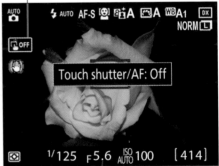

FIGURE 1-34: Tap the Touch Shutter symbol to tell the camera to set focus only, set focus and release the shutter, or disable both functions.

IN THIS CHAPTER

» **Selecting an exposure mode**

» **Changing the shutter-release mode**

» **Choosing the right Image Size setting**

» **Understanding the Image Quality setting: JPEG or Raw?**

» **Exploring the 1.3x crop option (Image Area setting)**

Chapter **2**

Reviewing Five Essential Picture-Taking Options

E very camera manufacturer strives to ensure that your initial encounter with the camera is a happy one. To that end, the D7500's default settings are designed to make it easy to take a good picture the first time you press the shutter button. The camera is set to the Auto exposure mode, which means that all you need to do is frame, focus, and shoot, as outlined at the end of Chapter 1.

Although the default settings deliver acceptable pictures in many cases, they don't produce optimal results in every situation. You may be able to take a decent portrait in Auto mode, for example, but by tweaking a few settings, you can turn that decent portrait into a stunning one.

This chapter helps you start fine-tuning the camera settings by explaining five basic picture-taking options: exposure mode, shutter-release mode, image size, image quality, and image area. They're not the most exciting features (don't think I didn't notice you stifling a yawn), but they make a big difference in how easily you can capture the photo you have in mind. You should review these settings before each photo outing.

Choosing an Exposure Mode

REMEMBER

The first setting to consider is the exposure mode, which determines how much control you have over two critical exposure settings — aperture and shutter speed — as well as many other options. Select the exposure mode by pressing the Mode dial unlock button, labeled in Figure 2-1, and then rotating the dial until the symbol representing the mode you want to use aligns with the white bar to the right of the dial. In the figure, Auto mode is selected.

Exposure modes fall into three categories: fully automatic, semiautomatic, and manual. The next three sections provide the background you need to choose the right mode.

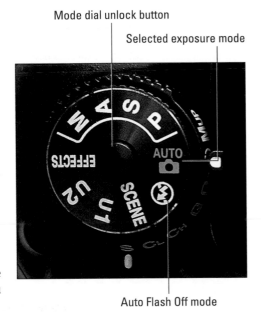

Mode dial unlock button

Selected exposure mode

Auto Flash Off mode

FIGURE 2-1:
The Mode setting determines how much input you have over exposure, color, and other picture options.

Fully automatic exposure modes

My guess is that you bought this book for help with using the camera's advanced exposure modes, so they receive the majority of the page space. But until you have time to digest that information — or if you just need a break from thinking about the advanced options — you can take advantage of point-and-shoot modes outlined in the next three sections.

WARNING

Because these modes are designed to make picture-taking simple, they prevent you from accessing many of the camera's features. You can't use the White Balance control, for example, to tweak picture colors. Options that are off-limits appear dimmed in the camera menus and other settings screens.

Auto and Auto Flash Off modes

In both Auto and Auto Flash Off modes, the camera analyzes the scene and selects what it considers the most appropriate settings to capture the image. The only difference between the two modes is that Auto Flash Off (labeled in Figure 2-1) disables flash. In Auto mode, you can choose from a few Flash modes, which I detail in Chapter 3.

The last two sections in Chapter 1 show you how to take pictures using Auto mode. Follow the same steps to use Auto Flash Off.

Effects mode

Effects mode works like Auto except that the camera applies your choice of ten special effects to the picture as you shoot. Chapter 12 provides details on Effects mode and also explains how you can apply effects to existing pictures via the Retouch menu.

Scene modes

Setting the Mode dial to Scene provides access to automatic exposure modes designed to capture specific subjects in ways deemed best according to photography tradition. For example, in Portrait mode, skin tones are manipulated to appear warmer and softer, and the background appears blurry to bring attention to your subject. In Landscape mode, greens and blues are intensified, and the camera tries to maintain sharpness in both near and distant objects. Figure 2-2 offers examples of both modes.

Portrait mode

Landscape mode

FIGURE 2-2: Portrait mode produces pleasant skin tones and a soft background; Landscape mode delivers vivid colors and keeps both foreground and background objects sharp.

An icon representing the current Scene type appears in the upper-left corner of the monitor, as shown in Figure 2-3. (In Live View mode, you may need to press the Info button to cycle through the various Live View displays until you reach one that shows the icon.)

Current Scene mode (Portrait)

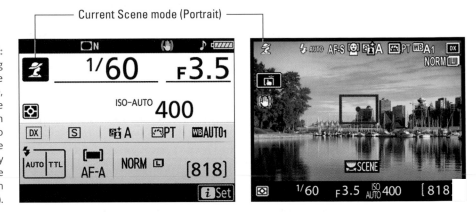

FIGURE 2-3: After setting the Mode dial to Scene, the exposure mode icon changes to indicate the currently selected scene (Portrait, in these screens).

To access other Scene modes, rotate the Main command dial to display a selection screen, as shown in Figure 2-4. Keep rotating the dial to advance through the available scenes. When you land on a scene you want to try, exit the selection screen by pressing the shutter button halfway and releasing it. Then just compose, focus, and shoot.

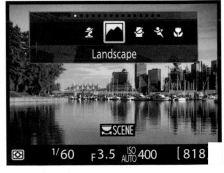

FIGURE 2-4: To scroll through the available scenes, rotate the Main command dial.

WB The names of the Scene modes are pretty self-explanatory, but if you need a hint as you scroll through your options, press the Help button to display a brief description of the mode currently selected. Unfortunately, this trick works only for viewfinder photography and not during Live View shooting.

For the most part, the process of taking pictures in the Scene modes is the same as for shooting in Auto mode, a process I outline at the end of Chapter 1. A few Scene

modes, however, use different default settings for Release mode, flash, and auto-focusing. I provide details when discussing the Release mode later in this chapter; see Chapter 3 for flash information and Chapter 4 for autofocusing help.

REMEMBER

Finally, understand that in very dim or very bright light, the camera may not be able to produce the results promised by the Scene mode. For example, Sports mode can't freeze action unless the scene is very brightly lit. The focal length and range of aperture settings on your lens, which affect how much of a scene appears in focus, also may limit the camera's ability to produce the look you expect. Chapters 3 and 4 explain these issues, so I won't get into them here; for now, just know that moving up to the advanced modes described next gives you a greater chance of success.

Semi-automatic modes (P, S, and A)

To take more creative control but still get some exposure assistance from the camera, choose one of these modes:

>> **P (programmed autoexposure):** The camera selects the aperture and shutter speed necessary to ensure a good exposure. But you can choose from different combinations of the two to vary the creative results. For example, shutter speed affects whether moving objects appear blurry or sharp. So you can use a fast shutter speed to freeze action, or you might go the other direction, choosing a shutter speed slow enough to blur the action, creating a heightened sense of motion.

TECHNICAL STUFF

Because this mode gives you the option to choose different aperture and shutter speed combos, it's sometimes referred to as *flexible programmed autoexposure.*

>> **S (shutter-priority autoexposure):** You select the shutter speed, and the camera selects the aperture. This mode is ideal for capturing moving subjects because it gives you direct control over shutter speed.

>> **A (aperture-priority autoexposure):** In this mode, you choose the aperture, and the camera sets the shutter speed. Because aperture affects *depth of field,* or the distance over which objects in a scene appear sharply focused, this setting is great for portraits. You can select an aperture that results in a soft, blurry background, putting the emphasis on your subject. For landscape shots, on the other hand, you might choose an aperture that produces a large depth of field so that both near and distant objects appear sharp.

TIP

All three modes give you access to all the camera's features. So even if you're not ready to explore aperture and shutter speed, go ahead and set the mode dial to P if you need to access a setting that's off-limits in the fully automated modes. The camera then operates pretty much as it does in Auto mode, but without limiting your ability to control picture settings if you need to do so.

When you're ready to make the leap to P, S, or A mode, look to Chapter 4 for assistance. In addition, check out Chapter 5 to find out ways beyond aperture to manipulate depth of field.

Manual exposure mode (M)

In Manual mode, you take the exposure reins completely, selecting both aperture and shutter speed as follows:

>> **To set the shutter speed:** Rotate the Main command dial.

>> **To set the aperture:** Rotate the Sub-command dial.

Even in Manual exposure mode, the camera offers an assist by displaying an exposure meter to help you dial in the right settings. (See Chapter 4 for details.) You have complete control over all other picture settings, too.

REMEMBER

One important and often misunderstood aspect of Manual exposure mode: Setting the Mode dial to M has no bearing on focusing. You can still choose manual focusing or autofocusing, assuming that your lens offers autofocusing.

U1 and U2

Your camera enables you to create two custom exposure modes, User 1 and User 2 — U1 and U2 on the Mode dial. This feature gives you a quick way to immediately set the camera to use all the picture settings you prefer for a specific type of shot. For example, you might store options for indoor portraits as U1 and store settings for sports shots as U2.

For step-by-step instructions on creating a user mode, check out Chapter 11.

Setting the Release Mode

Through the Release mode setting, you control what happens when you press the shutter button all the way down. For example, instead of capturing a single frame each time you press the button, you can opt to record a continuous burst of frames as long as you hold the button down.

TECHNICAL
STUFF

Why *Release mode?* It's short for *shutter-release mode.* Pressing the shutter button tells the camera to release the *shutter* — an internal light-control mechanism — so that light can strike the image sensor and expose the image.

You can check the current setting by looking at the Release mode dial, shown in Figure 2-5. The letter displayed next to the white marker represents the selected setting.

REMEMBER

To change the setting, press and hold the Release mode dial unlock button (labeled in Figure 2-5) while rotating the dial.

During viewfinder shooting, the Information display includes a symbol representing the Release mode as well, as shown in Figure 2-6. Given that you can always just look at the Release mode dial to see the setting, what's the point of including the symbol in the display? Well, for some settings, the Information display includes some additional details about the selected Release mode. For example, when you use the Continuous Low mode, you can choose how many frames the camera takes at a time, and that number appears with the symbol. In Figure 2-6, the symbol indicates that the frame rate is set to three frames per second.

Upcoming sections explain each Release mode and introduce you to a few menu options that also affect the shutter release.

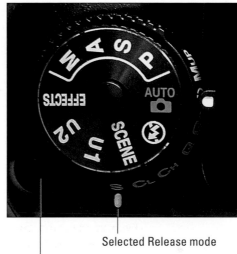

Selected Release mode

Release Mode dial unlock button

FIGURE 2-5:
You can choose from a variety of Release modes.

Release mode symbol

FIGURE 2-6:
For some Release modes, you can glean additional details from the Information display.

Single Frame and Quiet Shutter modes

S Single Frame Release mode captures one picture at a time. The picture is recorded as soon as you fully depress the shutter button. If the Touch Shutter is enabled, you also can tap the screen to record the photo during Live View photography. Focus is set when you touch the screen, and the shutter is released when you lift your finger off the monitor. See the last part of Chapter 1 to find out how to enable and disable the Touch Shutter.

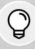

TIP

HEY, MY SHUTTER BUTTON ISN'T WORKING!

You press the shutter button . . . and press it, and press it — and nothing happens. Don't panic: Your problem is likely related to one of these issues:

- **AF-S Priority Selection:** This option determines whether the camera releases the shutter if focus has not been achieved. By default, the shutter is *not* released, so if nothing happens when you press the shutter button, the most likely cause is that the camera couldn't lock onto a focusing target. To allow the camera to take the picture regardless of whether focus is finalized, open the Custom Setting menu, choose Autofocus, and change the AF-S Priority Selection option to Release.

 It's important to note, though, that the setting comes into play only when you use certain autofocus settings, which I detail in Chapter 5. Specifically, the option is related to the AF-S Focus mode. The companion Custom Setting menu option, AF-C Priority Selection, controls shutter release before focus when you use the AF-C Focus mode (continuous autofocusing). By default, that option is set to Release; you can prevent shutter release before focus is achieved by changing that setting to Focus. Both options, by the way, also affect shutter release when the Focus mode is set to AF-A, which lets the camera decide whether to use AF-S or AF-C autofocusing.

- **Slot Empty Release Lock:** Located on the Setup menu, this option controls whether the shutter button is released if you don't have a memory card in the camera. If you took my advice at the end of Chapter 1 and set the option to Release Locked, the shutter button ignores you until you insert a card.

Q Quiet Shutter mode works just like Single Frame mode but makes less noise as it goes about its business. First, the camera disables the beep that it emits by default when it achieves focus. Additionally, if you keep the shutter button depressed after you take a picture, you can delay the sound the camera makes at the end of an image capture. The idea is that you can delay the final sounds to a moment when the noise won't be objectionable — say, after the groom says "I do."

You can use the Touch Shutter with Quiet Shutter mode, but the end-of-capture sounds occur as they normally do — you can't delay them as you can when you use the shutter button.

Continuous (burst mode) shooting

Setting the Release mode dial to Continuous Low or Continuous High enables *burst mode* shooting. That is, the camera records a continuous burst of images for as long as you hold down the shutter button, making it easier to capture fast-paced action.

You can choose from three continuous Release options:

CL

» **Continuous Low:** In this mode, you can tell the camera to capture from 1 to 7 frames per second (fps). Set the value by opening the Custom Setting menu, choosing Shooting/Display, and then selecting Continuous Low-speed, as shown in Figure 2-7. The default is 3 fps.

Why would you want to capture fewer than the maximum number of shots? Well, frankly, unless you're shooting something that's moving at a really fast pace, not much is going to change between frames when you shoot at 7 frames per second. So when you set the burst rate that high, you typically wind up with lots of shots that show the exact same thing, wasting space on your memory card. I keep this value set to the default 3 fps and then, if I want a higher burst rate, I use the Continuous High setting, explained next.

d Shooting/display		
d1 CL mode shooting speed		3
d2 Max. continuous release		100
d3 Exposure delay mode		OFF
d4 Electronic front-curtain shutter		OFF
d5 File number sequence		ON
d6 Viewfinder grid display		OFF
d7 ISO display		OFF
d8 LCD illumination		OFF

FIGURE 2-7:
You can modify the maximum frame rate for Continuous Low Release mode.

The Release mode symbol in the Information display shows you the current frames-per-second setting, as shown in Figure 2-6.

TIP

CH

» **Continuous High:** This mode works just like Continuous Low except that it records up to 8 frames per second. You can't adjust the maximum capture rate as you can for Continuous Low.

QC

» **Qc (Quiet Continuous):** A spin-off of the normal Quiet Release mode, this one also dampens camera sounds as much as possible and permits a maximum frame rate of three frames per second. This setting is not affected by the frame rate you set for the Continuous Low mode.

REMEMBER

A few other critical details about these release modes:

» **In Live View mode, you can't use the Touch Shutter to capture photos in either of the continuous Release modes.** You must press and hold down the shutter button. Additionally, as the camera captures frames, they appear in succession on the monitor. When all frames are recorded, the normal live preview appears.

» **You can limit the maximum number of shots recorded in a single burst.** By default, you can capture 100 frames at a time. If you want to restrain yourself to recording shorter bursts, head for the Custom Setting menu, choose Shooting/Display, and then select Max Continuous Release. (The option lives directly below the Continuous Low-Speed option shown in Figure 2-7.)

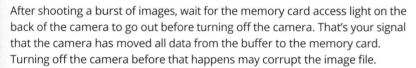

>> **You can't use flash.** The time that the flash needs to recycle between shots slows down the continuous capture rate too much. So even if the Release mode dial is set at continuous release mode, you get one shot for each press of the shutter button if the flash is raised.

>> **Images are stored temporarily in the memory buffer.** The camera has some internal memory — a *buffer* — where it stores picture data until it has time to record it to the memory card. The number of pictures the buffer can hold depends on certain camera settings, such as resolution and file type (JPEG or Raw). In the viewfinder, Information display, and Live View display, the buffer capacity appears in place of the shots-remaining value when you press the shutter button halfway. For example, if you see the value [r 98], the buffer can hold 98 frames.

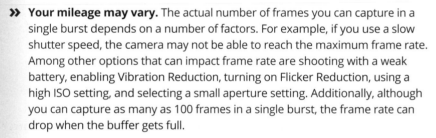

After shooting a burst of images, wait for the memory card access light on the back of the camera to go out before turning off the camera. That's your signal that the camera has moved all data from the buffer to the memory card. Turning off the camera before that happens may corrupt the image file.

WARNING

>> **Your mileage may vary.** The actual number of frames you can capture in a single burst depends on a number of factors. For example, if you use a slow shutter speed, the camera may not be able to reach the maximum frame rate. Among other options that can impact frame rate are shooting with a weak battery, enabling Vibration Reduction, turning on Flicker Reduction, using a high ISO setting, and selecting a small aperture setting. Additionally, although you can capture as many as 100 frames in a single burst, the frame rate can drop when the buffer gets full.

Self-timer shooting

You're no doubt familiar with Self-Timer mode, which delays the shutter release for a few seconds after you press the shutter button, giving you time to dash into the picture. Here's how it works on the D7500: After you press the shutter button, the AF-assist illuminator on the front of the camera starts to blink. If you enabled the camera's voice via the Beep option on the Custom Setting menu, you also hear a series of beeps. A few seconds later, the camera captures the image.

During Live View shooting, you can use the Touch Shutter to set focus and trigger the shutter release. Just tap the spot you want to focus, and when you lift your finger, the self-timer countdown begins.

TIP

By default, the camera waits 10 seconds after you press the shutter button and then records a single image. But you can tweak the delay time, set the camera to capture as many as nine shots each time you press the shutter button, and specify how long you want the camera to wait between recording those successive shots. To set these preferences, open the Custom Setting menu, choose Timers/AE Lock, and choose Self-Timer, as shown in Figure 2-8.

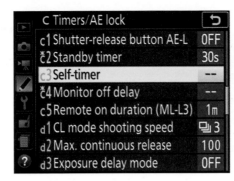 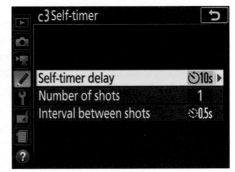

FIGURE 2-8:
Set up self-timer shooting via this Custom Setting menu option.

Two more points about self-timer shooting:

>> **Using flash disables the multiple frames recording option.** The camera records just a single image, regardless of the Number of Shots setting.

>> **Cover the viewfinder if possible.** Otherwise, light may seep into the camera through the viewfinder and affect exposure. Your camera comes with a viewfinder cover made just for this purpose.

Mirror lockup (MUP)

One component of the optical system of your camera is a mirror that moves every time you press the shutter button. The small vibration caused by the action of the mirror can result in slight blurring of the image when you use a very slow shutter speed, shoot with a long telephoto lens, or take extreme close-up shots.

MUP To cope with that issue, the D7500 offers mirror-lockup shooting, which delays opening the shutter until after the mirror movement is complete. Enable the feature by setting the Release mode to Mirror Up (labeled MUP on the Release Mode dial). Here's what you need to know to use this special Release mode:

>> **You need to press the shutter button twice to take a picture.** After framing and focusing, press the shutter button all the way down. This step locks up the mirror, and you can no longer see anything through the viewfinder. To record the shot, let up on the shutter button and then press it all the way down again. (If you don't take the shot within about 30 seconds, the camera will record a picture for you automatically.)

>> **You can add another layer of blur-protection by enabling the Electronic Front-Curtain Shutter feature.** Your camera has a mechanical shutter that consists of two parts: A front curtain that opens to allow light to strike the image sensor when you press the shutter button and a rear curtain that moves to cover the sensor back up when the exposure is complete.

In rare cases, the movement of the front curtain can create enough vibration to slightly blur the image, and that's the point of the Electronic Front-Curtain Shutter option. When you enable this feature, the camera waits for the front curtain to open and then sends an electronic signal that tells the sensor to start reacting to the light allowed in by the open shutter. In this way, any vibration caused by the shutter opening is over by the time the exposure begins.

The feature is found on the Custom Setting menu, in the Shooting/Display section. It's disabled by default, and it works only when the Release mode is set to Mirror Lockup.

» **Situations that call for mirror lockup also call for a tripod.** Even with the mirror locked up, the slightest jostle of the camera can cause blurring. Using a remote control to trigger the shutter release is also a good idea.

And what about Live View shooting in Mirror Lockup mode, you ask? (I know you weren't really wondering about that, but indulge my need to cover all bases, okay?) Because the viewfinder isn't in play when Live View is engaged, there's no mirror involved and thus no need for Mirror Lockup shutter release mode. If the Release mode is set to Mirror Lockup, though, you still have to press the shutter button twice to record the picture.

TIP

It's a good idea to reset the Release mode to a setting other than Mirror Up after you finish shooting the subject that prompted you to use that setting. Otherwise, you may forget that Mirror Lockup is in force and spend a lot of time trying to figure out why pressing the shutter button once doesn't deliver a picture.

Off-the-dial shutter release features

In addition to the Release modes you can select from the Release mode dial, you have access to several related features, explained in the next three sections.

Exposure Delay mode

As an alternative to mirror lockup, you can use the Exposure Delay feature to ensure that the movement of the mirror doesn't cause enough vibration to blur the shot. Through this option, you can tell the camera to wait 1, 2, or 3 seconds after the mirror is raised to capture the image. To turn on the feature, open the Custom Setting menu, select Shooting/Display, and then choose Exposure Delay Mode to set the delay time.

To help remind you that the feature is enabled, the letters DLY appear in the Information display and default Live View display. (Press the Info button to change the display during Live View shooting.)

REMEMBER

Exposure Delay mode isn't compatible with Continuous High or Continuous Low shooting. If you enable it in those modes, you get one image for each press of the shutter button rather than a burst of frames.

At the end of your Exposure Delay series, always return to the menu and turn the feature off. Otherwise, I pretty much guarantee that you'll forget that you asked for the delay and spend frustrating moments trying to figure out why the shutter isn't responding immediately to the shutter button. (Or maybe it's just me. . . .)

Remote control shooting

You have two ways to release the shutter via remote control:

>> **Wired remote control:** Plug the Nikon MC-DC2 remote cord into the accessory terminal (right connection port under the lower cover on the left side of the camera).

>> **Wireless remote control:** If you own a smartphone or other device that's compatible with the Nikon SnapBridge app, you can use that device as a wireless remote. The appendix of this book offers more information about that option.

You also can purchase dedicated Nikon wireless remote control units. Your camera responds to the ML-L3 wireless remote; the WR-R10 transceiver/WR-T10 controller; and the WR-1 remote controller. To read more about these products, visit the Nikon website (www.nikon.com).

REMEMBER

If you opt for one of the wireless remote units, a few camera menus may require your attention:

>> **Remote Control Mode (ML-L3):**
Found on the Photo Shooting menu and shown in Figure 2-9, this option relates to the ML-L3 wireless remote, as the name suggests. You can't use the remote until you change the setting from the default, Off. Choose from these alternative settings:

 • *Delayed Remote:* The shutter is released 2 seconds after you press the button on the remote control unit.

 • *Quick-Response Remote:* The shutter opens immediately after you press the button.

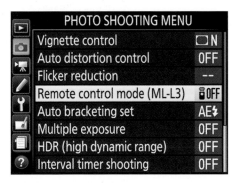

FIGURE 2-9:
When this menu option is set to Off, as it is by default, the camera won't respond to the ML-L3 wireless remote.

- *Remote Mirror-Up:* Enables you to use the remote for mirror-up shooting, a technique explained earlier in the chapter. You still have to set the Release Mode dial to the MUP position, and you must press the shutter-release button on the remote control twice, just as you do when using the camera's shutter button in Mirror Lockup mode.

 If the camera doesn't receive a signal from the remote within one minute, it resets the option to Off, cancelling out of remote-control mode.

» **Remote On Duration (ML-L3):** Again, this option is specific to the ML-L3 remote. It enables you to extend the automatic cancellation delay up to a maximum of 15 minutes. Look for the option on the Custom Setting menu, in the Timers/AE Lock submenu.

» **Wireless Remote (WR) Options:** This Setup menu option enables you to modify the link mode settings for certain wireless remote controllers. You also can modify LED lamp behavior. The option is dimmed unless a compatible wireless remote is being used.

» **Assign Remote (WR) Fn button:** If your wireless remote has a Fn (Function) button, choose this Setup menu option if you want to give the button a job. You can set the button to shift the camera into Live View mode, for example, or have it perform the same function as the Fn1 or Fn2 button on the camera. By default, the option is set to None, so nothing happens when you press the button.

Because remote-control features vary, be sure to read the instruction manual for your unit for the full story on how to set focus and trigger the shutter. Also be aware that even if the Release Mode dial is set to one of the continuous-shooting modes, you can capture only one frame at a time when using the ML-L3 wireless unit.

Interval Timer Shooting

With Interval Timer Shooting, you can set the camera to automatically release the shutter at intervals ranging from seconds to hours apart. This feature enables you to capture a subject as it changes over time — a technique commonly known as *time-lapse photography* — without having to stand around pressing the shutter button the whole time.

Here's how to set up the camera for time-lapse photography:

1. **Set the Release mode to any setting except Self-Timer or Mirror Up (Mup).**

To adjust the setting, hold down the Release Mode button while rotating the dial.

2. **Display the Photo Shooting menu and select Interval Timer Shooting, as shown on the left in Figure 2-10.**

The screen on the right in Figure 2-10 appears, offering options that enable you to specify how and when you want your interval frames to be captured.

>> **Between intervals, you can adjust settings, access menus, and view photos in playback mode.** However, in some instances, changing settings may cancel interval timer shooting, so it's best to set up all the picture options to your liking before you begin the interval-shooting session. The monitor turns off automatically about four seconds before the next interval is set to begin.

>> **To prevent exposure miscues, cover the viewfinder.** This prevents light from entering the viewfinder and fooling the exposure meter.

>> **When the interval sequence is complete, the Interval Timer Shooting menu option is reset to Off.** The card access light stops blinking shortly after the final image is recorded to the memory card.

TIP

If you want to get really tricky, you can combine automatic bracketing with Interval Timer Shooting. At each interval, the camera records the number of shots specified for the bracketed series. See the end of Chapter 4 for details on how to establish bracketing settings. (You must set these options before beginning Interval Timer Shooting.)

Time-Lapse Movie

A variation of Interval Timer Shooting, the Time-Lapse Movie feature also records a series of photographs at specified intervals. But it takes things a step further, stitching the photos together into a silent movie.

You can shoot a Time-Lapse movie in any exposure mode except Effects. Set the Release mode to S (Single-Frame); this feature doesn't appreciate the other Release modes.

Here's the rest of what you need to know:

>> **You can't access the Time-Lapse Movie option when the camera is connected via HDMI cable to a monitor or other HD device.** That limitation means that I can't show you the menu screens for this feature because to capture those screens, I cable the camera to an HDMI video-capture card. Luckily, most of the screens are very similar to the Interval Timer Shooting screens, which you can see in the preceding section.

>> **Set the camera to Movie mode.** A time-lapse movie has the same 16:9 aspect ration as a regular movie. You can see the 16:9 framing indicators only in Movie mode, so rotate the LV switch to the Movie camera position and then press the LV button to enter Movie mode.

>> **The movie is recorded using the current Movie Quality, Frame Size/ Frame Rate, and Movie Format options on the Movie Shooting menu.** To find out more about these and other movie settings, check out Chapter 8.

FIGURE 2-10:
After selecting
Interval Timer
Shooting (left),
choose Start
Options to
specify when
you want
the capture
session to
begin (right).

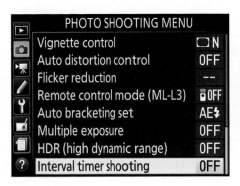

3. **Select Start Options, as shown on the right in Figure 2-10.**

 This setting determines when the camera begins capturing frames. You get two choices:

 - *Now:* Capture begins immediately after you complete the rest of the interval-timing setup steps.

 - *Choose start day and start time:* Choose this option to display a screen that enables you to set the date, hour, and minute that you want the interval captures to begin. After setting the start time, press OK or tap the OK icon to return to the setup screen.

 The Start Time option is based on a 24-hour clock, as is the Interval option (explained next). The current time appears in the lower-right corner of the screen.

REMEMBER

4. **Set the delay time between captures.**

 The default setting is a one-minute interval. To change that setting, choose Interval, as shown on the left in Figure 2-11, and then enter the desired delay time, as shown on the right. Make sure that the delay time between frames is longer than the shutter speed you plan to use. Press or tap OK after entering the interval values.

FIGURE 2-11:
Choose
Interval to
specify the
delay time
between
frames.

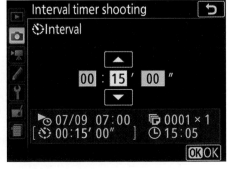

5. **Select Number of Intervals x Shots/Interval, as shown on the left in Figure 2-12.**

FIGURE 2-12: This option determines the number of intervals and how many frames are captured per interval.

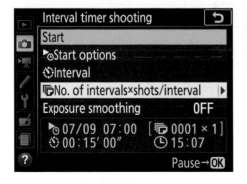 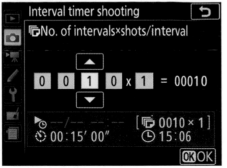

The screen shown on the right in the figure appears.

6. **Set the number intervals and frames per interval.**

The left value is the number of intervals — set to 10, in the figure. The number after the times symbol (x) is the number of frames you want to record per interval. In the figure, the value is set to 1, but you can specify a maximum of nine frames per interval.

Multiplying the two values determines the total number of frames that will be recorded, which appears after the equal sign. The setup shown in Figure 2-12 will result in a total of ten frames, for example.

After entering the interval and frames values, tap or press OK to return to the main setup screen.

One more detail to note on this option: If the Release mode is set to S (Single Frame) and you specify that you want multiple frames per interval, the camera will capture those frames at the frame rate specified for the CL Mode Shooting Speed option, found on the Custom Setting menu. The default is 3 frames per second. In fact, the camera always takes the number of shots you specify regardless of the Release mode.

7. **Enable or disable Exposure Smoothing.**

Exposure Smoothing tells the camera to try to match the exposure of each shot to the one taken previously. Obviously, if your goal is a series of frames that show how the subject appears as the sun rises and falls, you should turn this option off, as it is by default. You may want to enable it, however, if you're shooting a subject that will be illuminated with a consistent light source throughout the entire shooting time or if the light may change only slightly, such as when recording a hummingbird at a feeder during an afternoon.

WARNING

The Exposure Smoothing option doesn't work in the M (manual) exposure mode unless you enable Auto ISO Sensitivity, which gives the camera permission to increase the ISO setting as necessary to maintain a consistent exposure. (The next chapter explains this setting.)

If you adjust the setting, tap or press OK to return to the setup screen.

8. **Review all your capture settings.**

You can see the chosen start time, interval time, number of intervals, shots per interval, and current time at the bottom of the setup screen, as shown in Figure 2-13. If you want to adjust any of the settings, now's the time.

9. **Select Start, as shown in Figure 2-13.**

If you selected Now as the Start Time option, the first shot is recorded about 3 seconds after you select Start. If you set a delayed start time, the camera displays the message *Interval Timer Shooting* for a few seconds.

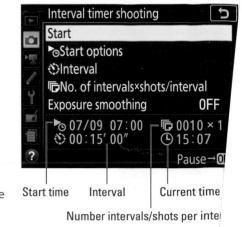

Start time Interval Current time

Number intervals/shots per inte

FIGURE 2-13: After reviewing your capture settings, sele Start.

A few additional points about the Interval Timer Shooting feature:

» **Monitor the shot progress.** The letters INTVL blink in the Control panel and Information display while an interval sequence is in progress. Before each shot is captured, the display changes to show the number of intervals remaining and the number of shots remaining in the current interval. The fi value appears in the space usually occupied by the shutter speed; the secor takes the place of the f-stop setting. You also can view the values at any tim by pressing the shutter button halfway.

» **Pause interval shooting.** Between shots, open the Photo Shooting menu, choose Interval Timer Shooting, and then tap Pause (or highlight it and pre OK). You can also interrupt the interval sequence by pressing the OK butto To resume shooting, select Restart from the Interval Timer Shooting scree To cancel the sequence entirely, choose Off instead of Restart.

» **Autofocus.** If you're using autofocusing, the camera initiates focusing bet each shot. Be sure that the camera can focus on your subject; if it can't, the shots won't be recorded. To ensure that the focus distance doesn't change between shots, opt for manual focusing instead of autofocus.

>> **To set up and start the recording, open the Movie Shooting menu and select Time-Lapse Movie.** You see a setup screen similar to the one provided for Interval Timer Shooting. Two options, Interval and Exposure Smoothing, work as described in the preceding section. The Shooting Time setting determines how long the camera records photographs after you start the capture session.

By default, pictures are taken every 5 seconds for 25 minutes, with a frame size of 1920 x 1080, a frame rate of 60 frames per second, and the High quality setting. With those settings, the finished movie length is 5.1 minutes. As you change the Shooting Time value, the camera updates the movie length value, shown in blue near the bottom of the screen.

After setting recording options, choose Start from the top of the screen. When the camera finishes shooting all the pictures, it stitches the frames and presents you with a movie file. You also hear a series of beeps to let you know that the movie is ready for viewing.

See Chapter 8 for details on playing movies.

Selecting Image Size and Image Quality

Your preflight camera check should also include a look at the Image Size and Image Quality settings. The first option sets resolution (pixel count); the second, file type (JPEG or Raw/NEF).

The names of these settings are a little misleading, though, because the Image Size setting also contributes to picture quality, and the Image Quality setting affects the file size of the picture. Because the two work in tandem to determine quality and size, it's important to consider them together. The next few sections explain each option; following that, I offer a few final tips and show how to select the settings you want to use.

Considering Image Size (resolution)

The Image Size setting determines how many pixels are used to create your photo. *Pixels* are the square tiles from which digital images are made. You can see some pixels close up in the right image in Figure 2-14, which shows a greatly magnified view of the eye area in the left image.

TECHNICAL STUFF

Pixel is short for *picture element.*

The number of pixels in an image is referred to as *resolution.* You can define resolution in terms of either the *pixel dimensions* — the number of horizontal pixels and vertical pixels — or total resolution, which you get by multiplying those two values. This number is usually stated in *megapixels,* with 1 megapixel equal to 1 million pixels.

Your camera offers three Image Size options: Large, Medium, and Small. But the resolution you get at any setting depends on the Image Area option, which I explain at the end of this chapter. At the default (DX) setting, the camera captures the image using the entire image sensor (the part of the camera on which the image is formed). If you instead use the 1.3x crop setting, which captures the image using only the central portion of the sensor, you get fewer pixels at each Image Size setting. Table 2-1 shows the pixel count for each Image Area setting, followed by the megapixel count. (Note that this book uses the abbreviation M for *megapixel,* as does Nikon, but the abbreviation MP is more commonly used.)

TABLE 2-1 **Image Size (Resolution) Options**

Image Size	DX Image Area	1.3 Crop Image Area
Large	5568 x 3712 (20.7M)	4272 x 2848 (12.2M)
Medium	4176 x 2784 (11.6M)	3200 x 2136 (6.8M)
Small	2784 x 1856 (5.2M)	2128 x 1424 (3.0M)

REMEMBER

However, if you select Raw (NEF) as the Image Quality setting, images are captured at the Large setting. You can vary the resolution only for pictures taken in the JPEG format. The upcoming section "Understanding Image Quality options (JPEG or Raw/NEF)" explains file formats.

To choose the right Image Size setting, you need to understand the three ways that resolution affects your pictures:

>> **Print size:** Pixel count determines the size at which you can produce a high-quality print. When an image contains too few pixels, details appear muddy, and curved and diagonal lines appear jagged. Such pictures are said to exhibit *pixelation.*

To ensure good print quality, aim for approximately 300 pixels per linear inch, or *ppi.* To produce an 8 x 10-inch print at 300 ppi, for example, you need a pixel count of 2400 x 3000, or about 7.2 megapixels. Depending on the printer and the photo, you may be happy with a lower resolution, however, so don't consider 300 ppi a hard and fast rule.

WARNING

Even though many photo-editing programs enable you to add pixels to an existing image — known as *upsampling* — doing so doesn't enable you to success-fully enlarge your photo. In fact, upsampling typically makes matters worse.

To give you a better idea of the impact of resolution on print quality, Figures 2-15, 2-16, and 2-17 show you the same image at 300 ppi, at 50 ppi, and then resampled from 50 ppi to 300 ppi (respectively). As you can see, there's no way around the rule: If you want quality prints, you need the right pixel count from the get-go.

300 ppi

FIGURE 2-15:
A high-quality print depends on a high-resolution original.

>> **Screen display size:** Resolution doesn't affect the quality of images viewed on a monitor, TV, or other screen device the way it does printed photos. Instead, resolution determines the *size* at which the image appears. I explain this issue in a bit more detail in Chapter 9; for now, just know that you need way fewer pixels for onscreen photos than you do for prints.

>> **File size:** Every pixel increases the amount of data required to create the picture file. So a higher-resolution image has a larger file size than a low-resolution image.

50 ppi

FIGURE 2-16:
At 50 ppi,
the image
has a jagged,
pixelated look.

50 ppi resampled to 300 ppi

FIGURE 2-17:
Adding pixels
in a photo
editor doesn't
rescue a low-
resolution
original.

WARNING

Large files present several problems:

» You can store fewer images on the memory card, your computer's hard drive, an online storage site, and other storage media, such as a DVD.

» The camera needs more time to process and store the image data on the memory card after you press the shutter button. This extra time can hamper fast-action shooting.

» When you share photos online, larger files take longer to upload and download.

» When you edit photos in your photo software, your computer needs more resources and time to process large files.

TIP

As you can see, resolution is a bit of a sticky wicket. What if you aren't sure how large you want to print your images? What if you want to print your photos *and* share them online? I take the better-safe-than-sorry route, which leads to the following recommendations:

>> **Always shoot at a resolution suitable for print.** You then can create a low-resolution copy of the image for use online. In fact, your camera offers a built-in resizing option that I cover in Chapter 10.

>> **For everyday images, Medium is a good choice.** I find Large to be overkill for casual shooting, creating huge files for no good reason.

TIP

>> **Choose Large for an image that you plan to crop or print very large, or both.** The benefit of maxing out the resolution is that you have the flexibility to crop your photo and still generate a decently sized print of the remaining image. Figure 2-18 offers an example. When I was shooting this photograph, I couldn't get close enough to fill the frame with my main interest — the two juvenile herons at the center of the scene. But because I had the resolution cranked up to Large, I could later crop the shot to the composition you see on the right and still produce a great-looking print. In fact, I could have printed the cropped image at a much larger size than fits on the page here.

FIGURE 2-18:
A high-resolution original (left) enabled me to crop the photo and still have enough pixels to produce a quality print (right).

Understanding Image Quality options (JPEG or Raw/NEF)

If I had my druthers, the Image Quality option would instead be called File Type because that's what the setting affects. Here's the deal: The file type, sometimes also known as a file *format*, determines how your picture data is recorded and stored. Your choice does affect picture quality, but so does the Image Size setting, as described in the preceding section, and the ISO setting and exposure time, both

covered in Chapter 4. (A high ISO setting and long exposure time can produce a defect called *noise,* which makes your image appear grainy.) In addition, your choice of file type has ramifications beyond picture quality.

At any rate, your camera offers two file types: JPEG and Camera Raw — or Raw, for short, which goes by the specific moniker NEF (Nikon Electronic Format) on Nikon cameras. The next couple of sections explain the pros and cons of each format. If your mind is already made up, skip ahead to the section "Adjusting the Image Size and Image Quality settings," to find out how to make your selection.

JPEG: The imaging (and web) standard

Pronounced "jay-peg," this format is the default setting on your D7500, as it is on most digital cameras. JPEG is popular for two main reasons:

>> **Immediate usability:** All web browsers and e-mail programs can display JPEG files, so you can share pictures online immediately after you shoot them. You also can get a JPEG file printed at any retail photo outlet. The same can't be said for Raw (NEF) files, which must be converted to JPEG for online sharing and to JPEG or another standard format, such as TIFF, for retail printing.

>> **Small files:** JPEG files are smaller than Raw files. And smaller files consume less room on your camera memory card and in your computer's storage tank.

The downside (you knew there had to be one) is that JPEG creates smaller files by applying *lossy compression.* This process actually throws away some image data. Too much compression produces a defect called *JPEG artifacting.* Figure 2-19 compares a high-quality original (left photo) with a heavily compressed version that exhibits artifacting (right photo).

FIGURE 2-19: The reduced quality of the right image is caused by excessive JPEG compression.

Fortunately, your camera enables you to specify how much compression you're willing to accept. You can choose from three JPEG settings, which produce the following results:

>> **JPEG Fine:** The compression ratio is 1:4 — that is, the file is four times smaller than it would otherwise be. Because very little compression is applied, you shouldn't see many compression artifacts, if any.

>> **JPEG Normal:** The compression ratio rises to 1:8. The chance of seeing some artifacting increases as well. This setting is the default.

>> **JPEG Basic:** The compression ratio jumps to 1:16. That's a substantial amount of compression that brings with it a lot more risk of artifacting.

Additionally, each of the settings comes in two flavors: Size Priority and Optimal Quality. When Size Priority is in effect, which is the default, the camera compresses files with a goal of producing consistent file sizes between shots. How much compression is needed to produce those consistent file sizes depends on the level of detail in the photo. Therefore, complex subjects may be more highly compressed — and, thus, suffer more quality loss — than simple subjects. Optimal Quality tells the camera to concentrate on producing the best image quality for each individual image, regardless of any variation in file size from frame to frame.

REMEMBER

In the menus and other displays, a star next to the JPEG setting indicates that optimal-quality compression is in force. In Figure 2-20, for example, the Fine/Optimal Quality setting is selected. No star means that Size Priority is used instead.

Note, though, that even the Basic, size-priority (no star) setting doesn't result in anywhere near the level of artifacting you see in the right image in Figure 2-19. I've exaggerated the defect in that example to help you recognize artifacting and understand how it differs from the quality loss that occurs when you have too few pixels. In fact, if

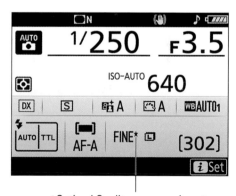

Optimal Quality compression star

FIGURE 2-20:
A star next to the JPEG setting indicates that compression is applied with image quality as the priority.

you keep the image print or display size small, you aren't likely to notice a great deal of quality difference between the Fine, Normal, and Basic compression levels. It's only when you greatly enlarge a photo that the differences become apparent.

Given that the differences between the compression settings aren't that easy to spot until you enlarge the photo, is it okay to choose a setting other than Fine in order to reduce file size? Or to go with Size Priority compression over Optimal Quality compression? Only you can decide what level of quality your pictures demand, but I use Fine/Optimal Quality when I shoot in the JPEG format. You never know when a casual snapshot will be so great that you want to print or display it large enough that minor quality loss becomes a concern. And of all the defects that you can correct in a photo editor, artifacting is one of the hardest to remove.

If you don't want *any* risk of artifacting, change the file type to Raw (NEF). Or consider your other option, which is to record two versions of each file — one Raw and one JPEG. The next section offers details.

Raw (NEF): The purist's choice

The other picture file type you can create is *Camera Raw*, or just *Raw* (as in uncooked), for short.

Each manufacturer has its own flavor of Raw. Nikon's is NEF, for Nikon Electronic Format, so you see the three-letter extension NEF at the end of Raw filenames.

Raw is popular with advanced, very demanding photographers for three reasons:

>> **Greater creative control:** With JPEG, internal camera software tweaks your images, adjusting color, exposure, and sharpness as needed to produce the results that Nikon believes its customers prefer. With Raw, the camera simply records the original, unprocessed image data. The photographer then copies the image file to the computer and uses special software known as a *Raw converter* to produce the actual image, making decisions about color, exposure, and so on at that point. Your camera has a built-in Raw converter, which I cover in Chapter 10. The Nikon website also offers software you can download to do the job (Nikon Capture NX-D).

>> **Higher bit depth:** *Bit depth* is a measure of how many distinct color values an image file can contain. JPEG files restrict you to 8 bits each for the red, blue, and green color components, or *channels,* that make up a digital image, for a total of 24 bits. That translates to roughly 16.7 million possible colors.

On the D7500, you can set the camera to capture either 12 or 14 bits per channel when you shoot in the Raw format. (How-to's upcoming.) Although jumping from 8 to 12 or 14 bits sounds like a huge difference, you may never notice any difference in your photos — that 8-bit palette of 16.7 million values is more than enough for superb images. Where the extra bits can come in handy is if you adjust exposure, contrast, or color in your photo-editing program. When you apply extreme adjustments, the extra bits sometimes help avoid a problem known as *banding* or *posterization,* which creates abrupt

color breaks where you should see smooth, seamless transitions. (A higher bit depth doesn't always prevent this problem, however.)

>> **Best picture quality:** Because Raw doesn't apply the destructive compression associated with JPEG, you don't run the risk of the artifacting that can occur with JPEG.

But Raw isn't without its disadvantages:

>> **You can't do much with your pictures until you process them in a Raw converter.** You can't share them online or put them into a text document or multimedia presentation. You can view and print them immediately if you use the available Nikon software, but most other photo programs require you to convert the Raw files to a standard format first, such as JPEG or TIFF. Ditto for retail photo printing.

>> **Raw files are larger than JPEGs.** Unlike JPEG, Raw doesn't apply lossy compression to shrink files. In addition, Raw files are always captured at the maximum resolution. For both reasons, Raw files are significantly larger than JPEGs, so they take up more room on your memory card and on your computer's hard drive or other picture-storage device.

Whether the upside of Raw outweighs the downside is a decision that you need to ponder based on your photographic needs and whether you have the time to, and interest in, converting Raw files.

If you opt for Raw, you can adjust two aspects of how the file is captured by opening the Photo Shooting menu and choosing NEF (RAW) Recording, as shown on the left in Figure 2-21. On the next screen, shown on the right in the figure, you have access to these options:

>> **NEF (Raw) Compression:** Even Raw files receive a minute amount of file compression to keep file sizes within reason. This setting lets you choose between two levels of compression. The default is Lossless Compressed, which results in no visible loss of quality and yet reduces file sizes by about 20 to 40 percent. In addition, any quality loss that does occur through the compression process is reversed at the time you process your Raw images. (Technically, some original data may be altered, but you're unlikely to notice the difference in your pictures.)

Changing the setting to Compressed results in a greater degree of compression, shrinking files by about 35 to 55 percent. Nikon promises that this setting has "almost no effect" on image quality. But the compression in this case is not reversible, so if you do experience some quality loss, there's no going back.

>> **NEF (RAW) bit depth:** By default, the D7500 goes for 14-bit images, but you can reduce the bit depth to 12 through this option.

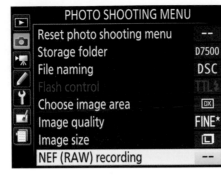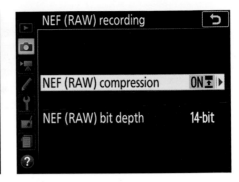

PHOTO SHOOTING MENU

Reset photo shooting menu --
Storage folder D7500
File naming DSC
Flash control TTL
Choose image area DX
Image quality FINE*
Image size
NEF (RAW) recording --

NEF (RAW) recording ↺

NEF (RAW) compression ON
NEF (RAW) bit depth 14-bit

FIGURE 2-21: Choose this menu option to specify the bit-depth and compression type of Raw files.

REMEMBER

Together, these settings make a big difference in file size: 14-bit Lossless Compressed photos weigh in at about 28.0MB; 12-bit Compressed files are about 20.6MB. Most photographers, I think, will be perfectly happy with 12-bit, Compressed images, and frankly, I doubt that too many people could perceive much difference between a photo captured at that setting and a 14-bit, Lossless Compressed picture. But if you're doing commercial photography or shoot fine-art photography for sale, you may feel more comfortable knowing that you're capturing files at maximum quality and bit depth.

Raw+JPEG: Covering both bases

TIP

You do have the option to capture a picture in the Raw and JPEG formats at the same time. I often take this route when I'm shooting pictures I want to share right away with people who don't have software for viewing Raw files. I upload the JPEGs to a photo-sharing site where everyone can view them, and then I process the Raw versions when I have time.

If you choose to create both a Raw and JPEG file, note a few things:

>> The list of Raw+JPEG options includes all the Image Quality options for the JPEG version. The JPEG file size is based on the current Image Size setting. The Raw file, however, is always captured at the Large resolution setting.

>> During picture playback, you see the JPEG version of the photo. However, the Image Quality data that appears with the photo reflects your capture setting (Raw+Fine, for example). The size value relates to the JPEG version.

WARNING

>> Deleting the JPEG image also deletes the Raw file if you use the in-camera delete function. After you transfer the two files to your computer, deleting one doesn't affect the other.

Chapter 10 explains more about deleting photos.

My take: Choose JPEG Fine or Raw (NEF)

At this point, you may be finding all this technical goop a bit overwhelming, so allow me to simplify things for you. Until you have the time or energy to completely digest all the ramifications of JPEG versus Raw, here's a quick summary of my thoughts on the matter:

» If you require the absolute best image quality and have the time and interest in doing the Raw conversion, shoot Raw.

» If great photo quality is good enough and you don't have time to spend processing images, stick with JPEG Fine. The trade-off for the smaller files produced by the Normal and Basic settings isn't worth the risk of compression artifacts.

» If you don't mind the added file-storage space requirement and want the flexibility of both formats, choose a Raw+JPEG option, which stores one copy of the image in each format. Set the JPEG size and quality depending on how you plan to use the JPEG image.

Adjusting the Image Size and Image Quality settings

You can view the current Image Quality and Image Size settings in the Information and Live View displays, in the areas labeled in Figure 2-22. The figures show how things look when you use the default settings, Normal with Size Priority compression (no star) for the Image Quality setting and Large as the Image Size.

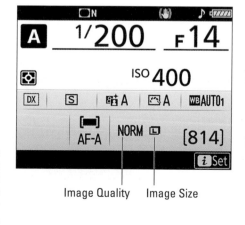

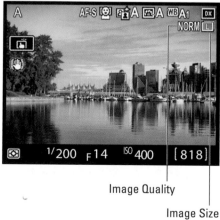

FIGURE 2-22: The current Image Size and Image Quality settings appear in the displays.

Image Quality Image Size

Image Quality

Image Size

 If needed, press the Info button to bring up the Information display during viewfinder photography; press the button to change the display style during Live View photography.

To adjust the settings, use these controls:

Press to access Image Quality/Size screen

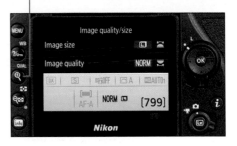

FIGURE 2-23:
While pressing the Qual button, rotate the Main command dial to adjust Image Quality and rotate the Sub-command dial to change the Image Size.

QUAL

>> **Qual button + command dials (viewfinder photography only):** When you press and hold the Qual button, the camera displays the Image Size and Image Quality settings together, as shown in Figure 2-23. The symbols on the screen indicate that you can rotate the Main command dial to adjust the Image Quality setting and rotate the Sub-command dial to change the Image Size setting.

Image Size Image Quality

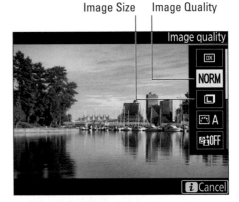

>> ***i*-button menu (Live View only):** During Live View, pressing the Qual button magnifies the on-screen display. So instead, press the *i* button to display the *i*-button menu. The Image Quality and Image Size options are labeled in Figure 2-24.

>> **Photo Shooting menu (viewfinder and Live View modes):** You also can set Image Quality and Image Size via the Photo Shooting menu, as shown in Figure 2-25.

FIGURE 2-24:
During Live View photography, press the *i* button to change the settings from the *i*-button menu.

REMEMBER Because the Image Size and Image Quality settings affect file size, the shots–remaining value changes when you adjust either setting.

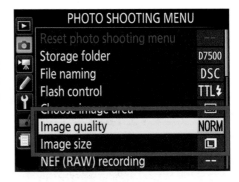

FIGURE 2-25:
You also can adjust the Image Size and Image Quality settings via the Photo Shooting menu.

Setting the Image Area

Normally, your D7500 captures photos using the entire *image sensor,* which is the part of the camera on which the picture is formed — similar to the negative in a film camera. However, you have the option to record a smaller area at the center of the sensor. The result is the same as using the entire sensor and then cropping the image by a factor of 1.3.

What's the point? Well, the idea is that you wind up with a picture that has the same angle of view you would get by switching to a lens with a longer focal length. Your subject fills more of the frame, and less background is included. To put it another way, think of this option as on-the-fly cropping.

Of course, because you're using a smaller portion of the image sensor, you're recording the image using fewer pixels, so the resulting image has a lower resolution than one captured using the entire sensor. And as discussed earlier in this chapter, the higher the pixel count, the larger you can print the photo and maintain good print quality. On the flip side, because the camera is working with fewer pixels, the resulting file size is smaller, and it takes less time to record the image to the camera memory card. You also can capture more frames per second when you set the Release mode to the Continuous High or Continuous Low options, as I detail in the earlier section devoted to those two Release modes.

I prefer to shoot using the entire sensor and then crop the image myself if I deem it necessary. You can even crop the image in the camera, by using the Trim feature that I cover in Chapter 12. Even when I'm shooting fast action, I don't find that the small bump up in the maximum frames per second worth the loss of frame area in most situations.

When you use the whole-sensor recording option, you see the letters DX in the Information and Live View displays, as shown in Figure 2-26. (DX is the moniker that Nikon uses to refer to the size of sensor used in the D7500 and similar cameras.) If you opt for the cropped sensor setting, the label 1.3x appears instead.

To change the Image Area setting, you have these options:

>> ***i*-button menu:** Figure 2-27 shows the menu and the settings screen as they appear during viewfinder photography. During Live View photography, the Image Area option is at the top of the *i*-button menu.

The numbers that appear with each setting indicate the image sensor size in millimeters: 24 x 16mm for the DX setting, and 18 x 12mm for the 1.3x crop setting.

REMEMBER

Image Area setting

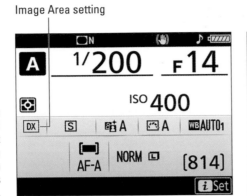

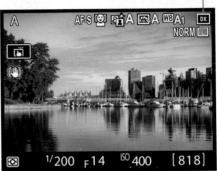

Image Area setting

FIGURE 2-26:
The DX symbol indicates that the maximum Image Area option is selected.

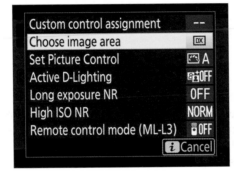

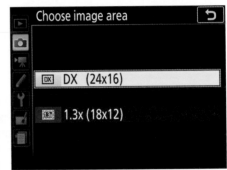

FIGURE 2-27:
The fastest way to change the Image Area setting is through the *i*-button menu.

>> **Photo Shooting menu:** You also can adjust the setting via the Image Area option on this menu.

Fn2

>> **Fn2 button + Main command dial (viewfinder photography only):** By default, the Fn2 button is set to display an Image Area setting screen. Press the button while rotating the Main command dial to toggle between the DX and 1.3x settings.

TIP

When you set the Image Size option to 1.3x, a rectangle indicating the available framing area appears in the viewfinder, along with a 1.3x symbol. In Live View mode, you don't see the framing marks; instead, the area to be captured at the 1.3x frame size fills the screen.

Also notice that when you shift from DX to 1.3x, the shots-remaining value increases because the file size of a 1.3x image is smaller than a DX-size image. Just something to keep in mind if you are running short on memory-card space and you can get by with using the smaller sensor area.

Chapter **3**

Adding Flash

C ameras have gone through many evolutions since photography was invented. But one thing that remains constant is that you can't create a photograph without light. In fact, the term *photograph* comes from the Greek words *photo,* for light, and *graph,* for drawing. Thanks to the built-in flash on your D7500, you're never without at least a little light. You also have the option to attach an external flash for times when you need more power or flexibility than the built-in unit provides.

This chapter begins with an introduction to working with the built-in flash and then moves on to advanced flash options, many of which work with external flash units. For more tips on better flash results, especially for portraiture, see Chapter 7.

Turning the Built-in Flash On and Off

REMEMBER

In certain exposure modes, the camera decides when flash is needed; in other exposure modes, you have control over that aspect of your shots. Here's the breakdown by exposure mode:

>> **Autoexposure mode, all Scene modes that permit flash *except* Food mode:** After you press the shutter button halfway to set focus and exposure, the camera automatically raises the built-in flash if it finds the ambient light insufficient. If you don't want to use flash, you may be able to disable it by

changing the Flash mode to Flash Off, as explained in the upcoming section "Choosing a Flash Mode."

>> **P, S, A, and M modes and the Food Scene mode:** You are the sole flash decider. If you want to use the built-in flash, raise it by pressing the Flash button on the side of the camera, labeled in Figure 3-1. Don't want flash? Just press down gently on the top of the flash to close the unit.

The P, S, A, and M exposure modes also give you the option of leaving the flash raised but preventing it from firing by setting the Flash mode to Flash Off. The camera keeps the flash charged as long as the unit is up, however, so to save battery power, close the flash unit when possible.

Flash button

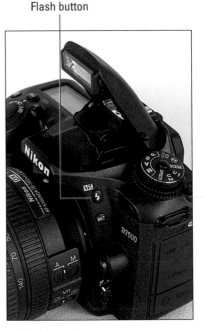

FIGURE 3-1:
In P, S, A, and M exposure modes and Food Scene mode, raise the built-in flash by pressing the Flash button.

When the flash is charged and ready to go, a red lightning bolt appears at the right end of the viewfinder display and, during Live View shooting, in the lower-right corner of that display. If flash isn't enabled and the camera thinks you need more light, the red lighting bolt blinks in the display. Find this feature annoying? In the P, S, A and M exposure modes, open the Setup menu and set the Flash Warning option to off.

Comparing Built-in and External Flashes

Although I appreciate the convenience of the built-in flash and use it often, it does have some limitations:

>> **The range of the built-in flash is about 2 to 28 feet.** In most cases, it's the far end of that range that presents the most problems. You just can't position the camera very far from the subject. On the other hand, if you shoot lots of close-ups, the minimum flash distance can become an issue. Ironically, when you get very close to your subject, it may not be fully illuminated by the built-in flash because the flash emits a very narrow, focused light. Keep in mind that using *any* flash within very close range can harm the eyes of a human or animal subject.

TECHNICAL STUFF

The effective range of any flash depends on the current ISO and f-stop settings, two exposure options I explain in Chapter 4. At some combinations of ISO and shutter speed, you must be much closer to your subject than 28 feet when using the built-in flash. Your camera manual lists the flash range at various aperture and ISO combinations.

>> **Some exposure modes prevent you from using the built-in flash.** Obviously, Auto Flash Off mode is one such mode. But flash is also disabled in these Scene and Effects modes:

- *Scene modes:* Landscape, Sports, Night Landscape, Beach/Snow, Sunset, Dusk/Dawn, Candlelight, Blossom, and Autumn Colors

- *Effects modes:* All modes *except* Super Vivid, Pop, Photo Illustration, and Toy Camera

>> **Don't expect to use the built-in flash for action photography.** Three issues get in the way:

- *Burst-mode shooting doesn't work.* If flash is enabled when you use either Continuous Release mode, the camera takes one photograph for each press of the shutter button instead of recording a burst of frames. Chapter 2 details Release modes.

- *By default, the top shutter speed you can use with the built-in flash is 1/250 second.* The faster the action, the higher the shutter speed you need to freeze the motion. Through a feature called Auto FP Flash, detailed later in this chapter, you can notch the shutter speed up to 1/320 second. But even at that speed, a moving subject may blur. For help understanding how shutter speed affects motion blur, see Chapter 4.

- *The flash needs time to recycle between shots.* And Murphy's Law being, well, a law, it's pretty much certain that your flash will be recharging when the highlight-reel moment of the day occurs.

So do those limitations mean that you need to invest in an external flash? The following information may help you decide:

>> **When using an external flash, you *can* use flash in most exposure modes that disable the built-in flash.** The exception, of course, is Flash Off Mode.

>> **An external flash head has a much longer reach than the built-in flash.** The maximum flash range varies depending on the flash unit, so this is a specification to investigate when shopping for a flash.

>> **The light coming from an external flash has a wider spread than the built-in flash.** And the wider the area over which the light is spread, the softer the lighting. In this regard, an external flash has it all over the built-in flash.

TIP

You can improve the quality of light coming from any flash by adding a *diffuser,* which is a piece of translucent plastic or fabric that you place over the flash to soften and spread the light. Diffusers come in many designs, so do an online search or visit a camera store to check out the options.

>> **With compatible flash units, you can shoot at much faster shutter speeds than you can with the built-in flash.** In fact, the Auto FP flash feature enables you to access the camera's entire range of shutter speeds. Even so, one action-photography problem remains: You can't fire a burst of shots in the Continuous Release modes. But you can set the shutter speed high enough to freeze action for a single shot.

TIP

Being able to use a high shutter speed also improves outdoor portraits because you can use a large *aperture* (low f-stop number). As detailed in Chapter 4, a large aperture produces a blurry background that's perfect for portraits. But with a large aperture, more light enters the camera, which means that you need a fast shutter speed (short exposure time) to expose the image properly. The top shutter speed available with the built-in flash won't be fast enough to avoid overexposure when you use a large aperture in bright sunlight. That problem goes away when you use an external flash because you can use shutter speeds as high as 1/8000 second.

>> **If you buy a flash that has a rotating head, you can take advantage of** *bounce flash.* That's the term for aiming the flash head upward so that the light bounces off the ceiling and falls softly down onto the subject. Not only does this technique produce more flattering lighting but also reduces or eliminates distracting background shadows. Figure 3-2 has an example of a subject photographed with the flash coming directly onto the subject and with bounce flash.

WARNING

Make sure that the ceiling or other surface you use to bounce the light is white or another neutral color; otherwise, the flash light will pick up the color of the surface and influence the color of your subject.

>> **You can create an easy, two-light setup with an external flash and the built-in flash.** Assuming that you buy a flash compatible with the Nikon Creative Lighting system, you can use the built-in flash to trigger the external flash when it's not attached to the camera. You might use the built-in flash to light the front of your subject and set up the external flash to add light from the side, for example.

The downside to an external flash? Well, the most obvious disadvantages are the cost and added bulk of the equipment you have to lug around. In addition, external flash heads require their own power source, whereas the built–in flash works off the camera's battery. The flash I use, for example, takes four AA batteries. A flash eats up battery power quickly, so you should always carry at least one set of spare batteries.

Direct flash　　　　　　　　Bounce flash

FIGURE 3-2:
Blasting
the subject
from the
front creates
harsh lighting
and strong
shadows (left);
bouncing
the light off
the ceiling
produces
softer results
(right).

WARNING

IN SYNC: FLASH TIMING AND SHUTTER SPEED

To properly expose flash pictures, the camera has to synchronize the firing of the flash with the opening and closing of the shutter. For this reason, the range of available shutter speeds is limited when you use flash. The maximum shutter speed for the built-in flash is 1/250 second (or 1/320, if you enable high-speed flash). Minimum shutter speeds vary depending on the exposure mode, as follows:

- **Auto mode and all Scene modes except Portrait and Night Portrait:** 1/60 second

- **Night Portrait:** 1 second

- **Portrait:** 1/30 second

- **P, A:** 1/60 second (unless you use one of the Slow-Sync Flash modes, which permit a shutter speed as slow as 30 seconds)

- **S:** 30 seconds

- **M:** 30 seconds (for Fill Flash mode, you can exceed that limit if the shutter speed is set to Bulb or Time, which are two special shutter speeds I discuss in Chapter 4)

Despite those drawbacks, I consider an external flash a necessity for portrait photography. An external flash is also especially helpful for product photography because of the lighting flexibility you get when you use the built-in flash to trigger the external flash. On the other hand, if you're primarily interested in wildlife or landscape photography, which don't normally involve flash, I recommend waiting to buy an external flash until you feel limited by the abilities of the built-in flash.

Understanding Flash Modes

The Flash mode determines how and when the flash fires, which in turn affects the lighting in your photo. The next section explains how to adjust the Flash mode; following that, you can find explanations of each mode.

Note: If you use an external flash, consult its instruction manual to find out whether you can set the Flash mode via the camera controls or need to use controls on the flash unit. You also may discover that some modes available with the built-in flash aren't compatible with your external flash.

Viewing and changing the Flash mode

When flash is enabled, the current Flash mode appears in the Information and Live View displays, as shown in Figure 3-3. The symbol labeled in the figures represents Fill Flash mode; see the margins in upcoming sections for a look at the symbols used for other modes.

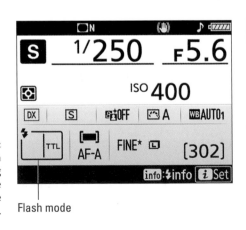
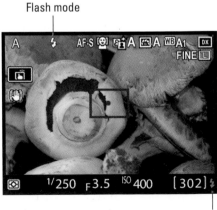

FIGURE 3-3: An icon representing the Flash mode appears in the displays.

Flash mode

Flash mode

Flash ready

REMEMBER

In the P, S, A, and M exposure modes, the Flash mode appears only if the flash is raised. Ditto for the Food Scene mode.

TECHNICAL STUFF

The TTL part of the Flash mode symbol on the Information display stands for *through the lens*, which refers to the way the camera decides how much flash power is needed. In TTL mode, the camera measures the ambient light and sets the flash output accordingly. Later sections explain some ways to tweak flash power if you don't like what the TTL metering produces.

Back to the topic at hand: To change the Flash mode, press and hold the Flash button. The Information display and Live View display then appear as shown in Figure 3-4. Keep the button pressed and then rotate the Main command dial to cycle through the available flash modes.

Main dial symbol Flash mode (Fill Flash)

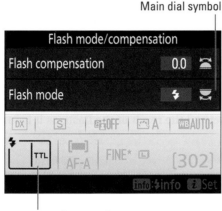
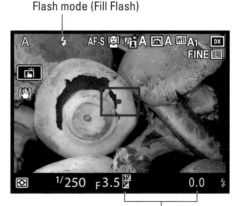

FIGURE 3-4: Press the Flash button while rotating the Main command dial to change the Flash mode.

Flash mode (Fill Flash)

Flash Compensation setting

As you can see from Figure 3-4, the Flash mode setting is presented together with another flash option, Flash Compensation, which you can read about later in this chapter. In the Information display, the two settings are labeled, and the wheel graphic next to each one shows which dial to use to change the setting. (The wheel with the arrow underneath represents the Main command dial.) The Live View display doesn't offer this guidance; I labeled both flash settings so that you know which is which.

Choosing the right Flash mode

Which Flash modes are available depend on your exposure mode. As with most features, you have the most flexibility in the P, S, A, and M exposure modes, although some of the fully automatic exposure modes give you a couple of options as well. The next sections describe all the Flash modes and spell out which exposure modes enable you to access each one.

TECHNICAL STUFF

Flash Compensation settings are stated in terms of EV (Exposure Value) numbers. A setting of 0.0 indicates no flash adjustment. You can increase the flash power to EV +1.0 or decrease it to EV –3.0. Each whole number change equates to a one-stop shift. (*Stop* is camera lingo for an increment of exposure change. A one-stop change doubles or halves the current exposure.)

As an example, see Figure 3-9. The first image shows a flash-free shot. Clearly, I needed a flash to compensate for the fact that the horses were shadowed by the roof of the carousel. But at normal flash power, the flash was too strong, creating glare in some spots on the horse's neck and blowing out the highlights in the white mane. By dialing the flash power down to EV –1.0, I got a softer flash that straddled the line perfectly between no flash and too much flash.

No flash Flash EV 0.0 Flash EV -1.0

FIGURE 3-9:
When normal flash output is too strong, dial in a lower Flash Compensation setting.

WARNING

Any flash-power adjustment you make remains in force until you reset the control. So be sure to check the setting before you next use your flash. Set the value to 0.0 to disable Flash Compensation.

Here's what you need to know to take advantage of Flash Compensation:

>> **Setting the Flash Compensation amount:** Press the Flash button while rotating the Sub-command dial.

While the button is pressed, the displays show the current Flash Compensation amount. As you rotate the Sub-command dial, a plus or minus sign also appears to indicate whether you're dialing in a positive or negative value. Figure 3-10 shows you where to find the setting in the Information and Live View displays. In the Control panel, all data disappears except the Flash Compensation value and the symbol that represents Flash Compensation, as shown in Figure 3-11. In the viewfinder display, you see the same data as shown in the Live View display.

Sub-command dial symbol

Flash Compensation amount

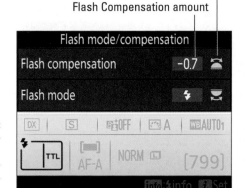

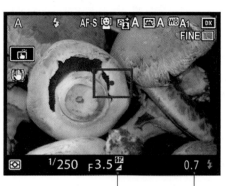

FIGURE 3-10:
Rotate the
Sub-command
dial while
pressing the
Flash button
to apply Flash
Compensation
(adjust flash
output).

Negative value symbol

Flash Compensation amount

FIGURE 3-11:
While the
Flash button
is pressed,
the Flash
Compensation
amount also
appears in the
Control panel.

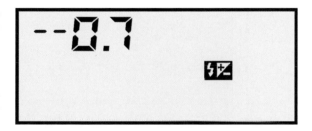

REMEMBER

In the viewfinder and Live View display, the lower half of the Flash Compensation symbol initially appears as shown in Figure 3-4, displaying both a plus sign and a minus sign. When you adjust the setting, one of the signs disappears to indicate whether you're dialing in a negative or positive value. In Figure 3-10, for example, the minus-sign part of the symbol is visible, which means that the Flash Compensation setting is EV -0.7. (The symbols are hard to see in the figures, so you may want to grab your camera so that you can get a better idea of how things look.)

After you release the Flash button, you see the Flash Compensation amount in the Information display, in the area shown in Figure 3-12. But the Live View display, viewfinder, and Control panel show just the Flash Compensation icon. You can press the Flash button at any time to reveal the Flash Compensation value.

REMEMBER

» **Disabling flash adjustment during Exposure Compensation:** Exposure Compensation, a cousin of Flash Compensation, gives you a way to produce a darker or lighter overall exposure. (Chapter 4 covers this feature.) By default, if you use flash when Exposure Compensation is in force, the flash power is affected by your Exposure Compensation setting. But you can tell the camera to leave the flash out of the Exposure Compensation equation. To do so, open the Custom Setting menu. Choose Bracketing/Flash and then change the Exposure Comp. for Flash setting from Entire Frame to Background Only. You then can use Flash Compensation to vary the flash output as you see fit.

Flash Compensation setting

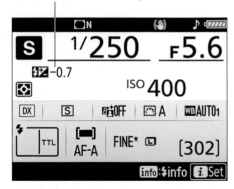

FIGURE 3-12:
The Flash Compensation setting appears in the display only when you select a value other than 0.0.

Switching to manual flash-power control

Normally, your flash operates in the TTL (through the lens) mode, in which the camera automatically determines the flash output for you. If you prefer, you can switch to manual flash control and select a specific flash power. You can use this option only in the P, S, A, and M exposure modes.

To switch to manual flash control, open the Photo Shooting menu and choose Flash Control to display the screen shown on the left in Figure 3-13. Choose Flash Control Mode (built-in) to display the screen shown on the right in the figure. Select Manual to access the screen where you can set the flash power. Settings range from full power to 1/128 power. (If you're hip to rating flash power by Guide Numbers, the camera manual spells out the ratings for the built-in flash.)

If an external flash is attached, the menu option name changes from Flash Control Mode (built-in) to Flash Control Mode (external). Again, consult your flash instruction guide to find out whether you need to do anything special to use manual flash control.

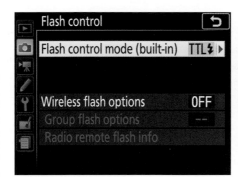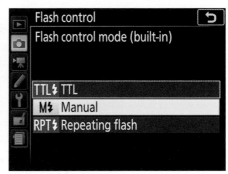

FIGURE 3-13:
In the P, S,
A, and M
exposure
modes,
you can set
flash power
manually.

Enabling High-Speed Flash (Auto FP)

To properly expose flash pictures, the camera has to synchronize the timing of the flash output with the opening and closing of the shutter. On the D7500, this synchronization normally dictates a maximum shutter speed of 1/250 second when you use the built-in flash. But by enabling Auto FP flash, you can bump the maximum sync speed up to 1/320 second for the built-in flash. If you attach a compatible Nikon flash unit, you can access the full range of shutter speeds.

WARNING

When Auto FP flash is used, the flash fires a little differently. Instead of a single pop of light, it emits a continuous, rapid-fire burst while the shutter is open. Although that sounds like a good thing, it actually forces a reduction of the flash power, thereby shortening the distance over which subjects remain illuminated. The faster your shutter speed, the greater the impact on the flash power. So at very high speeds, your subject needs to be pretty close to the camera to be properly exposed by the flash.

Because of this limitation, high-speed flash is mostly useful for shooting portraits or other close-up subjects. In fact, it's very useful when you're shooting portraits outside in the daytime and you want the background to appear blurry. One way to get that blurry background is to use a low f-stop number (large aperture). Problem is, a large aperture lets a ton of light into the camera, and at a shutter speed of 1/250 second, all that light typically overexposes the picture even at ISO 100. With high-speed flash, you can increase the shutter speed enough to compensate for the large aperture. (Chapters 4 and 5 explain f-stops and other exposure and focus issues.)

To access the high-speed flash option, open the Bracketing/Flash section of the Custom Setting menu and select Flash Sync Speed, as shown in Figure 3-14. You can choose from the following settings:

>> **1/320 s (Auto FP):** At this setting, you can use the built-in flash with shutter speeds up to 1/320 second. For select Nikon flash units, you can use any shutter speed.

FIGURE 3-14:
Through this
option, you
can enable
high-speed
flash,
permitting
a faster
maximum
shutter speed
for flash
photos.

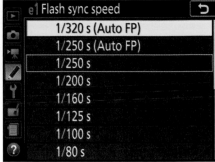

>> **1/250 s (Auto FP):** For compatible external flash units, the high-speed flash behavior kicks in at shutter speeds over 1/250 second. With the built-in flash, the flash sync speed is set to 1/250 second. In P and A exposure modes, the high-speed flash sync is activated if the camera needs to use a shutter speed faster than 1/250 second. (Note that the camera may sometimes use a shutter speed faster than 1/250 second in those modes even if the shutter speed readout is 1/250.)

>> **1/250 s to 1/60 s:** The other settings on the menu establish a fixed maximum sync speed. By default, it's set to 1/250 second, and high-speed flash operation is disabled.

Using Flash Value Lock (FV Lock)

By default, the camera measures the light throughout the entire frame to calculate exposure and flash settings when you press the shutter button halfway. But it adjusts those settings up to the time you press the shutter button fully to record the image, ensuring that exposure remains correct even if the light changes between your initial shutter button press and the image capture. FV Lock (Flash Value Lock) enables you to lock flash power at any time before you fully depress the shutter button.

Here's the most common reason for using this feature: Suppose that you want to compose your photo so that your subject is located at the edge of the frame. You frame the scene initially so the subject is at the center of the frame, lock the flash power, and then reframe. If you don't lock the flash value, the camera calculates flash power on your final framing, which could be inappropriate for your subject. You also can use FV Lock to maintain a consistent flash power for a series of shots.

This feature is one of the few advanced flash options that works in Auto mode and in the Scene and Effects modes that permit flash — but only if the camera sees the need for flash in the first place. In Food Scene mode, which doesn't offer Auto Flash, you must pop up the flash by pressing the Flash button.

Whatever the exposure mode, FV Lock is available only for viewfinder photography; it doesn't work in Live View mode. And when using the built-in flash, you must use the TTL setting for the Flash Control Mode (built-in) option. That setting is the default, but if you have changed to another setting, open the Photo Shooting menu and choose Flash Control to access the option.

REMEMBER

You also need to assign the FV Lock function to a button — there's no other way to implement the feature. The most likely candidate for the job is the Fn2 button, which isn't set by default to handle any operation. You also can assign FV Lock to the Fn1 button, AE-L/AF-L button, or BKT (bracketing) button, but those buttons are all set by default to perform other functions, so while working with this book, leave those buttons alone to avoid confusion.

The fastest way to set the FN2 button to activate FV Lock is to display the *i*-button menu and choose Custom Control Assignment, as shown on the left in Figure 3-15. Select the Fn2 button, as shown on the right in the figure, to display the screen showing possible button functions. Select FV Lock, which is at the top of the list.

FIGURE 3-15:
You can set the Fn2 button to perform the FV Lock function via the *i*-button menu.

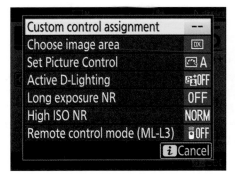
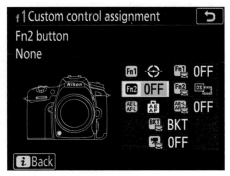

After assigning FV Lock to the Fn2 button, follow these steps:

1. **Frame the shot so that your subject is in the center of the viewfinder.**

2. **Press and hold the shutter button halfway to engage the exposure meter and, if autofocusing is used, set focus.**

3. **Press and release the Fn 2 button (or whatever button that you assigned to FV Lock).**

The flash fires a brief light to determine the correct flash power. When flash power is locked, you see a little flash symbol with the letter L at the left end of the viewfinder. The same symbol appears in the Information display (look in the upper-left corner of the screen).

4. **Recompose the picture if desired and then take the shot.**

To disable FV Lock, press the Fn2 button (or other assigned button) again.

Exploring Additional Flash Options

For most people, the flash options covered earlier in the chapter are the most useful on a regular basis, but your camera does offer a few other features you may appreciate on occasion. Take a look:

TECHNICAL STUFF

>> **Use the built-in flash as a wireless trigger for remote flash units.** If you purchase external flash units that are compatible with the Nikon Creative Lighting system, you can use the built-in flash to trigger them wirelessly.

In the past, this feature was known as *Commander mode,* and that's still the common vernacular in the Nikon world. Some folks also use the term *master* to refer to the flash that triggers remote units and *slave* to refer to remote units. I bring all this up only so that when a Nikon enthusiast asks whether your D7500 can act as a flash master or commander, you know to answer "Oh, absolutely!"

Whatever you call this feature, if you've used it before, you may be used to setting it up via the Bracketing/Flash section of the Custom Setting menu. On the D7500, Nikon rearranged things: You now access the wireless trigger function through the Photo Shooting menu. Choose Flash Control to display the screen shown on the left in Figure 3-16 and then select Wireless Flash options to access the screen shown on the right. You then see one or both of the following options:

- *Optical AWL:* This is the go-to setting and is available when the built-in flash is raised or when the SB-500 external flash is attached to the camera. The AWL stands for Advanced Wireless Lighting; the *optical* part means that the whole thing works based on the remote units having a sensor that can "see" and then react to the light put out by the built-in flash.

- *Optical/Radio AWL:* This option is available only when the WR-R10 wireless remote is attached to the camera and the built-in flash is raised. It enables you to set up a multiple flash system with remote units that can communicate either via the usual optical signal or by radio control.

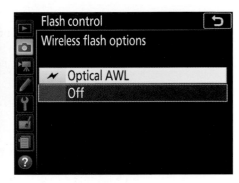

FIGURE 3-16:
Set up wireless
remote flash
control via the
Flash Control
option on the
Photo Shooting
menu.

>> **Create a multiple-exposure effect by using the Repeating Flash feature.**
When this setting is in force, the flash fires repeatedly as long as the shutter is
open. The result is that when you photograph a moving subject, it appears at
partial opacity at several spots in the frame, following the path of the move-
ment. In other words, this is strictly a special-effects option. To try it out,
choose Flash Control from the Photo Shooting menu, select Flash Control
Mode (built-in), and select Repeating Flash. If an external flash is attached, the
option name is Flash Control Mode (external).

>> **Enable a slower flash-sync speed in P and A exposure modes:** In those exposure
modes, the camera normally restricts itself to using a shutter speed no slower than
1/60 second when you use flash. If you need a longer exposure — as may be the
case when shooting in very dark conditions — you can waive that 1/60 second limit
through the Flash Shutter Speed option, found in the Bracketing/Flash section of
the Custom Setting menu. You can set the minimum as slow as 30 seconds.

WARNING

Note that the camera totally ignores this value if you set the Flash mode to
Slow-Sync flash, Slow-Sync with Red Eye, or Slow Rear-Curtain Sync, which
already drops the shutter speed below 1/60 second. Flip back to the section
"Choosing the right Flash mode" for help with these settings.

>> **Preview lighting with modeling flash.** Before you take a flash picture, you
can get an idea of where the flash light will fall on your subject by telling the
camera to emit a *modeling flash,* which is a rapid series of flash pulses. If you
want to take advantage of this option, however, you must assign the task to
one of the Function (Fn) buttons or one of the other customizable buttons.
Chapter 11 has more information on button customization. After making the
button assignment, just press that button to fire the modeling flash.

>> **Bracket flash exposures.** Your camera's automatic bracketing feature enables
you to easily shoot a series of shots using different exposure settings. As part of
that option, you can have the camera adjust flash output as it captures a series of
bracketed shots. See the last section of Chapter 4 for details on bracketing.

>> **Set Auto ISO preferences for flash pictures:** Detailed in Chapter 4, ISO deter-
mines the camera's sensitivity to light, which in turn plays a role in how much

flash power is needed to expose the image. You can tell the camera to adjust the ISO setting for you by turning on Auto ISO Sensitivity Control. When that feature is enabled, specify how you want the camera to calculate the proper ISO when you shoot flash pictures. You can tell it to consider both the subject and the background or the subject only. Make the call by opening the Custom Setting menu, choosing Bracketing/Flash, and choosing the Auto Flash ISO Sensitivity Control option. (In the menu, the word Flash is replaced by a lightning bolt symbol.)

» **Press the Info button to display a summary of flash and exposure settings.** When the flash is raised during viewfinder shooting, an Info symbol appears in the lower-right corner of the Information display, as shown on the left in Figure 3-17. It's an indication that you can bring up a screen showing just flash and exposure settings, as shown on the right in the figure. The screen is officially known as the Flash Information display.

For everyday flash photography, the screen doesn't offer any information you can't already see in the Information display other than the flash-ready symbol (which is visible in the viewfinder). The Flash Information screen just enables you to consider exposure and flash settings without being distracted by other Information screen data.

Personally, I don't find the screen helpful unless I'm using the wireless-flash control feature to trigger multiple external flashes at once. In that situation, the Flash Information screen displays details that aren't visible in the Information display.

In case you're interested, the *TTL BL* symbol at the top of the Flash Information screen in Figure 3-17 refers to the fact that the flash is set to meter exposure using Nikon's *through-the-lens balanced fill* formula. Which is to say, the default Nikon automatic flash-metering system.

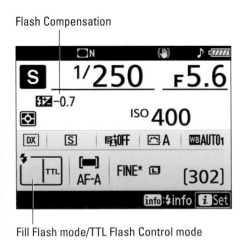

FIGURE 3-17: Press the Info button while the flash is raised to view flash and exposure settings as a group.

Flash Compensation

Flash ready symbol

TTL Flash Control mode

Fill Flash mode/TTL Flash Control mode

Fill Flash mode

Flash Compensation

2
Taking Creative Control

IN THIS CHAPTER

» **Understanding the basics of exposure**

» **Choosing the right exposure mode: P, S, A, or M?**

» **Reading meters and other exposure cues**

» **Solving exposure problems**

» **Taking advantage of automatic exposure bracketing**

Chapter **4**

Taking Charge of Exposure

U nderstanding exposure is one of the most intimidating challenges for a new photographer. Discussions of the topic are loaded with technical terms — *aperture, metering, shutter speed, ISO,* and the like. Add the fact that your camera offers many exposure controls, all sporting equally foreign names, and it's no wonder that most people throw up their hands and decide that their best option is to stick with the Auto exposure mode and let the camera take care of all exposure decisions.

You can, of course, turn out good shots in Auto mode, and I fully relate to the confusion you may be feeling — I've been there. But I can also promise that when you take things nice and slow, digesting a piece of the exposure pie at a time, the topic is *not* as complicated as it seems on the surface. I guarantee that the payoff will be worth your time, too. You'll not only gain the know-how to solve just about any exposure problem but also discover ways to use exposure to put your creative stamp on a scene.

To that end, this chapter provides everything you need to know about controlling exposure, from a primer in exposure terminology (it's not as bad as it sounds) to tips on using the P, S, A, and M exposure modes, which are the only ones that offer access to all exposure features.

Note: The one exposure-related topic not covered in this chapter is flash; I discuss flash in Chapter 3 because it's among the options you can access even in Auto mode and many of the other point-and-shoot modes. Also, this chapter deals with still photography; see Chapter 8 for information on movie-recording exposure issues.

Meeting the Exposure Trio: Aperture, Shutter Speed, and ISO

Any photograph is created by focusing light through a lens onto a light-sensitive recording medium. In a film camera, the film negative serves as that medium; in a digital camera, it's the image sensor, which is an array of light-responsive computer chips.

Between lens and sensor are two barriers — the aperture and shutter — which work in concert to control how much light makes its way to the sensor. In the digital world, the design and arrangement of the aperture, shutter, and sensor vary depending on the camera; Figure 4-1 illustrates the basic concept.

The aperture and shutter, along with a third feature, ISO, determine *exposure,* or overall brightness and contrast. This three-part exposure formula works as follows:

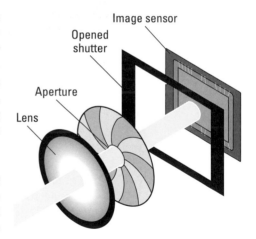

FIGURE 4-1:
The aperture size and shutter speed determine how much light strikes the image sensor.

>> **Aperture (controls the amount of light):** The *aperture* is an adjustable hole in a diaphragm inside the lens. You change the aperture size to control the size of the light beam that can enter the camera.

Aperture settings are stated as *f-stop numbers,* or simply *f-stops,* and are expressed by the letter *f* followed by a number: f/2, f/5.6, f/16, and so on.

The lower the f-stop number, the larger the aperture, and the more light is permitted into the camera, as illustrated by Figure 4-2. (If it seems backward to use a higher number for a smaller aperture, think of it this way: A higher value creates a bigger light barrier than a lower value.) The range of aperture settings varies from lens to lens.

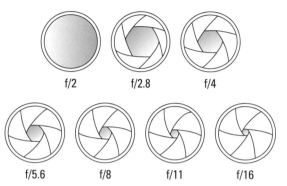

FIGURE 4-2: A lower f-stop number means a larger aperture, allowing more light into the camera.

>> **Shutter speed (controls the duration of light):** The shutter works something like, er, the shutters on a window. The camera's shutter stays closed, preventing light from striking the image sensor (just as closed window shutters prevent sunlight from entering a room) until you press the shutter button. Then the shutter opens briefly to allow light that passes through the aperture to hit the sensor. The exception is when you enable Live View mode: As soon as you switch to Live View mode, the shutter opens and remains open so that the image can form on the sensor and be displayed on the monitor. When you press the shutter button, the shutter first closes and then reopens for the actual exposure.

Either way, the length of time that the shutter is open is the *shutter speed,* which is measured in seconds: 1/60 second, 1/250 second, 2 seconds, and so on.

>> **ISO (controls light sensitivity):** *ISO,* which is a digital function rather than a mechanical structure, enables you to adjust how responsive the image sensor is to light.

TECHNICAL STUFF

The term *ISO* is a holdover from film days, when an international standards organization rated film stock according to light sensitivity: ISO 200, ISO 400, ISO 800, and so on. On a digital camera, the sensor doesn't actually get more or less sensitive when you change the ISO. Instead, the light that hits the sensor is either amplified or dampened through electronics wizardry. The upshot is the same as changing to a more light-reactive film stock, though: Using a higher ISO means that you need less light to produce the image, enabling you to use a smaller aperture, faster shutter speed, or both.

Distilled to its essence, the image-exposure formula is this simple:

>> Together, aperture and shutter speed determine how much light strikes the image sensor.

>> ISO determines how much the sensor reacts to that light and thus how much light is needed to expose the picture.

REMEMBER

The tricky part of the equation is that aperture, shutter speed, and ISO settings affect pictures in ways that go beyond exposure:

>> Aperture affects *depth of field,* or the distance over which focus remains acceptably sharp.

>> Shutter speed determines whether moving objects appear blurry or sharply focused.

>> ISO affects the amount of image *noise,* which is a defect that looks like specks of sand.

Understanding these side effects is critical to choosing the combination of aperture, shutter speed, and ISO that will work best for your subject. The next sections explore each issue.

Aperture affects depth of field

The aperture setting, or f-stop, affects *depth of field,* which is the distance over which focus appears acceptably sharp. With a shallow depth of field, your subject appears more sharply focused than faraway objects; with a large depth of field, the sharp-focus zone spreads over a greater distance.

REMEMBER

As you reduce the aperture size by choosing a higher f-stop number — *stop down the aperture,* in photo lingo — you increase the depth of field. As an example, see Figure 4-3. For both shots, I established focus on the fountain statue. Notice that the background in the first image, taken at f/13, is sharper than in the right example, taken at f/5.6. Aperture is just one contributor to depth of field, however; the focal length of the lens and the distance between that lens and your subject also affect how much of the scene stays in focus. See Chapter 5 for the complete story.

TIP

One way to remember the relationship between f-stop and depth of field is to think of the *f* as standing for *focus.* A higher f-stop number produces a larger depth of field, so if you want to extend the zone of sharp focus to cover a greater distance from your subject, you set the aperture to a higher f-stop. Higher *f*-stop number, greater zone of sharp *focus.* (Please *don't* share this tip with photography elites, who will roll their eyes and inform you that the *f* in *f-stop* most certainly

does *not* stand for focus but for the ratio between the aperture size and lens focal length — as if *that's* helpful to know if you're not an optical engineer. Chapter 1 explains focal length, which *is* helpful to know.)

f/13, 1/25 second, ISO 200 f/5.6, 1/125 second, ISO 200

FIGURE 4-3: Widening the aperture (choosing a lower f-stop number) decreases depth of field.

Shutter speed affects motion blur

At a slow shutter speed, moving objects appear blurry; a fast shutter speed captures motion cleanly. This phenomenon has nothing to do with the actual focus point of the camera but rather on the movement occurring — and being recorded by the camera — while the shutter is open.

Compare the photos in Figure 4-3. The static elements are perfectly focused in both images although the background in the left photo appears sharper because I shot that image using a higher f-stop, increasing the depth of field. But how the camera rendered the moving portion of the scene — the fountain water — was determined by shutter speed. At 1/25 second (left photo), the water blurs, giving it a misty look. At 1/125 second (right photo), the droplets appear more sharply focused, almost frozen in mid-air. How high a shutter speed you need to freeze action depends on the speed of your subject.

If your picture suffers from overall image blur, like the picture shown in Figure 4-4, where even stationary objects appear out of focus, the camera moved during the exposure. This movement, or *camera shake,* is always a danger when you handhold the camera at slow shutter speeds. The longer the exposure time, the longer you have to hold the camera still to avoid the blur caused by camera shake.

How slow a shutter speed can you use before camera shake becomes a problem? The answer depends on a couple factors, including your physical abilities and your lens — the heavier the lens, the harder it is to hold steady. Camera shake also affects your picture more when you shoot with a lens that has a long focal length. You may be able to use a slower shutter speed with a 55mm lens than with a 200mm lens, for example. Finally, it's easier to detect slight blurring in an image that shows a close-up view of a subject than in one that captures a wider area. Moral of the story: Take test shots to determine the slowest shutter speed you can use with each of your lenses.

FIGURE 4-4:
If both stationary and moving objects are blurry, camera shake is the usual cause.

Of course, to avoid the possibility of camera shake altogether, mount your camera on a tripod. If you must handhold the camera, investigate whether your lens offers Vibration Compensation, a feature that helps compensate for small amounts of camera shake. The 18-140mm kit lens featured in this book does provide that feature; enable it by moving the VC switch on the lens to the On position.

TIP

Freezing action isn't the only way to use shutter speed to creative effect. When shooting waterfalls, for example, many photographers use a slow shutter speed to give the water even more of a blurry, romantic look than you see in the fountain example. With colorful subjects, a slow shutter can produce some cool abstract effects and create a heightened sense of motion. Chapter 7 offers examples of both effects.

ISO affects image noise

As ISO increases, making the image sensor more reactive to light, you increase the risk of noise. *Noise* is a defect that looks similar in appearance to film *grain,*

a defect that often mars pictures taken with high ISO film. Both problems make your photo look like it was sprinkled with tiny grains of sand. Figure 4-5 offers an example.

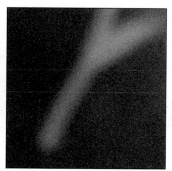

FIGURE 4-5:
Caused by a very high ISO or long exposure time, noise becomes more visible as you enlarge the image.

Ideally, then, you should always use the lowest ISO setting on your camera to ensure top image quality. But sometimes the lighting conditions don't permit you to do so. Take the rose photos in Figure 4-6 as an example. When I shot these pictures, I didn't have a tripod, so I needed a shutter speed fast enough to allow a sharp handheld image. I opened the aperture to f/5.6, which was the widest setting on the lens I was using, to allow as much light as possible into the camera. At ISO 100, the camera needed a shutter speed of 1/40 second to expose the picture, and that shutter speed wasn't fast enough for a successful handheld shot. You see the blurred result on the left in Figure 4-6. Raising the ISO to 200 allowed a shutter speed of 1/80 second, which was fast enough to capture the flower cleanly, as shown on the right in the figure.

Fortunately, you don't encounter serious noise on the D7500 until you really crank up the ISO, which is why the one-step bump from ISO 100 to ISO 200 produced no noticeable change in the amount of noise in my rose photo. In fact, some people probably wouldn't even notice the noise in the left image in Figure 4-5 unless they were looking for it. But as with other image defects, noise becomes more apparent as you enlarge the photo, as shown on the right in that same figure. Noise is also easier to spot in shadowed areas of the picture and in large areas of solid color.

ISO 100, f/5.6, 1/40 second ISO 200, f/5.6, 1/80 second

FIGURE 4-6:
Raising the ISO
from 100 to
200 allowed
a faster
shutter speed,
enabling
a sharper
handheld
shot without
introducing
objectionable
noise.

How much noise is acceptable — and, therefore, how high of an ISO is safe — is your choice. Even a little noise isn't acceptable for pictures that require the highest quality, such as images for a product catalog or a travel shot that you want to blow up to poster size.

WARNING

A high ISO isn't the only cause of noise. A long exposure time (slow shutter speed) can also produce the defect. So if you use both a high ISO and slow shutter speed, expect a double-whammy in the noise department.

Doing the exposure balancing act

Aperture, shutter speed, and ISO combine to determine image brightness. So changing any one setting means that one or both of the others must also shift to maintain the same image brightness.

Suppose that you're shooting a soccer game and you notice that although the overall exposure looks great, the players appear slightly blurry at the current shutter speed. If you raise the shutter speed, you have to compensate with either a larger aperture (to allow in more light during the shorter exposure time) or a higher ISO setting (to make the camera more sensitive to the light). Which way should you go? Well, it depends on whether you prefer the shallower depth of field that comes with a larger aperture or the increased risk of noise that accompanies a higher ISO. Of course, you can also adjust both settings to get the exposure results you need, perhaps upping ISO slightly and opening the aperture just a bit as well.

All photographers have their own approaches to finding the right combination of aperture, shutter speed, and ISO, and you'll no doubt develop your own system when you become more practiced at using the advanced exposure modes. In the meantime, here are some recommendations:

>> Use the lowest possible ISO setting unless the lighting conditions are so poor that you can't use the aperture and shutter speed you want without raising the ISO.

>> If your subject is moving, give shutter speed the next highest priority in your exposure decision. Choose a fast shutter speed to ensure a blur-free photo or, on the flip side, select a slow shutter speed to intentionally blur that moving object, an effect that can create a heightened sense of motion.

>> For nonmoving subjects, make aperture a priority over shutter speed, setting the aperture according to the depth of field you have in mind. For portraits, for example, try using a wide-open aperture (a low f-stop number) to create a shallow depth of field and a nice, soft background for your subject.

WARNING

Be careful not to go too shallow with depth of field when shooting a group portrait — unless all the subjects are the same distance from the camera, some may be outside the zone of sharp focus. A shallow depth of field also makes action shots more difficult because you have to be absolutely spot on with focus. With a larger depth of field, the subject can move a greater distance toward or away from you before leaving the sharp-focus area, giving you a bit of a focusing safety net.

Keeping all this information straight is a little overwhelming at first, but the more you work with your camera, the more the whole exposure equation will make sense to you. You can find tips in Chapter 7 for choosing exposure settings for specific types of pictures; keep moving through this chapter for details on how to monitor and adjust aperture, shutter speed, and ISO settings.

Stepping Up to Advanced Exposure Modes (P, S, A, and M)

In the Auto, Auto Flash Off, Scene, and Effects exposure modes, you have little control over exposure. You may be able to choose from one or two Flash modes, and you can adjust ISO in all modes except Auto, Auto Flash Off, and Night Vision Effects mode. But to gain full control over exposure, set the Mode dial to one of the advanced modes highlighted in Figure 4-7. You also need to use the P, S, A, or M modes to take advantage of other camera features, including some color and autofocus options.

The major difference between the four modes is the level of control you have over aperture and shutter speed. Here's how things shake out:

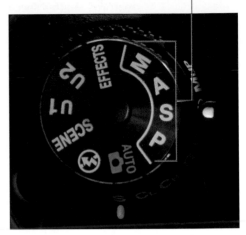

>> **P (programmed autoexposure):** The camera selects an initial aperture setting and shutter speed that it thinks will deliver a good exposure at the current ISO setting. But you can choose from different combinations of the two for creative flexibility. For example, if you're shooting action, you can pick the combo that offers the fastest shutter speed. Or, if you're taking a portrait, you can choose the pairing that offers the lowest f-stop number in order to blur the background as much as possible.

FIGURE 4-7:
Only the P, S, A, and M exposure modes offer full control over exposure and certain other camera settings.

>> **S (shutter-priority autoexposure):** You set the shutter speed, and the camera chooses the aperture setting that produces a good exposure at that shutter speed and the current ISO setting.

>> **A (aperture-priority autoexposure):** The opposite of shutter-priority autoexposure, this mode asks you to select the aperture setting. The camera then selects the appropriate shutter speed — again, based on the selected ISO setting.

>> **M (manual exposure):** In this mode, you specify both shutter speed and aperture. The brightness of your photo depends on the settings you select and the current ISO setting.

REMEMBER

To sum up, the first three modes are semiautomatic modes that offer exposure assistance while still providing some creative control. Note one important point about P, S, and A modes, however: In extreme lighting conditions, the camera may not be able to select settings that will produce a good exposure, and it doesn't stop you from taking a poorly exposed photo. You may be able to solve the problem by using features designed to modify autoexposure results, such as Active D–Lighting (explained later in this chapter) or by adding flash, but you get no guarantees.

Manual mode puts all exposure control in your hands. If you're a longtime photographer who comes from the days when manual exposure was the only game in town, you may prefer to stick with this mode. If it ain't broke, don't fix it, as they say. And in some ways, manual mode is simpler than the semiautomatic modes — if you're not happy with the exposure, you just change the aperture, shutter speed, or ISO setting and shoot again. By contrast, when you use the P, S, and A modes, you have to experiment with features that modify autoexposure results.

So which mode should you use? Well, P mode is useful when you're first starting out because it automates exposure but gives you access to the camera's other controls (color options, focus options, and so on). But after you understand aperture and shutter speed and know what settings you want to use, I recommend leaving P mode behind. It's just too time consuming to work your way through a batch of shutter speed and aperture combinations to find one that is appropriate.

TIP

EXPOSURE STOPS: HOW MANY DO YOU WANT TO SEE?

In photo terminology, *stop* refers to an increment of exposure. To increase exposure by one stop means to adjust the aperture or shutter speed to allow twice as much light into the camera as the current settings permit. To reduce exposure a stop, you use settings that allow half as much light. Doubling or halving the ISO value also adjusts exposure by one stop.

By default, most exposure-related settings on your camera are based on 1/3 stop adjustments. If you prefer, you can tell the camera to present exposure adjustments in 1/2 stop increments so that you don't have to cycle through as many settings each time you want to make a change.

Make your preferences known through these options, found in the Metering/Exposure section of the Custom Setting menu:

- **ISO Sensitivity Step Value:** Affects ISO settings only.

- **EV Steps for Exposure Cntrl (Control):** Affects shutter speed, aperture, Exposure Compensation, Flash Compensation, and exposure bracketing settings. Also determines the increment used to indicate the amount of under- or overexposure in the exposure meter.

The default setting, 1/3 stop, provides the greatest degree of exposure fine-tuning, so I stick with that option. In this book, all instructions assume that you're using the defaults as well.

My choice is to use aperture-priority autoexposure (A) when I'm shooting stationary subjects and want to control depth of field — aperture is my *priority* — and to switch to shutter-priority autoexposure (S) when I'm shooting a moving subject and I'm most concerned with controlling shutter speed. Frankly, my brain is taxed enough by all the other issues involved in taking pictures — what my Release mode setting is, what resolution I need, where I'm going for lunch as soon as I make this shot work — that I appreciate having the camera do some of the exposure "lifting."

However, when I know exactly what aperture and shutter speed I want to use or I'm after an out-of-the-ordinary exposure, I use manual exposure. For example, sometimes when I'm doing a still life in my studio, I want to create a certain mood by underexposing a subject or even shooting it in silhouette. The camera will always fight you on that result in the P, S, and A modes because it so dearly wants to provide a good exposure. Rather than dial in all the autoexposure tweaks that could eventually force the result I want, I simply set the mode to M, adjust the shutter speed and aperture directly, and give the autoexposure system the afternoon off.

Reading the Meter

In the P, S, A, and M exposure modes, you have access to an *exposure meter*, which is a bar graph that indicates whether your picture will be properly exposed at your chosen f-stop, shutter speed, and ISO settings.

Figure 4-8 shows the exposure meter as it appears in the Information display, Control panel, and viewfinder. Notice that the design of the meter in the viewfinder is a little different from the one in the other displays: The limited viewfinder display space requires a truncated version of the meter. (More on how to understand both versions later.)

By default, the Live View display doesn't include an exposure meter. You can either check the meter in the Control panel or enable Exposure Preview, which not only adds a meter to the display but also tells the camera to adjust the preview to approximate the final image brightness. Turn on Exposure Preview from the *i*-button menu, as shown on the left in Figure 4-9. The Live View version of the meter has a vertical orientation, as shown on the right in the figure.

REMEMBER

Your exposure mode determines how the meter works, as follows:

>> **In M (manual) exposure mode, the meter is always visible and works like a traditional light meter.** That is, after the camera analyzes the light in the scene, considers your exposure settings, and the meter indicates whether your picture will be properly exposed, underexposed, or over exposed.

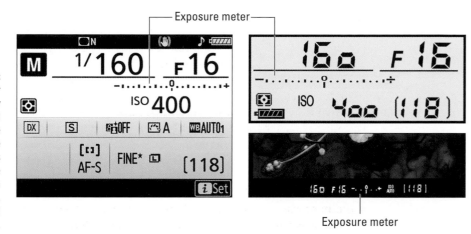

Exposure meter

Exposure meter

FIGURE 4-8: For viewfinder photography in the M exposure mode, the meter is always visible in the Information display, viewfinder, and Control panel.

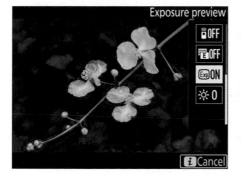

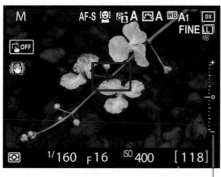

Exposure meter

FIGURE 4-9: For Live View photography, enable Exposure Preview from the *i*-button menu (left) to display the meter (right).

REMEMBER

Figure 4-10 offers three meter readouts, showing a good exposure, underexposure, and overexposure. When you see just a single bar under the 0 at the middle of the meter, all's well. Bars appearing to the left of that 0 mark, heading toward the minus sign, indicate underexposure. Bars running toward the plus sign indicate overexposure. (Details about determining the extent of the problem to come shortly.)

» **In P, A, and S modes, the meter doesn't appear unless one of the following occurs:**

- *The camera anticipates an exposure problem.* In these exposure modes, the camera takes care of aperture, shutter speed, or both. In cases where the light conditions are such that the camera can't choose the settings that will deliver a good exposure, the meter appears and starts blinking to alert you to the problem. In A exposure mode, shutter speed value also blinks; in S mode, the f-stop blinks.

Good exposure

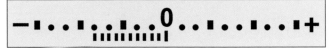

FIGURE 4-10:
A single bar
under 0
indicates a
good exposure
(top); smaller
bars appearing
to the left
or right of 0
indicate an
exposure
problem.

1 2/3 stops underexposed

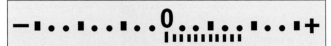

1 2/3 stops overexposed

- *You enable Exposure Compensation.* Detailed later in this chapter, this feature gives you a way to force the autoexposure system to deliver a different exposure than the camera has in mind.

 When Exposure Compensation is turned on, the bars that indicate exposure under- or overexposure in M exposure mode instead reflect the amount of adjustment you requested. Bars to the left of the 0 mark indicate that you asked for a darker picture on your next shot. Bars to the right appear when you request a brighter picture.

Now for the promised meter-reading details:

» **The meter is divided into stops.** A *stop,* as explained in the earlier sidebar, represents an increment of exposure shift. How many stops the meter shows and how they are represented depends on which meter you're viewing:

- *Control panel, Information display, and Live View display:* The meter takes on the form shown in Figure 4-10 (the Live View version is rotated 90 degrees). This meter spans six stops, from three stops underexposed to three stops overexposed. The dots between each rectangle represent a third of a stop. So the second meter in the figure indicates an underexposure of 1 2/3 stops. The third readout shows an overexposure of 1 2/3 stops. (In the P, S, and A modes, again, the reading shows the amount of Exposure Compensation requested.)

- *Viewfinder:* The viewfinder meter, shown in Figure 4-11, spans only four stops, with small squares at each full-stop mark. Tick marks indicating under- or overexposure are still provided in 1/3 stop increments, however. The middle and right readouts in the figure indicate 1 2/3 stops of under- and overexposure, respectively.

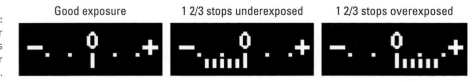

REMEMBER

TIP

FIGURE 4-11:
The viewfinder meter shows spans just four stops.

Good exposure 1 2/3 stops underexposed 1 2/3 stops overexposed

The 1/3-stop setup assumes that you haven't strayed from the default setting of the EV Stops for Exposure Control setting (found on the Custom Setting menu, in the Metering/Exposure neighborhood). If you switch to the half-stop option, the markings on the meter reflect that change.

>> **You may need to press the shutter button halfway to initiate exposure metering.** During viewfinder photography, the camera saves battery power by turning off the metering system after a few seconds of inactivity. To initiate exposure metering, press the shutter button halfway. (If you're using autofocusing, your button press also fires up the autofocus system.) In Live View mode, the meter is always on — at least, until automatic sleep mode kicks in, which happens at the ten-minute mark by default.

>> **You can customize certain aspects of the exposure metering system.** You can make the following adjustments via the Custom Setting menu:

- *Adjust meter shutdown timing:* Choose Timers/AE Lock and then select Standby Timer, as shown in Figure 4-12, to reduce or extend the automatic meter shutdown timing.

 If you rely on the Information display to read the meter, you may also want to adjust a nearby option: Monitor Off Delay. By default, the Information display turns off after just four seconds of no activity, which I find maddeningly short. You can choose a delay of up to 10 minutes. Just keep in mind that the monitor consumes a lot of battery power, so use the shortest delay that's workable.

FIGURE 4-12:
You can adjust the timing of the automatic meter and Information display shutdown.

- *Reverse the meter orientation.* For photographers used to a camera that orients the meter with the positive (overexposure) side appearing on the left and the negative (underexposure) side on the right — the design that Nikon used for years — the D7500 offers the option to flip the meter to that orientation. From the Custom Setting menu, choose Controls and then select Reverse Indicators. Choose the first menu option (+0-) to flip the meter.

- *Recalibrate the meter:* The Fine-Tune Optimal Exposure option, found in the Metering/Exposure section of the Custom Setting menu, is provided for photographers who *always* want a brighter or darker exposure than the camera delivers by default. In other words, it enables you to recalibrate the meter. Although it's nice to have this level of control, I advise against making this adjustment. It's sort of like reengineering your oven so that it heats to 300 degrees when the dial is set to 325 degrees. It's easy to forget that you made the shift and not be able to figure out why your exposure settings aren't delivering the results you expected.

>> **Exposure calculations are based on the *Metering mode.*** This setting determines which part of the frame the camera considers when analyzing the light. At the default setting, exposure is based on the entire frame, but you can select other options. See the next section for details.

Finally, keep in mind that the meter readout is a guide, not a dictator. For example, if you want a backlit subject to appear in silhouette, ignore the meter when it reports that your photo is about to be underexposed.

Choosing an Exposure Metering Mode

REMEMBER

Your camera's exposure decisions and exposure-meter reading vary depending on the *metering mode*, which defines the area of the frame being analyzed. Your D7500 offers the following metering modes, which are represented in the Information display, Control panel, and Live View display by the symbols shown in the margins:

>> **Matrix:** Produces a balanced exposure based on the entire frame. Nikon calls this mode *3D Color Matrix II,* which refers to the proprietary metering technology the camera employs.

For viewfinder photography, the D7500 puts a twist on standard whole-frame metering: By default, it scans the frame for faces (of the human variety). If any are detected, metering is based on those faces, making it easier to properly expose portraits. In other words, even if matrix metering is selected, the entire frame may not be given equal consideration when people are in the scene.

I don't have a problem with face-detection being enabled by default; after all, if you're shooting a portrait, you want the exposure of the faces to be correct. Unfortunately, the camera isn't always successful at detecting faces, and there's no way to know if it did or didn't identify one. For a more reliable option when shooting portraits — or any time you need to base exposure on a specific area of the frame, opt for one of the following two metering modes.

To turn off face detection, open the Custom Setting menu, choose Metering/ Exposure, and then set Matrix Metering to Off, as shown in Figure 4-13.

» Center-weighted: Bases exposure on the entire frame but puts extra emphasis — *weight* — on the center of the frame. Specifically, the camera assigns 75 percent of the metering weight to an 8mm circle in the center of the frame.

You can adjust the size of the center-weighted metering circle by choosing the Center-Weighted Area option, which lives just downstairs from the Matrix Metering option shown in Figure 4-13. You can change the size of the circle to 6mm, 10mm, or 13mm.

FIGURE 4-13:
Turn this feature off if you don't want the camera to use face-detection when the matrix metering mode is selected.

The final Center-Weighted Area menu option, Avg, is a goofy one: It doesn't provide center-weighted metering at all, but rather produces whole-frame metering using a formula older than what Nikon developed for matrix metering. Longtime Nikon shooters who are familiar with average metering may appreciate its inclusion, but I suggest that anyone else stick with matrix for the best whole-frame exposure metering.

» Spot: Bases exposure on a circular area about 3.5mm in diameter, or about 2.5 percent of the frame.

The spot that's metered depends on an autofocusing option called AF-area mode. Detailed in Chapter 5, the AF-area mode determines which focus point the camera uses to establish focus. Here's how the camera handles focusing and spot metering at the various AF-area mode settings:

- *Auto Area AF-area mode:* The camera may select any point for focusing, usually choosing the one that falls over the closest object. But *exposure* metering is always based on the *center* focus point. So unless your subject is at the center of the frame, exposure may be incorrect.

- *Any other AF-area mode or manual focusing:* Focus and exposure are both based on a single focus point that you select. (Chapter 5 shows you how.) Obviously, this setup provides the most reliable focus and exposure metering.

» Highlight-weighted: Try this option when the most important part of your photo is also the brightest — for example, a white flower or bird set against a dark background. The camera meters exposure based on the highlights, helping to avoid a loss of detail in those areas. Of course, because exposure is

set for the highlights, the darkest parts of your image become even darker, so you may lose details in the shadows.

Some lenses aren't compatible with Highlight-weighted metering. If you select this metering option with such a lens, the camera uses center-weighted metering instead. (The camera user manual includes a list of which lenses are incompatible with various features, but if you're using the kit lens or most other, newer Nikon lenses, you probably don't have to worry about this issue.)

As an example of how the metering mode affects exposure, Figure 4-14 shows the same image captured using matrix, center-weighted, and spot metering. In the matrix example, the bright background caused the camera to select an exposure that left the statue quite dark. Switching to center-weighted metering helped somewhat but didn't quite bring the statue out of the shadows. Spot metering produced the best result as far as the statue goes, although the resulting increase in exposure left the sky a little washed out. (Highlight-weighted metering would have produced a result similar to the matrix metering example.)

Matrix metering	Center-weighted metering	Spot metering

FIGURE 4-14: The Metering Mode setting determines which area of the frame the camera considers when calculating exposure.

Figures 4-15 and 4-16 show where to find the symbol representing the current metering mode. In both figures, matrix metering is in force. Note, though, that although the Metering Mode symbol appears regardless of your exposure mode, the camera controls the setting in the Auto, Auto Flash Off, Scene, and Effects exposure modes.

 In the P, S, A, and M exposure modes, you select the metering mode. To change the setting, press the Metering Mode button, labeled in Figure 4-17, while rotating the Main command dial.

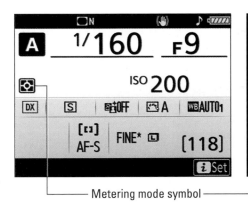

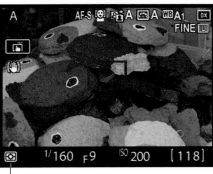

FIGURE 4-15: Here's where to find the metering mode symbol in the Information and Live View displays.

Metering mode symbol

During viewfinder photography, the screen shown in Figure 4-17 appears while you press the Metering Mode button. In the Control panel, all data except the Metering Mode symbol disappears; in the Live View display, the symbol turns yellow to indicate that it's the active setting. As you rotate the Main command dial, icons indicating each metering mode appear.

Metering mode symbol

FIGURE 4-16:
You also can view the metering mode symbol In the Control panel.

Unfortunately, Nikon opted not to give you any text labels to remind you which symbol represents which metering mode. So just remember that the matrix symbol looks like the one on the Metering Mode button, and the central portion of the symbol becomes progressively smaller as you cycle from matrix to center-weighted to spot metering. When you get to highlight-weighted metering, an asterisk appears.

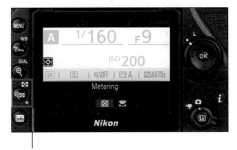

Metering mode button

FIGURE 4-17:
Press and hold the Metering Mode button while rotating the Main command dial to cycle through the available metering modes.

TIP

In theory, the best practice is to check the metering mode before you shoot and choose the one that best matches your exposure goals. But frankly, matrix metering produces good results in most situations, so my suggestion is to stick with that option until you're familiar with all the other controls on your camera. After all, you can see in the monitor whether you disagree with how the camera exposed the image and simply reshoot after adjusting the exposure settings to your liking. This option, in my mind, makes the Metering Mode setting less critical than it is when you shoot with film.

The exception might be when you're shooting a series of images in which a significant contrast in lighting exists between subject and background. Then, switching to center-weighted metering, spot metering, or highlight-weighted metering may save you the time spent having to adjust the exposure for each image. Many portrait photographers always use spot metering, for example, basing exposure only on the subject. If the background is too dark or too bright, so be it. What matters is whether your subject is well exposed.

Setting Aperture, Shutter Speed, and ISO

The next sections detail how to view and adjust these critical exposure settings. For a review of how each setting affects your pictures, check out the first part of this chapter.

REMEMBER

In P, S, or A mode, the settings that the camera selects are based on what it thinks is the proper exposure. If you don't agree, you can switch the camera to manual exposure mode and dial in the aperture and shutter speed that deliver the exposure you want. Or, if you want to stay in P, S, or A mode, you can tweak the results the autoexposure system produces by using features explained in the section "Solving Exposure Problems," later in this chapter.

Adjusting aperture and shutter speed

You can view the aperture setting (f-stop) and shutter speed at the top of the Information display and Control panel, as shown in Figure 4-18, and at the bottom of the viewfinder and Live View display, as shown in Figure 4-19. You may need to give the shutter button a quick half-press to wake up the exposure system before the data appears. Or, in Live View mode, you may need to press the Info button to change to a display mode that reveals the data.

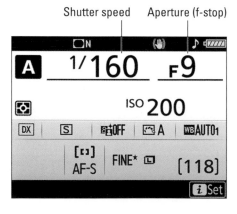
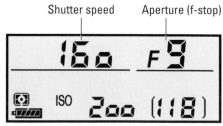

FIGURE 4-18: You can view the current f-stop and shutter speed at the top of the Information display and Control panel.

FIGURE 4-19:
In the Live
View display
and viewfinder,
exposure
settings appear
at the bottom
of the display.

Shutter speed Aperture (f-stop) Shutter speed Aperture (f-stop)

REMEMBER

In the viewfinder, shutter speeds are presented as whole numbers, even if the 160 shown in the display shown on the left in Figure 4-19 indicates a shutter speed of 1/160 second. When the shutter speed slows to 1 second or more, quote marks appear after the number — 1" indicates a shutter speed of 1 second, 4" means 4 seconds, and so on.

Which of the settings you can adjust — and how you dial in those settings — depends on your exposure mode. The next four sections explain.

M (manual exposure)

You control both settings, as follows:

>> **Shutter speed:** Rotate the Main command dial (back of the camera).

>> **Aperture (f-stop):** Rotate the Sub-command dial (front of the camera).

As you change the settings, the exposure meter indicates whether the camera thinks you're headed for a good result or an under- or over-exposed image, basing its decision on the metering mode and ISO setting.

TIP

In Manual mode, you can access two shutter speeds not available in the other modes:

>> *Bulb:* Lower the shutter speed one notch past the 30-second setting to access the *Bulb* setting, which keeps the shutter open as long as the shutter button is pressed. This option is perfect when you want to experiment with shutter speed but don't have time to change the setting between frames — for example, when shooting fireworks. In Bulb mode, you press the shutter button down, count off a few seconds, release the button to record the image, and then press the button and start the count anew for the next frame, varying the exposure time for each shot.

>> *Time:* This setting, found one step past Bulb and represented by two dashes (- -), is a variation on the theme. Instead of keeping your finger on the shutter button during the exposure, press it down once to begin the exposure, lift your finger, and press a second time to close the shutter. The maximum exposure time is 30 minutes.

If you set the shutter speed to Bulb or Time and then change the Mode dial to S, the word *Bulb* or *Time* blinks in the displays to let you know that you can't use that option in S mode. You must shift back to M mode to take advantage of these two shutter-speed settings.

A (aperture-priority autoexposure)

You control the aperture setting, or f-stop. To change the setting, rotate the Sub-command dial.

REMEMBER

As you change the aperture setting, the camera automatically adjusts the shutter speed as needed to expose the image at your chosen aperture and current ISO setting. Don't be confused by the fact that both the f-stop and shutter speed are changing at the same time — in A exposure mode, you control the f-stop value only.

A few other tips on using A mode:

>> **The range of f-stop settings depends on your lens.** For zoom lenses, the range typically also changes as you zoom in and out. For example, a lens may offer a maximum aperture of f/3.5 when set to its widest angle (shortest focal length) but limit you to f/5.6 when you zoom in to a longer focal length. Check your lens manual for details on the minimum and maximum aperture settings.

WARNING

>> **Always note the shutter speed that the camera selects.** If you're hand-holding the camera, make sure that the shutter speed isn't so low that you risk blurring the image due to camera shake. And if your scene contains moving objects, make sure that the shutter speed is fast enough to stop action (or slow enough to blur it, if that's your creative goal).

REMEMBER

>> **If the camera can't expose the image at your selected f-stop, warnings appear in the displays.** The exposure meter in the Information display, viewfinder, and Control panel blink, as does the shutter speed value. In the Live View display, the shutter speed blinks, but you see the meter only if you enable the Exposure Preview feature (access that feature via the *i*-button menu). To fix the issue, you can modify the light hitting your subject, change the ISO, or choose a different f-stop setting.

S (shutter-priority autoexposure)

Rotate the Main command dial to set shutter speed. Again, the camera automatically adjusts the aperture to maintain proper exposure at the current ISO.

Available shutter speeds range from 30 seconds to 1/8000 second *except* when flash is enabled. When you use the built-in flash, the top shutter speed is 1/250 second. See Chapter 3 for information on how you may be able to use a faster shutter speed with flash.

WARNING

Remember that the range of f-stops the camera can choose is limited by the capabilities of your lens. In some lighting conditions, the camera may not be able to expose the image properly at the shutter speed you chose. Again, the camera alerts you with a blinking exposure meter and f-stop value. If you can't change the lighting, your choices are to adjust ISO or shutter speed.

P (programmed autoexposure)

The camera displays its recommended f-stop and shutter speed when you press the shutter button halfway. But you can rotate the Main command dial to select a different combination. The number of possible combinations depends on the aperture settings the camera can select, which depends on your lens.

An asterisk (*) appears next to the P symbol in the upper-left corner of the Information and Live View displays if you adjust the aperture/shutter speed settings. You see a tiny P* symbol at the left end of the viewfinder display as well. To get back to the initial combo of shutter speed and aperture, rotate the Main command dial until the asterisk disappears from the displays and the P* viewfinder symbol turns off.

Because the camera can modify both the shutter speed and f-stop setting in P mode, you're unlikely to encounter under- or overexposure issues. However, there's no guarantee that you can use a shutter speed fast enough to freeze your subject (or handhold your camera) or to use an f-stop that provides sufficient depth of field. So be alert if you use this mode: The camera doesn't warn you of these pitfalls as long as it knows the exposure will be okay.

Controlling ISO

REMEMBER

The ISO setting adjusts the camera's sensitivity to light. A higher ISO enables you to use a faster shutter speed or a smaller aperture (higher f-stop number) because less light is needed to expose the image. But a higher ISO also increases the possibility of noise (refer to Figure 4-5).

Your ISO choices vary by exposure mode:

>> **Night Vision Effects mode:** Because this effect is meant to produce a grainy, black-and-white picture, the camera automatically chooses a high ISO setting, intentionally creating noise. You can't adjust the ISO setting.

>> **Scene modes and all Effects modes except Night Vision:** By default, the camera sets the ISO option to Auto and chooses the ISO for you. However, this is one exposure setting you can control if you prefer.

Available ISO settings range from 100 to 51200. You can also exceed that range by choosing one of the Lo or Hi ISO options, which set the sensitivity as much as one stop below ISO 100 and as much as five stops above ISO 51200.

WARNING

The Lo and Hi settings are given a special label for a reason: Nikon wants you to know that images taken at those settings may lose image quality, so you shouldn't use them unless it's absolutely necessary. At the Lo settings, you may notice an increase in image contrast, which may or may not be a problem, depending on your exposure goals. At the Hi settings, you can expect a great deal of noise, which definitely will be a problem if you need good image quality.

>> **P, S, A, and M modes:** You can dial in a specific ISO setting or choose Auto ISO Sensitivity, which gives you manual control with auto override. With Auto ISO Sensitivity, you select an ISO value, and then if the camera can't expose the photo at that setting, it changes the ISO automatically. The advantage of this feature over the regular Auto setting provided in other exposure modes is that you can limit the maximum ISO the camera can select and specify the shutter speed at which you want the override to occur. (Details shortly.)

TIP

When Auto ISO Sensitivity is enabled, the camera alerts you that it is about to override your ISO setting by blinking the ISO Auto label in the displays. When you view your pictures in the monitor, the ISO value appears in red if you use certain playback display modes. (Chapter 9 has details.)

You can view the ISO setting in the Information, Live View, and Control panel displays, as shown in Figure 4-20. To view the value in the viewfinder, press the ISO button; the ISO value temporarily replaces the shots remaining value, as shown in Figure 4-21. When you release the button, ISO data disappears unless you use Auto ISO, in which case the words ISO Auto appear.

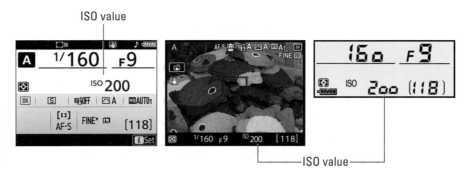

FIGURE 4-20:
You can view the ISO setting in these displays.

ISO value

ISO value

To change the ISO setting, choose from these options:

>> **ISO button + command dials:** To adjust ISO Sensitivity — which most of us refer to as simply the ISO setting — press the ISO button while rotating the Main command dial. In the P, S, A, and M modes, you can toggle Auto ISO Sensitivity Control on and off by rotating the Sub-command dial while pressing the button.

During viewfinder photography, the options shown in Figure 4-22 appear when you shoot in the P, S, A, and M modes. As always, the wheel symbols to the right of each setting remind you of which dial to use to adjust which setting. In exposure modes other than P, S, A, and M, the Auto ISO Sensitivity Control option is dimmed.

While the ISO button is pressed, you can also monitor the settings in the Control panel, viewfinder, and Live View display.

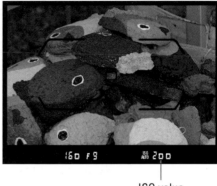

ISO value

FIGURE 4-21:
Press the ISO button to display the current setting in the viewfinder.

FIGURE 4-22:
Press the ISO button and rotate the Main command dial to change the ISO setting.

>> **Photo Shooting menu:** Select ISO Sensitivity Settings, as shown on the left in Figure 4-23, and choose ISO Sensitivity, as shown on the right, to dial in your preferred ISO setting.

FIGURE 4-23: You also can change the ISO setting and enable automatic ISO override from the Photo Shooting menu.

In the P, S, A, and M exposure modes, use the other menu options to control these ISO features:

- *Auto ISO Sensitivity Control:* This option turns Auto ISO override on and off. After you change the setting from Off (the default) to on, you gain access to three more options, as shown in Figure 4-24.

- *Maximum Sensitivity:* This option sets the highest ISO that the camera can use when it overrides the selected setting — a great feature because it enables you to decide how much noise you're willing to accept in order to get a good exposure. By default, the ISO limit is 51200 — way too high, in my opinion, unless you're willing to accept lots of image noise. I set my limit to 6400 for most shoots, but go even lower when it's critical to avoid noise (such as when I plan to print the picture very large).

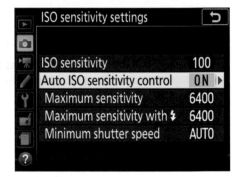

FIGURE 4-24:
After enabling Auto ISO Sensitivity Control, use the remaining menu options to customize when and how the camera overrides your ISO setting.

- *Maximum Sensitivity with Flash:* If you want to enforce a different high ISO limit for flash photos, choose this option and select the setting you prefer.

Choose Same as Without Flash to automatically change the value to whatever you selected for the Maximum Sensitivity value.

- *Minimum Shutter Speed*: Set the minimum shutter speed at which the Auto ISO override engages. At the Auto setting, the camera selects the minimum shutter speed based on the focal length of your lens, the idea being that with a longer lens, you need a faster shutter speed to avoid the blur that camera shake can cause when you handhold the camera. However, exposure is given priority over camera-shake considerations, so if the camera can't expose the picture at a "safe" shutter speed even when it uses the maximum ISO value you set, it will use a slower speed.

In P, S, A, and M exposure modes, you also have access to two more ISO-related options, both found on the Custom Setting menu:

» **ISO Display:** Enable this option to replace the shots-remaining value in the viewfinder with the ISO value so that you don't have to press the ISO button to see the value. The tradeoff is that you have to check the other displays for the shots-remaining value. Look for the option in the Shooting/Display section of the Custom Setting menu.

» **Auto Flash ISO Sensitivity Control:** Found in the Bracketing/Flash section of the menu and shown in Figure 4-25, this option controls how the camera determines ISO when you use flash and enable Auto ISO Sensitivity. You can choose to have the ISO calculated based on both the subject and the background (the default) or the subject only.

When you're handholding the camera, sticking with the default setting is best because at that setting, the camera takes the possibility of camera shake — and

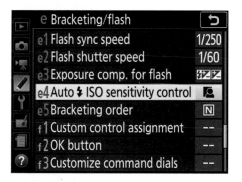

FIGURE 4-25:
This option determines how the Auto ISO Sensitivity Control calculates the necessary ISO for flash pictures.

the blurring it causes — into account. The ISO is set high enough that you can use a faster shutter speed and thus get sharper handheld shots. If you choose Subject Only, ISO is based only on the ambient light hitting the subject. Remember that you can press the ISO button to display the selected ISO if you want to compare the difference between the two options. In some cases, the camera will choose the same ISO for both settings.

DAMPENING NOISE

High ISO settings and long exposure times can result in *noise,* a defect that gives pictures a speckled look. To help solve the problem, your camera offers two noise-removal filters: *Long Exposure Noise Reduction,* which dampens the type of noise that occurs during long exposures; and *High ISO Noise Reduction,* designed to reduce the appearance of ISO-related noise. You enable both filters from the Photo Shooting menu or, during viewfinder photography, via the *i*-button menu.

If you turn on Long Exposure Noise Reduction, the camera applies the filter to pictures taken at shutter speeds of longer than one second. For High ISO Noise Reduction, you can choose from four settings: The High, Normal, and Low settings let you control the strength of the noise-removal effect; at the fourth setting, Off, the camera actually still applies a tiny amount of noise removal "as required." In other words, you can't really disable this function altogether. Nikon does promise that the amount of noise reduction at the Off setting is less than at the Low setting, so that's something.

Why would you want to turn off noise reduction anyway? Because enabling these features has a few disadvantages. First, the filters are applied after you take the picture, as the camera processes the image data. While the Long Exposure Noise Reduction filter is being applied, the message "Job Nr" appears in the viewfinder. The time needed to apply this filter can significantly slow your shooting speed. In fact, it can double the time the camera needs to record the file to the memory card.

Second, although filters that go after long-exposure noise work fairly well, those that attack high ISO noise work primarily by applying a slight blur to the image. Don't expect this process to totally eliminate noise, and do expect some resulting image softness. You may be able to get better results by using the blur tools or noise-removal filters found in many photo editors, because you can blur just the parts of the image where noise is most noticeable.

Note, too, that if you shoot in the Raw format, you can apply High ISO Noise Reduction after the fact through the in-camera Raw processing tool. Nikon Capture NX-D also has a noise-removal tool built into its Raw converter. (Chapter 10 covers both Raw conversion options.)

Solving Exposure Problems

Along with controls over aperture, shutter speed, and ISO, your camera offers a collection of tools designed to solve tricky exposure problems.

If the problem is underexposure due to a lack of ambient light, your camera's built-in flash is at the top of the list of exposure aids to consider. Chapter 3 explains

how to get good flash results. But you also have several other exposure-correction features at your disposal, whether your subject appears under- or overexposed. The next several sections introduce you to these features.

Applying Exposure Compensation

In the P, S, and A exposure modes, you have some input over exposure: In P mode, you can choose from different combinations of aperture and shutter speed; in S mode, you can dial in the shutter speed; and in A mode, you can select the aperture setting. But because these are semiautomatic modes, the camera ultimately controls the final exposure. If your picture turns out too bright or too dark in P mode, you can't simply choose a different f-stop/shutter speed combo because they all deliver the same exposure — which is to say, the exposure that the camera has in mind. And changing the shutter speed in S mode or adjusting the f-stop in A mode won't help either because as soon as you change the setting that you're controlling, the camera automatically adjusts the other setting to produce the same exposure it initially delivered. What about changing the ISO? Nope, won't do the trick. The camera just recalculates the f-stop or shutter speed (or both) it needs to maintain the "proper" exposure at that new ISO.

TIP

Not to worry. You actually do have final say over exposure, and not just in the P, S, and A exposure modes: Unlike most exposure features, this one is available in the Scene and Effects modes as well as when you shoot movies.

The secret is Exposure Compensation, which tells the camera to produce a brighter or darker exposure on your next shot. As an example, take a look at the first image in Figure 4-26. The initial exposure selected by the camera left the balloon too dark, so I used Exposure Compensation to produce the brighter image.

How the camera arrives at the brighter or darker image depends on the exposure mode: In A mode, the camera adjusts the shutter speed but leaves your selected f-stop in force. In S mode, the camera adjusts the f-stop and keeps its hands off the shutter speed control. In P, the camera decides whether to adjust aperture, shutter speed, or both. In all three modes, the camera may also adjust ISO if you enable Auto ISO Sensitivity Control. For the Scene and Effects modes, the camera decides which of the three exposure settings to adjust to achieve the Exposure Compensation shift.

Keep in mind, though, that the camera can adjust f-stop only so much, according to the aperture range of your lens. And the range of shutter speeds, too, is limited by the camera itself. So there's no guarantee that the camera can actually deliver a better exposure when you dial in Exposure Compensation. If you reach the end of the f-stop or shutter speed range, you have to adjust ISO or compromise on your selected f-stop or shutter speed.

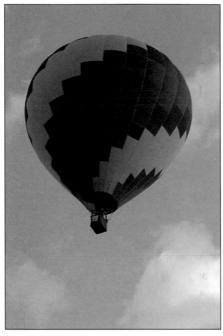 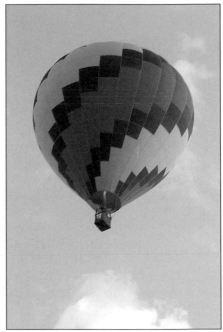

FIGURE 4-26: For a brighter exposure, raise the Exposure Compensation value.

With that background out of the way, here are details you need to know to take best advantage of this feature:

>> **Exposure Compensation settings are stated in terms of EV numbers, as in EV +2.0.** *EV* stands for *exposure value.* Possible values range from EV +5.0 to EV –5.0. Each full number on the EV scale represents an exposure shift of one stop. A setting of EV 0.0 results in no exposure adjustment. For a brighter image, raise the Exposure Compensation value; for a darker image, lower the value. For my balloon image, I set the value to EV +1.0.

>> **Where and how you check the current setting depends on the display, as follows:**

- *Information display:* This one's straightforward: The setting appears in the area labeled on the left in Figure 4-27. In addition, the meter shows the amount of compensation being applied. In Figure 4-27, for example, the meter indicator appears one stop toward the positive end of the meter, reflecting the EV +1.0 setting. The 0 in the meter blinks to remind you that the meter is reporting the Exposure Compensation setting.

- *Live View display:* If Exposure Compensation is turned on, you see the plus/minus symbol labeled on the right in Figure 4-27. Otherwise, that area of the display appears empty.

Exposure Compensation amount

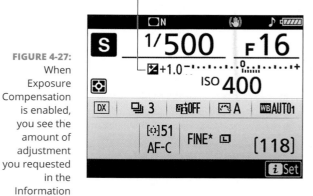

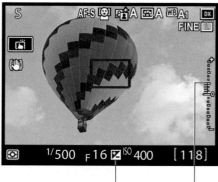

Exposure Compensation enabled Amount

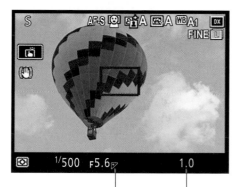

To view the selected adjustment amount, press and hold the Exposure Compensation button. The EV value takes the place of the shots remaining value, and the Exposure Compensation symbol changes to show a plus sign for a positive EV value and a minus sign for a negative value.

The meter shown in the figure also indicates the amount of adjustment, but by default, it appears only when the Exposure Compensation button is displayed. If you want the meter to remain onscreen, as in Figure 4-28, open the *i*-button menu and enable the Exposure Preview feature. (See the section "Reading the Meter" for more details.)

Positive value symbol Adjustment amount

FIGURE 4-28:
Press the Exposure Compensation button to view the current EV value in the Live View display.

- *Viewfinder and Control panel:* These displays also show the plus/minus symbol only, but again, you can press the Exposure Compensation button to temporarily view the EV setting. Or just look at the exposure meter, which tells you how much exposure shift is in force.

» **To set the Exposure Compensation value, press the Exposure Compensation button while rotating the Main command dial.** In Live View mode, the monitor brightness updates to show you how the change will affect exposure. However — and this is a biggie, so stop texting and pay attention — the preview can only show an adjustment up to +/– EV 3.0, even though you can set the adjustment as high as +/– EV 5.0.

>> **Exposure Compensation affects the meter in M exposure mode.** Although the camera doesn't change your selected exposure settings in M exposure mode if Exposure Compensation is enabled, the exposure *meter* is affected. It indicates whether your shot will be properly exposed based on the Exposure Compensation setting.

WARNING

>> **In the P, S, A, and M exposure modes, your Exposure Compensation setting remains in force until you change it, even if you power off the camera.** So check the setting before each shoot or always set the value to EV 0.0 after taking the last shot that needs compensation.

For the Scene and Effects modes that allow you to set Exposure Compensation, the adjustment is reset to zero when you turn the camera off or choose a different exposure mode.

>> **For flash photos, the Exposure Compensation setting normally affects background brightness and flash power.** If you don't want flash power adjusted, open the Custom Setting menu, choose Bracketing/Flash, and then change the Exposure Comp. for Flash setting from Entire Frame to Background Only. You then can use Flash Compensation to vary the flash output as you see fit. (Chapter 3 details that option.)

WARNING

>> **Think twice before enabling the Easy Exposure Compensation option on the Custom Setting menu.** This feature is a cousin to the Easy ISO option discussed earlier: If you enable Easy Exposure Compensation, you can adjust Exposure Compensation without having to press the Exposure Compensation button. In the P and S exposure modes, rotate the Sub-command dial; in A exposure mode, rotate the Main command dial. (You can't use either trick in M mode.)

As with the Easy ISO feature, I don't recommend enabling this feature because you can easily rotate the dials by mistake and not realize that Exposure Compensation is in force. But if you think differently, access the setting from the Metering/Exposure section of the Custom Setting menu. The default is Off; you also get two On settings: On (Auto Reset) and plain old On. With Auto Reset, the Exposure Compensation setting you establish by using just the command dials is reset to EV 0.0 when you turn off the camera or the metering system goes to sleep. Settings you establish by using the Exposure Compensation button along with a command dial are *not* reset. If you select On, the Exposure Compensation selected by using just a command dial isn't reset.

Expanding tonal range

A scene like the one in Figure 4-29 presents the classic photographer's challenge. Choosing exposure settings that capture the darkest parts of the subject appropriately causes the brightest areas to be overexposed. And if you instead *expose for the highlights* — set the exposure settings to capture the brightest regions properly — darker areas are underexposed.

Active D-Lighting Off Active D-Lighting Auto

FIGURE 4-29:
Active
D-Lighting
captured
the shadows
without
blowing out
the highlights.

With many other cameras, you have to choose between favoring highlights or shadows. But with the D7500, you can expand *tonal range* — the range of brightness values in an image — through two features: Active D-Lighting and automatic HDR (high dynamic range). The next two sections explain both options.

Applying Active D-Lighting

One way to cope with a high-contrast scene like the one in Figure 4-29 is to turn on Active D-Lighting. The *D* is a reference to *dynamic range,* the term used to describe the range of brightness values that an imaging device can capture. By turning on this feature, you enable the camera to produce an image with a slightly greater dynamic range than usual.

REMEMBER

Specifically, Active D-Lighting gives you a better chance of keeping highlights intact while better exposing the darkest areas. In my seal scene, Active D-Lighting produced a brighter rendition of the darkest parts of the rocks and the seals, for example, yet the color in the sky didn't get blown out, as it did when I captured the image with Active D-Lighting turned off. The highlights in the seal and in the rocks in the lower-right corner of the image also are toned down a tad in the Active D-Lighting version.

Active D-Lighting does its thing in two stages. First, it selects exposure settings that result in a slightly darker exposure than normal, which helps to retain

highlight details. After you snap the photo, the camera brightens the darkest areas of the image to rescue shadow detail.

Symbols representing the current Active D-Lighting setting appear in the Information and Live View displays, in the areas labeled in Figure 4-30. The symbol that you see in the figures represents the default setting, Off.

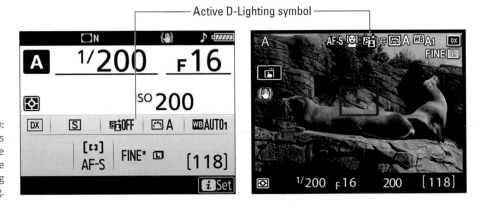

FIGURE 4-30: These symbols represent the Auto Active D-Lighting setting.

For Auto, Auto Flash Off, Scene, and Effects exposure mode, the camera controls the amount of Active D-Lighting. In the P, S, A, and M exposure modes, you can choose from these Active D-Lighting settings: Auto (the camera selects the proper amount of adjustment), H* (extra high), H (high), N (normal), L (low), and Off. In M exposure mode, choosing Auto produces the same results as selecting Normal.

For the record, I used the Auto setting for the seal image in Figure 4-30. However, I usually keep the option set to Off so that I can decide for myself whether I want any adjustment instead of having the camera apply it to every shot. Even with a high-contrast scene that's designed for the Active D-Lighting feature, you may decide that you prefer the "contrasty" look that results from disabling the option. Just don't forget that the option is available to you — in scenes like the example image, applying Active D-Lighting can dramatically improve the photo.

To change the Active D-Lighting setting, you can take two paths:

>> *i*-button menu: Figure 4-31 shows how the menu appears during viewfinder photography (left) and Live View mode (right). After you select Active D-Lighting, the camera displays a screen where you can set the adjustment level.

>> Photo Shooting menu: You also can change the Active D-Lighting setting via the Photo Shooting menu. (Scroll to the second page of the menu to get to the option.)

TIP

A few final pointers about Active D–Lighting:

>> You get the best results in matrix metering mode.

>> Nikon doesn't recommend that you use Active D-Lighting in the M exposure mode, but it's worth trying if you can't get results you like with the feature turned off. In M mode, the camera doesn't change the shutter speed or f-stop to achieve the darker exposure it needs for Active D-Lighting to work; instead, the meter readout guides you to select the right settings unless you have automatic ISO override enabled. In that case, the camera may instead adjust ISO to manipulate the exposure.

>> If you're not sure whether the picture will benefit from Active D-Lighting, try Active D-Lighting bracketing, which automatically records the scene at different settings. See the last section in this chapter for details.

>> You can apply a similar exposure change to an existing image by using the D-Lighting filter on the Retouch menu, as outlined in Chapter 12. For Raw (NEF) images, the in-camera Raw-processing tool also has a D-Lighting adjustment. Chapter 10 details that feature.

Exploring high dynamic range (HDR) photography

HDR photography refers to a technique that enables you to create an image that features a greater spectrum of brightness values — a higher *dynamic range* — than a camera or another imaging device can record in a single frame.

To produce an HDR image, you capture the same shot multiple times, using different exposure settings for each image. You then use special imaging software, called *tone mapping software,* to combine the exposures in a way that uses specific brightness values from each shot.

TIP

For quick and easy HDR photography, the D7500 offers automated HDR. When you enable this option, the camera records two images, each at different exposure settings, and then does the tone-mapping manipulation for you to produce a single HDR image. This feature is available only in the P, S, A, and M exposure modes.

So how is HDR different from Active D-Lighting — other than the fact that it records two photos instead of manipulating a single capture? Well, with the HDR feature, you can request an exposure shift that results in up to three stops difference between the two photos. That enables you to create an image that has a broader dynamic range than you can get with Active D-Lighting.

Figure 4-32 shows an example of a scene that may benefit from the HDR feature. Half the area is in bright sunshine, and the other is in shadow. When taking the left photo in the figure, I exposed for the highlights, which left the right side of the scene too dark. For the center image, I set exposure for the shaded area, which blew out the highlights in the sunny areas. By enabling the HDR feature, I was able to produce the right image in the figure. The shadows aren't completely eliminated, and some parts of the rose bush on the left side of the shot are a little brighter than I want, but on the whole, the camera balanced out the exposure fairly well.

FIGURE 4-32:
The HDR option enables you to produce an image with an even greater tonal range than Active D-Lighting.

Exposed for highlights Exposed for shadows HDR, Extra High

Before you try the HDR feature, note these important points:

>> **Although the camera shoots two frames, you wind up with a single HDR photo.** The two original shots aren't retained.

>> **Because the camera is merging two photos, the feature works well only on stationary subjects.** If the subject is moving, it appears as two translucent forms in the merged frame.

>> **You can't use auto HDR if you set the Image Quality option to Raw (NEF) or Raw+JPEG.** It works only for JPEG photos. (The JPEG options are named Fine, Normal, and Basic; Chapter 2 explains.)

>> **Some other features also are incompatible with auto HDR.** These include flash, autobracketing, movie recording, bulb and time shutter speeds, Multiple Exposure, and Time-Lapse Movie. You can, however, enable Active D-Lighting

for your HDR shots. Because both features affect tonal range, experiment to see whether you get better results with or without Active D-Lighting turned on.

>> **Burst mode shooting doesn't work.** Even if the Release mode is set to one of the Continuous settings, you get one HDR image per press of the shutter button.

I should also explain that to produce the more-extreme HDR imagery that you see in photography magazines, you need to go beyond the two-frame, three-stop limitations of the auto HDR features. To give you a point of comparison, Figure 4-33 shows an example I created by blending five frames with a variation of five stops between frames. The first two images show you the brightest and darkest exposures; the last image shows the HDR composite.

FIGURE 4-33: Using HDR software tools, I merged the brightest and darkest exposures (left and middle) along with several intermediate exposures, to produce the composite image (right).

The effect created by the camera's HDR tool looks more realistic than the one in Figure 4-33 because the tonal range isn't stretched to such an extent. When applied to its extreme limits, HDR produces something of a graphic-novel look. My example is pretty tame; some people might not even realize that any digital trickery has been involved. To me, it has the look of a hand-tinted photo.

And of course, even though the in-camera HDR tool may not be enough to produce the surreal HDR look that's all the rage these days, you can still use your D7500 for HDR work — you just have to adjust the exposure settings yourself between shots and then merge the frames using your own HDR software. You should also shoot the images in the Raw format because HDR tone-mapping tools work best on Raw images, which contain more bits of picture data than JPEG files. Also, it's best to use the same f-stop throughout all frames so that depth of field remains consistent.

All that said, the HDR feature is worth investigating when you're confronted with a high-contrast scene and you want to see how much you can broaden the

dynamic range. Just take one shot with the feature enabled and a second with it turned off, and then compare the results to see which setting works best.

To try out automated HDR, open the Photo Shooting menu and select HDR (High Dynamic Range), as shown on the left in Figure 4-34. You then see the screen shown on the right, offering the following options:

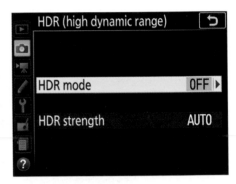

FIGURE 4-34: The HDR feature lives on the Photo Shooting menu.

>> **HDR Mode:** Select On (Series), as shown in Figure 4-35, to enable HDR for all shots until you disable the feature. Choose On (Single Photo) to enable the option for just your next shot. Choose Off to disable the feature.

>> **HDR Strength:** You can choose from four levels of exposure shift: Low, Normal, High, or Extra High. Choose Extra High for the 3-stop exposure maximum. I used this setting to produce the image in Figure 4-32. At the Auto setting, the camera chooses what it considers the best adjustment. However, when a metering mode other than matrix is in effect, choosing Auto results in the same adjustment you get at the Normal setting.

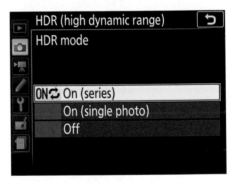

FIGURE 4-35: Choose Series to capture more than one image during an HDR shooting session.

After you exit the menus, the Information display shows the symbols labeled in Figure 4-36, reminding you that HDR shooting is enabled. In Live View mode, the symbols appear in the upper-right corner of the display.

In both displays, the initial and symbol next to the letters HDR indicate which HDR Mode and HDR Strength settings are selected. The symbols look like the ones you see on the HDR menu screens. For example, in the figures, the symbols indicate that the HDR Strength is set to Extra High and the HDR Mode is set to On (Series).

When you press the shutter button, the camera records two frames in quick succession and then creates the merged HDR image. The message "Job Hdr" appears in the viewfinder and Control panel as this digital manipulation is being accomplished.

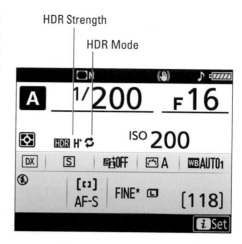

HDR Strength

HDR Mode

FIGURE 4-36:
These symbols indicate that HDR is enabled, with the On (Series) and Extra High settings selected.

Some tips to help you get the best results from the automated HDR feature:

TIP

>> **Frame your subject a little loosely.** The camera may need to trim the edges of the frame to perfectly align the two shots in the HDR image. (This tip also applies to HDR frames you shoot manually and combine in HDR software, by the way.)

>> **Use a tripod to make sure that you don't move the camera between shots.** Otherwise, the merged shots may not align.

>> **Shoot in the M or A exposure modes so that the aperture setting doesn't change between shots.** It's important to keep the aperture setting (f-stop) the same so that depth of field remains consistent for both frames. In P or S modes, the camera may adjust the f-stop to achieve the exposure shift between frames. (See the first part of this chapter to understand how the aperture setting affects depth of field.)

>> **If you want to get fancy, you can use Interval Timer Shooting (time-lapse photography) with HDR enabled.** In other words, you can create a time-lapse sequence that uses HDR for every image. Just be sure to select the On (Series) HDR setting *before* you begin Interval Timer shooting. (Chapter 2 details Interval Timer shooting).

Eliminating vignetting

Because of some optical science principles that are too boring to explore, some lenses produce pictures that appear darker around the edges of the frame than

in the center, even when the lighting is consistent throughout. This phenom-enon goes by several names, but the two heard most often are *vignetting* and *light fall-off.* How much vignetting occurs depends on the lens, your aperture setting, and the lens focal length.

To help compensate for vignetting, your camera offers a Vignette Control feature, which adjusts image brightness around the edges of the frame. Figure 4-37 shows an example. In the left image, just a slight amount of light fall-off occurs at the corners, most noticeably at the top of the image. The right image shows the same scene with Vignette Control enabled.

Vignette Control Off

Vignette Control, Normal setting

FIGURE 4-37: Vignette Control tries to correct the corner darkening that can occur with some lenses.

Now, this "before" example hardly exhibits serious vignetting. It's likely that most people wouldn't even notice if it weren't shown next to the "after" example. But if you're a stickler for this sort of thing or your lens suffers from stronger vignetting, it's worth trying the feature. The adjustment is available in all your camera's exposure modes.

The only way to enable Vignette Control is via the Photo Shooting menu, as shown on the left in Figure 4-38. You can choose from four settings: High, Normal, Low, and Off. (Normal is the default.)

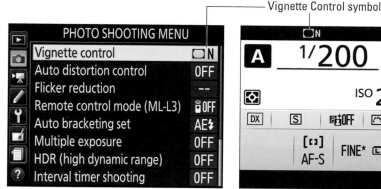

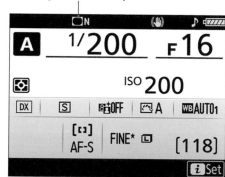

FIGURE 4-38:
If you enable Vignette Control (left), a symbol indicating the setting appears in the Information display (right).

REMEMBER

When the feature is enabled, the Information display contains a symbol showing the setting at the top of the screen, as shown on the right in Figure 4-38. The other displays don't offer any indication of the Vignette Control status.

Also be aware of these issues:

WARNING

» **The correction is available only for still photos.** Sorry, video shooters; this feature doesn't apply in Movie mode.

» **Vignette Correction works only with certain lenses.** First, your lens must be Nikon Type G, E, or D (PC, or Perspective Control, lenses excluded). If the menu option is dimmed, the feature isn't available for your lens. Also, enabling the feature may not make any difference with certain lenses.

» **In some circumstances, the correction may produce increased noise at the corners of the photo.** This problem occurs because exposure adjustment can make noise more apparent.

Using autoexposure lock

To help ensure a proper exposure, your camera continually meters the light until the moment you depress the shutter button fully. In autoexposure modes, it also keeps adjusting exposure settings as needed to maintain a good exposure.

For most situations, this approach works great, resulting in the right settings for the light that's striking your subject at the moment you capture the image. But on occasion, you may want to lock in a certain combination of exposure settings. For example, perhaps you want your subject to appear at the far edge of the frame. If you were to use the normal shooting technique, you'd place the subject under a focus point, press the shutter button halfway to lock focus and set the initial exposure, and then reframe to your desired composition to take the shot.

The problem is that exposure is then recalculated based on the new framing, which can leave your subject under- or overexposed.

 The easiest way to lock in exposure settings is to switch to M (manual) exposure mode and use the f-stop, shutter speed, and ISO settings that work best for your subject. But if you prefer to stay with an autoexposure mode, you can press the AE-L/AF-L button to lock exposure before you reframe. This feature is known as *autoexposure lock*, or AE Lock for short. You can take advantage of AE Lock in any autoexposure mode — even Auto or Auto Flash Off.

A few fine points about using this feature:

>> **While AE Lock is in force, the letters AE-L appear in the viewfinder and Live View display.** Look for this indicator near the Metering Mode symbol, which appears at the left end of the viewfinder data display and in the bottom left corner of the Live View display.

>> **By default, focus is also locked when you press the button if you're using autofocusing.** You can change this behavior by customizing the AE-L/AF-L button function, as outlined in Chapter 11.

>> **For the best results, pair this feature with the Spot Metering mode and autofocus settings that enable you to select a single focus point.** Then, if you frame your subject under that focus point, exposure is set and locked based on your subject.

 Press the Metering mode button while rotating the Main command dial to change the metering mode; see Chapter 5 for help with autofocus settings.

>> **Don't release the AE-L/AF-L button until after you snap the picture.** And if you want to use the same focus and exposure settings for your next shot, just keep the AE-L/AF-L button pressed between shots.

Taking Advantage of Automatic Bracketing

Many photographers use *exposure bracketing* to ensure that at least one shot of a subject is properly exposed. *Bracketing* simply means to shoot the same subject multiple times, slightly varying the exposure settings for each image.

In the P, S, A, and M exposure modes, your camera offers *automatic exposure bracketing.* You specify how many frames you want to record, how much adjustment should be made between frames, and then just press the shutter button to record the images. The camera automatically adjusts the exposure settings between each click.

The D7500, however, takes things further than most cameras that offer automatic bracketing, enabling you to bracket not just exposure, but also flash and exposure together, flash only, Active D–Lighting, or white balance.

Chapter 6 explains how to use the white–balance bracketing option. To try your hand at exposure, flash, or Active D–Lighting bracketing, follow these steps:

1. **Set your camera to the P, S, A, or M exposure mode.**

TIP

 If you want depth-of-field to remain consistent between frames, shoot in the A or M modes. In both modes, the camera sticks with your selected f-stop and varies shutter speed to achieve the exposure shift between bracketed frames. On the other hand, if using the same shutter speed for all frames is important, shoot in the S mode. Just know that depth of field may be different from frame to frame. No matter what your exposure mode, the camera also may adjust ISO between frames if Auto ISO Sensitivity is enabled.

2. **Open the Photo Shooting menu, choose Auto Bracketing Set, and then select the feature you want to bracket, as shown in Figure 4-39.**

FIGURE 4-39: Select this Photo Shooting menu option to select the feature you want the camera to adjust between shots.

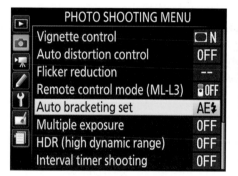
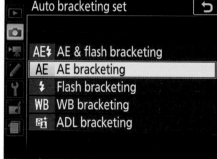

3. **Choose the order in which you want the bracketed shots recorded.**

 To control this aspect of your bracketed shots, open the Custom Setting menu, choose Bracketing Flash, and select Bracketing Order. You get two options:

 ● *Normal (MTR>Under>Over):* This option is the default. For a three-shot exposure bracketing series, your first shot is captured at your original settings. (MTR stands for *metered* and designates the initial settings suggested by the camera's exposure meter.) The second image is captured at settings that produce a darker image, and the third, at settings that produce a brighter image.

 ● *Under>MTR>Over:* The darkest image is captured first, then the metered image, and then the brightest image.

This sequence varies depending on how many frames you include in your bracketed series. If you're a detail nut, the camera manual lists the order used in every scenario.

4. **Press and hold the BKT button to access the bracketing options.**

While the button is pressed, bracketing settings appear in the Information display and Control panel. Figure 4-40 shows the displays as they appear when you bracket autoexposure (AE). The Number of Shots setting controls the number of bracketed frames; the Increment setting, the amount of exposure shift between frames, is shown in stops. So in Figure 4-40, the settings reflect a three-frame bracketed series with a one-stop exposure shift between frames.

Number of shots Increment

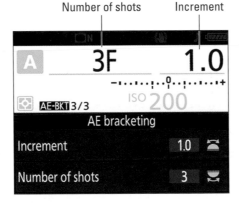

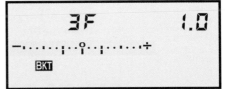

FIGURE 4-40:
Press the BKT button to set the number of bracketed frames and the amount of change between frames.

In Live View mode, the settings for AE bracketing appear as shown in Figure 4-41, with the bars on the exposure meter indicating both the number of frames and the bracketing increment. The top value, highlighted in yellow, shows the number of selected frames and the number of remaining frames in that series. For example, 3/3 means that you're set to shoot the first frame in a three-frame series.

Note that in this case, the meter appears when the BKT button is pushed regardless of the setting of the Exposure Preview option on the *i*-button menu. It disappears after you release the button unless you enable Exposure Preview.

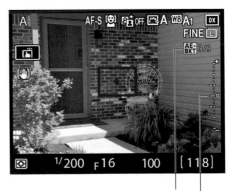

Total Frames/Current Frame

Increment

FIGURE 4-41:
In Live View mode, the bracketing settings appear as shown here.

5. **Set the number of bracketed frames and bracketing increment, as follows:**

- *AE, AE+Flash, and Flash bracketing:* Rotate the Main command dial while pressing the BKT button to set the number of shots; rotate the Sub-command dial to set the increment of adjustment between frames.

REMEMBER

The maximum allowable frames in each bracketed series depends on the bracketing increment. For example, if you set the bracketing increment at one stop or less, you can ask for as many as nine bracketed frames. But if you go higher than one stop, you can shoot only five frames in a bracketed series. The maximum increment of shift for exposure bracketing is three stops.

- *Active D-Lighting (ADL) bracketing:* Rotate the Main command dial to set the number of shots, which in turn determines the level of Active D-Lighting adjustment applied to each frame. Set the frame number to 2, and you get one frame with the feature disabled and one using the current Active D-Lighting setting. (You can choose Auto as that setting or select a specific amount.) Raise the number of frames, and you get one shot with no adjustment and the rest captured with increasing amounts of adjustment (Low, Normal, High, and Extra High). Set the Number of shots to 5 to capture the subject using all Active D-Lighting settings except Auto.

6. **Release the BKT button to return to shooting mode.**

7. **Shoot your first bracketed series.**

REMEMBER

When AE, AE+flash, or Flash bracketing is enabled, the Information display shows several bits of bracketing information, as shown in Figure 4-42. The exposure meter appears, with the bars underneath indicating the number of frames and the bracketing increment. You also see a label that indicates the setting that you're bracketing, the number of frames in each series, and how many frames are left to shoot in the series. For example, in the left screen in Figure 4-42, AE-BKT indicates that autoexposure is being bracketed. The 3/3 shows the number of the frame that will be captured next and the total number of frames requested. So when the numbers match, as in the figure, your next shot will be the first one in the bracketed series.

The indicators update after you capture each first frame. For example, the right screen in the figure shows how the indicators appear after the first shot is captured. One bar disappears under the meter, and the frame count changes to 2 — thus, two shots left in the series. After you capture the final shot in the series, the numbers and meter reset to show that you're about to start a new bracketed series.

You also can see bracketing information in the Control panel, although it's not quite as complete as in the Information display: All you get is a meter with frame-count markers and the word BKT. In the Live View display, you see the basic bracketing symbol and the number of shots/frames remaining value. Again, the meter appears only if Exposure Preview is enabled via the *i*-button menu. To redisplay the bracketing settings in these displays, press the BKT button.

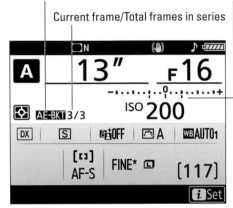

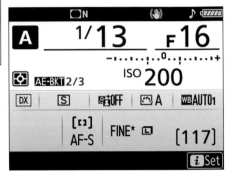

Setting being bracketing

Current frame/Total frames in series

Bracketing increment and frame indicators

FIGURE 4-42:
The Information display shows you which feature you're bracketing, the bracketing increment, and which frame in the series you're about to shoot.

ADL bracketing displays are a little different: Instead of setting the meter, you see the letters ADL followed by the word Off and initials representing each of the other shots in the series. For example, if you set the camera to shoot a three-shot ADL series, you see Off L N, for Off, Low, and Normal. A bar appears under the setting for the shot you're about to take.

In the viewfinder, the letters BKT appear to the left of the shots-remaining value when bracketing is enabled, but no other information is displayed.

TIP

8. **To disable bracketing, press the BKT button while rotating the Main command dial until the number of shots is set to 0.**

If you set the Release mode to Continuous Low or Continuous High, you can save yourself some button pressing: In those two Release modes, the camera records bracketed frames as long as you hold down the shutter button. The trick is to keep count of each click so that you know when one series is completed and the next one begins. (You can always check the bracketing indicators on the exposure meter if you get lost.) Remember that you can't use flash in either Continuous Release mode. See Chapter 2 for details about the Release mode setting.

IN THIS CHAPTER

» **Understanding autofocusing options**

» **Choosing a specific autofocusing point**

» **Tracking focus when shooting moving subjects**

» **Taking advantage of manual-focusing aids**

» **Manipulating depth of field**

Chapter **5**

Controlling Focus and Depth of Field

To many people, the word *focus* has just one interpretation when applied to a photograph: Either the subject is in focus or it's blurry. But an artful photographer knows that there's more to focus than simply getting a sharp image of a subject. You also need to consider *depth of field*, or the distance over which other objects in the scene appear sharply focused. This chapter explains how to manipulate both aspects of an image.

Setting the Basic Focusing Method

Assuming that your lens supports both manual and autofocusing with the D7500, you need to take two steps to specify the focusing method you prefer:

>> **Set the lens to automatic or manual focusing.** Most lenses have a switch with two settings: A (or AF) for autofocusing and M (or MF) for manual focusing, as shown in Figure 5-1. Some lenses, though, sport a switch with a dual setting, such as AF/M, which enables you to use autofocusing initially

but then fine-tune focus by turning the manual focusing ring. On this type of lens, select the M (or MF) setting for manual-only focusing.

TIP

Although being able to fine-tune autofocus with the manual focus ring is a handy feature, you have to be careful not to inadvertently move the ring and change the focusing distance. For certain lenses, such as some of Nikon's AF-P lenses, you can disable manual autofocus override: Open the Custom Setting menu, choose Autofocus, and change the Manual Focus Ring in AF Mode option from Enable to Disable. If you don't see this menu option, your lens isn't compatible with it.

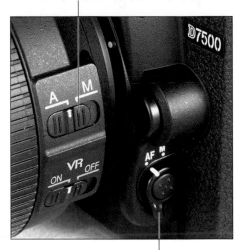

FIGURE 5-1:
Set the focus method (auto or manual) via these two switches.

>> **Set the Focus-mode selector switch on the camera to automatic or manual focusing.** I labeled the switch in Figure 5-1. Move the switch to the AF position to use autofocusing. For manual focusing, you *may* need to move the switch to the M position. If your lens has the specification AF-S in the name — AF-S standing for *silent-wave autofocusing* — you can leave the camera switch set to AF and still focus manually.

WARNING

With other lenses (or if you're not sure if your lens is the AF-S type), set the switch to M. You can damage the lens and camera if you don't.

In P, S, A, and M exposure modes, as well as in certain Scene and Effects modes, you can control autofocusing behavior through two settings: Focus mode and AF-area mode. But the available settings and focusing techniques depend on whether you're using the viewfinder or shooting in Live View mode, whether for stills or movies.

That means, unfortunately, that you have to master two autofocusing systems. I'm not going to kid you: Figuring out one system is challenging enough, without adding a second into the mix. So I suggest that you first nail down normal (viewfinder) focusing, which is covered next. Then move on to explore Live View focusing, presented in the second part of the chapter. Of course, if movie recording is your primary interest, that advice is reversed; you can't use the viewfinder to record movies.

Exploring Standard Focusing Options (Viewfinder Photography)

When you use autofocusing, the Information display includes symbols that represent the Focus mode and AF-area mode. Figure 5-2 shows you where to look. The next sections describe each setting and offer advice on which ones work best for different subjects. Following that, you can find information about manual focusing.

Setting the Focus mode

When you use autofocusing during viewfinder photography, pressing the shutter button halfway kick-starts the autofocus system. Whether the camera locks focus at that point or adjusts focus until you press the button the rest of the way depends on the Focus mode.

AF-area mode

Focus mode

FIGURE 5-2:
Symbols representing the Focus mode and AF-area mode appear here.

You can control this aspect of the autofocus system in all exposure modes except the Miniature and Selective Color Effects modes. You have the following Focus mode options:

>> **AF-A (auto-servo autofocus):** This mode gives the camera control over whether focus is locked when you press the shutter button halfway or is adjusted until you snap the picture. The camera bases its decision on whether it detects motion in front of the lens. AF-A is the default setting for most exposure modes and is the only option when you shoot in the Miniature and Selective Color exposure modes.

WARNING

The problem with AF-A mode is that if your subject is stationary but people or objects are moving nearby, the camera may see that surrounding movement and mistakenly switch to continuous autofocus. By the same token, if the subject is moving only slightly, the camera may *not* select continuous autofocusing. So my advice is that in exposure modes that give you the choice, select one of the next two Focus modes instead.

>> **AF-S (single-servo autofocus):** Designed for shooting stationary subjects, this mode locks focus when you depress the shutter button halfway. (Think *S* for *still, stationary.*)

CHAPTER 5 **Controlling Focus and Depth of Field** 149

In AF-S mode, the camera insists on achieving focus before it releases the shutter. If this behavior annoys you, open the Custom Setting menu, choose Autofocus, and then choose AF-S Priority Selection. If you change the setting to Release, the picture is then recorded when you fully depress the shutter button even if focus isn't yet achieved.

» **AF-C (continuous-servo autofocus):** Geared to capturing moving targets, AF-C mode adjusts focus as needed as long as the shutter button is pressed halfway. (Think *C* for *continuous motion*.) Remember that a focus-adjustment occurs only if the subject moves closer to or farther from the camera. If the subject is moving but only shifts a short distance in a horizontal direction, no adjustment is needed because the focusing distance remains the same.

By default, the camera records the shot in AF-C mode the instant you fully depress the shutter button, regardless of whether focus is set. As with AF-S mode, though, you can alter the focus/shutter-release connection. Again, head for the Autofocus section of the Custom Setting menu, but this time choose AF-C Priority Selection. Change the setting from Release to Focus to prevent the shutter from being released before focus is set.

To decide which shutter-release option is right for you, consider whether you'd rather have any shot, even if it's out of focus, or capture only those that are in focus. I prefer the latter, so I set both AF-S and AF-C modes to Focus. Why waste battery power, memory card space, and inevitable time deleting out-of-focus pictures? Yes, if you're shooting rapid action, you may miss a few shots waiting for the focus to occur — but if they're going to be lousy shots, who cares? Sports shooters who fire off hundreds of shots while covering an event, though, may want to unlock shutter release for both AF-C and AF-S modes. Again, you may wind up with lots of wasted shots, but you increase the odds that you'll capture that split-second "highlight reel" moment.

AF-mode button

FIGURE 5-3:
Lurking in the center of the Focus-mode selector switch, the AF-mode button offers access to both the Focus mode and AF-area mode settings.

To change the Focus mode, press and hold the AF-mode button, labeled in Figure 5-3. Given that the button is the only way to access both the Focus mode and AF-area mode setting, it's odd that it bears no identifying label to remind you of its purpose. Not sure why; all I know is that if you spent a while trying to figure out how to adjust these two settings before you discovered the secret button — well, let's just say that I, too, would like that half hour of my life back.

At any rate, when you press the AF-mode button, the selection screen shown on the left of Figure 5-4 appears. In the Control panel, all data but the Focus mode and AF-area mode settings disappear, as shown on the right.

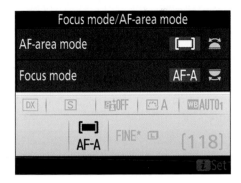

The viewfinder display also changes when you press the AF-mode button, showing the Focus mode and AF-area mode settings in the areas labeled in Figure 5-5. The autofocus brackets, which indicate the area of the frame that contains the camera's autofocus points, also appear, as do rectangles representing the active points. One quirk to note: In the default AF-area mode, AF-A (Auto Area), all 51 autofocus points are active. But the viewfinder displays points only around the perimeter of the autofocus brackets, as shown in the figure, so that you can get a good view of your subject. The hidden points are spaced evenly throughout the area enclosed by the autofocus brackets.

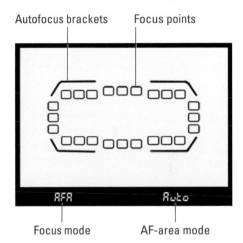

FIGURE 5-5:
The viewfinder also shows the current Focus mode and AF-area mode settings while you press the AF-mode button.

Choosing an AF-area mode: One focus point or many?

In addition to controlling whether focus is locked or continually adjusted when you press the shutter button halfway, you can tell the camera which autofocus point (or points) to consider when setting the focusing distance. Make your wishes known through the AF-area mode.

You can control this setting in any exposure mode except the Night Vision and Miniature Effects modes. To adjust the setting, press the AF-mode button while rotating the Sub-command dial. (Refer to Figure 5-3 for a look at the button.)

While the AF-mode button is pressed, all data except the current AF-area mode and Focus mode disappear from the Information display and Control panel, as shown in Figure 5-4. The viewfinder also shows you which autofocus points are active, and the current AF-area mode setting appears at the right end of the display, as shown in Figure 5-5.

The next sections tell you more about the AF-areas modes to help you understand which one to choose in different situations.

Understanding the AF-area modes

The following list explains your AF-area mode choices, showing the symbols and text labels used to represent each mode in the displays:

>> **Single Point (S):** This mode is designed to quickly and easily lock focus on a still subject. You select a single focus point, and the camera bases focus on that point only. See the next section for details on selecting an autofocus point.

>> **Dynamic Area:** This option is meant for photographing moving subjects. You select an initial focus point, and the camera focuses on that point when you press the shutter button halfway. But if your subject moves away from that focus point before you snap the picture, the camera looks to surrounding points for focusing information and adjusts focus if needed.

WARNING

To use Dynamic Area autofocusing, you must set the Focus mode to AF-C or AF-A. Assuming that condition is met, you can choose from three Dynamic Area settings:

- *9-point Dynamic Area (d9):* The camera takes focusing cues from your selected point plus the eight surrounding points. This setting is ideal when you have a moment or two to compose your shot and your subject is moving in a predictable way, making it easy to reframe as needed to keep the subject within the 9-point area.

 This setting also provides the fastest Dynamic Area autofocusing because the camera has to analyze the fewest autofocusing points.

- *21-point Dynamic Area (d21):* Focusing is based on the selected point plus the 20 surrounding points. This setting enables your subject to move a little farther from your selected focus point and still remain in the target zone, so it works better than 9-point mode when you can't quite predict the path your subject is going to take.

- *51-point Dynamic Area (d51):* The camera makes use of the full complement of autofocus points. This mode is designed for subjects that are moving so rapidly that it's hard to keep them within the framing area of the 21-point or 9-point setting — a flock of birds, for example. The drawback is that with all 51 points to consider, the camera may be slower in adjusting focus.

» **3D Tracking (3d):** This setting is a variation of 51-point Dynamic Area mode. Like that mode, the 3D Tracking option is available only when the Focus mode is set to AF-C or AF-A.

Start by selecting a single focus point and then press the shutter button halfway to set focus. If you recompose the shot before taking the picture, the camera tries to refocus on your subject.

The problem with 3D Tracking is that it works by analyzing the colors of the object under your selected focus point. So, if not much difference exists between the subject and other objects in the frame, the camera may not be able to find a new focusing target when needed. And if your subject moves out of the frame, you must release the shutter button and reset focus by pressing it halfway again.

» **Group-area (GrP):** Like Dynamic-area, Group-area mode sets focus initially and then tracks your subject, adjusting focus as needed until you take the picture. The difference lies in how the camera acquires and maintains the focusing distance.

In Group-area mode, four focus points appear in the viewfinder. A fifth point, in the center of those four points, is hidden but also active. (The symbol used to represent this mode reflects this setup.) Unlike Dynamic Area, though, the camera considers all five focus points equally instead of giving your selected focus point priority. Focus is then set on the nearest object that falls under the group of focus points. If you use Group-area mode with the AF-S Focus mode, the camera also uses face detection. When a face is found, the camera tries to set focus on the eyes in that face.

TIP

Here's an example of when this focusing option may work better than the Dynamic-area options. Imagine that you're shooting a marathon, aiming your camera at runners approaching the finish line. Two runners are in the frame, one trailing slightly behind the other. In Group-area mode, the camera focuses on the leader, who is closer to the camera than the runner in second place. If the picture features a short depth of field (the background is blurry), the winner will be in sharper focus than the second-place finisher — a nice result unless the runner-up happens to be your kid, spouse, or otherwise more important to your photograph. And if face detection kicks in, you have a better chance of the runner's eyes being in sharp focus. (Face detection isn't always reliable — if the runner is looking down or sideways, it probably won't work.)

Just as with the other continuous autofocusing options, you need to reframe the shot as needed to keep your subject under the focus points until you press the shutter button all the way to take the picture..

 » **Auto Area (Auto):** The camera chooses which of the 51 focus points to use; all you do to focus is press the shutter button halfway. Focus is typically set on the object closest to the camera. Remember that when you press the AF-mode button while Auto Area is in force, only the points around the perimeter of the autofocus brackets light up in the viewfinder (refer to Figure 5-5), but all 51 points are active nonetheless.

Selecting an autofocus point (or group)

When you use any AF-area mode except Auto-area or Group-area, you see a single autofocus point in the viewfinder. That point is the one the camera will use to set focus in the Single Point mode and to establish the starting focusing distance in the Dynamic Area and 3D Tracking modes. By default, the center point is selected.

REMEMBER

To choose a different focus point, first check the position of the Focus Selector Lock switch, shown on the left in Figure 5-6. Make sure that the white line is aligned with the white dot, as shown in the figure. When you set the switch to the L position, focus-point selection is locked, and you can't choose a point different from the one you last chose.

After setting the switch to the unlocked position, press the Multi Selector right, left, up, or down to cycle through the available focus points, which are located within the area surrounded by the autofocus brackets. I choose a focus point positioned over the obelisk in the example shown on the right in Figure 5-6. (If nothing happens when you press the Multi Selector — and the Focus Selector Lock switch is correctly positioned — press the shutter button halfway to activate the metering system. Then release the button and try again.)

For Group-area mode, use the Multi Selector to position the four-point grid over your subject. Again, those four points and the hidden point are active, and the point that falls over the closest object is used to set the focusing distance.

A couple of additional tips:

» **You can reduce the number of focus points available for selection from 51 to 11.** The advantage of doing so is that you can choose a focus point more quickly — you don't have to keep pressing the Multi Selector zillions of times to get to the one you want to use. Make the change via the Number of Focus Points option, found in the Autofocus section of the Custom Setting menu and shown on the left in Figure 5-7. The right half of the figure shows you which points are available at the reduced setting.

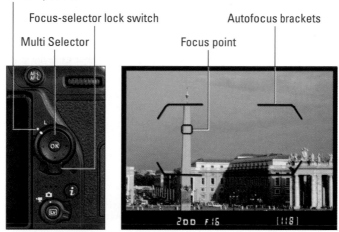

Unlock position

Focus-selector lock switch

Multi Selector

Focus point

Autofocus brackets

FIGURE 5-6:
When the Focus Selector Lock switch is set to unlock (left), use the Multi Selector to choose a focus point (right).

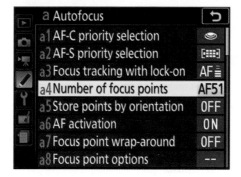

FIGURE 5-7:
You can limit the number of available focus points to the 11 shown here.

TIP

The obvious downside is that with only 11 points, you may not be able to frame your subject so that it falls under one of those points. As a workaround, frame your subject so that it is under a focus point, lock focus, and then reframe to your desired composition. In addition, the camera still uses the full complement of normal focus points to focus in the Dynamic Area and 3D Tracking modes. The Number of Focus Points option just limits the points you can choose for your initial focus point.

>> **You can quickly select the center focus point by pressing OK.** This assumes that you haven't changed the function of that button, an option you can explore in Chapter 11.

>> **If you want to use a certain focus point for a while (or always), move the Focus Selector Lock switch to the L position.** This step ensures that an errant press of the Multi Selector doesn't accidentally change your selected point.

>> **The selected focus point is also used to meter exposure when you use spot metering.** See Chapter 4 for details about metering.

Autofocusing for still subjects: AF-S + Single Point

TIP

For stationary subjects, I recommend pairing AF-S Focus mode with Single Point AF-area mode, as shown in Figure 5-8. To access both settings, press the AF-mode button. (Refer to Figure 5-3.) Rotate the Main command dial to set the Focus mode, and rotate the Sub-command dial to change the AF-area mode.

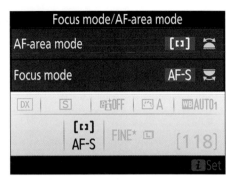

FIGURE 5-8:
For stationary subjects, I recommend these autofocus settings.

Follow these steps to focus:

1. Looking through the viewfinder, use the Multi Selector to position the focus point over your subject.

You may need to press the shutter button halfway and release it to wake up the camera before you can take this step. (By default, the system automatically shuts down after a period of inactivity.) Also make sure that the Focus-selector lock switch isn't set to the L (locked) position. To change the focus point, the white marker on the switch must point to the white dot (refer to Figure 5-6).

2. Press the shutter button halfway to set focus.

When focus is achieved, the camera displays a dot at the left end of the viewfinder, as shown in Figure 5-9. Focus is locked as long as you keep the shutter button pressed halfway.

3. Press the shutter button the rest of the way to take the shot.

Here are a few additional details about this autofocusing setup:

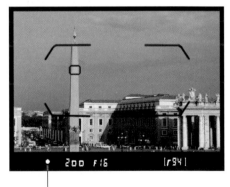

Focus achieved

FIGURE 5-9:
In AF-S mode, a white dot appears when focus is achieved.

» **Triangles appear instead of the focus dot when the current focusing distance is in front of or behind the subject.** A right-pointing arrow means that focus is set in front of the subject; a left-pointing arrow means that focus is set behind the subject. Release the shutter button, reposition the focus point over your subject, and try again. Still no luck? Try backing away from your subject a little; you may be exceeding the minimum focusing distance of the lens.

The autofocusing system also can have trouble locking onto some subjects, especially reflective objects or those that contain little contrast. Don't waste too much time letting the camera hunt for a focusing point; it's easier to switch to manual focus.

>> **Remember that by default, the camera doesn't release the shutter if it can't achieve focus.** If you want the shutter to release regardless of focus, open the Custom Setting menu, select Autofocus, and then set the AF-S Priority option to Release.

>> **You can ask the camera to beep when focus is achieved.** You enable and disable the sound via the Beep On/Off option on the Setup menu. When the feature is turned on, a musical note appears near the battery symbol in the upper-right corner of the Information display. Even when the beep is enabled, it won't sound in the Quiet and Quiet Continuous Release modes, though — because, you know, "Quiet."

TIP

>> **Initial exposure settings are also chosen at the moment you press the shutter button halfway.** However, assuming that you're relying on autoexposure, settings are adjusted as needed until you take the shot.

>> **If needed, you can position your subject outside a focus point.** Just compose the scene initially so that your subject is under a point, press the shutter button halfway to lock focus, and then reframe.

You may want to lock focus and exposure together before you reframe. Just press and hold the AE-L/AF-L button. Otherwise, exposure is adjusted to match the new framing, which may not work well for your subject. See Chapter 4 for more details about autoexposure lock.

TECHNICAL STUFF

>> **Your half-press of the shutter button also replaces the shots-remaining value with the buffer capacity (r94 in Figure 5-9).** This bit of data comes into play only when you use the Continuous Release modes; the number indicates how many shots the camera can record in a continuous burst before filling the buffer (temporary data storage space). When the value drops to 0, the camera pauses until it has time to finish recording all current images to the memory card.

Focusing on moving subjects: AF-C + Dynamic Area

When shooting most moving subjects, I select AF-C for the Focus mode and choose one of the Dynamic Area options for the AF-area mode, as shown in Figure 5-10. The earlier section "Choosing an AF-area mode: One focus point or many?" provides information to help you decide whether to use the 9-, 21-, or 51-point Dynamic Area setting.

The initial focusing process is the same as when you use the AF-S and Single Point autofocusing combo: Choose a focus point, position your subject under that

point, and press the shutter button halfway. The difference is that in AF–C mode, focus isn't locked at that point. Instead, if your subject moves from the focus point, the camera checks surrounding points for focus information and adjusts focus using that data.

Also, the focus dot in the viewfinder may flash on and off as focus is adjusted. Note, though, that even if you enable the Beep On/Off option, the camera doesn't provide audio confirmation of focus as it does in AF–S mode, which is a Good Thing — things could get pretty noisy if the beep sounded every time the camera adjusted focus.

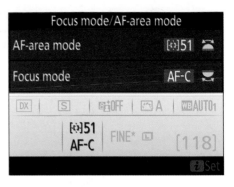

FIGURE 5-10:
For moving subjects, I combine AF-C Focus mode (continuous autofocusing) with one of the Dynamic Area AF-area settings.

Keep these additional thoughts in mind to get the best results when photographing moving subjects:

>> **Try to keep the subject under the selected focus point to increase the odds of good focus.** If the subject moves away from that point, it should still find the focus target as long as it falls under one of the other focus points (9, 21, or 51, depending on which Dynamic Area mode you selected). But reframing to keep the subject under the selected point gives the camera a focusing assist. Note that you don't see the focus point actually move in the viewfinder, but the focus tweak happens just the same. You can feel and hear the focus motor doing its thing, if you pay attention.

>> **Prevent focusing miscues with tracking lock-on.** You're shooting your friend's volleyball game, practicing your action-autofocusing skills. You set the initial focus, and the camera is doing its part by adjusting focus to accommodate her pre-serve moves. Then all of a sudden, some clueless interloper walks in front of the camera. Okay, it *was* the referee, who probably did have a right to be there, but *still*.

The good news is that as long as the ref gets out of the way before the action happens, you're probably okay. A feature called *focus tracking with lock-on* tells the camera to ignore objects that appear temporarily in the scene after you begin focusing. Instead of resetting focus on the newcomer, the camera continues focusing on the original subject.

You can vary the length of time the camera waits before starting to refocus through the Focus Tracking with Lock-On option, found in the Autofocus section of the Custom Setting menu and shown in Figure 5-11. Normal (3 seconds) is the default setting. You can choose a longer or shorter delay or turn off the lock-on altogether. If you turn off the lock-on, the camera starts refocusing on any object that appears in the frame between you and your original subject.

>> **You can interrupt continuous autofocusing and lock focus by pressing the AE-L/AF-L button.** Focus remains set as long as you hold down the button. Don't forget, though, that by default, pressing the AE-L/AF-L button also locks autoexposure. You can change this setup so that the button locks just one or the other; Chapter 11 explains how.

TIP

>> **On occasion, you may want to switch to Single Point AF-area mode when using continuous autofocusing.** For example, if you're photographing a tuba player in a

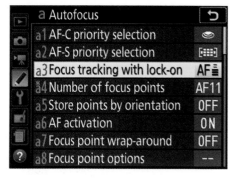

FIGURE 5-11:
This option controls how the autofocus system deals with objects that appear between the lens and the subject after you initiate focusing.

marching band, you want to be sure that the camera tracks focus on just that musician. With Dynamic Area, it's possible that the focus may drift to another nearby band member. The difficulty with the Single Point/AF-C pairing is that you must constantly reframe to keep your subject under the point you selected. I like to use the center point with this setup; I find it more intuitive because I just reframe as needed to keep my subject in the center of the frame. (You can always crop your image to achieve a different composition after the shot.)

>> **Some subjects may be easier to track with the Group-area mode.** This mode also provides continuous autofocusing. But rather than favoring a single focus point, the camera considers a cluster of five focus points and locks focus on the closest object that falls under one of those points. Before initiating autofocusing, use the Multi Selector to move the focus points over your subject. (Four points appear in the viewfinder; the fifth, in the center of the group, is invisible.)

Going back to the marching band scenario, you might use Group-area mode if your subject is the drum major rather than a musician. (If you aren't a band geek like me, the drum major is the person leading the band down the street — usually wearing a tall hat shaped like Marge Simpson's hairdo.) Assuming that you're shooting at an angle that has the band coming towards you, the fact that Group-area mode targets the closest object should make it easy to lock focus on the drum major.

Remember, too, that if you pair Group-area mode with the AF-S Focus mode, the autofocusing system incorporates face detection into the mix. If the portion of the scene under the five-point grid contains a face, that face is used as the focusing target, regardless of whether another object is closer to the camera. Face detection usually works only when the subject is facing directly into the camera, however, and probably won't be successful if the eyes are shaded by the brim of a Simpsonesque hat.

EXPLORING EVEN MORE AUTOFOCUS OPTIONS

You can further customize the autofocus system via these options, found in the Autofocus section of the Custom Setting menu:

Store Points by Orientation: Suppose that you're shooting a landscape, framing the shot in a horizontal orientation, and select the top-right focus point. Normally, that focus point remains selected when you rotate the camera to a vertical orientation. But if you turn on this menu option, the camera instead automatically activates the focus point that was on duty the last time you shot a vertically oriented photo.

AF Activation: By default, pressing the shutter button halfway initiates autofocusing as well as exposure metering. Some photographers prefer to use separate buttons for each function, so this menu option enables you to relieve the shutter button of its focusing assignment. (Change the setting to AF-ON only.) You can then use the button-customization tools that I cover in Chapter 11 to assign focusing duties to another button, such as the AE-L/AF-L button.

- **Focus Point Wrap-Around:** When you press the Multi Selector to cycle through the available focus points, you normally hit a "wall" when you reach the edge of the focusing area. So if the leftmost point is selected, for example, pressing left again gets you nowhere. But if you turn on this option, you instead jump to the rightmost point.

- **Focus Point Options:** Selecting this menu item gives you access to two settings. The first, Focus Point Illumination, determines how the focus points appear in the viewfinder when you press the shutter button halfway. At the default setting, Auto, the selected focus point flashes red and then goes back to black if the background is dark, making the black points hard to see. Change the setting for this option to On to make the highlights appear all the time; choose Off to disable the highlights altogether.

 The second Focus Point Options setting, Manual Focus Mode, controls whether the active focus point is displayed when you use manual focusing. By default, the option is set to On, and the focus point appears. Set the option to Off if you want the point to appear only when you're selecting a focus point. (See the section related to manual focusing, elsewhere in this chapter, to find out why you'd even want to see a focus point when focusing manually.)

- **Built-In AF-Assist Illuminator:** In dim lighting, the AF-assist lamp on the front of the camera shoots out a beam of light to help the focusing system find its target. If the light is distracting, you can disable it by setting this menu option to Off.

Additionally, the Setup menu offers an AF Fine Tune option, which enables you to create custom focus adjustments for specific lenses. This feature is one for the experts, though; even Nikon doesn't recommend that you use this tool unless it's unavoidable. If you consistently have focusing trouble with a lens, have your local camera tech inspect the lens to be sure it doesn't need repair.

Focusing manually

Some subjects confuse even the most sophisticated autofocusing systems, causing the autofocus motor to spend a long time hunting for a focus point. Animals behind fences, reflective objects, water, and low-contrast subjects are just some of the autofocus troublemakers. Autofocus systems also struggle in dim lighting, although that difficulty is often offset by the AF-assist lamp, which shoots out a beam of light to help the camera find its focusing target.

When you encounter situations that cause an autofocus hang-up, you can try adjusting the autofocus options discussed earlier in this chapter. But often, it's easier and faster to switch to manual focusing. For the best results, follow these manual-focusing steps:

1. **Adjust the viewfinder to your eyesight.**

 If you don't adjust the viewfinder, scenes that are in focus may appear blurry, and vice versa. If you haven't already done so, look through the viewfinder and rotate the little dial near its upper-right corner. As you do, the viewfinder data and the AF-area brackets become more or less sharp. (Press the shutter button halfway to wake up the meter if you don't see any data in the viewfinder.)

2. **Set the lens and camera to manual focusing.**

 First, move the focus-method switch on the lens to the manual position. Next, set the camera to manual focusing by setting the Focus-mode switch on the front-left side of the camera to M.

3. **Select a focus point.**

 Technically speaking, you don't *have* to choose a focus point for manual focusing; the camera focuses according to the position you set by turning the focusing ring. However, choosing a focus point offers two benefits: First, the camera displays the same focus-achieved symbol in the viewfinder as when you autofocus, and that feedback is based on the selected focus point. Second, if you use spot metering, an exposure option covered in Chapter 4, exposure is metered on the selected focus point.

 REMEMBER

 Select a focus point for manual focusing the same way you do when autofocusing: Press the Multi Selector right, left, up, or down to select a point. Again, you may need to press the shutter button halfway to display the points. Also make sure that the Focus-selector lock switch is set to the unlock position. (Refer to Figure 5-6.)

4. **Frame the shot so that your subject is under the selected focus point.**

5. **Press and hold the shutter button halfway to initiate exposure metering.**

6. **Rotate the focusing ring on the lens to bring the subject into focus.**

 When focus is set on the object under the focus point, the focus dot in the viewfinder lights. If you see a triangle in that part of the display instead, focus is set in front of or behind the object in the focus point.

7. **Press the shutter button the rest of the way to take the shot.**

I know that when you first start working with an SLR-style camera, focusing manually can be intimidating. But if you practice a little, you'll find that it's really no big deal and saves you the time and aggravation of trying to bend the autofocus system to your will when it has "issues."

WARNING

PREVENTING SLOW-SHUTTER BLUR

A poorly focused photo isn't always caused by incorrect focusing. A slow shutter speed can also cause blurring if your subject or the camera itself moves during the exposure.

Chapter 4 explains shutter speed in detail, but here's the short story as it relates to focus: When you photograph moving subjects, a slow shutter speed can make them appear blurry. And when you handhold the camera, camera shake can blur the entire photo.

You can avoid camera shake by using a tripod, of course. But for times when you don't have a tripod or other way to steady the camera, some lenses offer a feature that can compensate for small amounts of camera shake. On Nikon lenses, this feature is called Vibration Reduction (VR), but other manufacturers use other names, such as Vibration Compensation or Image Stabilization. The Nikon lens featured in this book offers this feature; enable and disable it via the VR switch, found just under the Auto/Manual Focus mode switch (refer to Figure 5-1). Note that some lenses offer two levels of vibration reduction, one for very normal levels of vibration and one for extreme vibration (such as when you're taking pictures while zipping across a lake in a speed boat). Either way, when Vibration Reduction is turned on, the Information and Live View screens display the hand symbol. If you turn the feature off, the hand disappears.

For Nikon lenses, turn off Vibration Reduction when you use a tripod so that the camera doesn't try to compensate for movement that isn't occurring. If you use a third-party lens, check the user manual for details on whether the lens offers this feature and, if so, when and how to enable it.

One final note: In Movie mode, you have the option to enable a digital version of vibration reduction, which Nikon calls Electronic VR. You can find details in Chapter 8, which concentrates on movie-recording features.

Mastering Live View Focusing

Whether you're shooting stills or movies, you control Live View autofocusing through the same two settings as for viewfinder photography: Focus mode and AF-area mode. I explain the Live View versions of these settings in this part of the chapter. For help with other movie-recording topics, see Chapter 8.

REMEMBER

In Live View mode, you have access to the Touch Shutter. This feature enables you to tap the screen to indicate where you want the camera to focus. By default, the camera takes the picture as soon as you lift your finger off the screen. If you prefer, you can use the touchscreen to set focus only. See the last part of Chapter 1 for details on using the Touch Shutter.

Controlling autofocus behavior

When you use Live View, either for shooting stills or recording video, the initial focusing setup is the same as for viewfinder photography: First, set the lens and camera to automatic or manual focusing, as outlined at the start of this chapter. Then specify your autofocusing preferences through the Focus mode and AF-area mode settings. A quick reminder of what each setting does:

>> **Focus mode:** This setting tells the camera whether to use continuous autofocusing or lock focus at a specific distance.

>> **AF-area:** This option determines which part of the frame is analyzed to set focus.

As with viewfinder photography, you access both settings by pressing the AF-mode button, shown on the left in Figure 5-12. While the button is pressed, the Focus mode and AF-area mode settings appear highlighted in the Live View display, as shown on the right in the figure. (The figure shows the display for still photography; the symbols appear in the same spot in Movie mode.) Rotate the Main command dial to change the Focus mode; use the Sub-command dial to set the AF-area mode.

It's at this point that things diverge from viewfinder photography. As you rotate the dials to set the Focus mode and AF-area mode, the settings that appear are different in Live View mode, save for one Focus mode option (AF-S). The technique you use to establish focus varies from normal focusing, too.

Upcoming sections provide details on the various Focus mode and AF-area mode settings. But here are a few general rules of the road:

>> **You can control the Focus mode and AF-area mode in all but a few exposure modes.** The camera chooses the Focus mode in three Effects

modes: Photo Illustration, Toy Camera, and Miniature. The Miniature Effects mode also prevents you from adjusting the AF-area mode.

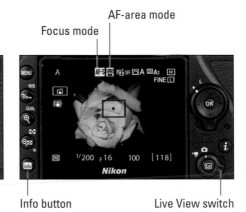

FIGURE 5-12: Press the AF-mode button (left) to access the Live View Focus mode and AF-area mode options (right).

AF-mode button Info button Live View switch

Focus mode

AF-area mode

>> **After you release the AF-mode button, the Focus mode and AF-area mode symbols appear only in the default Live View display.** In other displays modes, press the AF-mode button to temporarily display the symbols. Neither setting appears in the Control panel even when the button is pressed — the monitor is your only avenue for checking Focus mode and AF-area mode during Live View shooting.

Press the Info button, labeled on the right in Figure 5-12, to cycle through the available Live View display modes. The figure also reminds you where to find the control that engages Live View. Rotate the switch to either the still or movie camera position, depending on what you want to shoot, and then press the LV button to turn Live View on and off. Refer to Chapter 1 for a review of basic Live View tips and precautions.

>> **In Live View mode, you see a focus frame rather than the focus points displayed during viewfinder photography.** The appearance of the frame varies depending on your AF-area mode. Figure 5-13 shows the frame for the Wide-area mode. In this mode, you move the frame over your desired focusing area, as I did in the left screen in Figure 5-13. When focus is achieved, the focus frame turns green, as shown on the right in the figure. See the upcoming section "Selecting the AF-area mode" for a look at the other focusing frames and details on how to focus in those modes.

>> **Live View autofocusing is slower than viewfinder autofocusing.** The reason why isn't important; just understand that Live View isn't your best choice for focusing on fast-moving targets. Unfortunately, for movie shooting, you don't have a choice: You can't use the viewfinder to compose shots when you set the Live View switch to Movie mode.

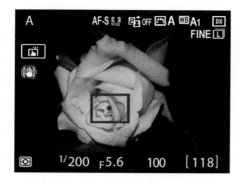

FIGURE 5-13: In Live View mode, you move a focus frame over your autofocus target (left); the frame turns green when focus is set (right).

Choosing a Live View Focus mode

In Live View mode, you don't have the AF–A option provided in viewfinder photography — the setting that lets the camera decide whether to lock focus immediately after focus is achieved or to continuously adjust focus as needed to track a moving subject. Instead, you specify which autofocus operation you prefer by choosing one of two Focus modes:

» **AF-S (single-servo autofocus):** The camera locks focus when you press the shutter button halfway or tap the touchscreen, if the Touch Shutter is enabled. This focus setting is one of the few that works the same during Live View shooting as it does during viewfinder photography. Generally speaking, AF-S works best for focusing on still subjects.

» **AF-F (full-time servo autofocus):** Choose this option for continuous autofocusing, which is the best way to go when shooting a moving subject. Although very similar to the AF-C continuous focusing feature used during viewfinder photography, a few differences exist:

REMEMBER

- *As soon as you set the camera to AF-F mode, autofocusing begins automatically.* You don't have to press the shutter button halfway or tap the touchscreen. Just make sure that your subject is under the Live View focus frame. The next section shows how the frame appears in each of the AF-area modes and explains how to reposition the frame if needed.

- *When the camera finds its target, the focus frame turns green.* Focus is adjusted as needed if your subject moves through the frame or you pan the camera. If the frame turns red, the camera lost its focusing way; when it reacquires the focus target, the frame turns green again.

- To lock focus at the current distance, press and hold the shutter button halfway down or put your finger on the touchscreen. As soon as you lift your finger from the button or touchscreen, continuous autofocusing begins again.

When recording movies, AF-F seems like the obvious choice if you're shooting moving subjects. But if you shoot a movie with sound recording enabled and use the internal microphone, the microphone may pick up the sound of the autofocus motor as it adjusts focus. The best solution is to invest in an external microphone, which you can plug into the camera's microphone jack. You then can position the mic far enough from the camera that the focusing sounds aren't recorded. Manual focusing is another option, but for moving subjects, it's fairly difficult to pull off because you have to keep turning the lens focusing ring to adjust focus as your subject moves.

Selecting the AF-area mode

Just as with viewfinder autofocusing, the AF-area mode determines what part of the frame the camera uses to set the focusing distance. But again, the available settings differ from those used for viewfinder photography. Additionally, instead of selecting an autofocus point as you do when using the viewfinder, you specify the focus target by moving a focus frame over your subject.

An icon representing the current AF-area mode appears at the top of the Live View display, as labeled in Figure 5-12. The following list provides details about all four modes, along with a look at their respective screen symbols.

>> **Wide-area and Normal-area:** In both modes, you position a red focus frame over your subject to specify the focusing target. The only difference between the two modes is the size of that frame. As its name implies, Wide-area has a larger frame, as shown on the left in Figure 5-14. The right side of the figure shows the Normal-area frame.

Wide-area focus frame Normal-area focus frame

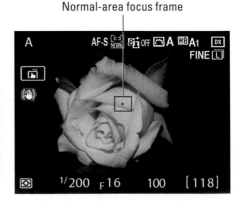

FIGURE 5-14: In Wide-area and Normal-area modes, position the focus red frame over your subject.

The smaller frame presented in Normal-area mode enables you to base focus on a very specific area. With such a small focusing frame, however, you can easily miss your focus target when handholding the camera. If you move the camera slightly as you're setting focus and the focusing frame shifts off your subject as a result, focus will be incorrect. For the best results, use a tripod in this mode.

Whichever mode you choose, move the frame over your subject by using the Multi Selector or, if the touchscreen is enabled, by tapping the desired focus area on the screen.

>> **Face Priority:** Designed for portrait shooting, this mode displays a yellow focus frame over each face the camera detects, as shown on the left in Figure 5-15. If more than one face is detected, one frame sports interior corner marks — in the figure, it's the frame on the left. The brackets indicate the face that the camera will use to set focus. Typically, the camera selects the person closest to the camera as the target. When your subjects are side-by-side, as in the example here, it doesn't matter which framing box is selected as the focus point. But if you want to select a different face, use the Multi Selector to move the selected-for-focus frame over that face. You also can just tap the face if the touchscreen is enabled.

Face Priority typically works only when your subjects are facing the camera. If the camera can't detect a face, things work as they do in Wide- area mode.

>> **Subject-tracking:** Here's another option designed for photographing moving subjects. When you select this mode, you see a focus frame similar to the one shown on the right in Figure 5-15. After moving the frame over your subject, press OK or, if you enabled the touchscreen, tap the OK symbol. If your subject moves, the focus frame moves with it. The idea is to keep the camera informed about your subject's position so that when you initiate autofocusing, focus can be set more quickly. To stop tracking, press OK again. You need to take this step if your subject leaves the frame: Press or tap OK to stop tracking, reframe, and press or tap OK to start tracking again.

Selected face Subject-tracking focus frame

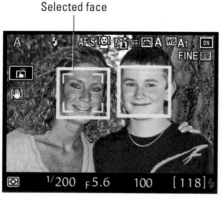 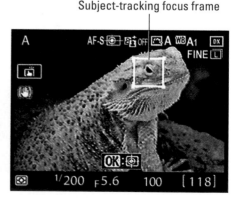

FIGURE 5-15: The focusing frames appear differently in Face Priority mode (left) and Subject Tracking mode (right).

In AF-F Focus mode, you can see focus being adjusted as the Subject Tracking frame moves; in AF-S mode, focusing doesn't occur until you press the shutter button halfway.

Sadly, subject tracking isn't always as successful as you might hope. For a subject that occupies only a small part of the frame — say, a butterfly flitting through a garden — autofocus may lose its way. Ditto for subjects moving at a fast pace, subjects getting larger or smaller in the frame (when moving toward you and then away from you, for example), or scenes in which not much contrast exists between the subject and the background. Oh, and scenes in which there's a great deal of contrast can create problems, too. My take on this feature is that when the conditions are right, it works well, but otherwise Wide-area mode gives you a better chance of keeping a moving subject in focus.

REMEMBER

You control the AF-area mode in any exposure mode except Miniature Effects mode. However, Subject Tracking isn't available in certain Effects modes: Night Vision, Photo Illustration, Toy Camera, and Selective Color. To change the setting, press the AF-mode button while rotating the Sub-command dial.

Choosing the right Live View autofocusing pairs

To recap, the way the camera sets focus during Live View still photography and movie shooting depends on your Focus mode and AF-area mode settings. Until you get fully acquainted with the various combinations of Focus mode and AF-area mode settings and can make your own decisions about which pairings you like best, I recommend the following settings (assuming, of course, that the exposure mode you're using permits them):

» **For moving subjects:** Set the Focus mode to AF-F and the AF-area mode to Wide-area. You also can try the Subject-tracking AF-area mode, but see my comments in the preceding section regarding which subjects may not be well suited to that mode.

» **For stationary subjects:** Set the Focus mode to AF-S and the AF-area mode to Wide-area. Or, if you're shooting a portrait, give the Face-priority AF-area option a try.

» **For difficult-to-focus subjects:** If the camera has trouble finding the right focusing point when you use autofocus, don't spend too much time fiddling with the different autofocus settings. Just set the camera to manual focusing and set focus yourself. Remember that every lens has a minimum focusing distance, so if you can't focus automatically or manually, you may simply be too close to your subject.

Manual focusing in Live View mode

After setting your lens to manual focusing mode, as outlined at the start of this chapter, rotate the lens focusing ring to bring the scene into focus. But note these quirks about manual focusing in Live View mode:

>> Even with manual focusing, you still see the focusing frame; its appearance depends on the current AF-area mode setting. In Face-priority mode, the frame automatically jumps into place over a face if it detects one. And if you press OK when Subject-tracking mode is enabled, the camera tries to track the subject under the frame until you press OK again. I find these two behaviors irritating, so I always set the AF-area mode to Wide-area or Normal-area for manual focusing.

>> The focusing frame doesn't turn green to indicate successful focusing as it does with autofocusing.

Zooming in to check focus

Here's a cool feature available only during Live View shooting: You can magnify the display so that you can get a better view of whether your subject is in focus. This tool is available both during autofocusing and manual focusing.

 QUAL

To zoom the display, press the Zoom In button. Each press gives you a closer look at the subject. A thumbnail appears in the lower-right corner of the screen, as shown in Figure 5-16, with the yellow highlight box indicating the area that's being magnified. Press the Multi Selector to scroll the display if needed.

To reduce the magnification level, press the Zoom Out button. If you're not using Subject-tracking mode, you also can press OK to return to normal magnification.

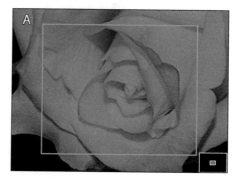

FIGURE 5-16:
Press the Zoom In button to magnify the display and double-check focus.

Manipulating Depth of Field

Getting familiar with the concept of depth of field is one of the biggest steps you can take to becoming a better photographer. I introduce you to depth of field in Chapter 4, but here's a quick recap:

>> *Depth of field* refers to the distance over which objects in a photograph appear acceptably sharp.

>> With a shallow depth of field, your subject is sharply focused, but objects behind and in front of it appear blurry.

>> With a large depth of field, the zone of sharp focus extends to include objects in front of and behind your subject.

Which arrangement works best depends on your creative goals. In portraits, for example, a classic technique is to use a short depth of field, as I did for the photo on the left in Figure 5-17. This approach draws the eye to the subject while diminishing the impact of the background. But for the photo shown on the right, I wanted to emphasize that the foreground figures were in St. Peter's Square. So I used a large depth of field, which kept the background buildings sharply focused, giving them equal visual weight to the people in the foreground.

Shallow depth of field Large depth of field

FIGURE 5-17: A shallow depth of field blurs the background (left); a large depth of field keeps both foreground and background in focus (right).

REMEMBER

Depth of field depends on the aperture setting, lens focal length, and distance from the subject, as follows:

>> **Aperture setting (f-stop):** The aperture is one of three main exposure settings explained in Chapter 4. Depth of field increases as you stop down the aperture (by choosing a higher f-stop number). For shallow depth of field, open the aperture (by choosing a lower f-stop number). Figure 5-18 offers an example; in the f/22 version on the left, focus is sharp all the way through the frame; in the f/2.8 version on the right, focus softens as the distance from the flag increases. I snapped both images using the same focal length and camera-to-subject distance, setting focus on the flag.

Aperture, f/22; Focal length, 93mm

Aperture, f/2.8; Focal length, 93mm

FIGURE 5-18:
A lower f-stop number (wider aperture) decreases depth of field.

>> **Lens focal length:** In lay terms, *focal length* determines what the lens "sees." As you increase focal length, measured in millimeters, the angle of view narrows, objects appear larger in the frame, and depth of field decreases. As an example, Figure 5-19 compares the same scene shot at a focal length of 127mm and 183mm. I used the same aperture and camera-to-subject distance for each shot, setting focus on the parrot.

Aperture, f/5.6; focal length, 127mm

Aperture, f/5.6; focal length, 183mm

FIGURE 5-19:
Zooming to a longer focal length also reduces depth of field.

For more details about focal length, flip to Chapter 1 and explore the sidebar related to that topic.

>> **Camera-to-subject distance:** As you move the lens closer to your subject, depth of field decreases.

REMEMBER

Together, these three factors determine the maximum and minimum depth of field that you can achieve:

>> **To produce the shallowest depth of field:** Open the aperture as wide as possible (the lowest f-stop number), zoom in to the maximum focal length of your lens (if you have a zoom lens), and get as close as possible to your subject.

>> **To produce maximum depth of field:** Stop down the aperture to the highest f-stop number, zoom out to the shortest focal length your lens offers, and move farther from your subject.

A couple of final tips related to depth of field:

>> **For greater background blurring, move the subject farther from the background.** The portrait in Figure 5-17 offers an example: Notice that the wicker chair in which my model is sitting appears just slightly blurrier than she does, but the vines in the distance almost blur into a solid color.

WARNING

>> **In Live View mode, depth of field doesn't change in the preview as you change the f-stop setting.** The camera can't display the effect of aperture on depth of field because the aperture doesn't actually open or close until you take the photo.

TIP

CORRECTING LENS DISTORTION

When you shoot with a wide-angle lens, vertical structures sometimes appear to bend outward. This is known as *barrel distortion*. Shooting with a telephoto lens can cause vertical structures to bow inward, which is known as *pincushion distortion*. The Retouch menu offers a post-capture Distortion Control filter you can apply to try to correct both problems. But the D7500 also has a feature that attempts to correct the image as you're shooting. It works with only certain lenses — specifically, Nikon type G, E, or D, excluding PC, fisheye, and certain other lenses. To activate the option, open the Shooting menu and set the Auto Distortion Control option to On.

One caveat: Some of the area you see in the viewfinder or Live View display may not be visible in your photo because the anti-distortion manipulation requires some cropping of the scene. Also, this feature isn't available for movie recording.

Chapter **6**

Mastering Color Controls

Compared with understanding certain aspects of digital photography, making sense of your camera's color options is easy-breezy. First, color problems aren't common, and when they occur, they're usually simple to fix with your camera's White Balance setting. Second, getting a grip on color requires learning only a few new terms, an unusual state of affairs for an endeavor that often seems more like high-tech science than art. This chapter explains White Balance along with other features that enable you to fine-tune the way your camera renders colors, whether you're shooting photos or movies.

Understanding White Balance

Every light source emits a particular color cast. The fluorescent lights in some restrooms, for example, put out a yellowish-green light that makes everyone look sick. And if you think that your beloved looks especially attractive by candlelight, you aren't imagining it: Candlelight casts a flattering yellow-red glow onto the skin.

TECHNICAL
STUFF

Science-y types measure the color of light, officially known as *color temperature*, on the Kelvin scale, which is named after its creator. You can see the Kelvin scale in Figure 6-1.

When photographers talk about "warm light" and "cool light," though, they aren't referring to the position on the Kelvin scale — or at least not in the way most people think of temperatures, with a higher number meaning hotter. Instead, the terms describe the visual appearance of the light. Warm light, produced by candles and incandescent lights, falls in the red-yellow spectrum at the bottom of the Kelvin scale; cool light, in the blue spectrum, appears in the upper part of the Kelvin scale.

8000	Snow, water, shade
	Overcast skies
	Flash
5000	Bright sunshine
	Fluorescent bulbs
	Tungsten lights
3000	Incandescent bulbs
2000	Candlelight

FIGURE 6-1:
Each light source emits a specific color.

Most people don't notice fluctuating colors of light because human eyes automatically compensate for them. Similarly, a digital camera compensates for different colors of light through *white balancing*. Simply put, this feature neutralizes light so that whites are always white, which in turn ensures that other colors are rendered accurately. If the camera senses warm light, it shifts colors slightly to the cool side of the color spectrum; in cool light, the camera shifts colors in the opposite direction.

When the White Balance option is set to AWB — Auto White Balance — the camera takes care of this color neutralizing for you. In most cases, things work out just fine. But if the scene is lit by two or more light sources that cast different colors, the white balance sensor can get confused, producing an unwanted color cast like the one you see in the left image in Figure 6-2.

FIGURE 6-2:
Multiple light sources resulted in a yellow color cast in Auto White Balance mode (left); switching to the Incandescent setting solved the problem (right).

I shot this image in my home studio — which is a fancy name for "guest bedroom" — using tungsten photo lights, which produce light with a color temperature similar to incandescent bulbs. The problem is that windows in that room permit strong daylight to filter through. In Auto White Balance mode, the camera reacted to the daylight — which has a cooler color cast — and applied too much warming, giving my original image a yellow tint. No problem: I switched the White Balance mode from Auto to the Incandescent setting. The image on the right in Figure 6-2 shows the corrected colors.

Unfortunately, you can control the White Balance setting only when you shoot in the advanced exposure modes: P, S, A, and M, which I introduce in Chapter 4. The next section explains how to make a simple white balance correction; following that, you can explore advanced options.

TIP

If you notice a color problem when shooting in other exposure modes and you're not comfortable using the advanced exposure modes, you may be able to set the Image Quality option to Raw (NEF). With Raw files, you can fine-tune colors when you process the Raw file. In fact, Raw is a better option even in the P, S, A, and M modes when you're shooting color-critical photographs because if the White Balance setting you select isn't quite right, you can tweak it when you process the file. Chapter 2 explains this Raw stuff; Chapter 10 shows you how to use the in-camera Raw converter as well as the one provided in Nikon Capture NX-D, a free photo program you can download from the Nikon website.

Changing the White Balance setting

You can view the White Balance setting in the Information and Live View displays, as shown in Figure 6-3. The figures show the symbols that represent the Auto setting; other settings are represented by the icons in Table 6-1.

White Balance setting

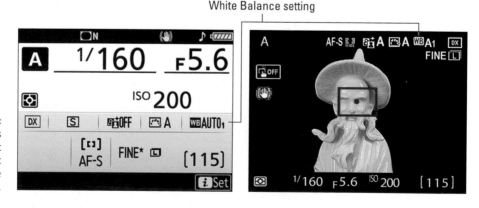

FIGURE 6-3: These icons represent the current White Balance setting.

TABLE 6-1 ## Manual White Balance Settings

Symbol	Light Source
🔆	Incandescent
〰️	Fluorescent
☀️	Direct sunlight
⚡	Flash
☁️	Cloudy
🏠	Shade
K	Choose Kelvin color temperature
PRE	Custom preset

Again, you can control the White Balance setting only when shooting in the P, S, A, or M exposure modes. To access the setting, you have two options:

WB

» **WB button plus command dials:** During viewfinder shooting, press the WB button to display the screen shown in Figure 6-4, offering two options. The bottom option controls the White Balance setting; the top one enables you to fine-tune the results produced by that setting. In Live View mode, the White Balance and fine-tuning options become highlighted when you press the WB button, as shown in Figure 6-5.

Because both options are active, be sure to rotate the correct command dial to adjust the settings:

Fine-tuning adjustment

WB button White Balance setting

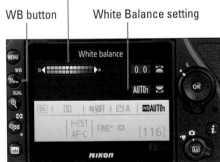

FIGURE 6-4:
Press the WB button to access the White Balance setting and the fine-tuning option.

- *Choose a White Balance setting:* Rotate the Main command dial while pressing the WB button.

- *Fine-tune white balance:* Rotate the Sub-command dial while pressing the button. (See the next section for details on this feature.)

White Balance setting

FIGURE 6-5:
In Live View
mode, the
preview
updates to
show how the
chosen White
Balance setting
affects colors.

Fine-tuning adjustment

TIP

In Live View mode, the display simulates how each White Balance setting affects colors. As an example, see the right side of Figure 6-5, which shows how the colors from the original shifted after I changed the setting from Auto 1 to Incandescent. So if you're not sure which setting to select, experiment in Live View mode even if you plan to return to viewfinder photography to take the shot.

>> **Photo Shooting menu/Movie Shooting menu:** Scroll to the second page of the Photo Shooting menu to find the White Balance setting for still photography, as shown on the left in Figure 6-6. On the Movie Shooting menu, the option is at the bottom of the first page, as shown on the right.

FIGURE 6-6:
You can use
different White
Balance
settings for
stills and
movies.

TIP

If you change the movie White Balance setting through the menu, you can access a setting not available via the WB button: Same as Photo Settings. When that option is selected, as it is by default, the camera uses your still-photography White Balance setting when you switch to movie recording. Any other setting you choose from the Movie Shooting menu affects only movie recording.

For some White Balance settings, you get a couple of additional options:

>> **Select from two Auto settings:** I know what you're thinking: "For heaven's sake, even the Auto setting is complicated?" Yeah, but just a little: See the subscript number 1 next to the Auto label in the displays and menus in Figures 6-3 and 6-6? The 1 represents the default Auto White Balance setting, Normal. At this setting, the camera adjusts colors to render the scene accurately. Your other Auto option, Keep Warm Lighting Colors, is marked with a subscript 2 and does pretty much what it says: Leaves warm hues produced by incandescent lighting intact.

I prefer the default, but if you want to use the other setting, you must select it via the Photo Shooting menu (or Movie Shooting menu, if you only want to make the adjustment for movie recording). Select White Balance and then select Auto, as shown on the left in Figure 6-7, to display the selection screen shown on the right. Select Auto 2 and press OK. (The Adjust icon in the lower-right corner takes you to a screen where you can fine-tune the setting, as explained later; the exit arrow in the upper-right corner takes you back to the main menu without changing the setting.)

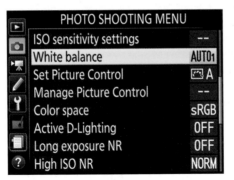
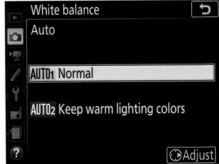

>> **Specify a fluorescent bulb type:** This option also is available only via the Photo Shooting and Movie Shooting menus. After selecting Fluorescent as your White Balance setting, press the Multi Selector right to display the list of bulbs, as shown in Figure 6-8. Select the option that most closely matches your bulbs and press OK or tap the OK symbol.

After you select a bulb type, it's used for the Fluorescent setting until you return to the menu and choose another bulb.

REMEMBER

>> **Specify a Kelvin color temperature:** Start by selecting the K White Balance setting. (*K* for *Kelvin,* get it?) If you go through the menus, scroll to the second screen to find this setting.

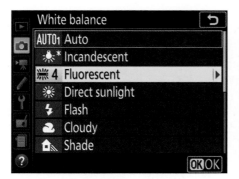

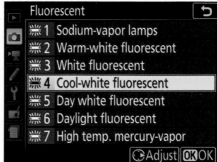

FIGURE 6-8:
You can select a specific type of fluorescent bulb.

The default temperature is 5000; to raise or lower the value, you have two options.

WB

- *Press the WB button while rotating the Sub-command dial.* During viewfinder photography, you see the screen shown in Figure 6-9, with the temperature setting displayed as the first of the two White Balance options. During Live View, the Kelvin temperature appears at the bottom of the display. You also can monitor the Kelvin temperature in the Control panel while the WB button is pressed.

FIGURE 6-9:
Press the WB button and rotate the Sub-command dial to display this screen and adjust the color temperature for the K White Balance.

- *Go through the Photo Shooting or Movie Shooting menu.* Select White Balance from the menu and then select K (Choose Color Temp), as shown on the left in Figure 6-10. Press the Multi Selector right to display the second screen in the figure. This screen offers two controls: The one on the left adjusts the Kelvin temperature; the one on the right enables you to fine-tune colors, as outlined in the next section. If the yellow box doesn't surround the color temperature setting, as shown in the figure, press the Multi Selector left to put it there. Then tap the up/down arrows or press the Multi Selector up or down to adjust the Kelvin value. Tap OK or press the OK button to make the change official. Tap or press OK again to exit the White Balance selection screen.

» **Create a custom White Balance preset:** The PRE (Preset Manual) option enables you to store a customized White Balance setting. This feature provides the fastest way to achieve accurate colors when your scene is lit by multiple light sources that have differing color temperatures. I explain it a few miles down the road from here.

Set color temperature Fine-tune setting

 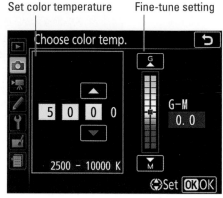

WARNING

Your selected White Balance setting remains in force for the P, S, A, and M exposure modes until you change it. So you may want to get in the habit of resetting the option to your preferred Auto setting after you finish shooting whatever subject it was that caused you to switch out of that mode.

Fine-tuning white balance

In the P, S, A, and M exposure modes, you can modify the results produced by any White Balance setting. Specifically, you can adjust colors along two spectrums: blue to amber and green to magenta. So for example, if you think that the Cloudy setting leaves colors a bit too cool, you can tell the camera to add more amber and more magenta when you use that White Balance setting.

Fine-tuning a White Balance preset that you create via the PRE option requires a special process that I spell out later, in the section "Editing presets." For other White Balance settings, follow these steps:

1. **Open the Photo Shooting or Movie Shooting menu and select White Balance.**

REMEMBER

If you want to use the same settings for both stills and movies, you don't have to go through these fine-tuning steps twice. Input your changes via the Photo Shooting menu and then open the Movie Shooting menu, choose White Balance, and select Same as Photo Settings.

2. **Use the Multi Selector to highlight the White Balance setting you want to adjust.**

For example, I highlighted Incandescent in Figure 6-11.

3. **Press the Multi Selector right or tap the Adjust symbol, labeled on the left in Figure 6-11.**

What you see and do next depends on the White Balance setting you're adjusting, as follows:

- *All settings except Fluorescent and K:* The color grid shown on the right in Figure 6-11 appears. The grid is set up around the aforementioned color pairs: Green and Magenta, represented by G and M; and Blue and Amber, represented by B and A. To adjust the White Balance setting, move the marker in the direction you want to shift colors. You can either tap inside the grid, tap the arrows on the sides of the grid, or press the Multi Selector to reposition the marker.

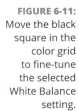

As you move the marker, the A–B and G–M boxes on the right side of the screen show you the current amount of color shift. In Figure 6-11, for example, I moved the marker one level toward amber and one level toward magenta. A value of 0 indicates no adjustment.

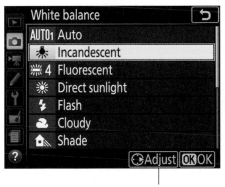
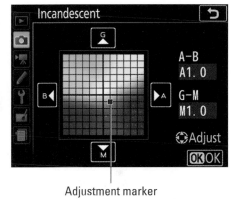

FIGURE 6-11: Move the black square in the color grid to fine-tune the selected White Balance setting.

Tap to display fine-tuning screen Adjustment marker

With traditional colored lens filters, the density of a filter determines the degree of correction it provides. Density is measured in *mireds* (pronounced *my-redds*). The white balance grid is designed around this system: Moving the marker one level is the equivalent of a five-mired shift.

- *Fluorescent:* When you press the Multi Selector right, you see the screen where you select a specific type of bulb. Select your choice and *then* tap Adjust or press the Multi Selector right to get to the fine-tuning screen shown in Figure 6-11.

- *K (Choose Color Temperature):* Instead of the four-way grid, you see the two-part screen shown in Figure 6-10, with the only obvious fine-tuning setting being the green-to-magenta bar on the right. What gives? Well, raising or lowering the Kelvin temperature is equivalent to shifting colors along the blue to amber spectrum. Remember, colors at the top of the Kelvin temperature scale are blue; at the bottom, amber. (Refer to Figure 6-1.) So for the K White Balance setting, you control the amber-to-blue shift by raising or lowering the Kelvin temperature. Then press the

Multi Selector right to activate the green-to-magenta bar. Tap the arrows at the top and bottom of the bar to move the adjustment marker to set the amount of color shift. You also can press the Multi Selector up and down to move the marker.

4. **Tap OK or press the OK button to complete the adjustment.**

After you take this step, the camera reminds you of the adjustment by adding an asterisk to the White Balance setting in the Information display, as shown in Figure 6-12. An asterisk also appears with the icon in the Photo Shooting and Movie Shooting menus and in the Live View display.

 TIP

If you want to make an adjustment along the blue–to–amber setting only, you can take this shortcut for any White Balance settings except PRE (custom preset):

 WB

1. **Press the WB button to display the White Balance setting screens shown in Figure 6-13.**

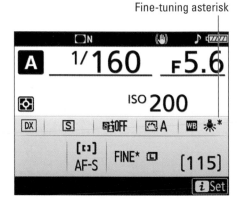

Fine-tuning asterisk

FIGURE 6-12:
An asterisk next to the White Balance symbol indicates that you fine-tuned the setting.

The amount of amber-to-blue adjustment appears as the top control on the Information display and at the bottom of the Live View displays. You also can see this value in the Control panel.

For the K White Balance setting, the color bar shown in the figure is replaced by the Kelvin temperature. (Refer to Figure 6-9.)

Blue-to-amber color adjustment Adjustment amount/direction

FIGURE 6-13:
For a blue-to-amber shift, press the WB button while rotating the Sub-command dial.

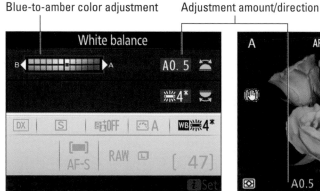
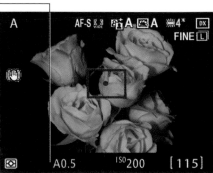

2. **Rotate the Sub-command dial to adjust colors.**

Rotate the dial to the right to nudge colors toward the blue end of the scale; rotate the dial to the left to add an amber shift. (Yes, you rotate in exactly the opposite direction you would expect, given that blue is on the left side of the scale and amber is on the right.)

The letter B indicates that you're moving toward the blue end of the color scale; A, the amber end. In Figure 6-13, I selected the Fluorescent White Balance setting and dialed in a .5 amber adjustment. As soon as you change the value from the default (0.0), the adjustment asterisk appears next to the White Balance icon, as shown in the figures.

REMEMBER

If you're adjusting the Kelvin temperature for the K White Balance setting, raising the value sends colors toward the cool end of the scale; lowering it, toward the warm end.

Creating Custom White Balance Presets

TIP

If none of the White Balance settings do the trick and you don't want to fool with fine-tuning one, take advantage of the PRE (Preset Manual) feature to create a custom White Balance setting. You can create up to six presets; the next few sections show you how to take advantage of this handy feature.

REMEMBER

Any presets you create are shared by the Photo Shooting menu and Movie Shooting menu. In other words, you can't create a set of six presets for still photography and another set for movies. It doesn't matter which menu you use to create the presets; they always go into the same container of presets.

Setting white balance with direct measurement

This technique requires taking a reference photo of a *gray card*, which is a piece of neutral card stock. You can buy gray cards (or equivalent materials) in many camera stores for less than $20.

The following steps show you how to create a preset when Live View isn't engaged; I spell out the Live View variation later.

1. **Set the exposure mode to P, S, A, or M.**

As with all white balance features, you can take advantage of this one only in those exposure modes.

2. **Open the Photo Shooting menu, choose White Balance, and highlight PRE (Preset Manual), as shown on the left in Figure 6-14.**

Again, if you prefer, you can create presets via the Movie Shooting menu.

FIGURE 6-14: You can store as many as six custom White Balance presets.

3. **Press the Multi Selector right to display the screen shown on the right in Figure 6-14.**

4. **Highlight the preset number (d-1 through d-6) you want to assign to the custom White Balance setting.**

If you select an existing preset, it will be overwritten by your new preset.

5. **Press the OK button or tap the OK symbol at the bottom of the screen.**

You're returned to the screen shown on the left in Figure 6-14.

6. **Exit the menus and return to shooting mode.**

7. **Position your gray card so that it receives the same light that will illuminate your subject.**

8. **Frame your shot so that the gray card fills the viewfinder.**

9. **Check exposure and adjust settings if needed.**

This process won't work if your settings produce an underexposed or overexposed shot of your reference card.

WB

10. **Press the WB button until the letters PRE flash in the Control panel, Information display, and viewfinder.**

11. **Release the WB button and take a picture of the reference card before the PRE alert stops flashing.**

If the camera records the white balance data, you see the letters *Gd* or *Good* in the displays. If you see the message *No Gd,* adjust your lighting or exposure settings and try again. Remember, the reference card shot must be properly exposed for the camera to create the preset successfully.

TIP

If you create presets regularly, you can save time by memorizing this shortcut instead of going through the menus:

1. **With the camera in shooting mode, press the WB button while rotating the Main command dial to set the White Balance to Pre.**

2. **Keep pressing the WB button while rotating the Sub-command dial to select the number of the preset you want to create.**

3. **Release the WB button.**

4. **Press and hold the button until the letters *PRE* flash in the display.**

 You can then take your reference shot.

Now for the promised Live View variation: Everything works the same until the letters PRE start to flash onscreen. (You can follow either of the preceding sets of steps to get to that point.) After you see the flashing PRE signal, release the WB button. A little box appears in the center of the Live View display. Position that box over your reference card and press the OK button or tap the OK Measure box at the bottom of the screen. After you see the Data Acquired message, press the WB button again or tap the Done symbol.

Matching white balance to an existing photo

Suppose that you're the marketing manager for a small business, and one of your jobs is to shoot portraits of the company bigwigs for the annual report. You build a small studio just for that purpose, complete with photo lights and a conservative beige backdrop. The bigwigs can't all come to get their pictures taken on the same day, but you have to make sure that the colors in that backdrop remain consistent for each shot, no matter how much time passes between photo sessions. This scenario is one possible reason for creating a preset based on an existing photo. After photographing the first subject, you use that file as a White Balance reference for the other shots.

WARNING

Basing white balance on an existing photo works only in situations where the color temperature of your lights is consistent from day to day. Otherwise, the White Balance setting that works for Big Boss Number One may add an ugly color cast to Big Boss Number Two.

To use this option, the reference photo needs to be stored on the memory card that's in the camera. If the photo isn't on the card, use a card reader to copy it from its current hard drive or other storage location to the card. When viewing

the card contents on your computer, you should see a main folder named DCIM; open that folder to view the camera-created folders. By default, the first folder created by the camera carries the label 100D7500. Copy the reference photo to that folder.

After putting the reference photo on the card, put the card back in the camera and follow these steps:

1. **Open the Photo Shooting or Movie Shooting menu.**

2. **Choose White Balance, select PRE (Preset Manual) and press the Multi Selector right.**

 You see the screen shown on the left in Figure 6-15.

Selected preset

FIGURE 6-15:
Select a preset (left) and then choose Select Image (right) to base a preset on an existing image.

3. **Use the Multi Selector to select the number of the preset you want to create (d-1 through d-6).**

 If you already created a preset, choosing its number will overwrite that preset with your new one. In the figure, d-1 holds the preset I created using a gray card, as outlined in the preceding section, so I selected d-2 to hold the new preset.

 4. **Press the Zoom Out button to display the menu shown on the right in Figure 6-15.**

5. **Highlight Select Image and press the Multi Selector right.**

 You see thumbnails of your photos.

6. **Use the Multi Selector to move the yellow highlight box over your reference photo and then press OK.**

 You return to the screen showing your White Balance preset thumbnails. The thumbnail for the photo you selected appears as the thumbnail for the preset you chose in Step 3.

7. **Press the OK button or tap the OK symbol to return to the Photo or Movie Shooting menu.**

 The White Balance setting is automatically changed to use the new preset.

Selecting the preset you want to use

If you create multiple presets, take either of these approaches to select the one you want to use:

» **WB button + command dials:** First, select PRE as the White Balance setting by pressing the WB button as you rotate the Main command dial. Then press the button while rotating the Sub-command dial to cycle through the available presets. The number of the selected preset (d1 through d6) appears in the displays while the button is pressed.

» **Photo Shooting or Movie Shooting menu:** Select White Balance, choose PRE, and press the Multi Selector right to display the screen shown on the left in Figure 6-15. Use the Multi Selector to highlight a preset and press the OK button or tap the OK symbol.

Editing presets

After creating a preset, the only way to get rid of it is to overwrite it with a new one. However, you can edit a preset in a few ways.

To access the editing features, choose White Balance from the Photo Shooting or Movie Shooting menu. Select PRE (Preset Manual), press the Multi Selector right, and move the yellow frame over the preset you want to edit. Finally, press the Zoom Out button or tap the Set symbol at the bottom of the screen. You then see the editing screen, shown on the left in Figure 6-16.

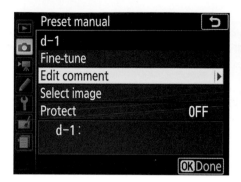
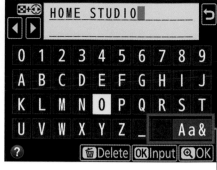

Blank space/Change keyboard

Here's what you can accomplish with each menu option:

» **Fine-tune:** Press the Multi Selector right to access the same fine-tuning grid available for other White Balance settings. See "Fine-tuning white balance," earlier in this chapter, for help.

» **Edit comment:** This option enables you to name a preset. After highlighting Edit Comment, press the Multi Selector right to display the text-entry screen shown on the right in Figure 6-16. Use these techniques to create your text:

TIP

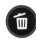

QUAL

- *Enter a character:* If the touch screen is enabled, just tap a character in the keyboard. You also can use the Multi Selector to highlight a character and then tap the OK Input symbol at the bottom of the screen or press the OK button. Either way, the characters appear in the text box at the top of the screen. Your comment can be up to 36 characters long.

 To cycle from the keyboard shown in the figure to screens that contain uppercase characters and symbols, select the Aa& key, which is the last one on the keyboard. Select the empty box just to the left of that key to enter a space. I labeled both keys in Figure 6-16.

- *Move the cursor in the text box:* Tap the arrows to the left of the text box or press the Zoom Out button while pressing the Multi Selector right or left.

- *Delete a letter:* Move the cursor under the letter in the text box and then tap the Delete symbol at the bottom of the screen or press the Delete button.

 After you enter your text, press the Zoom In button or tap OK (not OK Input — just OK) to exit the keyboard screen. Your text appears at the bottom of the preset editing menu page.

>> **Select Image:** This option enables you to base a preset on an existing photo. If you want to select a different photo for a current preset, choose this option and follow the steps laid out in the section "Matching white balance to an existing photo."

>> **Protect:** Set this option to On to lock a preset so that you can't accidentally overwrite it. If you enable this feature, you can't alter the preset comment or fine-tune the setting.

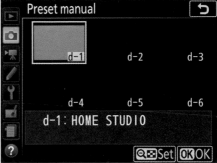

To exit the editing screen (left screen in Figure 6-16), tap OK or press the OK button. You see the Preset Manual selection screen again; if you entered a text comment, it appears at the bottom of the screen, as shown in Figure 6-17. To exit *that* screen, tap OK or press the OK button. To exit the menus and return to shooting, press the Menu button twice or just give the shutter button a quick half press and release.

FIGURE 6-17:
Your comment appears with the selected preset.

Bracketing White Balance

Chapter 4 introduces you to automatic exposure bracketing, which records the same image at different exposure, flash, or Active D-Lighting settings. You also can bracket white balance, producing either two or three images, each recorded using a different white balance setting. (Whether you get two or three images depends on the bracketing setting you select.)

REMEMBER

Note the following details about this feature:

>> **Bracketing is available only in the P, S, A, and M exposure modes.** Chapter 4 tells you how to use these exposure modes, if you haven't yet discovered them.

>> **You must set the Image Quality option to one of the JPEG options (Fine, Normal, or Basic).** Why is the Raw (NEF) setting off-limits? Because with Raw, white balance and other color settings aren't established until you process your images. The camera does use the selected White Balance setting to create the image that's displayed on the camera during playback mode and on your computer after you download the file. But you can change the White Balance setting or otherwise adjust colors when you process the Raw file, a step I discuss in Chapter 10. Long story short, there's no reason to waste time bracketing white balance when you shoot in the Raw format.

>> **A single press of the shutter button creates all the images.** The camera captures the first photo at the selected White Balance setting and then creates the adjusted copy (or copies, depending on your bracketing settings).

>> **You can shift colors from one to three steps between frames.** As an example of the maximum color shift you can achieve, check out Figure 6-18, which I created using a three-step shift. As you can see, even at that "max" setting, the differences between the shots are subtle.

| Neutral | Amber +3 | Blue +3 |

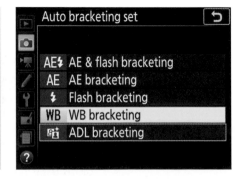

FIGURE 6-18: I created three color variations by using white balance bracketing.

To use white balance bracketing, take these steps:

1. **Open the Photo Shooting menu and select Auto Bracketing Set, as shown on the left in Figure 6-19.**

FIGURE 6-19: Tell the camera you want to bracket white balance by way of this Photo Shooting menu option.

2. **Select the WB Bracketing setting, as shown on the right in the figure.**

3. **Press the shutter button halfway and release it to return to shooting mode.**

4. **Press the BKT button to access the white-balance bracketing options, shown in Figure 6-20.**

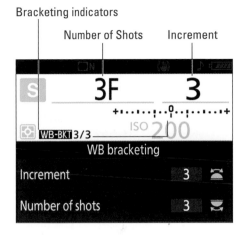

Bracketing indicators

Number of Shots Increment

The figure shows the options as they appear in the Information display; they also show up in the Control panel and, if you're using Live View, in the Live View display.

If nothing happens when you press the button, check the Image Quality setting — remember, you can't bracket White Balance unless you use one of the JPEG settings (Basic, Normal, or Fine).

FIGURE 6-20:
While pressing the BKT button, rotate the Main command dial to set the Number of Shots value; rotate the Sub-command dial to set the Increment.

5. **Keep pressing the BKT button and rotate the Main command dial to select a Number of Shots setting.**

This setting affects how many frames the camera creates, which in turn dictates the type of color adjustment between frames. You have these options:

- *3F:* Records three frames: one neutral, one pushed toward amber, and one shifted toward blue. I used this option to create the images in Figure 6-18.

- *b2F:* Records two frames: one without any adjustment and one shifted toward blue.

- *a2F:* Again, you get two frames, but the second is shifted toward amber.

- *0F:* Turns off bracketing.

6. **Press the BKT button while rotating the Sub-command dial to set the Increment value (level of color shift between frames).**

Again, the current value appears in the displays while the BKT button is pressed. You can set the amount to 1, 2, or 3.

TECHNICAL
STUFF

As with the White Balance fine-tuning grid, this setting is based on mireds, the standard used to measure lens-filter density. Each step is equivalent to a change of five mireds.

In Figure 6-20, the values show a 3-frame series, with a 3-step adjustment between frames — again, this is the setting I used to create the candle images.

Notice that as you adjust the settings, the selection screen displays bracketing indicators, showing the frame count (number of shots) and the increment. In addition, the exposure meter appears, with bars underneath also representing the frame count and increment.

CHOOSING A COLOR SPACE: sRGB VERSUS ADOBE RGB

By default, your camera captures photographs using the *sRGB color space,* which refers to an industry-standard spectrum of colors. (The *s* is for *standard,* and the *RGB* is for *red, green, blue,* which are the primary colors in the digital color world.) This color space was created to help ensure color consistency as an image moves from camera (or scanner) to monitor and printer; the idea was to create a spectrum of colors that all devices can reproduce.

Because sRGB excludes some colors that *can* be reproduced in print and onscreen, at least by some devices, your camera also enables you to shoot photographs in the Adobe RGB color space, which contains a larger spectrum of colors. Tell the camera which color space you prefer via the Color Space option on the Photo Shooting menu. (Movies always use the sRGB color space.)

Although using a larger color spectrum sounds like a no-brainer, choosing Adobe RGB isn't necessarily the right choice. Consider these factors when making your decision:

- Some colors in the Adobe RGB spectrum can't be reproduced in print; the printer substitutes the closest printable color, if necessary.

- If you print and share photos without making adjustments in your photo editor, sRGB is a better choice because most printers and web browsers are designed around sRGB.

- To retain the original Adobe RGB colors when you work with your photos, your editing software must support that color space — not all programs do. You also must be willing to study the topic of digital color a little because you need to use specific software and printing settings to avoid mucking up the color works.

One final tip: The picture filename indicates which color space you used. Filenames of Adobe RGB images start with an underscore, as in _DSC0627.jpg. For pictures captured in sRGB, the underscore appears in the middle of the filename, as in DSC_0627.jpg.

7. **Release the BKT button to return to shooting mode.**

 When you release the button, the bracketing indicators shown in the setup screen (Figure 6-20) appear in the Information display.

8. **Take a picture.**

 After capturing the neutral image, the camera makes the additional color-shifted copies according to your bracketing instructions. (The shutter is released just once; the rest of the magic occurs during post-capture processing.)

9. **To disable bracketing, set the frame number to 0F.**

 Just hold down the BKT button and rotate the Main command dial to adjust the frame number.

TIP

If you view your photos in a playback mode that displays color data, the White Balance readout indicates the shift applied to the bracketing shots. For the amber version, you see the letter *A;* for the blue version, *B.* Next to the letter, the value 1, 2, or 3 indicates the increment of color shift. For the neutral shot, the readout displays 0, 0. Chapter 9 shows you how to view this type of data during playback.

Taking a Quick Look at Picture Controls

When you shoot movies or capture photos using the JPEG Image Quality settings (Fine, Normal, or Basic), colors are also affected by the Picture Control setting. This option also sets other visual characteristics, including contrast and sharpening.

TECHNICAL STUFF

Sharpening is a software process that boosts contrast in a way that creates the illusion of slightly sharper focus. Let me emphasize, "slightly sharper focus." Sharpening produces a subtle *tweak;* it's not a fix for poor focus.

In the Information and Live View displays, the Picture Control setting is represented by the symbol labeled in Figure 6-21, with the initial (or initials) immediately after the symbol indicated the current setting. In the figure, the letter A means that the Auto Picture Control setting is in force.

Picture Control

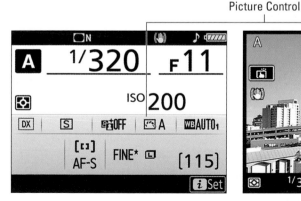

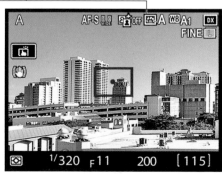

FIGURE 6-21: This symbol represents the Picture Control setting.

In the P, S, A, and M exposure modes, you can choose from the following Picture Controls. In other exposure modes, the camera selects the Picture Control for you.

>> **Standard (SD):** This option captures the image "normally" — that is, using the characteristics that Nikon research has determined suitable for most subjects.

>> **Auto (A):** This setting, which is the default in the P, S, A, and M exposure modes, uses the characteristics of the Standard setting as a baseline. Then, if the camera recognizes that you're shooting a portrait, it softens skin tones and warms colors slightly. If the camera instead determines that your subject is a landscape, it strengthens blues and greens to make skies and foliage appear more vivid.

>> **Neutral (NL):** The camera doesn't enhance color, contrast, and sharpening as much as in Standard mode. The setting is designed for people who want to manipulate these characteristics in a photo editor. By not overworking colors, sharpening, and so on when producing your original file, the camera gives you more latitude in the digital darkroom.

>> **Vivid (VI):** This mode amps up saturation, contrast, and sharpening.

>> **Monochrome (MC):** This setting creates a black-and-white photo. However, I suggest that you instead shoot in color and then create a black-and-white copy in your photo software. Good photo programs have tools that let you choose how original tones are translated to the black-and-white palette. And remember that you can always convert a color image to black and white, but you can't go the other direction.

That said, Monochrome is a fun option to try for movie recording, producing an instant *film noir* look. For still photos, also check out the Monochrome tool on the Retouch menu, which I explain in Chapter 12.

>> **Portrait (PT):** This mode tweaks colors and sharpening to flatter skin.

>> **Landscape (LS):** This mode emphasizes blues and greens.

>> **Flat (FL):** Flat images display even less contrast, sharpness, and saturation than Neutral and, according to Nikon, capture the widest tonal range possible with the D7500. Videographers who do a lot of post-processing to their footage may find this setting especially useful.

Obviously, the Monochrome option produces a drastic change in the look of your image. The extent to which other settings affect an image depends on the subject, but to give you a general idea, Figure 6-22 shows the same scene as rendered by six of the full-color Picture Controls. As you can see, Standard, Vivid, and Landscape produce pretty similar results, as do Portrait and Neutral. As for Flat — well, to my eye, that rendition *needs* extensive editing to bring it to life. I left Auto out of the

example because results depend on what you're shooting (and how well the camera does in determining whether it's a landscape, a portrait, or something else).

Standard

Neutral

Vivid

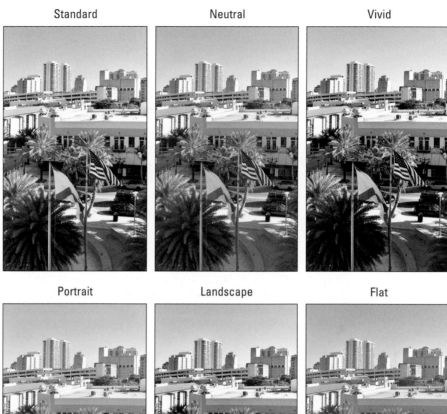

Portrait

Landscape

Flat

FIGURE 6-22: The Picture Control settings apply various adjustments to color, sharpening, and contrast of JPEG images.

TIP

While you're new to the camera, I recommend sticking with Auto or Standard. I prefer Standard because I want to be the one to decide whether to make the sort of adjustment the camera makes when it recognizes portrait or landscape subjects. But either option handles most subjects well, and you have lots of other, more important settings to remember.

Also keep in mind that if you shoot in the Raw format, you choose a Picture Control during Raw processing (the camera uses the currently selected setting just to create the image preview you see on the monitor). See Chapter 10 to find out more about Raw processing.

If you do want to experiment with Picture Controls, here are the basics:

>> **Changing the Picture Control setting:** Your fastest option is to use the *i*-button menu, as shown in Figure 6-23. You also can access the setting via the Photo Shooting or Movie Shooting menu.

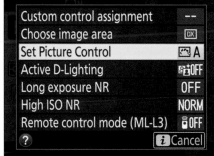 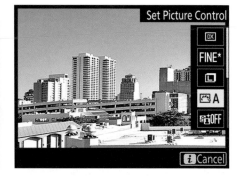

FIGURE 6-23: The fastest route to the Picture Control setting is the *i*-button menu.

>> **Modifying a Picture Control:** You can modify any Picture Control to more closely render a scene the way you envision it.

After selecting a Picture Control from the *i*-button menu or regular menus, tap the Adjust symbol at the bottom of the screen, shown on the left in Figure 6-24 or press the Multi Selector right to access customization options.

After you customize a setting, the camera reminds you of that fact by adding an asterisk next to the Picture Control symbol in the displays and menus.

>> **Storing custom Picture Control settings:** Choose the Manage Picture Control option from the Photo Shooting menu if you want to create your own Picture Control settings. You can create as many as nine settings.

To reserve page space in this book for functions that will be the most useful to the most readers, this discussion is the extent of the Picture Control information in this book. For more details, check out the camera's user guide. You can download an electronic version of the guide from the Nikon website (www.Nikon.com).

Chapter **7**

Putting It All Together

E arlier chapters of this book break down almost every picture-taking feature on your camera, describing in detail how the controls affect exposure, picture quality, focus, color, and the like. This chapter pulls together all that information to help you set up your camera for specific types of photography.

Keep in mind, though, that there are no hard-and-fast rules for the "right way" to shoot a portrait, a landscape, or whatever. So feel free to wander off on your own, tweaking this exposure setting or adjusting that focus control, to discover your own creative vision. Experimentation is part of the fun of photography, after all — and thanks to your camera monitor and the Delete button, it's an easy, completely free proposition.

Recapping Basic Picture Settings

Your subject, creative goals, and lighting conditions determine which settings you should use for certain picture-taking options, such as aperture and shutter speed. I offer my take on those options throughout this chapter. But for many basic options, I recommend the same settings for almost every shooting scenario. Table 7-1 shows you those recommendations and also lists the chapter where you can find details about each setting.

TABLE 7-1 **All-Purpose Picture-Taking Settings**

Option	Recommended Setting	See This Chapter
Active D-Lighting	Off	4
AF-area mode	Still subjects, Single-point; moving subjects, 9-, 21-, or 51-point Dynamic-area	5
Exposure mode	P, S, A, or M	4
Focus mode	For autofocusing on still subjects, AF-S; moving subjects, AF-C	5
Image Area	DX	2
Image Quality	JPEG Fine or Raw (NEF)	2
Image Size	Large or medium	2
ISO Sensitivity	100	4
Metering	Matrix	4
Picture Control	Auto	6
Release mode	Action photos: Continuous Low or High; all others: Single Frame	2
White Balance	Auto$_1$	6

One key point: The instructions in this chapter assume you set the exposure mode to P, S, A, or M, as indicated in the table. These modes, detailed in Chapter 4, are the only ones that give you access to the entire cadre of camera features. In most cases, I recommend using S (shutter-priority autoexposure) when controlling motion blur is important, and A (aperture-priority autoexposure) when controlling depth of field is important. These two modes let you concentrate on one side of the exposure equation and let the camera handle the other. Of course, if you're

comfortable making both the aperture and shutter speed decisions, you may prefer to work in M (manual) exposure mode instead. P (programmed autoexposure) is my last choice because it makes choosing a specific aperture or shutter speed more cumbersome.

Additionally, this chapter discusses choices for viewfinder photography. Although most picture settings work the same way during Live View photography as they do for viewfinder photography, the focusing process is quite different. For help with Live View focusing, visit Chapter 5.

REMEMBER

During viewfinder photography, you can monitor the aperture and shutter speed settings in the Information display, Control panel, and viewfinder. Figure 7-1 shows where to look for these critical exposure settings.

FIGURE 7-1: Check the shutter speed and aperture (f-stop) settings in the Information display, Control panel, or viewfinder.

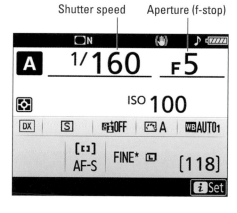

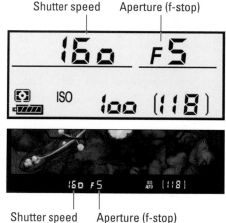

Shooting Still Portraits

By *still portrait,* I mean that your subject isn't moving. For subjects who aren't keen on sitting still, skip to the next section and use the techniques given for action photography instead. Assuming you do have a subject willing to pose, the classic portraiture approach is to keep the subject sharply focused while throwing the background into soft focus, as shown in Figure 7-2. This artistic choice emphasizes the subject and helps diminish the impact of any distracting background objects.

The following steps show you how to achieve this look:

1. **Set the Mode dial to A (aperture-priority autoexposure) and select a low f-stop value.**

 A low f-stop setting opens the aperture, which not only allows more light to enter the camera but also shortens *depth of field,* or the distance over which focus appears acceptably sharp. So dialing in a low f-stop value is the first step in softening your portrait background.

 WARNING

 For a group portrait, you typically need a higher f-stop than for a single portrait. At a very low f-stop, depth of field may not be large enough to keep everyone in the sharp-focus zone. Take test shots and inspect the results at different f-stops to find the right setting.

 To adjust f-stop in A mode, rotate the Sub-command dial. As soon as you set the f-stop, the camera selects the shutter speed for you, but you need to make sure the selected speed isn't so slow that movement of the subject or camera will blur the image.

2. **Check the lens focal length.**

 A focal length of 85–120mm is ideal for a classic head-and-shoulders portrait. Avoid using a short focal length (wide-angle lens) for portraits. It can cause features to appear distorted — sort of like how people look when you view them through a security peephole in a door. On the flip side, a very long focal length can flatten and widen a face.

3. **To further soften the background, increase focal length, get closer to your subject, and put more distance between subject and background.**

4. **Check composition.**

 Two quick pointers on this topic:

 - *Consider the background.* Scan the entire frame, looking for distracting background objects. If necessary and possible, reposition the subject against a more flattering backdrop.

 - *Frame the subject loosely to allow for later cropping to a variety of frame sizes.* Your camera produces images that have an aspect ratio of 3:2. That means your portrait perfectly fits a 4-x-6 print size but requires cropping to print at other proportion, such as 5 x 7 or 8 x 10.

5. **For indoor portraits, shoot flash-free if possible.**

 Shooting by available light rather than flash produces softer illumination and avoids the problem of red-eye. During daytime hours, pose your subject near a large window to get results similar to what you see in Figure 7-3.

 REMEMBER

 In A exposure mode, simply keeping the built-in flash unit closed disables the flash. If flash is unavoidable, see my flash tips at the end of this step list to get better results.

6. **For outdoor portraits, use a flash if possible.**

 Even in daylight, a flash can add a beneficial pop of light to subjects' faces, as illustrated in Figure 7-4.

 Courtesy of Mandy Holmes

 FIGURE 7-3:
 For soft, even lighting, forego flash and instead expose your subject using daylight coming through a nearby window.

 A flash is especially important when the background is brighter than the subject; when the subject is wearing a hat; or when the sun is directly overhead, creating harsh shadows under the eyes, nose, and chin.

 In A exposure mode, press the Flash button on the side of the camera to raise the built-in flash. For daytime portraits, set the Flash mode to Fill Flash. (That's the regular, basic Flash mode.) For nighttime images, try red-eye reduction or slow-sync flash; again, see the flash tips at the end of these steps to use these modes effectively.

No flash

Fill flash

FIGURE 7-4:
To properly illuminate the face in outdoor portraits, use flash.

WARNING

The fastest shutter speed you can use with the built-in flash is 1/250 second, so in bright light, you may need to stop down the aperture to avoid overexposing the photo, as I did for the right image in Figure 7-4. Doing so, of course, brings the background into sharper focus, so if that creates an issue, move the subject into a shaded area instead. If you use an external flash, you may be able to select a faster shutter speed; see Chapter 3 for details about high-speed flash.

7. **Press and hold the shutter button halfway to initiate exposure metering and autofocusing.**

 Or, if you're focusing manually, set focus by rotating the focusing ring on the lens.

8. **Press the shutter button the rest of the way.**

TIP

When flash is unavoidable, try these tricks for better results:

>> **Pay attention to white balance if your subject is lit by both flash and ambient light.** If you set the White Balance setting to Auto$_1$, as I recommend in Table 7-1, enabling flash tells the camera to warm colors to compensate for the cool light of a flash. If your subject is also lit by other light sources, such as sunlight, the result may be colors that are slightly warmer or cooler (more blue) than neutral. A warming effect typically looks nice in portraits, giving the skin a subtle glow. If you aren't happy with the result, see Chapter 6 to find out how to fine-tune white balance.

>> **Indoors, turn on as many room lights as possible.** With more ambient light, you reduce the flash power that's needed to expose the picture. Adding light also causes the pupils to constrict, further reducing the chances of red-eye. As an added benefit, the smaller pupil allows more of the subject's iris to be visible in the portrait, so you see more eye color.

>> **Try using a Flash mode that enables red-eye reduction or slow-sync flash.** If you choose the first option, warn your subject to expect both a preliminary light from the AF-assist lamp, which constricts pupils, and the flash. And remember that slow-sync flash uses a slower-than-normal shutter speed, which produces softer lighting and brighter backgrounds than normal flash. (Chapter 3 explains the various Flash modes.)

Figure 7-5 offers an example of how using slow-sync flash can improve an indoor portrait. When I used regular flash, the shutter speed was 1/60 second. At that speed, the camera has little time to soak up any ambient light. As a result, the scene is lit primarily by the flash. That caused two problems: The strong flash created glare on the subject's skin, and the window frame is more prominent because of the contrast between it and the darker bushes outside the window. Although it was daylight when I took the picture, the skies were overcast, so at 1/60 second, the exterior appears dark.

Regular fill flash, 1/60 second

Slow-sync flash, 1/4 second

FIGURE 7-5: Slow-sync flash produces softer, more even lighting and brighter backgrounds.

In the slow-sync example, shot at 1/4 second, the exposure time was long enough to permit the ambient light to brighten the exteriors to the point that the window frame almost blends into the background. And because much less flash power was needed to expose the subject, the lighting is much more flattering. In this case, the bright background also helps to set the subject apart because of her dark hair and shirt. If the subject had been a pale blonde, this setup wouldn't have worked as well. Again, note the warming effect that can occur when you use Auto White Balance and shoot in a combination of flash and daylight.

WARNING

Using a slow shutter speed increases the risk of blur due to camera shake, so use a tripod. Remind your subjects to stay still, too, because they'll appear blurry if they move during the exposure.

» **Remember that you can adjust flash power through Flash Compensation.** To do so, press the Flash button while rotating the Sub-command dial. You also can modify the light from a flash by attaching a flash diffuser, which spreads and softens the light.

» **For professional results, use an external flash with a rotating flash head.** Aim the flash head upward so that the flash light bounces off the ceiling and falls softly down onto the subject. See Chapter 3 for an example of this technique and for other flash photography tips.

Capturing Action

Using a fast shutter speed is the key to capturing a blur-free shot of any moving subject, whether it's a flower in the breeze, a spinning Ferris wheel, or, as in the case of Figure 7-6, a racing cyclist.

Along with the basic capture settings outlined earlier, in Table 7-1, try the techniques in the following steps to photograph a subject in motion:

1. **Set the Mode dial to S (shutter-priority autoexposure).**

In this mode, you control the shutter speed, and the camera takes care of choosing an aperture setting that will produce a good exposure.

2. **Rotate the Main dial to set the shutter speed.**

Refer to Figure 7-1 to locate shutter speed in the Information display, Control panel, and viewfinder.

The right shutter speed depends on the speed of your subject, so you need to experiment. But generally speaking, 1/320 second should be plenty for all but the fastest subjects (race cars, boats, and so on). For slow subjects, you can even go as low as 1/250 or 1/125 second. My subject in Figure 7-6

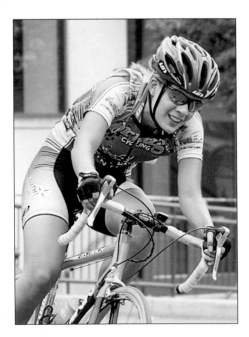

FIGURE 7-6:
Use a high shutter speed to freeze motion.

zipped along at a pretty fast pace, so I set the shutter speed to 1/640 second. Remember, though, that when you increase shutter speed, the camera opens the aperture to maintain the same exposure. At low f-stop numbers, depth of field becomes shorter, so you have to be more careful to keep your subject within the sharp-focus zone as you compose and focus the shot.

TIP

You also can take an entirely different approach to capturing action: Rather than choose a fast shutter speed, select a speed slow enough to blur the moving objects, which can create a heightened sense of motion and, in scenes that feature very colorful subjects, cool abstract images. I took this approach when shooting the carnival ride featured in Figure 7-7. For the left image, I set the shutter speed to 1/30 second; for the right version, I slowed things down to 1/5 second. In both cases, I used a tripod, but because nearly everything in the frame was moving, the entirety of both photos is blurry — the 1/5 second version is simply more blurry because of the slower shutter.

| 1/30 second | 1/5 second |

FIGURE 7-7: Using a shutter speed slow enough to blur moving objects can be a fun creative choice, too.

3. **For rapid-fire shooting, set the Release mode to Continuous Low or Continuous High.**

In both modes, the camera shoots a continuous burst of images as long as you hold down the shutter button. At the camera's default settings, Continuous Low captures up to 3 frames per second (fps), and Continuous High bumps the frame rate up to about 8 fps.

4. **Consider raising the ISO setting to permit a faster shutter speed.**

Unless you're shooting in bright daylight, you may not be able to use a fast shutter speed at a low ISO, even if the camera opens the aperture as far as possible. Raising the ISO does increase the possibility of noise, but a little noise is usually preferable to a blurry subject.

5. **If you use autofocusing, select speed-oriented focusing options.**

 Specifically, try these settings:

 - *Focus mode:* AF-C (continuous-servo autofocus).
 - *AF-area mode:* Choose one of the Dynamic-area settings or Group-area mode. Chapter 4 has information to help you decide which setting is best for your subject.

REMEMBER

 Adjust the AF-area mode by holding down the AF-mode button while rotating the Sub-command dial; change the Focus mode by rotating the Main command dial while pressing the button. (The button is in the center of the Focus-mode selector switch on the left front side of the camera.)

6. **Compose the subject to allow for movement across the frame.**

 Frame your shot a little wider than you normally might so that you lessen the risk your subject will move out of the frame before you record the image. You can always crop to a tighter composition later. (I used this approach for my cyclist image — the original shot includes a lot of background that I later cropped away.) It's also a good idea to leave more room in front of the subject than behind it. This makes it obvious that your subject is going somewhere.

Capturing Scenic Vistas

Providing specific capture settings for landscape photography is tricky because there's no single best approach to capturing a beautiful stretch of countryside, a city skyline, or another vast subject. Most people prefer using a wide-angle lens, for example, to incorporate a large area of the landscape into the scene, but if you're far away from your subject, you may like the results you get from a telephoto or medium-angle lens. When shooting the scene in Figure 7-8, for example, I had to position myself across the street from the buildings, so I captured the shot using a focal length of 82mm.

And consider depth of field: One person's idea of a super cityscape might be to keep all buildings in the scene sharply focused, but another photographer might prefer to shoot the same scene so that a foreground building is sharply focused while the others are less so, thus drawing the eye to that first building.

I can, however, offer tips to help you photograph a landscape the way *you* see it:

>> **Shoot in aperture-priority autoexposure mode (A) so you can control depth of field.** If you want extreme depth of field so that both near and distant objects are sharply focused (refer to Figure 7-8), select a high f-stop value. I used an aperture of f/18 for this shot. For short depth of field, use a low value.

FIGURE 7-8:
Use a high f-stop value to keep the foreground and background sharply focused.

>> **If the exposure requires a slow shutter speed, use a tripod to avoid blurring.** The downside to a high f-stop is that you may need a slower shutter speed to produce a good exposure. If the shutter speed drops below what you can comfortably handhold, use a tripod to avoid picture-blurring camera shake. If you don't have a tripod handy and can't find any other way to stabilize the camera, turn on Vibration Reduction, if your lens offers that feature. This option helps to compensate for slight camera movement, increasing chances of a sharp handheld shot.

>> **For dramatic waterfall shots, consider using a slow shutter to create that "misty" look.** The slow shutter blurs the water, giving it a soft, romantic appearance, as shown in Figure 7-9. Again, use a tripod to ensure that the rest of the scene doesn't also blur due to camera shake. Shutter speed for the image in Figure 7-9 was 1/5 second.

TIP

In very bright light, you may overexpose the image at a very slow shutter, even if you stop the aperture all the way down and select the camera's lowest ISO setting. As a solution, consider investing in a

FIGURE 7-9:
For misty waterfalls, use a slow shutter speed and a tripod.

neutral density filter for your lens. This type of filter works something like sunglasses for your camera: It simply reduces the amount of light that passes through the lens, without affecting image colors, so that you can use a slower shutter than would otherwise be possible.

» **At sunrise or sunset, base exposure on the sky.** The foreground will be dark, but you can usually brighten it in a photo editor, if needed. If you base exposure on the foreground, on the other hand, the sky will become so bright that all the color will be washed out — a problem you usually can't fix after the fact. You can also invest in a *graduated neutral-density filter,* which transitions from dark to clear. You orient the filter so the dark half falls over the sky and the clear part falls over the dimly lit portion of the scene. This setup enables you to better expose the foreground without blowing out the sky colors.

Also experiment with the Active D-Lighting and HDR features that I cover in Chapter 4; both are designed to create images that contain a greater range of brightness values than is normally possible.

» **For cool nighttime city pics, experiment with slow shutter speeds.** Assuming that cars or other vehicles with their lights on are moving through the scene, the result is neon trails of light like those you see in the foreground of the image in Figure 7-10. Shutter speed for this image was about 10 seconds.

As is the case for other slow-shutter photos, using a tripod is a must for this type of shot; any camera shake will blur the stationary objects in the scene.

» **For the best lighting, shoot during the *magic hours.*** That's the term photographers use for early morning and late afternoon, when the light cast by the sun gives everything that beautiful, gently warmed look.

» **In tricky light, bracket exposures.** *Bracketing* means to take the same picture at several different exposure settings to increase the odds that at least one of them will capture the scene the way you envision. Chapter 4 shows you how to make bracketing easier by using automatic exposure bracketing.

FIGURE 7-10:
Using a slow shutter speed creates neon light trails in nighttime city street scenes.

Capturing Dynamic Close-Ups

For great close-up shots, try these techniques:

» **Check your lens manual to find out its minimum close-focusing distance.** How "up close and personal" you can get to your subject depends on your lens.

» **Take control over depth of field by setting the camera mode to A (aperture-priority autoexposure) mode.** Whether you want a shallow, medium, or extreme depth of field depends on the point of your photo. In Figure 7-11, for example, I used a shallow depth of field to help separate the subjects from the similarly colored background, so I opened the aperture to f/5.6. If you want the viewer to be able to clearly see all details throughout the frame — for example, you're shooting a product shot for a sales catalog — you need to go in the other direction, stopping down the aperture as far as possible.

FIGURE 7-11:
Shallow depth of field is a classic technique for close-up images.

» **Remember that depth of field decreases when you zoom in or move closer to your subject.** Go back to that product shot: If you need depth of field beyond what you can achieve with the aperture setting, you may need to back away, zoom out, or both. (You can always crop your image to show just the parts of the subject that you want to feature.)

» **When shooting flowers and other nature scenes outdoors, pay attention to shutter speed, too.** Even a slight breeze may cause your subject to move, causing blurring at slow shutter speeds.

» **Experiment with using flash for better outdoor lighting.** Again, though, keep in mind that the maximum shutter speed possible when you use the built-in flash is 1/250 second. So in very bright light, you may need to use a high f-stop setting to avoid overexposing the picture. You can also adjust the flash output via the Flash Compensation control. Chapter 3 offers details.

» **When shooting indoors, avoid using the built-in flash as your primary light source when you're positioned very near the subject.** At close range, the light from your flash may be too harsh even if you reduce flash power by using the Flash Compensation feature. If flash is inevitable, the same tips provided earlier for flash portraits can improve close-up shots.

>> **To get really close to your subject, invest in a macro lens or a set of diopters.** A macro lens enables you to focus at a very short distance so that you can capture even the tiniest of critters or, if you're not into nature, details of an object. I used a 90mm macro lens to snap an image of the lady bug in Figure 7-12 just before she got annoyed and flew away home.

Unfortunately, a good macro lens isn't cheap; prices range from a few hundred to a couple thousand dollars. For a less-expensive way to go, you can spend about $40 for a set of *diopters,* which are like reading glasses that you screw onto your lens. Diopters come in several strengths — +1, +2, +4, and so on — with a higher number indicating a greater magnifying power. The downside of a diopter is that it typically produces images that are very soft around the edges, a problem that doesn't occur with a good macro lens.

FIGURE 7-12:
A macro lens enables you to focus close enough to fill the frame with even the tiniest subjects.

Chapter **8**

Shooting, Viewing, and Trimming Movies

I n addition to being a stellar still-photography camera, your D7500 enables you to record HD (high-definition) video. In fact, this model offers UHD — Ultra High Definition recording, better known as 4K video.

This chapter tells you everything you need to know to take advantage of the movie-recording options. Check that: This chapter tells you *almost* everything about movie recording. What's missing is detailed information about focusing, which works the same way for movie shooting as it does when you use Live View to take a still photo. Rather than cover the subject twice, I detail your focusing options in Chapter 5 and provide a basic recap in these pages.

Also be sure to visit the end of Chapter 1, which lists precautions to take while Live View is engaged, whether you're shooting stills or movies. (To answer your question: No, you can't use the viewfinder for movie recording; Live View is your only option.)

Understanding a Few Recording Basics

Before you dip your toe into movie–recording waters, your lifeguard would like you to be aware of the following rules of the pool:

» **The maximum recording time is 29 minutes and 59 seconds.** Of course, this maximum assumes that you have enough free space on your memory card to hold all the data required to store that many movie frames.

Exactly how much space you need depends on your recording settings, but if you want to record more than a few minutes of video, I recommend a 32GB or greater-capacity card. (You can find more details about how recording settings affect file size in the section "Setting Frame Size, Rate, and Quality" later in this chapter.)

» **A single recording may be split into as many as 8 different files.** Why? Because a movie file (as created on your camera) can be only 4GB in size. When you use the maximum-quality video recording settings, which create a ton of data, the camera can fit only a few minutes into a single 4GB movie file. So although the camera is capable of recording approximately 30 minutes of video at a time, it does so by automatically creating a new 4GB movie-container after the first one is full.

Unfortunately, the individual files don't play back in a continuous stream; you have to start each file manually. The only way to turn those files into a complete movie is to join the files in a video-editing program.

How many files are created for each recording depends on two settings, Frame Size/Frame Rate and Movie Quality. Again, both are explained later in the chapter.

» **Focusing works the same way in Movie mode as it does during Live View still photography.** For a review of Live View and Movie focusing options, see Chapter 5.

» **You can stop recording and capture a still image in one fell swoop.** Just press and hold the shutter button until you hear the shutter release. Your image is recorded in the JPEG format, at the frame size selected for the movie recording. For another option, you can save a single frame of your movie as a still photo. The last section of this chapter tells you how.

» **To restore the Movie Shooting menu to the default settings, you must exit Live View.** So if you're currently viewing the live preview on the monitor, press the LV button to exit Live View. Then open the menu and choose Reset Movie Shooting Menu, as shown in Figure 8-1. After finishing that task, press the LV button again to re-engage Live View.

>> **The *i*-button menu offers movie-recording options.** However, the camera Live View switch must be set to the Movie setting *and* Live View must be engaged. Otherwise, the *i*-button menu offers still-photography options, even if the switch is set to the Movie setting.

With those bits of business out of the way, you can find instructions for recording a movie using the default settings in the next section.

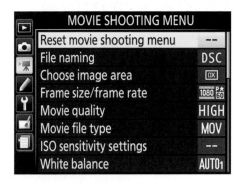

FIGURE 8-1:
You must exit Live View to access this setting, which resets Movie menu options to their defaults.

Shooting a Movie Using Default Settings

Video enthusiasts will appreciate the fact that the D7500 enables you to tweak a variety of movie-recording settings. But if you're not up to sorting through those options, just use the default settings. The defaults produce a full-HD movie, stored in a standard file format (MOV) and with sound-recording enabled.

Follow these steps to record a movie using the default settings and autofocusing:

1. **Set the Mode dial on top of the camera to Auto.**

 In this mode, the camera takes care of most movie settings for you.

2. **Set the camera to movie mode by rotating the Live View switch to the movie-camera icon, as shown in Figure 8-2.**

3. **Press the LV (Live View) button to engage the Live View display.**

 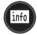

 The viewfinder goes dark, and your subject appears on the monitor. By default, the camera displays the data shown in Figure 8-2. If your camera is set to a different display mode, press the Info button as needed to get to the display shown in the figure.

 Later sections decode the various bits of data; for now, just pay attention to the maximum recording time readout, labeled in the figure. At the default settings, your movie can be 29 minutes and 59 seconds long.

 As stated in the preceding section, a movie file can be only 4GB in size. At the default recording settings, about 10 minutes of video fit in that 4GB file. So if you record for the maximum allowable time, you wind up with three files.

Touch Shutter setting Focus mode Maximum recording time

FIGURE 8-2:
Rotate the Live
View switch to
the movie-
camera symbol
and press
the Live View
button to set
the camera to
Movie mode.

Press to change display mode Movie mode

Live View button

Live View switch

If the upper-left corner of the screen displays the letters *REC* with a slash through them, movie recording isn't possible. You see this symbol if no memory card is inserted or the card is full, for example.

4. **Check the settings of the lens focus-method switch and the camera's Focus-mode selector switch, shown in Figure 8-3.**

Your lens may feature a slightly different auto/manual focus switch; check the lens user guide if you're not sure which setting to use. On the kit lens featured in this book, select the A position. Then move the Focus-mode selector switch on the camera to the AF position, as shown in the figure.

5. **Set the Focus mode by pressing the AF-mode button (see Figure 8-3) while rotating the Main command dial.**

This setting determines whether the camera uses continuous autofocusing or uses the same focusing

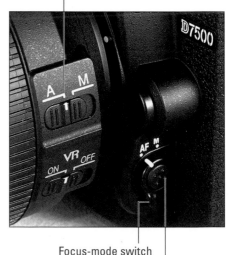

Lens auto/manual focus switch

Focus-mode switch

AF-mode button

FIGURE 8-3:
Set the lens and camera to autofocus mode.

distance throughout the movie. Here's a bit of information to help you decide which option is better:

- *AF-F:* Select this setting if you want the camera to adjust focus continuously as your subject moves or as you pan the camera to follow the action. (AF stands for *autofocus*; the second F, for *full-time.*)

Remember that if you use the built-in microphone, it sometimes picks up the sound of the focus motor, spoiling your movie audio. To avoid this issue, attach an external microphone and place it far enough from the camera body that it can't hear the focus motor.

- *AF-S:* This setting enables you to lock focus at a specific distance. Choose AF-S if you expect your subject to remain the same distance from the camera throughout the movie. (Think AF-*S,* for *stationary.*)

The current Focus mode setting appears at the top of the monitor, as shown in Figure 8-2.

6. **Compose your initial shot.**

The shaded areas at the top and bottom of the monitor indicate the boundaries of the frame. All movies are created using a 16:9 aspect ratio.

7. **If necessary, move the focusing frame over your subject.**

The appearance of the frame depends on a second autofocus setting, the AF-area mode. (The symbol representing this setting is just to the right of the Focus mode symbol in the display.)

At the default setting, Face Priority, the camera scans the frame looking for faces. If it finds one, a yellow focus frame appears over the face, which becomes the focusing target. If the scene contains more than one face, you see multiple frames; the one with the interior corner markings indicates the face chosen as the focus point. You can use the Multi Selector to move the frame over a different face or, if the touchscreen is enabled, tap the face.

If the camera doesn't detect a face, it uses the Wide Area AF-area mode, and the focus frame appears as a red rectangle, as shown in Figure 8-2. Tap your subject or use the Multi Selector to position the frame over your subject.

8. **Set focus.**

The process varies depending on the Focus mode as follows:

- *AF-F autofocusing:* As soon as you set the Focus mode to AF-F, autofocusing begins. You don't need to take any action except wait for the focusing frame to turn green, indicating that initial focus is set.

To interrupt continuous autofocusing and lock in the current focusing distance, press and hold the shutter button halfway down. You also can use the touchscreen, putting your finger on the desired focus point. When you lift your finger off the button or screen, continuous autofocusing begins again.

- *AF-S:* Press the shutter button halfway or tap the focus frame on the touchscreen. Again, the focus frame turns green when focus is achieved. Focus is locked at that distance and you can then take your finger off the shutter button or touchscreen if you want.

REMEMBER

If you want to use the touchscreen to focus, make sure that the Touch Shutter symbol looks like the one shown in Figure 8-2. Tap the symbol to toggle the tap-to-focus feature on and off. In movie mode, the Touch Shutter option that snaps a picture when you lift your finger off the screen is disabled.

9. **To begin recording, press the movie-record button, shown on the left in Figure 8-4.**

Most shooting data disappears from the screen, and a red Rec symbol appears in the upper-left corner, as shown on the right in the figure. The camera also displays the filename of the movie — DSC_0016, in the figure. As recording progresses, the area labeled *Time remaining* in the figure shows how many more minutes of video you can record.

Remaining recording time

Movie-record button Recording symbol Movie filename

FIGURE 8-4:
Press the red
button to
start and stop
recording (left);
the Rec symbol
appears while
recording is in
progress.

REMEMBER

Remember, though, that this value refers to the total length of a single video, which may be separated into multiple 4GB movie files. When the camera is about ready to create a new video file, the filename flashes yellow and then turns solid red. You then see the name of the new 4GB file, which appears white.

TIP

During recording, you can set a new focus point by pressing the shutter button halfway or by tapping the touchscreen. After the camera finds the new focus target, release the button or lift your finger off the touchscreen. In AF-S mode, focus is locked at the new distance; in AF-F mode, continuous autofocusing resumes. Keep in mind that the video footage may include some blurry frames during the time when the camera is finding the new focus point.

ENABLING ELECTRONIC VR

TIP

If your lens offers Vibration Reduction (VR, on a Nikon lens), enabling that feature helps you achieve steadier shots when handholding the camera. Unfortunately, as soon as you start a movie recording, that feature walks off the set, refusing to provide you with any camera-shake compensation.

However, you do have the option of enabling a digital version of the feature by enabling Electronic VR, which appears on the Movie Shooting menu and *i*-button menu when the camera is in Movie mode. When you change the setting from the default, Off, to On, the hand symbol that indicates Vibration Reduction takes on a slightly different appearance.

If you put the camera on a tripod, turn Electronic VR off. Also be aware of two limitations: First, the feature is off limits when you record movies using the maximum frame size (3840 x 2160). Additionally, if you set the Image Area to DX, your movie frames contain a little less image area than you see in the monitor during shooting.

10. **To stop recording, press the movie-record button again.**

Wait for the memory card access light to turn off before powering down the camera; while the light is on, data is still being written to the memory card. Look for the light on the back of the camera, just above the *i* button.

Choosing a Video Format: MOV or MP4

Your camera offers two video formats, MOV and MP4. Both provide excellent video quality and produce roughly the same file sizes. Where the two formats differ is in terms of compatibility with devices that play movies and software used to edit digital video.

MOV, which is the default format, was developed by Apple for playback and editing with its QuickTime software. So if you're firmly planted in the Mac camp, feel free to stick with it. Many non-Apple programs and devices also can play MOV files, but the support isn't quite as widespread as it is for MP4. So all other things being equal — which they pretty much are — MP4 is my choice unless I'm creating video for a client, player, or website that requires MOV files.

Set the format via the Movie File Type option on the Movie Shooting menu, as shown in Figure 8-5.

Setting Frame Size, Rate, and Quality

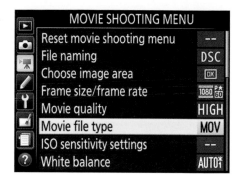

FIGURE 8-5:
Your camera can record movies in either the MOV or MP4 file format.

When it comes to the video-recording settings, the ones most likely to confuse novices are the Frame Size/Frame Rate and Movie Quality settings. Together, these options affect the look of your movie and the size of the file needed to hold all the video data.

Upcoming sections explain these options; for now, here's a quick primer in how to view and adjust them:

>> **Symbols representing both settings appear in the default Movie display, as shown in Figure 8-6.** The first number in the figure reflects a Frame Size of 1920 x 1080; only the second number, which shows the frame height, appears. The number 60 in the figure is the Frame Rate, or frames per second (fps). The star indicates that the Movie Quality is High. No star means that the other Quality option, Normal, is in force.

High Movie Quality

Frame Size/Frame Rate

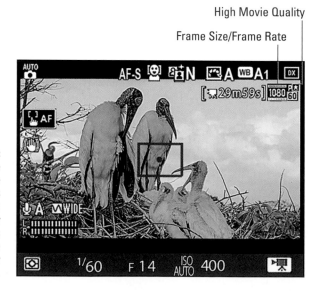

FIGURE 8-6:
The Frame Size/Frame Rate values always appear; the nearby star appears only when the Movie Quality is set to High.

The letter P, just above the Frame Rate value, refers to the *progressive video,* which is the recording technology used by the D7500. In menus and other screens, the *p* appears right after the Frame Size value, as in 1080*p.* Your camera doesn't offer an older technology, *interlaced video,* which is indicated by the initial *i* — as in 1080*i* — so the P in the display is mostly useless data. It does, however, come in handy to prove to the neighborhood video snob that you're using the latest technology.

>> **You can adjust the settings via the Movie Shooting menu or *i*-button menu.** Figure 8-7 offers a look at both menus. Notice that the same Frame Rate/Frame size symbol that's shown on the monitor appears on the menus.

If pressing the *i* button brings up a different menu than the one you see in the figure, press the Live View (LV) button to engage Live View and make certain that the Live View switch is set to the movie-camera position. Otherwise, the *i*-button menu offers options related to still photography.

REMEMBER

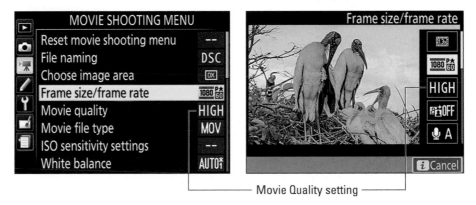

FIGURE 8-7: Adjust the Frame Size/ Frame Rate and Movie Quality options via the Movie Shooting menu or the *i*-button menu.

Picking the right frame size and rate (fps)

To choose the best Frame Size/Frame Rate setting for your video, you first need to know a little background about each part of this recording combo. Here's the scoop:

>> **Frame Size:** Just like digital photos, digital movie frames are made up of pixels, and the total pixel count equals the movie resolution. However, resolution does not affect picture quality of onscreen images as it does for print photos; video resolution only determines how much screen space the video occupies on your TV, monitor, or other viewing device. Also understand that the available display area is determined by the resolution of the display. The higher the monitor resolution, the more video pixels can fit onscreen.

Most newer TVs enable you to choose from a variety of resolution settings, but older models may not.

While photo resolution is discussed in terms of *ppi,* or pixels per inch, movie resolution is described by different terms, each of which represents a specific horizontal by vertical pixel count. For the purpose of recording with the D7500, you need to know three terms:

- *4K UHD (Ultra High Definition):* The latest craze in television sets (and thus, also among video-production enthusiasts), *4K* refers to video that comprises a horizontal frame size of about 4000 pixels wide. (*K* being the common abbreviation for a unit of 1000.) On the D7500, the actual frame width is 3840 — not quite 4K, but close enough for camera-marketing laws, apparently. The frame height at the 4K setting on the D7500 is 2160.

- *Full HD (High Definition):* For years the top dog in video — until rich-guy neighbor down the street brought home the first 4K TV — Full HD videos have frame sizes of 1920 x 1080 pixels.

- *Standard HD:* A step down from Full HD, this resolution produces a frame size of 1280 x 720 pixels.

All settings produce a movie that has an aspect ratio of 16:9, the same as an HDTV set, whether it offers 4K resolution or lower.

In the Live View display, only the vertical pixel count appears, which is the standard used by the television and video-recording industry. You can view the frame width only when you choose the Frame Rate/Frame Size option from the menus.

» **Frame Rate:** This setting determines how many frames are created to record each second of video, which in turn affects the visual quality of your video. Frame rate is measured in frames per second, or *fps.*

Available frame rates on the D7500 range from 24 to 60 frames per second. Here's a primer in how your choice affects your movie:

- *24 fps is the standard for motion pictures.* It gives your videos a softer, more movie-like look.

- *25 fps gives your videos a slightly sharper, more "realistic" look.* This frame rate is the standard for television broadcast in countries that follow the PAL video-signal standard, such as some European countries. If you bought your camera in a PAL part of the world, this setting should be the default.

- *30 fps produces an even crisper picture than 25 fps.* This frame rate is the broadcast video standard for the United States and other countries that use the NTSC signal standard. It's the default setting for cameras bought in those countries.

- *50 and 60 fps are often used for recording high-speed action and creating slow-motion footage.* With more frames per second, fast movements are rendered more smoothly, especially if you slow down the movie playback for a slo-mo review of the action.

- How about 50 versus 60? You're back to the PAL versus NTSC question: 50 fps is a PAL standard, and 60 is an NTSC standard.

TECHNICAL STUFF

In the interest of full disclosure, Nikon wants you to know that the stated frame rates are rounded up (as they are on most recording devices). The actual frames-per-second values for the 24, 30, and 60 fps values are: 23.976, 29.97, and 59.94, respectively.

After you choose the Frame Size/Frame Rate menu option, you're presented with the settings shown in Figure 8-8. Keep these considerations in mind as you scan the list of possibilities:

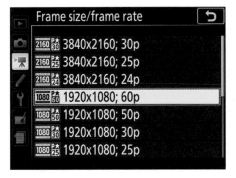

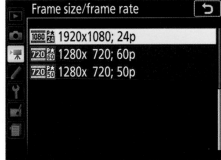

FIGURE 8-8:
You can choose from these combinations of frame size and frame rate.

» **Both frame size and frame rate contribute to the video file size.** The more pixels (frame size) and the higher the frame rate (fps), the larger the file. That's important because of the amount of space the video consumes on your memory card and on your computer's hard drive or whatever other long-term storage solution you choose.

Perhaps more important, the maximum size for a movie file is 4GB, as discussed in the first section of this chapter. When you reach that limit, the camera creates a new file to hold the next 4GB worth of frames, up to as many as 8 files per recording. So the larger the files your Frame Size/Frame Rate setting produces, the more individual files are needed to store your movie. With a smaller file size, you can contain a longer recording in a single 4GB clip.

Note that the Movie Quality setting, explained in the next section, also impacts file size and, therefore, how many minutes of video will fit in each 4GB file. See Table 8-1 for a rundown of the maximum recording time per 4GB file at each of the Frame Size/Frame Rate and Movie Quality combinations.

>> **The subject area that's recorded depends on the Image Area setting and the frame size.** As is the case with still photography, you have a choice to record movies using the entire image sensor or a smaller area at the center of the frame. The whole-sensor setting, DX, is the default for movie recording. If you change that option to 1.3x, the subject appears to get bigger in the frame, with less background visible, as if you had zoomed to a longer focal length. (You can change the Image Area option from the Movie Shooting menu or the Movie-mode version of the *i*-button menu.)

When you select the 4K frame size — 3840 x 2160 — the camera uses an even smaller area of the sensor, regardless of the Image Area setting. The result is similar to increasing the lens focal length by 1.5 over the DX (whole sensor) setting. Don't get too wrapped up in the math (friends don't let friends do math). The Live Preview automatically updates as you adjust these settings so that you always see the portion of your subject that will be recorded. Additionally, the symbol in the upper-right corner of the frame reflects the current image area: DX, 1.3x, or 1.5x.

The main thing to remember is that for the widest angle of view, choose the DX Image Area setting and a Frame Size other than 3840 x 2160.

>> **A couple of recording features are disabled when you use the 4K (3840 x 2160) frame size.** These include Electronic VR, explained in the sidebar elsewhere in this chapter, and Active D-Lighting, an exposure adjustment covered later, in the section "Controlling Movie Exposure."

TABLE 8-1 **Maximum Recording Time per Movie File***

Frame Size	Frame Rate	Movie Quality	Recording Time
3840 x 2160	24, 25, 30	High	03:21
1920 x 1080	50, 60	High	10:35
		Normal	20:45
1920 x 1080	24, 25, 30	High	20:45
		Normal	29:59
1280 x 720	50, 60	High	20:45
		Normal	29:59

*Based on maximum movie file size of 4GB; times shown are approximate.

ADDING INDEX MARKERS

TIP

When you spot a special moment during recording, you may want to tag it with an *index marker*. Then during playback or movie editing, you can quickly jump to that part of the movie by rotating the Sub-command dial.

By default, both the Fn1 and Fn2 buttons are set up to add an index marker when the camera is in Movie mode. When you press either button, a little blue mark appears for a second just above the movie filename, in the upper-right corner of the screen. The mark indicates that the index has been stored.

You can add as many as 20 index markers to a recording. The only restriction is that the feature isn't available when you shoot using the Miniature Effects exposure mode.

Understanding the Movie Quality setting

This setting determines how much compression is applied to the video file, which in turn affects the *bit rate,* or how much data is used to represent 1 second of video, measured in Mbps (megabits per second).

You get two choices: High and Normal (the default). The High setting results in a higher bit rate, which means better quality and larger files. Normal produces a lower bit rate and smaller files. In the Live View display, a star indicates the High setting. No star means that the option is set to Normal.

Adjust the setting from the Movie Shooting menu or *i*-button menu, keeping in mind that this setting, combined with the Frame Size/Frame Rate setting, determines how many minutes you can record in a single 4GB clip (the maximum size of a video file). See Table 8-1 for details.

Also, if you select any of the 4K Frame Size/Frame Rate settings (frame size of 3840 x 2160), the camera insists on using the High Movie Quality option.

Controlling Audio

Your camera offers a built-in stereo microphone, which sucks in sound via two tiny holes on the front of the camera. The left side of Figure 8-9 spotlights one of the microphone openings; the second opening is on the opposite side of the camera, just to the right of the AF-assist lamp. You also have the option of connecting an external microphone such as the Nikon ME-1 to the jack labeled on the

right in the figure. To monitor audio during recording, attach headphones via the headphone jack, also labeled in the figure.

The next sections explain options for controlling audio recording.

Internal microphone opening

Microphone jack

Headphone jack

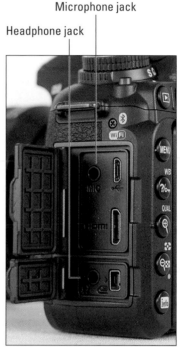

FIGURE 8-9:
You can record audio with the internal microphone (left) or plug in an external microphone and headphones (right).

Setting microphone sensitivity

The most critical audio control is the Microphone Sensitivity setting, which determines how loud a sound the microphone can "hear" and record. You can choose from the following options:

>> **Auto Sensitivity:** The camera automatically adjusts the volume according to the level of the ambient noise. This setting is the default.

>> **Manual Sensitivity:** You specify the volume level, with settings ranging from 1 to 20.

>> **Microphone Off:** Choose this setting to record video with no sound.

Symbols representing the current setting appear in the display, as shown in Figure 8-10. (If you don't see similar data on your screen, press the Info button to

change the display style.) The microphone symbol indicates that audio recording is enabled; the letter *A* indicates the Auto Sensitivity option. If you set the camera to Manual Sensitivity, your selected volume level appears instead. Turn audio recording off, and you see a microphone with a slash through it.

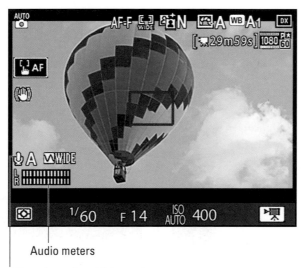

FIGURE 8-10:
These symbols indicate the Microphone Sensitivity setting and volume level.

Audio meters

Microphone Sensitivity setting

Beneath those symbols, you see two horizontal bars that indicate audio volume. When you're recording stereo sound, the top bar shows the sound level of the left audio channel; the bottom bar, the right channel. (The built-in mic offers stereo recording.)

TECHNICAL STUFF

Audio levels are measured in decibels (dB), and levels on the volume meter range from –40 (very, very soft) to 0 (as loud as can be measured digitally). Ideally, sound should peak consistently in the –12 range. The indicators on the meter turn yellow in this range. If the sound level is too high, the bar at the top of the meter turns red — a warning that audio may be distorted.

You can adjust the Microphone Sensitivity setting in two ways:

>> **Movie Shooting menu:** After choosing Microphone Sensitivity from the menu, as shown on the left in Figure 8-11, you see the selection screen shown on the right. If you choose Manual Sensitivity, the screen featured in Figure 8-12 appears, and you can set a specific volume level from 1 to 20. Press the Multi Selector up and down or tap the up/down arrows in the middle of the screen to change the setting. Again, the volume meters guide you as you adjust the level.

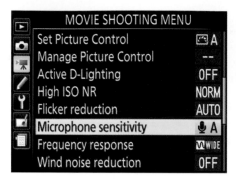

FIGURE 8-11: You can establish microphone sensitivity via the Movie Shooting menu.

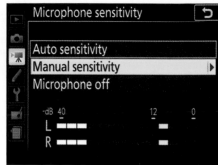

Be sure to press the OK button or tap the OK symbol to make your change official.

» *i-button menu:* Select Microphone Sensitivity, as shown on the left in Figure 8-13, to display the screen shown on the right. On this screen, you select your preferred setting (Auto, Manual, or Off) via the vertical scale on the right side of the screen. A yellow marker to the right of the bar indicates the current setting.

For example, in the figure, the Auto Sensitivity setting is selected. Press the Multi Selector up once to change the setting to Microphone Off; press up again to shift to Manual Sensitivity control. Then press up to raise the microphone sensitivity; press down to reduce it. The yellow marker moves to show you the current microphone level.

Again, tap OK or press the OK button before exiting the screen.

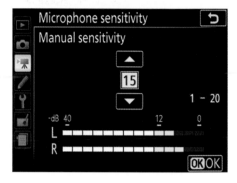

FIGURE 8-12: If you select the Manual option, you see this screen, where you can set a specific volume level.

FIGURE 8-13: You can also adjust the microphone setting via the i-button menu while in Movie mode.

Adjusting other audio settings

In addition to setting microphone sensitivity, you can control these audio-recording options:

» **Frequency Response:** By default, this option is set to Wide, which tells the camera to listen for sounds across a large sound frequency, from very high-pitched noises to deep, booming bass notes. If you're recording a speech, you may prefer to change the setting to Vocal, which focuses the microphone's recording efforts on the frequency of the human voice.

» **Wind Noise Reduction:** Ever seen a newscaster out in the field, carrying a microphone that looks like it's covered with a big piece of foam? That foam thing is a wind filter. It's designed to lessen the sounds that the wind makes when it hits the microphone. When using the built-in microphone, you can enable a digital version of the same thing via the Wind Noise Reduction option. Essentially, the filter works by reducing the volume of noises that are similar to those made by wind. The problem is that some noises *not* made by wind can also be muffled when the filter is enabled. So when you're indoors or shooting on a still day, keep this option set to Off, as it is by default. Also note that when you use an external microphone, the Wind Filter feature has no effect.

» **Headphone volume:** If you plug headphones into the camera, you can adjust the volume of the sound hitting your eardrums through this option.

In the default movie display mode, you see a symbol representing the Frequency Response setting, as shown in Figure 8-14. The Wind Noise Reduction icon and headphone volume data, also labeled in the figure, appear only if you take advantage of those features.

You can adjust the Frequency Response and Wind Noise Reduction Filter settings through either the Movie Shooting menu or the *i*-button menu. The headphone volume setting is available only through the *i*-button menu.

Headphone volume

Wind Noise Reduction on

Frequency Response setting

FIGURE 8-14:
The default movie-recording display mode offers these audio-recording clues.

Controlling Movie Exposure

In the P, S, A, and M exposure modes, you can tweak movie exposure through the options detailed in the following list. Two of the options, Exposure Compensation and AE Lock, are also available in certain other exposure modes.

Figure 8-15 shows you where to find the current settings for these options. A reminder, though: The Exposure Compensation setting appears only if that feature is enabled. Otherwise, that area of the display remains empty.

 If you don't see data similar to what's shown in Figure 8-15, press the Info button to cycle through the display styles until it appears. For more details about all these settings, pay a visit to Chapter 4.

Active D-Lighting

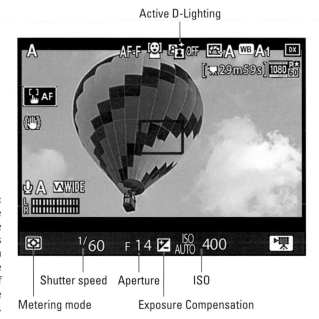

FIGURE 8-15: Your exposure mode determines whether you can change any or all of these exposure settings.

Metering mode Shutter speed Aperture Exposure Compensation ISO

>> **Metering mode:** This option determines what portion of the frame the camera considers when evaluating exposure. Matrix (whole-frame) metering is the default. In the P, S, A, and M exposure modes, you can opt instead to use center-weighted metering or highlight-priority metering. Spot metering isn't available. To change the setting, press the Metering mode button while rotating the Main command dial.

>> **ISO:** The camera adjusts ISO (light sensitivity) automatically in all exposure modes except M. But you have the following input on ISO:

- *You can specify an upper limit for the ISO setting chosen in the P, S, and A exposure modes.* By default, the camera can select a value as high as ISO 51200. To choose a higher or lower value, open the Movie Shooting menu, choose ISO Sensitivity Settings, and then choose Maximum Sensitivity. For movie recording, the lowest available setting is ISO 200.

- *In M mode, you can enable Auto ISO Sensitivity.* Again, just select ISO Sensitivity Settings from the Movie Shooting menu. Set Auto ISO Control (Mode M) to On and then set the maximum ISO value you want the camera to use.

 For M mode, Auto ISO Sensitivity works like it does for still photography: The camera uses your selected ISO unless it can't deliver a good exposure at that setting, in which case it raises or lowers ISO automatically. Set your preferred ISO by pressing the ISO button (top of the camera) while rotating the Main command dial.

>> **Shutter speed:** You must set the Mode dial to M to select the shutter speed; the camera automatically adjusts that setting in all other modes, including S (shutter-priority autoexposure). In M mode, rotate the Main command dial to set the shutter speed.

You can select shutter speeds as high as 1/8000 second. The slowest shutter speed matches your chosen frame rate. For example, at 30 fps, the slowest shutter speed is 1/30 second. The exception is 24 fps, which sets the low limit to 1/25 second.

>> **Aperture (f-stop):** You can adjust the f-stop in A (aperture-priority autoexposure) or M (manual exposure) modes. Rotate the Sub-command dial to change the setting.

By enabling the *Multi-Selector Power Aperture* setting, found on the Movie Shooting menu and *i*-button menu, you can use the Multi Selector to adjust aperture as well. Press up to lower the f-stop value (which widens the aperture) and press down to raise the f-stop (narrows the aperture).

When the option is turned on and you're shooting in A or M exposure modes, the camera reminds you about the power-aperture feature by displaying the symbol labeled in Figure 8-16. If you switch to an exposure mode that doesn't permit aperture control while the power-aperture features is turned on, you instead see the alert shown on the right in the figure.

Remember that as you raise the f-stop value, the aperture narrows, letting less light into the camera. In A mode, the shutter speed blinks if the camera can't exposure your movie at your selected aperture. Also keep in mind that the aperture setting is one of three factors contributing to depth of field. A higher f-stop number translates to a greater depth of field.

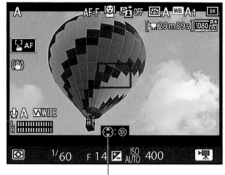

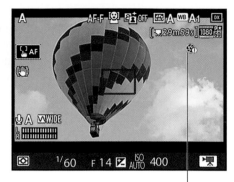

FIGURE 8-16:
These symbols relate to the Multi-Selector Power Aperture feature.

Multi Selector Power Aperture enabled

Multi Selector Power Aperture on but not available

>> **Exposure Compensation:** Exposure Compensation, detailed in Chapter 4, enables you to override the camera's autoexposure decisions, asking for a brighter or darker picture. You can apply this adjustment for movies when you shoot in P, S, or A exposure modes, any Scene mode, and any Effects mode. However, you're limited to an adjustment range of EV +3.0 to –3.0 rather than the usual five steps that are possible during normal photography.

To adjust the setting, press the Exposure Compensation button while rotating the Main command dial. While the button is pressed, the Exposure Compensation value appears in the display, along with a teeny tiny triangle sporting either a plus or minus sign to indicate whether you're asking for a brighter exposure (positive value) or darker exposure (negative value). After you release the button, you see just the plus/minus symbol in the display, as shown in Figure 8-15.

REMEMBER

You can request Exposure Compensation in M exposure mode, too, but the result is nil unless you enable the Auto ISO Sensitivity option on the Movie Shooting menu. In that case, the camera fiddles with ISO to achieve the exposure shift.

>> **Active D-Lighting:** This feature can improve high-contrast shots by brightening the shadows while leaving the highlights alone. You can specify the amount of Active D-Lighting you want the camera to apply only in the P, S, A, and M exposure modes. Select the setting you want to use either from the Movie Shooting menu or the *i*-button menu.

In any exposure mode, Active D-Lighting doesn't work when the movie frame size is 3840 x 2160 (the 4K UHD setting).

>> AE Lock: One exposure option available in any exposure mode is autoexposure lock, which interrupts the camera's normal, continuous autoexposure adjustment. Just press and hold the AE-L/AF-L button to use the currently selected exposure settings regardless of whether the lighting or your framing changes. Release the button to resume continuous exposure adjustment. Chapter 4 tells you more about this feature.

TIP

Movie mode also offers two display tools to help you gauge exposure:

>> Histogram Display: Press the Info button to cycle to a display that includes a histogram, as shown in Figure 8-17. A *histogram* is a chart that plots out the brightness values of pixels in the image, from black (left end of the chart) to white (right end). The vertical axis indicates how many pixels fall at a particular brightness value. So a heavy concentration of pixels at the right side of the histogram may indicate overexposure, and a large clump of pixels at the left end may indicate underexposure.

Histogram

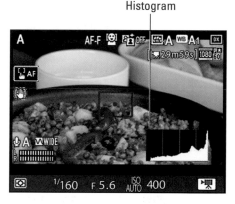

FIGURE 8-17:
Press the Info button to change the display to include a histogram.

>> Highlight Display: The problem with the histogram is that it doesn't tell you *where* in the scene the problem pixels lie, which is key to knowing whether you need to adjust exposure. Your subject may be perfectly exposed, with the under- or overexposed areas located entirely in the background — in which case, no exposure adjustment is needed, no matter what the histogram says.

The camera offers a great tool to help you watch for blown highlights in Movie mode. Enable the Highlight Display option, found on the second page of the *i*-button menu and shown on the left in Figure 8-18, to display a black-and-white striped pattern atop areas that have a concentration of white pixels, as shown on the right. The symbol labeled Highlight Display On appears in the default movie-display mode to let you know when the feature is turned on.

TIP

Why not just refer to the live preview to gauge exposure? Because it's simply not that reliable. The monitor can approximate exposure, but the apparent image brightness varies depending on the ambient lighting. Nikon enables you to adjust the brightness of the display (also via the *i*-button menu, in Movie mode), which can make things easier to see when you're composing your shots. But if you don't reset the brightness option to 0 before recording, any exposure decisions you make based on monitor brightness may be flawed.

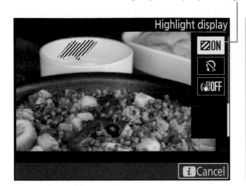

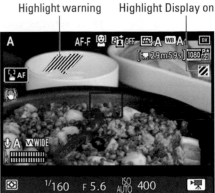

Highlight Display setting Highlight warning Highlight Display on

FIGURE 8-18:
When Highlight
Display is
turned on,
a black-and-
white pattern
appears to
alert you
to blown
highlights.

Exploring Other Recording Options

In addition to settings reviewed in the preceding sections, you can control a few other aspects of your cinematic effort. The following list runs through these options; Figure 8-19 labels the symbols that represent these settings in the display.

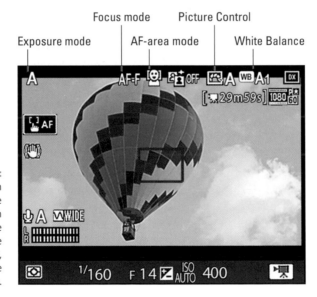

Exposure mode Focus mode AF-area mode Picture Control White Balance

FIGURE 8-19:
Depending on
your exposure
mode, you can
adjust some
or all of these
color, focus,
and exposure
settings.

>> **Exposure mode:** You can record movies in any exposure mode (Auto, Scene modes, Effects modes, P, M, and so on). As with still photography, your choice determines which camera settings you can access.

» **Autofocus:** Your options are the same as for Live View still photography, detailed in Chapter 5. As a quick recap, you adjust autofocusing behavior through Focus mode and AF-area mode; look for the current settings in the spots labeled in Figure 8-19.

- *Focus mode:* Choose AF-S to lock focus when you press the shutter button halfway or tap your subject on the touchscreen; choose AF-F for continuous autofocusing. See the first section of this chapter for details about how each option works for movie recording.

- *AF-area mode:* You can choose from Face-priority, Wide-area, Normal-area, or Subject-tracking. The default setting is Face- priority; if the camera doesn't detect a face in the frame, it automatically uses Wide-area focusing instead. With any of these modes, you start by moving the focusing frame over your subject. How things work from there depends on the specific mode; again, Chapter 5 provides step-by-step instructions.

To access these settings, press the AF-mode button (refer to Figure 8-3). While pressing the button, rotate the Main command dial to change the Focus mode; rotate the Sub-command dial to change the AF-area mode.

» **High ISO NR (Noise Reduction):** This option attempts to soften the appearance of *noise,* a defect that can appear when movies are recorded using a high ISO setting. Noise makes your movie appear grainy.

Normal is the default noise-removal setting; you can raise or lower the amount of correction a notch or disable it altogether by setting the option to Off. Adjust the setting via the Movie Shooting menu.

» **Flicker Reduction:** If you notice flickering in the monitor or in your movie, experiment with different Flicker Reduction settings. Found on the Movie Shooting menu, the option is designed to minimize the monitor flickering caused by certain types of lights, including fluorescent, mercury vapor, or sodium lamps. Note, too, that using the power-aperture feature can cause flickering.

» **White Balance:** The colors in your movie are rendered according to the current White Balance setting, detailed in Chapter 6. However, you have control over this option only in the P, S, A, or M exposure modes. The current settings appear in the area labeled in Figure 8-19.

The fastest way to change the White Balance setting is to press the WB button while rotating the Main command dial. You also can adjust White Balance via the Movie Shooting menu.

When the camera is in movie mode, you can tell the camera to use whatever setting is currently in force for still photography. Just choose the Same as Photo Settings for the White Balance option.

» **Picture Control:** Also covered in Chapter 6, this setting alters sharpness, color saturation, and contrast. Again, if you shoot the movie in the P, S, A, or M exposure mode, you can select the Picture Control you want to use; otherwise, the camera is in charge.

Want to record a black-and-white movie? Select Monochrome as the Picture Control. Instant *film noir*.

TIP

Screening Your Movies

To view a movie, press the Playback button to set the camera to playback mode. Assuming that the camera is in the default playback display mode, which shows one photo or movie at a time, your screen should look something like the one in Figure 8-20. (Press the Multi Selector up or down to cycle through the available display modes, all covered in Chapter 9.)

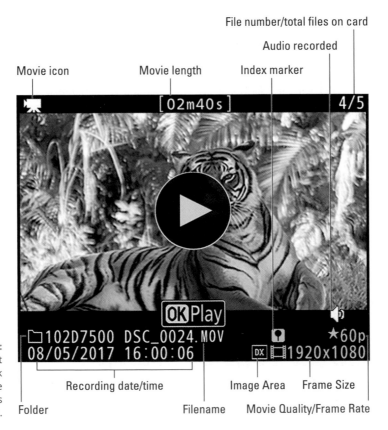

FIGURE 8-20:
The default playback display mode shows this movie data.

To help you distinguish a movie from a photo, the display includes a movie-camera symbol in the upper-left corner of the screen, along with a honking big "play" arrow also in the middle of the screen. The default display mode also shows other movie-related data, including the Frame Size, Frame Rate, and Movie Quality setting, as labeled in Figure 8-20. (Remember: A star next to the Frame Rate value means that you set the Movie Quality option to High.) To start playback, tap the play arrow or tap the OK/Play box located below the arrow. If the touchscreen is disabled, press the OK button instead.

In the Thumbnail and Calendar playback modes, both described in Chapter 9, you see little dots along the edges of image thumbnails to represent movie files. Tap the thumbnail or press OK to shift to single-image view and then start playback as just described.

After playback begins, you see the data labeled in Figure 8-21. The progress bar and Elapsed Time value show you how much of the movie has played so far; you can also see the total movie length. The other symbols at the bottom of the screen are there to remind you that you can use various dials and buttons to control playback, as follows:

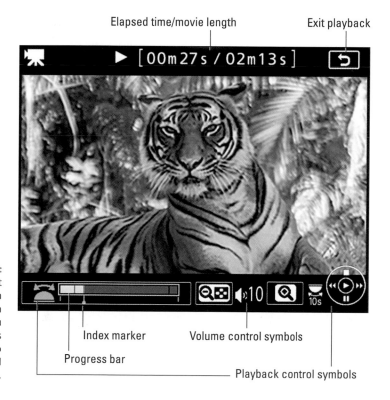

FIGURE 8-21: The icons at the bottom of the screen remind you which buttons and dials to use to control playback.

» **Stop playback:** Press the Multi Selector up. (That white circle labeled *Playback control symbols* in the figure is designed to remind you of the Multi Selector's movie-playback role.)

» **Pause/resume playback:** If the touchscreen is enabled, tap the display once to pause; tap again to resume playback. You also can press the Multi Selector down to pause playback and press OK to resume playback.

» **Fast-forward/rewind:** Press the Multi Selector right or left to fast-forward or rewind the movie, respectively. Press again to double the fast-forward or rewind speed; keep pressing to increase the speed. Hold the button down to fast-forward or rewind all the way to the end or beginning of the movie.

You also can tap on the progress bar at the left side of the control strip to advance or rewind the movie to the spot you tap. (Well, theoretically, anyway: If you suffer from fat-finger syndrome like me, finding the exact spot to tap on the progress bar isn't easy.)

» **Forward/rewind 10 seconds:** Rotate the Main command dial to the right to jump 10 seconds through the movie; rotate to the left to jump back 10 seconds. Again, note the white dial symbol near the Multi Selector symbol. It's your cue to use the Main command dial to jump 10 seconds forward or backward. The camera pauses playback after every jump; tap the screen or press OK to resume playback.

» **Skip to the next/previous index marker or first/last frame:** At the left end of the progress bar, the blue wheel represents the Sub-command dial. Rotate that dial to jump from one index marker to the next, if you added markers during recording. The index marker labeled in the figure appears only briefly after you rotate the dial and then disappears.

If your movie doesn't include any index markers, playback jumps to the first frame if you rotate the dial to the left and to the last frame if you rotate the dial right.

» **Advance frame by frame:** Press the Multi Selector down or tap the screen to pause playback. Then press right to advance one frame; press left to go back one frame.

» **Adjust volume:** See the markings labeled Volume controls in Figure 8-21? They remind you that you can press the Zoom In button to increase volume and press the Zoom Out button to lower it. The number tells you the current volume level (10, in the figure). You also can tap the symbols to adjust volume, but I find it difficult to tap just the right spot. And if you miss the tap target, the camera pauses the movie.

» **Exit the movie:** Tap the exit arrow, labeled in the figure, or press the Playback button to exit the movie and return to the playback screen.

Trimming Movies

You can do some limited movie editing in camera. I emphasize: *limited* editing. You can trim frames from the start of a movie and clip off frames from the end, and that's it.

To eliminate frames from the start of a movie, take these steps:

1. **Begin playing your movie.**

2. **When you reach the first frame you want to keep, pause the movie by tapping the screen or pressing the Multi Selector down.**

3. **Press the *i button* or tap the *i* symbol at the bottom of the screen.**

 You see the screen shown on the left in Figure 8-22.

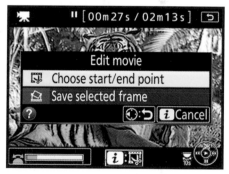

Tap to display editing tools

FIGURE 8-22: After pausing playback, tap the *i* symbol (left) and then select Choose Start/End Point (right).

4. **Select Choose Start/End Point and then select Start Point.**

 You're returned to the playback screen, which now sports additional symbols, as shown in Figure 8-23. First, you see two yellow markers on the progress bar at the bottom of the screen. The left marker indicates the start point; the right marker, the end point. The active marker is yellow.

5. **If the frame you want to use as the start point isn't onscreen, rewind or play the movie until the correct frame appears.**

 You can tap the Rewind and Fast-forward symbols, labeled in the figure, or use the normal advance and rewind techniques outlined in the preceding section.

6. **Press the Multi Selector up or tap the scissors symbol to trim all frames before the current frame.**

 Now you see options that enable you to preview the movie, save the movie as a new file, overwrite the original file, or cancel the operation. To preview the

movie, select Preview and press OK. After the preview plays, you're returned to the menu screen.

7. **To preserve your original movie and save the trimmed one as a new file, choose Save as New File.**

To trim footage from the end of a film, follow the same steps, but pause playback on the last frame you want to keep and choose End Point in Step 4.

You can trim an already trimmed movie, by the way. So you can go through the steps once to set a new start point and a second time to set a new end point.

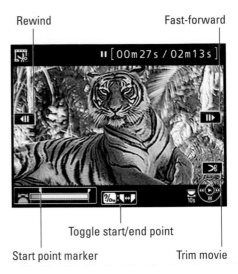

Toggle start/end point

Start point marker Trim movie

FIGURE 8-23:
The left triangle indicates the position of the start point.

 WB

If you prefer, you can trim files from both the beginning and end of a movie in one pass. Follow Steps 1 through 5 and then press the WB button or tap the symbol labeled *Toggle start/end point* in Figure 8-23. The marker at the right end of the progress bar turns yellow, indicating that you can now set the frame that you want to use as the end of the video. You can keep toggling between the start/end point controls as many times as needed until you get the exact first and last frames you want to keep. To finalize the edit, press the Multi Selector up or tap the scissors symbol, labeled *Trim movie* in the figure. During playback, edited files are indicated by a little scissors icon that looks like the one in the upper-left corner of Figure 8-23.

Saving a Movie Frame As a Still Image

To save a frame of the movie as a still photo, begin playing the movie and pause playback when you reach the frame you want to save.

Next, press the *i* button or tap the *i* symbol to bring up the Edit Movie screen. Choose Save Selected Frame and then press the Multi Selector up or tap the scissors symbol in the lower-right corner of the screen. On the confirmation screen that appears, select Yes. Your frame is saved as a JPEG photo; the resolution of the picture matches the movie frame size.

3
After the Shot

Get the details on picture playback, including how to customize playback screens.

Hide or delete files you don't like, assign ratings to pictures and movies, and protect your best work from being accidentally erased.

Transfer files from the camera to the computer.

Convert Raw images using the built-in conversion tool or the one available in Nikon Capture NX-D.

Prepare photos for online sharing.

Chapter **9**

Playback Mode: Viewing Your Photos

Without question, my favorite thing about digital photography is being able to view my pictures the instant after I shoot them. No more guessing whether I captured the image or need to try again, as in the film days; no more wasting money on developing pictures that stink.

Seeing your pictures is just the start of the things you can do when you switch your camera to playback mode, though. You also can review the settings you used to take the picture, display graphics that alert you to exposure problems, and magnify a photo to check details. This chapter introduces you to these playback features and more.

Note: Some information applies only to photos; if a feature also works for movies, I spell that out. For details on movie playback, see Chapter 8.

Picture Playback 101

Later sections detail special playback functions; the following steps provide a quick introduction to viewing your photos.

1. **Press the Playback button to put the camera in playback mode.**

Figure 9-1 shows you where to find the button. By default, you see a single photo along with some picture information, as shown in the figure. If you instead see multiple thumbnails, press the OK button to switch to single-photo view. If you see a calendar display, press OK twice. (Upcoming sections explain how to use these alternative displays.)

Playback button Multi Selector/OK button

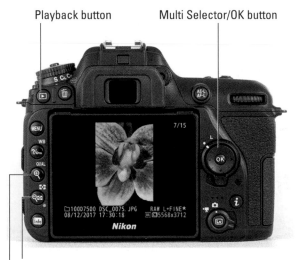

FIGURE 9-1: These buttons play the largest roles in picture playback.

Press to reduce magnification/display thumbnails

Press to magnify photo

Movie files have a movie-camera icon in the upper-left camera; again, Chapter 8 details movie playback.

2. **To scroll through your picture and movie files, flick a finger across the touchscreen or press the Multi Selector right or left.**

I labeled the Multi Selector in the figure. To view the next picture using the touchscreen, flick from right to left across the screen. Flick from the left to go back one picture.

A few quick tips on scrolling in single-picture view:

- Want to flick left to go forward and right to go back? Open the Setup menu, choose Touch Controls, and set the Full-frame Playback Flicks option to the one that bears the left-pointing arrow. (Both options are named Left/Right; the difference is the direction of that arrow.)

- If you put a finger on the bottom of the display, a gray frame-advance bar appears. Drag right or left on the bar to scroll quickly forward or backwards through your images. Lift your finger to hide the bar and return to the normal playback screen.

QUAL

- You can magnify the image by pressing the Zoom In button. If the touchscreen is enabled, you also can pinch outward to magnify the photo, just as you do on a smartphone or tablet. Use the Multi Selector or drag your finger across the screen to scroll the display so that you can view a different area of the picture.

To reduce the magnification, press the Zoom Out button or pinch inward on the touchscreen. The upcoming section "Magnifying Photos During Playback" talks more about the magnification feature. Note that the feature doesn't work for movies.

3. **To return to picture-taking mode, press the Playback button again or press the shutter button halfway and then release it.**

Choosing Which Images to View

Your camera organizes pictures automatically into folders that are assigned generic names: 100D7500, 101D7500, and so on. You can also create custom folders by using the process outlined in Chapter 11.

If your card contains multiple folders, tell the camera which folder or folders you want to view via the Playback Folder option on the Playback menu, shown on the left in Figure 9-2. You have the following options:

>> **D7500:** Displays all pictures taken with the D7500, regardless of which folder they call home.

>> **All:** Displays all pictures taken with the D7500 as well as any shot with another camera. The only requirement is that the files be in an image format the camera recognizes. (You can usually view JPEG files and Nikon Raw files, but not Raw files from another brand of camera.) This setting is the default.

>> **Current:** Displays images in the folder that the camera is currently using to store new images. To see the name of that folder, open the Photo Shooting menu and choose Storage Folder.

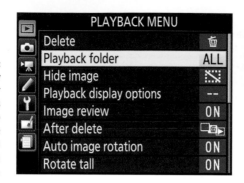

FIGURE 9-2:
Specify
which folder
or folders
you want to
view via the
Playback menu
or *i*-button
menu.

For a faster way to select a single folder, press the *i* button to display the Playback version of the *i*-button menu, shown on the right in Figure 9-2. Select Choose Folder to display a list of available folders. Tap the one you want to view or highlight it and press the OK button.

Adjusting Playback Timing

You can specify how long the camera displays each photo and whether you want to use the Image Review feature, which automatically displays an image for a few seconds after the camera records it to the memory card. Here are the details:

>> **Adjust playback display time:** By default, the monitor turns off after 10 seconds of inactivity when the camera is in Playback mode. To adjust the shutoff timing, open the Custom Setting menu, choose Timers/AE Lock, and then choose Monitor Off Delay, as shown on the left in Figure 9-3. The second screen in the figure appears. Select Playback to choose your desired shutoff time, keeping in mind that the longer the monitor remains on, the more battery juice the camera consumes.

FIGURE 9-3:
You can
control how
long pictures
are displayed
before the
monitor shuts
down to save
battery power.

C Timers/AE lock	
c1 Shutter-release button AE-L	OFF
c2 Standby timer	6s
c3 Self-timer	--
c4 Monitor off delay	--
c5 Remote on duration (ML-L3)	1m
d1 CL mode shooting speed	⏺3
d2 Max. continuous release	100
d3 Exposure delay mode	OFF

c4 Monitor off delay	
Playback	10s
Menus	1m
Information display	4s
Image review	4s
Live view	10m

» **Turn on and customize Image Review.** Open the Playback menu to turn on the Image Review feature, as shown in Figure 9-4. By default, the camera displays the photo for 4 seconds. You can change the length of that display time through the same Custom Setting menu option that controls regular playback shutoff. Just choose Image Review instead of Playback from the right screen shown in Figure 9-3.

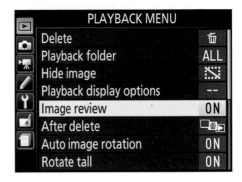

FIGURE 9-4:
Enable Image Review to display each photo for a few seconds immediately after you capture it.

Disabling Automatic Picture Rotation

By default, picture files include information about camera orientation — that is, whether you held the camera in the normal, horizontal position when taking the picture or rotated it to vertical. During playback, the camera reads the orientation data and rotates vertically oriented images so that they appear in the upright position, as shown on the left in Figure 9-5. The picture is also automatically rotated when you view it in any photo programs that can read the data.

FIGURE 9-5:
You can display vertically oriented pictures in their upright position (left) or sideways (right).

You can customize the rotation features via the following Playback menu options, both shown in Figure 9-6:

» **Auto Image Rotation:** This option tells the camera whether to include orientation data in the picture file. I'm not sure why you wouldn't want that information in the file, but if you have a reason, set this option to Off.

Vertically oriented pictures then appear horizontally on the camera monitor, as shown on the right in Figure 9-5, and you have to rotate them manually to their correct orientation in your photo software.

>> **Rotate Tall:** Change this setting to Off if you want vertically oriented pictures displayed horizontally during playback, regardless of whether they include orientation data. If Auto Image Rotation is turned on — again, that means that the orientation is noted in the picture file — photos are still rotated when you view them in photo programs that can read the orientation data.

FIGURE 9-6:
Customize image rotation through the bottom two menu options shown here.

Regardless of the settings you choose, no rotation occurs during the Image Review period or when you're viewing a movie. Also be aware that shooting with the lens pointing directly up or down sometimes confuses the camera, causing it to record the wrong orientation data.

Shifting to Thumbnail Display

Instead of displaying each photo or movie one at a time, you can display 4 or 9 thumbnails, as shown in Figure 9-7, or even a whopping 72 thumbnails.

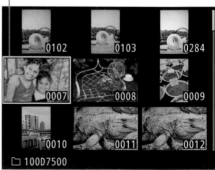

FIGURE 9-7:
You can view multiple image thumbnails at a time.

Here's how Thumbnail display works:

>> **Display thumbnails.** If the touchscreen is enabled, pinch in. Again, that means to put your thumb and a finger on opposite corners of the monitor and drag both toward the center of the screen. You also can press the Zoom Out button.

Either way, your first pinch in or press of the Zoom Out button cycles from single-picture view to 4-thumbnail view. Keep pinching or pressing to shift to 9-picture view and then to 72-thumbnail view. One more pinch or button press takes you to Calendar view, a nifty feature explained in the next section.

>> **Display fewer thumbnails.** For touchscreen operation, pinch out: Place your thumb and forefinger in the center of the screen and drag both toward the edge of the monitor. If you prefer, press the Zoom In button instead. Each pinch or press shifts you one step closer to full-frame view.

>> **Scroll to the next screen of thumbnails.** Drag your finger up or down the screen or press the Multi Selector up and down.

>> **Select an image.** To perform certain playback functions while in Thumbnail view, you first need to select an image. A yellow box surrounds the selected image (refer to Figure 9-7). To select a different image, just tap its thumbnail or use the Multi Selector to move the highlight box over the image.

>> **Toggle between thumbnails display and full-frame view.** To quickly shift from any thumbnails view to singe-image view, select the image you want to inspect. Then press OK or tap the selected thumbnail.

If a photo is displayed in single-image view, you can return to the previous thumbnails display by pressing the OK button. (There's no touchscreen equivalent for this operation.) If a movie is displayed, pressing OK begins movie playback. So instead, press the Zoom Out button to go back to Thumbnail view.

The four- and nine-thumbnail displays include the name of the folder that holds the images as well as the frame number of each file. In Figure 9-7, for example, the folder name is 100D7500 and the selected frame number is 0007. The frame number isn't the same thing as the filename; it just tells you which file you're viewing in a series of files. In 72-thumbnail view, the folder number and frame number of the currently selected image both appear at the bottom of the screen.

Displaying Photos in Calendar View

Calendar display mode, shown in Figure 9-8, makes it easy to locate pictures according to the date you shot them. Try it out:

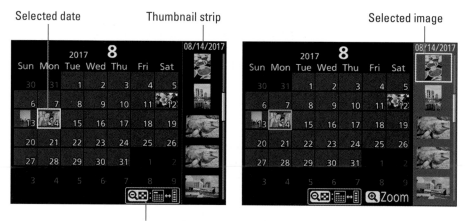

Selected date Thumbnail strip Selected image

FIGURE 9-8:
Calendar view makes it easy to view all photos shot on a particular day.

Tap to toggle between calendar and thumbnails

1. **Press the Zoom Out button or pinch in on the touchscreen as needed to bring up the calendar display.**

 If you're currently viewing images in full-frame view, for example, you need to press the button or pinch in four times to cycle through the thumbnail displays and then to Calendar view.

2. **Select the date on which you shot the images you want to see.**

 A yellow box highlights the currently selected date. To select a different date, tap it in the calendar or move the highlight box over it by using the Multi Selector. After you select a date, the right side of the screen displays thumbnails of pictures taken on that date.

 TIP

 The number of the month appears at the top of the screen. If the memory card contains more than one month's worth of pictures, left and right scroll arrows appear at the top of the display (not shown in Figure 9-8). You can tap those arrows or use the Multi Selector to display a different month.

3. **To access the images on the selected date, press the Zoom Out button.**

 Alternatively, you can tap the symbol at the bottom of the screen, highlighted on the left in Figure 9-8. The thumbnail strip becomes active (refer to the right side in Figure 9-8), and you can scroll through the thumbnails by using the touchscreen or Multi Selector. The currently selected image is highlighted by a yellow box.

QUAL

4. **To temporarily display a larger view of the selected thumbnail, as shown in Figure 9-9, hold down the Zoom In button.**

Release the button to exit the zoomed preview.

5. **To jump from the thumbnail strip back to the calendar so you can select a different date, press the Zoom Out button again.**

Or tap the symbol labeled in Figure 9-8.

6. **To exit calendar view and display a photo in single-image view, select the photo in the thumbnail strip and then tap the thumbnail or press OK.**

Press OK again to switch back to Calendar view.

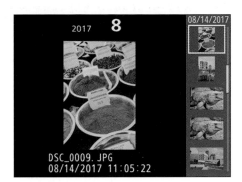

FIGURE 9-9:
Highlight a photo in the thumbnail strip and press the Zoom In button to temporarily display it at a larger size.

Magnifying Photos During Playback

After displaying a photo in single-frame view, as shown on the left in Figure 9-10, you can magnify it, as shown on the right. Here's how:

QUAL

» **Magnify the image.** Pinch out on the touchscreen or press the Zoom In button. The bar at the bottom of the navigation window gives you an indication of the magnification level; the bar turns green when you reach 100 percent magnification.

» **Reduce magnification.** Pinch in or press the Zoom Out button.

» **View another part of the magnified picture.** When an image is magnified, a thumbnail showing the entire image appears briefly in the lower-right corner of the monitor (refer to the right side of Figure 9-10). The yellow outline in the thumbnail indicates the area that's consuming the rest of the monitor space. To scroll the display and view a different portion of the image, use the Multi Selector or just drag your finger across the screen.

REMEMBER

After a few seconds, the navigation thumbnail disappears; tap the screen or press the Multi Selector in any direction to redisplay it.

Scroll to previous/next photo

Magnified area

Magnification bar

FIGURE 9-10:
Press the
Zoom In
button or pinch
out on the
touchscreen
to magnify an
image.

TIP

>> **Inspect faces.** When you magnify portraits, the picture-in-picture thumbnail displays a white border around each face. Rotate the Sub-command dial or tap a face in the thumbnail to scroll the display to show another face. Unfortunately, the camera sometimes fails to detect faces, especially if the subject isn't looking directly at the camera. When it works correctly, though, this is a pretty great tool for checking for closed eyes, red-eye, and, of course, spinach in the teeth.

>> **View more images at the same magnification.** While the display is zoomed, tap the scroll arrows at the bottom of the screen (labeled on the right in Figure 9-10) or rotate the Main command dial to display the same area of the next photo at the same magnification.

>> **Crop the photo to the currently displayed area.** This feature creates a new image that contains just the area visible in the magnified view. To try it out, press the *i* button and then choose Quick Crop from the *i*-button menu, as shown on the left in Figure 9-11. The camera creates your cropped copy, assigns it the next available filename, and displays it on the monitor, as shown on the right in the figure. The Retouch symbol, labeled in the figure, appears to remind you that you're not looking at an original image. The lower-right corner of the display also shows a scissors symbol, indicating that the photo was cropped. The resolution of the cropped copy appears as well.

Although handy, this feature limits you to cropping to the photo's original aspect ratio. For other options, check out the Trim function on the Retouch menu, which I detail in Chapter 11.

>> **Return to full-frame view.** You don't need to keep pressing the Zoom Out button or pinching in until the entire photo is displayed. Instead, just press OK.

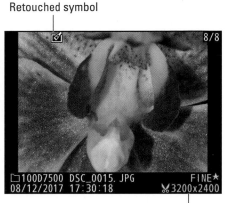

FIGURE 9-11:
While a photo is magnified, choose Quick Crop from the *i*-button menu (left) to create a new image that contains only the area visible in the zoomed view (right).

Trimmed image size

Viewing Picture Data

In single-image picture view, you can choose from a variety of display modes, all shown in Figure 9-12. Each mode presents different shooting data along with the image or movie file.

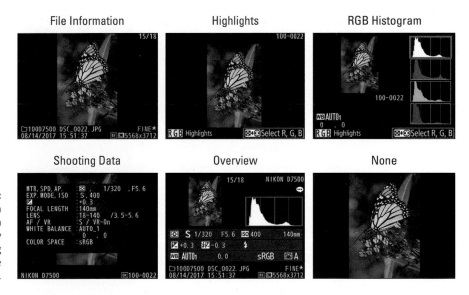

FIGURE 9-12:
You can choose from these display modes during picture playback.

During playback, you shift from one display to the next by pressing the Multi Selector up and down. However, File Information mode is the only one available by default; to use the others, you must enable them. The next section explains how to do that as well as how to display the focus point you used when shooting the picture. Following that, I help you decipher the data that each display mode offers.

Note: Information and figures in these sections relate to still photography. For help with understanding data that appears during movie playback, see the playback section of Chapter 8. Although you can view the first frame of your movie in any of the standard photo display modes, after you start playback, the movie takes over the whole screen and playback data appears as described in that part of Chapter 8.

Enabling additional display modes

Again, only the first display mode shown in Figure 9-12 appears by default. To take advantage of the other displays, you have to enable them via the Playback Display Options setting on the Playback menu. Figure 9-13 offers a look at the display options.

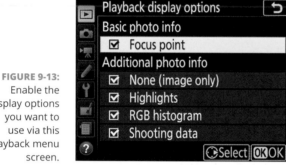

FIGURE 9-13: Enable the display options you want to use via this Playback menu screen.

The menu options work as follows:

>> **Focus Point:** When this option is turned on, a red rectangle marks the focus point (or points), as shown in Figure 9-14. You also see the same brackets that represent the autofocus area in the viewfinder. These focus indicators appear only when you use the display mode shown in the figure — File Information mode, covered in the next section. Also, focus marks aren't displayed if you focused manually or used the AF-C (continuous-servo) autofocusing mode setting (or the camera chose that setting for you in AF-A mode).

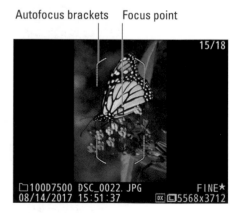

Autofocus brackets Focus point

FIGURE 9-14: You can view the focus point you used when taking the photo.

Chapter 5 explains these autofocusing options and how to select a specific focus point when shooting.

>> **Additional Photo Info:** This section of the menu lets you enable and disable all display modes except File Information, which can't be turned off. You have to scroll to the second page of options, as shown in Figure 9-13, to access the Overview display mode.

A check mark in the box next to an option means that the feature is turned on. To toggle the check mark on and off, highlight the option and then press the Multi Selector right or tap the Select symbol at the bottom of the screen. After turning on the options you want to use, press OK or tap the OK symbol.

REMEMBER

After enabling the additional display modes and returning to playback mode, press the Multi Selector up or down to cycle from one display to the next.

The next several sections explain exactly what details you can glean from each display mode, save for None (image-only).

File Information mode

In File Information display mode, the monitor displays the data shown in Figure 9-15. Again, the illustrations here and in the upcoming sections apply to still photos; Chapter 8 helps you sort out movie playback screens.

Here's the key to what information appears:

>> **Frame Number/Total Files:** The first value indicates the frame number of the photo; the second tells you the total number of files on the memory card.

>> **Focus point:** If you enable the Focus Point feature, as outlined in the preceding section, you may see the red focus-point indicator and the autofocus area brackets, as shown in Figure 9-14, depending on the focus settings you used when shooting the picture.

>> **Folder name:** Folders are named automatically by the camera unless you create custom folders, an advanced trick you can explore in Chapter 11.

>> **Filename:** The camera also automatically names your files. Filenames end with a three-letter code that represents the file format, which is either JPG (for JPEG) or NEF (for Raw) for still photos. Chapter 2 discusses these formats. If you record a movie, the file extension is MOV or MP4, depending on which movie format you selected.

Frame number/total files

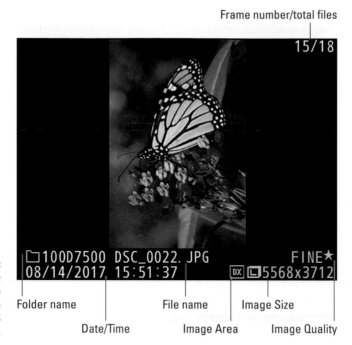

15/18

☐100D7500 DSC_0022. JPG FINE★
08/14/2017 15:51:37 DX ☐5568x3712

Folder name File name Image Size

Date/Time Image Area Image Quality

**TECHNICAL
STUFF**

The first four characters of filenames can also vary as follows:

- *DSC_:* You captured the photo in the default Color Space, sRGB. This setting is the best choice for most people, for reasons you can explore in Chapter 6.

- *_DSC:* If you change the Color Space setting to Adobe RGB, the underscore character comes first. (You can't use this color space when recording movies, by the way.)

REMEMBER

Each image is also assigned a four-digit file number, starting with 0001. When you reach image 9999, the file numbering restarts at 0001, and the new images go into a new folder to prevent any possibility of overwriting the existing image files. You can customize the numbering scheme via the File Number Sequence option on the Custom Setting menu.

» **Date and Time:** Of course, the accuracy of this data depends on whether you set the camera's date and time correctly, which you do via the Time Zone and Date option on the Setup menu.

» **Image Area:** This symbol tells you whether the DX or 1.3x crop area of the image sensor was used to record the photo. See Chapter 2 for an explanation.

» **Image Quality:** Again, Chapter 2 has details, but the short story is this: Fine, Normal, and Basic represent JPEG files. A star following the JPEG setting, as shown in the figure, indicates that you asked the camera to compress the file with an eye to producing optimal quality. No star means the file was compressed in a way that results in more consistent file sizes from one JPEG file to the next. Raw refers to the Nikon Camera Raw format, NEF. If you captured the photo in both formats, you see both labels, as in RAW+FINE.

» **Image Size:** This value tells you the image resolution, or pixel count. See Chapter 2 to find out about resolution.

Figure 9-16 shows additional symbols that appear when you use certain after-the-shot features, as follows:

» **Protected symbol:** The key icon indicates you used the file-protection feature to prevent the image or movie from being erased when you use the camera's Delete function. See the next chapter to find out more.

» **Retouch symbol:** This icon appears on images that you created by applying one of the Retouch menu features to a picture or the Quick Crop feature available via the *i*-button menu during playback. For some Retouch operations, the Image Size/Image Quality area of the display also changes. For example, if you use the Resize function to create a low-resolution copy of an image, you see the symbol labeled in the figure. Chapter 10 explains the Resize feature; Chapter 12 covers other retouching options.

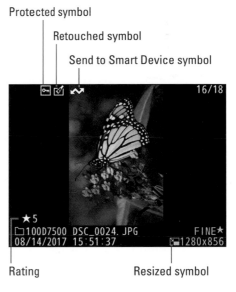

FIGURE 9-16:
These symbols appear only if you use the related features.

» **Send to Smart Device symbol:** After you tag a photo for transfer to a smartphone or tablet, this symbol appears. See this book's appendix for details about tagging files and other information about the camera's wireless-connection features.

>> **Rating symbol:** Chapter 10 explains how you can rate a picture or movie, assigning it one to five stars or, if you're totally disgusted with the file, labeling it with a trash can so that you can easily locate it to delete it. The rating shown in Figure 9-16 indicates a five-star photo, for example.

Highlights display mode

One of the most difficult photo problems to correct in a photo-editing program is known as *blown highlights* in some circles and *clipped highlights* in others. Both terms mean that the brightest areas of the image are so overexposed that areas that should include a variety of light shades are instead totally white.

In Highlights display mode, areas that the camera thinks may be overexposed blink in the camera monitor. To use this mode, you must first enable it via the Display Options setting on the Playback menu.

TECHNICAL STUFF

To fully understand all the features of Highlights mode, you need to know a little about digital imaging science. First, digital images are called *RGB images* because they're created from the three primary colors of light: red, green, and blue. In Highlights mode, you can display the exposure warning for all three color components — sometimes called color *channels* — combined or view the data for each individual channel.

When you look at the brightness data for a single channel, though, greatly overexposed areas don't translate to white in photos — rather, they result in a solid blob of some other color. I don't have space in this book to provide a full lesson in RGB color theory, but the short story is that when you mix red, green, and blue light, and each component is at maximum brightness, you get white. Zero brightness in all three channels gives you black. If you have maximum red and no blue or green, you have fully saturated red. If you mix two channels at maximum brightness, you also get full saturation. For example, maximum red and blue produce fully saturated magenta. And this is why it matters: Wherever colors are fully saturated, you can lose picture detail. For example, a rose petal that should have a range of tones from light to dark red may instead be bright red throughout.

The moral of the story is that when you view your photo in single-channel display, large areas of blinking highlights in one or two channels indicate that you may be losing color details. Blinking highlights that appear in the same spot in all three channels indicate blown highlights — again, because when you have maximum red, green, and blue, you get white. Either way, you may want to adjust your exposure settings and try again.

Okay, with today's science lesson out of the way, Figure 9-17 displays an image that contains some blown highlights to show you how things look in Highlights display mode. I captured the screen at the moment the highlight blinkies blinked "off" — the black areas in the figure indicate the blown highlights. (I labeled a few of them in the figure.) But as this image proves, just because you see the flashing alerts doesn't mean that you should adjust exposure — the decision depends on where the alerts occur and how the rest of the image is exposed.

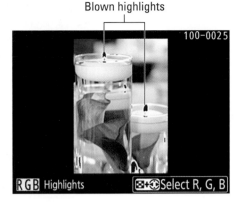

Blown highlights

100-0025

RGB Highlights Select R, G, B

FIGURE 9-17:
In Highlights mode, blinking areas indicate blown highlights.

In my candle photo, there are indeed small white areas in the flames and the glass vase, yet exposure in the majority of the image is fine. If I reduced exposure to darken the brightest spots, some areas of the flowers would be underexposed. In other words, sometimes you simply can't avoid a few clipped highlights when the scene includes a broad range of brightness values.

In the lower-left corner of the display, the letters highlighted in yellow tell you whether you're looking at a single channel (R, G, or B) or the three-channel, composite display (RGB). The latter is selected in the figure. To cycle between the settings, tap the Select R, G, B symbol in the lower-right corner of the screen or press the Zoom Out button as you press the Multi Selector right or left.

Highlights display mode also presents the same symbols shown in Figure 9-16 if you used the related features. In the upper-right corner, you see the folder number and the last four digits of the filename — 100 and 0025, respectively, in Figure 9-16. The label "Highlights" also appears next to the RGB symbol to let you know the current display mode.

RGB Histogram mode

From Highlights mode, press the Multi Selector down to get to RGB Histogram mode, which displays your image as shown on the left in Figure 9-18. (*Remember:* You can access this mode only if you enable it via the Playback Display Options setting on the Playback menu.)

Directly underneath the thumbnail, the values indicate the folder number and the last four digits of the filename (100 and 0022, in the figure). Below that, the data indicates the White Balance settings used for the shot. (White balance is a color

feature you can explore in Chapter 6.) The first value tells you the setting (Auto₁, in the figure), and the two number values tell you whether you fine-tuned that setting along the amber to blue axis (first value) or green to magenta axis (second value). Zeros, as in the figure, indicate no fine-tuning. You also see symbols representing the protect, retouched, send-to-smart device tag, and rating features, if you used them.

In addition, you get two types of *histograms*, which are the charts labeled in the figure: The top one is a Brightness histogram and reflects the composite, three-channel image data. The three others represent the data for the single red, green, and blue channels. This trio is sometimes called an *RGB histogram*, thus the display mode name.

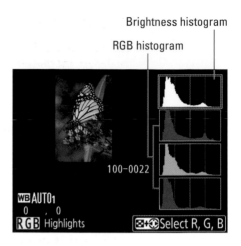

Brightness histogram

RGB histogram

FIGURE 9-18:
In RGB Histogram mode, you see both a brightness histogram and an RGB histogram.

The next two sections explain what information you can glean from the two types of histograms. But first, here are two quick tips:

>> **Highlights data:** As with Highlights mode, blown highlights blink in the thumbnail, and you can view the warning for either the composite image (RGB) or each individual channel. Tap the Select R, G, B symbol or press the Zoom Out button as you press the Multi Selector right to cycle between the single-channel and multichannel views. A yellow box also surrounds the histogram representing the active view. For example, the composite view is active in the figure.

To get rid of the blinkies, select the Blue channel and then press the Multi Selector right or tap the symbol one more time. The word Highlights is dimmed when the blinkies feature is disabled. Tap the symbol or use the Zoom Out and Multi Selector technique to redisplay the highlight warning.

QUAL

>> **Zooming the view:** Press the Zoom In button or pinch outward on the image thumbnail to zoom the thumbnail to a magnified view. The histograms then update to reflect only the magnified area of the photo. Press the Multi Selector or drag your finger in the thumbnail to scroll the display. Tap the left/right arrows at the bottom of the screen or rotate the Main dial to see the next photo at the same magnification.

To reduce the magnification, pinch inward on the thumbnail or press the Zoom Out button. To return quickly to a non-magnified view, press the OK button.

Reading a Brightness histogram

You can get an idea of image exposure by viewing your photo on the monitor and by looking at the blinkies in Highlights mode, but the Brightness histogram provides a way to gauge exposure that's a little more detailed.

REMEMBER

A Brightness histogram indicates the distribution of shadows, highlights, and *midtones* (areas of medium brightness) in your image. Figure 9-19 shows the histogram for the butterfly image featured in Figure 9-18, for example.

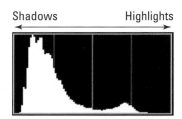

FIGURE 9-19:
The Brightness histogram indicates tonal range, from shadows on the left to highlights on the right.

The horizontal axis of the histogram represents possible brightness values — the maximum *tonal range*, in photography-speak — from the darkest shadows on the left to the brightest highlights on the right. And the vertical axis shows how many pixels fall at a particular brightness value. A spike indicates a heavy concentration of pixels at that brightness value.

TIP

There is no one "perfect" histogram that you should try to achieve. Instead, interpret the histogram with respect to the distribution of shadows, highlights, and midtones that comprise your subject. You wouldn't expect to see lots of shadows, for example, in a photo of a polar bear walking on a snowy landscape. Pay attention, however, if you see a very high concentration of pixels at the far right or left end of the histogram, which can indicate a seriously overexposed or underexposed image, respectively. To find out how to resolve exposure problems, visit Chapter 4.

Understanding RGB histograms

In RGB Histogram display mode, you see two histograms: the Brightness histogram, covered in the preceding section, and an RGB histogram. Figure 9-20 shows the RGB histogram for the butterfly image (refer to Figure 9-18).

As explained in the earlier section about Highlights mode, digital images are made up of red, green, and blue light. With the RGB histograms, you can view the brightness values for each of those color channels. Again, overexposure in

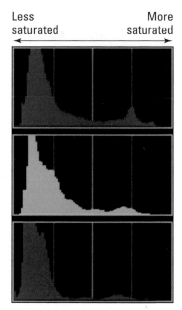

FIGURE 9-20:
The RGB histogram can indicate problems with color saturation.

one or two channels can produce oversaturated colors — and thus a loss of picture detail. So, if most of the pixels for one or two channels are clustered toward the right end of the histogram, adjust your exposure settings, as outlined in Chapter 4, and try again.

Photographers schooled in the science of RGB histograms can spot color-balance issues by looking at the pixel values, too. But frankly, color-balance problems are easy to notice just by looking at the image itself on the camera monitor. And understanding how to translate the histogram data for this purpose requires more knowledge about RGB color theory than I have room to present in this book. For information about manipulating color, see Chapter 6.

Shooting Data display mode

In Shooting Data display, you can view up to six screens of information, which you scroll through by pressing the Multi Selector up and down or by dragging your finger up and down the touchscreen. Figure 9-21 shows the first screen of data.

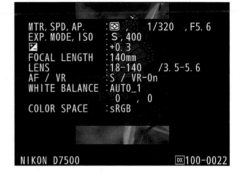

REMEMBER

Before you can access this mode, you must enable it via the Playback Display Options setting on the Playback menu.

FIGURE 9-21:
Here you see the first Shooting Data screen.

Most of the data won't make sense until you explore Chapters 3–6, which explain the flash, exposure, color, and focusing settings. But I want to call your attention to a few facts now:

>> The upper-left corner of the monitor shows the Protected, Retouch, and Send to Smart Device icons, if you used these features. If you rated the photo, the number of stars you gave it appears in the lower-left corner of the screen. (Refer to Figure 9-16 to see each of these icons.)

>> The current folder and the last four digits of the filename appear in the lower-right corner of the display, as does the Image Area setting (DX or 1.3x crop).

>> The Comment item, which is the final item on the fourth screen, contains a value if you use the Image Comment feature on the Setup menu.

>> If the ISO value on Shooting Data Page 1 appears in red, the camera overrode the ISO Sensitivity setting that you selected in order to produce a good

exposure. This shift occurs only if you enable automatic ISO adjustment in the P, S, A, and M exposure modes; see Chapter 4 for details.

» The fifth screen appears if you include copyright data with your picture, a feature you can explore in Chapter 11. The sixth screen appears if you attach the optional GPS unit to the camera, in which case GPS location data appears on that screen. Location data also appears if the camera was set to include the location data from your smartphone or device, a wireless option I discuss in the appendix. Nikon refers to this screen separately as the Location Data display mode, but it's really just another page of the Shooting Data mode. You can't enable or disable Location Data mode separately from Shooting Data mode.

Overview mode

In this mode, the screen contains a small thumbnail along with scads of shooting data plus a Brightness histogram. Figure 9-22 offers a look. Enable this mode via the Playback Display Options setting on the Playback menu.

The earlier section "Reading a Brightness histogram" tells you what to make of that part of the screen. The Frame Number/Total Pictures data appears near the upper-right corner of the image thumbnail (15/18, in the figure). As with the other display modes, symbols representing the protect, retouch, rating, and send-to-smart device tags show up if you used those features.

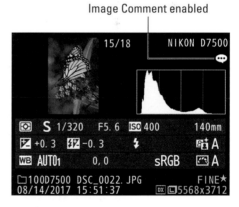

Image Comment enabled

FIGURE 9-22:
In Overview mode, you can view your picture along with the major camera settings you used to take the picture.

TIP

The speech bubble just above the histogram indicates that you enabled the Image Comment feature (Chapter 11). To read the comment, switch to Shooting Data display mode and scroll to the fourth page of data.

To sort out other information presented in Overview display mode, the following list breaks things down into the five rows that appear under the thumbnail and histogram. If any items don't appear on your screen, the relevant feature wasn't enabled when you captured the shot. For the figure, I enabled every possible feature just for the purpose of illustration; these aren't the actual settings I used to photograph the butterfly.

>> **Rows 1 and 2:** You see the exposure-related settings labeled in Figure 9-23 and 9-24. The ISO value appears red if you had Auto ISO override enabled and the camera adjusted the ISO for you. The focal length of the lens you used to capture the image appears at the right end of Row 1. See Chapter 4 for help understanding exposure settings; visit Chapter 1 to find out about focal length.

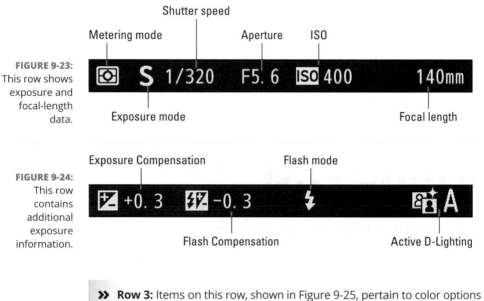

FIGURE 9-23: This row shows exposure and focal-length data.

Metering mode · Shutter speed · Aperture · ISO · Exposure mode · Focal length

FIGURE 9-24: This row contains additional exposure information.

Exposure Compensation · Flash mode · Flash Compensation · Active D-Lighting

>> **Row 3:** Items on this row, shown in Figure 9-25, pertain to color options that you can explore in Chapter 6.

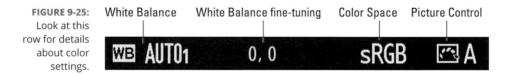

FIGURE 9-25: Look at this row for details about color settings.

White Balance · White Balance fine-tuning · Color Space · Picture Control

>> **Rows 4 and 5:** The final two rows in Figure 9-22 show the same information you get in File Information mode, explained earlier.

Chapter **10**

Working with Picture and Movie Files

E very creative pursuit involves its share of cleanup and organizational tasks. Painters have to wash brushes, embroiderers have to separate strands of floss, and woodcrafters have to haul out the wet/dry vac to suck up sawdust. Digital photography is no different: At some point, you have to stop shooting so that you can download and process your files.

This chapter explains these after-the-shot tasks. First up is a review of several in-camera file-management operations: rating files, marking files that you don't want displayed during playback, deleting unwanted files, and protecting your best work from accidental erasure.

Following that, you can get help with transferring files to your computer, processing files that you shot in the Raw (NEF) format, and creating low-resolution copies of photos for online sharing. Along the way, I introduce you to Nikon ViewNX-i and Capture NX-D, two free computer programs that you can use to handle some of these tasks.

Note: If you own a smartphone, tablet, or other device that can run Nikon's Snap-Bridge app, check out the appendix. It offers information about connecting your camera to the smart device so you can transfer photos wirelessly to that device and, from there, upload images to your favorite social media site or Nikon Image Space, a free online photo-storage and sharing site.

Rating Photos and Movies

Using your camera's Rating feature, you can assign a rating to a picture or movie file: five stars for your best shots, one star for those you wish you could reshoot, and so on. You can even assign a Discard rating to flag files that you think you want to delete.

TIP

Rating pictures has a couple of benefits. First, assigning the Discard tag makes it easy to spot the rotten apples amid all your great work when you take the step of erasing files. (Merely assigning the tag doesn't actually erase the file.) Additionally, some photo programs can read the rating and then sort files according to rating. That feature makes it easier to cull your photo and movie collection and gather your best work for printing and sharing.

WB

Before showing you how to rate files, I need to share one rule of the road: If you previously protected a file by using the Protect feature described in the next section, you can't assign a rating to it. To remove protection, display the file and press the Protect button.

Assuming that the file isn't protected, you can access the Rating feature in two ways:

>> ***i*-button menu:** When the camera is in playback mode, display the photo you want to rate and then select Rating from the *i*-button menu, as shown on the left in Figure 10-1. On the next screen, notice the rating bar, labeled on the right in the figure. Press the Multi Selector right or left to set the number of stars. You also can tap on the bar to add or remove stars.

To remove a rating, press the Multi Selector left until all the stars disappear from the rating bar and you reach the dot labeled No Rating in the figure. (Or tap the end of the bar to accomplish the same thing.) To assign the Discard rating, press left or tap the bar once more; a trash can symbol replaces the No Rating dot. When you're done assigning a rating, tap the OK symbol or press the OK button.

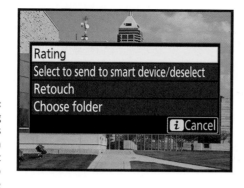
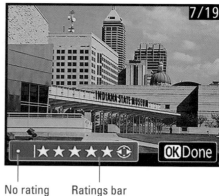

FIGURE 10-1:
During
playback, press
the *i* button
and select
Rating to
access the
ratings screen.

No rating Ratings bar

>> **Playback menu:** You can use this option whether the camera is in playback or shooting mode. After selecting Rating from the menu, as shown on the left in Figure 10-2, the camera displays thumbnails of your images, as shown on the right side of the figure. Select the photo or movie you want to rate by tapping it or by using the Multi Selector or Main command dial to move the yellow selection box over the image.

Discard rating Star rating

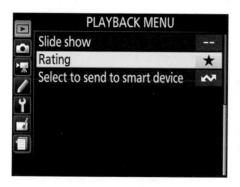
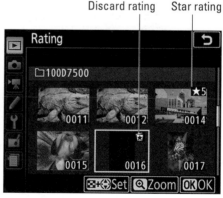

FIGURE 10-2:
You also can
rate photos
choosing
Rating from
the Playback
menu.

To assign a rating, press and hold the Zoom Out button while pressing the Multi Selector up or down. As you do, the current rating appears with the thumbnail, as labeled in the figure.

You also can use the touchscreen to assign a rating, but that option isn't really ready for prime time. You can tap the thumbnail or the Set symbol at the bottom of the screen according to how many stars you want to assign. But there's no way to lower the rating or remove it after you tap. You also can't get to the Discard rating via the touchscreen. So take a hint from the fact that

Nikon doesn't include this method in the user manual — a clue that you should just stick with using the Zoom Out button and Multi Selector to set the rating.

Remember these additional points about rating photos through the Playback menu:

QUAL

- If you need a closer look at an image than the Thumbnail view provides, select the image and then press the Zoom In button or tap the Zoom icon at the bottom of the screen. The image then appears in single-image view. After inspecting the photo, release the button or tap the return arrow in the upper-right corner of the monitor to return to the thumbnails screen.

- You can rate as many files as you want while the rating screen is open. Unfortunately, you have to select and rate each file individually; there's no way to select a batch of files and assign a particular rating.

- When you finish rating files, press the OK button or tap the OK symbol to return to the Playback menu. Don't forget this step: If you do, the rating doesn't stick.

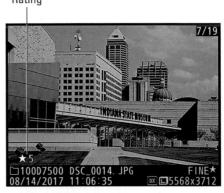

Rating

FIGURE 10-3:
The rating appears here in File Information playback mode.

However you assign a rating, it appears with the image in any playback display mode except None (the mode that doesn't display any data). Figure 10-3 shows you where to find the rating in the default display mode. For more about playback display modes, see Chapter 9.

Protecting Photos

You can safeguard files from being accidentally erased or altered by using the camera's Protect feature. After you protect a file, the camera doesn't allow you to delete the file.

WARNING

However, the protection only prevents you from erasing the file by using the camera's Delete functions, explained later in this chapter. Formatting your memory card *does* erase protected pictures, along with any other data on the card. See the Chapter 1 section related to working with memory cards for more about card formatting.

 To protect a picture, display it or, in Thumbnail or Calendar playback view, select it. Then press the Protect button (also known as the WB and Help button), highlighted in Figure 10-4. A key symbol appears on your photo, as shown in the figure. Press the button again to unlock the photo.

Press to toggle file protection on/off

Protected symbol

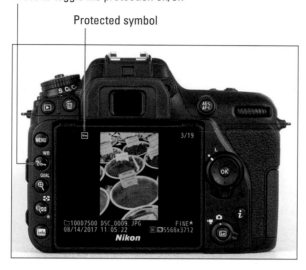

FIGURE 10-4:
Press the Protect button to prevent accidental deletion of the selected image.

 To unlock all protected files in the folder currently being viewed — which is determined by the Playback Folder setting on the Playback menu — don't waste time unlocking them one at a time. Instead, put the camera into Playback mode and then press and hold the Protect button and the Delete button at the same time for about two seconds.

One last bit of protection info: When you protect a picture, it may show up as a read-only file when you transfer it to your computer, depending on whether the software you use can read the protection tag. Files that have the read-only status can't be altered until you unlock them. To take that step in Nikon ViewNX-i, the photo software introduced later in this chapter, open the File menu, choose Protect Files, and then select Unprotect.

Hiding Photos During Playback

Suppose that you took 100 pictures of your staff at a business conference — 50 during official meetings and 50 at after-hours schmooze-fests. You want to show your boss photos of your team acting all businesslike at the meetings, but you'd

rather not share the images of your group dancing on the hotel-lobby bar. You can always delete the photos, but if you want to keep them — you never know when a good blackmail picture will come in handy — you can simply hide them during playback.

If you thought ahead and stored the party pictures in a separate folder from the work pictures, the easiest way to prevent the party photos from appearing is via the Playback menu. Choose Playback Folder, choose Select Folder, and then choose the folder that contains the work photos. The camera displays only files in that folder during playback.

Didn't think about the separate-folder thing before you took the incriminating frames? Yeah, I wouldn't either. Fortunately, you have a fallback position: Through the Hide Image option on the Playback menu, shown in Figure 10-5, you can tag files that you don't want the camera to display.

FIGURE 10-5:
The Hide Image function prevents photos from appearing during picture playback.

Use either of these techniques to apply the Hide Image tag:

>> **Tag photos one by one:** After selecting Hide Image from the menu, choose Select/Set, as shown on the left in Figure 10-6. The camera displays thumbnails of your images, as shown on the right in the figure. Select an image to hide by tapping it or by using the Multi Selector to move the yellow selection box over the thumbnail. Then press the Zoom Out button or tap the Set symbol at the bottom of the screen. The Hide Image symbol appears on the thumbnail, as shown on the right in Figure 10-6. If you change your mind, press the button or tap the Set symbol again to remove the symbol. Press the OK button or tap the OK symbol to return to the Playback menu. Your tagged pictures are now hidden.

>> **Hide all photos taken on a specific date:** Select Hide Image from the Playback menu and then choose Select Date, as shown on the left in Figure 10-7. You see a list of dates, as shown on the right in the figure. Highlight the date in question and press the Multi Selector right to select the box for that date. You also can simply tap the date to select its box. Press the OK button or tap the OK symbol to finalize the process.

Can't remember which photos or movies you took on which dates? These tricks can help:

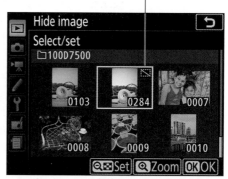
Hide image symbol

FIGURE 10-6: Choose this option to hide multiple files not taken on the same day.

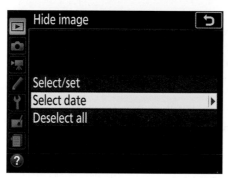

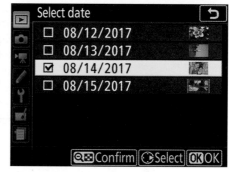

FIGURE 10-7: This option makes it easy to hide all photos taken on a specific date or dates.

QUAL

- To display thumbnails of all the files from the selected date, press the Zoom Out button or tap the Confirm symbol at the bottom of the screen.

- To temporarily view one of the thumbnails at full-size view, select the thumbnail and then press and hold the Zoom In button or tap the Zoom symbol at the bottom of the screen. Release the button or tap the exit arrow (upper-right corner of the screen) to return to the thumbnails screen.

- To return from the Thumbnail view to the date list, press the Zoom Out button again or tap the Back symbol.

A few more fine points to know about hiding images:

>> To redisplay hidden pictures, just reverse the process, removing the hide marker. Or, to redisplay all hidden pictures quickly, choose Deselect All from the first Hide Image screen (the left screen in Figure 10-7).

>> If you protected a photo before hiding it, redisplaying the picture removes its protected status.

WARNING

>> Before you can delete hidden photos, you must unhide them. Or you can format your memory card, which wipes out all files, regardless of whether you hid or protected them. Choose Format Card from the Setup menu to take advantage of that option.

>> Hidden images remain viewable from within the Hide Image file-selection screens. In other words, if your boss picks up your camera and selects Hide Image from the Playback menu, you're busted. Thumbnails of hidden images appear along with all your other pictures.

Deleting Files

You have three options for erasing files from a memory card when it's in your camera. The next few sections give you the lowdown.

REMEMBER

Two notes before you begin: First, and most important, none of the Delete features erase protected or hidden files. See the preceding two sections to find out how to remove protection and redisplay hidden files.

Second, if you really want to get down into your camera's customization weeds — and I do believe this is about as weedy as it gets — you can control which picture the camera displays after you delete the current one. Open the Playback menu, select After Delete, and then choose one of these options: Show Next displays the picture taken after the one you just deleted; Show Previous displays the one taken before the one you deleted; Continue as Before tells the camera to keep going in the same direction you were heading when scrolling pictures before deleting. Wow, now *that's* control. Have you thought about getting some help for that?

Deleting files one at a time

During picture playback, you press the Delete button to erase individual photos and movies. But the process varies depending on the playback mode:

>> In single-image view, press the Delete button.

>> In Thumbnail view, select the photo you want to erase and then press Delete.

>> In Calendar view, select the date that contains the image. Then press the Zoom Out button or tap the Zoom Out symbol at the bottom of the screen to activate the thumbnail list. Use the Multi Selector to highlight the image and then press the Delete button

After you press Delete, the camera asks whether you really want to erase the file. If you do, press Delete again. To cancel the process, press the Playback button.

Deleting all files

You can quickly delete all files — with some exceptions — by opening the Playback menu, selecting Delete, and then choosing All, as shown in Figure 10-8. A confirmation screen appears; select Yes and press OK.

FIGURE 10-8:
This menu
option deletes
all files
stored in the
folder you're
currently
viewing, except
for those you
protected
or hid.

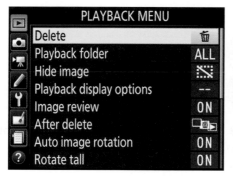
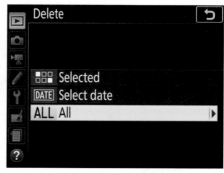

Regarding the exceptions: Again, images that you hid or protected are left unscathed. In addition, the only pictures deleted are the ones in the folder currently selected via the Playback Folder option on the Playback menu.

WARNING

Deleting a batch of selected files

To get rid of more than a few files — but not all of them — don't waste time erasing each file one at a time. Instead, you can tag multiple files for deletion and trash them all at once.

As with other Delete tools, remember that you can't delete hidden or protected files; see the first two sections of the chapter to find out how to remove the protected or hidden status from a file.

REMEMBER

After you take that step, select Delete from the Playback menu. Along with the All option just discussed, you get the following options for selecting specific files to erase:

>> **Selected:** Use this option if the files you want to delete weren't all taken on the same day. Choose Selected, as shown on the left in Figure 10-9, to display a screen of thumbnails, as shown on the right in the figure. Select the first

photo you want to delete by tapping it or by using the Multi Selector or Main command dial to move the yellow box over it. Then tap Set or press the Zoom Out button. A trash can appears in the upper-right corner of the thumbnail; in the figure, I labeled the symbol *Delete tag.*

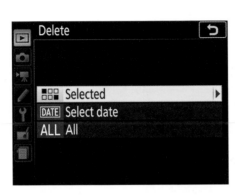
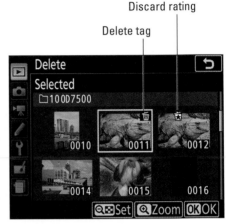

FIGURE 10-9: This Delete menu option offers a quick way to delete a batch of photos.

If you change your mind, tap Set or press the Zoom Out button again to remove the Delete tag. To remove the tag from all photos and exit the screen without dumping any of them, press the Playback button or tap the return arrow in the upper-right corner of the screen.

QUAL

For a closer look at the currently selected image, tap the Zoom symbol onscreen or press and hold the Zoom In button. To exit the magnified view, release the button or tap the return arrow.

REMEMBER

Images that you tag with the Discard rating, explained in the first section of this chapter, are *not* officially marked for the trash heap. The right screen in Figure 10-9 shows you the symbols representing both the Discard rating and the Delete tag. Notice that the Discard symbol includes a star, which you see with all rating symbols. The Delete tag, on the other hand, looks exactly like the symbol on the Delete button. At any rate, it's the Delete symbol that triggers the camera to dump the file. The Discard tag is just there to help you find images that you earlier decided you might want to erase. If you want to go ahead and trash the file, select it and then press the Zoom Out button or tap the Set symbol.

» **Select Date:** Choose this option, highlighted on the left in Figure 10-10, to quickly delete any record of that day you'd rather not remember. The camera displays a list of dates, as shown on the right in the figure. To trash all files from a date, put a check mark in the box to its left. The easiest option is to just

tap the box. But you also can press the Multi Selector up or down to highlight the date and then tap Select or press the Multi Selector right to toggle the check mark on and off.

 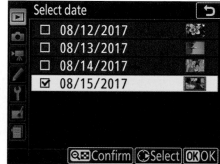

To verify which photos are associated with the selected date, you can use the same techniques that work when you use the Hide Image feature:

QUAL

- To view thumbnails of all files recorded on the selected date, tap the Confirm box at the bottom of the screen or press the Zoom Out button.

- While the thumbnails are displayed, tap Zoom or press the Zoom In button to magnify the selected thumbnail.

- To return to the date list, tap the Back symbol or press the Zoom Out button again.

After tagging individual files for deletion or specifying a date to delete, tap OK or press the OK button. Select Yes when the camera asks for confirmation that you want to erase the files.

You have one alternative way to quickly erase all files shot on a specific date: In Calendar display mode, highlight the date and then press the Delete button. You see the standard confirmation screen; press Delete again to wrap up. Visit Chapter 9 for the scoop on Calendar display mode.

TIP

Another timesaving option is to use the Protect feature when you want to keep a handful of pictures on the card but delete the rest. Rather than select all the pictures you want to trash, protect the handful you want to preserve. Then choose the All option from the Delete menu to dump all files but the protected ones.

Taking a Look a Nikon's Photo Software

If you don't have a favorite photo program for downloading, viewing, and managing your files, Nikon offers the following free solutions:

>> **Nikon ViewNX-i:** Shown in Figure 10-11, this program offers easy-to-use photo viewing and organizing files as well as basic editing tools. Your program may not look like the one in the figure because I customized the screen layout to suit my needs. You can do the same via the program's View and Window menu option.

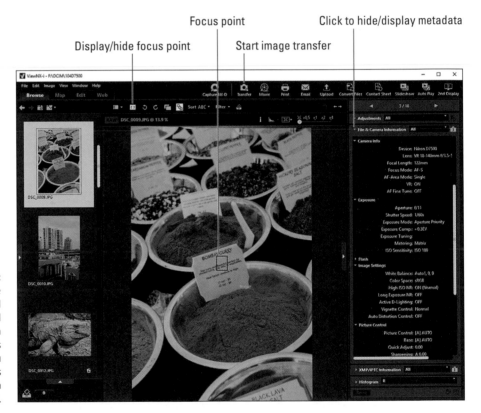

Focus point

Click to hide/display metadata

Display/hide focus point

Start image transfer

FIGURE 10-11: You can see the selected focus point and other camera settings when you view photos in Nikon ViewNX-i.

TIP

Here are two features I especially like about ViewNX-i:

- *Viewing picture settings (metadata):* You can display the settings you used when shooting the picture, as shown in Figure 10-11. The settings are stored as *metadata* (extra data) in each picture's file. To display the

metadata panel, open the Window menu and choose Adjustments/ Metadata. You may then need to click the triangle labeled *Click to hide/ display metadata* in the figure to expand the panel.

- *Displaying focus points:* Click the Focus Point button, also labeled in Figure 10-11, to display one or more red rectangles on the photo, as shown in the figure. The rectangles indicate which focus point (or points) the camera used to establish focus, which can be helpful for troubleshooting focus problems. If the focus point is over your subject, the focus issues are due to camera shake or subject movement during the exposure. (See the Chapter 5 section related to shutter speed for details.) Note that the focus point may not be displayed if you used manual focusing or continuous autofocusing.

≫ **Nikon Capture NX-D:** Shown in Figure 10-12, this program offers pro-level photo-editing tools, including a good Raw processing tool, which I show you how to use later in this chapter. You also can view camera metadata in this program, as shown in the figure. Click the tabs labeled in the figure to toggle the panel display between the Information tab, which displays metadata, and the Edit tab, which contains editing tools.

Click to view Information tab

Click to view Edit tab

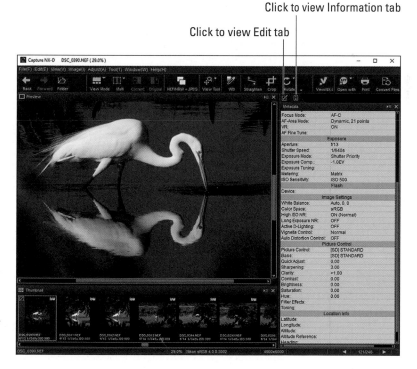

FIGURE 10-12: Capture NX-D offers a more advanced assortment of photo editing tools.

GETTING HELP WITH THE NIKON SOFTWARE

TIP

For details about using Nikon software, you can download a copy of the user manual or simply check the online help pages for answers. With your web browser open and connected to the Internet, launch the Nikon program whose Help system you want to access. In that program, open the Help menu and then choose Help. Your browser displays a window that offers two options. Click the Go to Help Site link to jump to the program's pages at the Nikon website, and click Get PDF Manual to download the instruction manual.

You can download both programs from the Nikon website (in the United States, www.nikonusa.com). Head for the Support section of the website, where you'll find a link to camera software. Be sure to download the latest versions. At the time I write this chapter, ViewNX-i is Version 1.2.8; NX-D is Version 1.4.5. Older versions of the software lack support for D7500 files. Also make sure that your computer meets the software operating-system requirements. (The program is available for both Windows-based and Mac computers.)

Downloading Pictures to Your Computer

Using your camera's wireless features, you can transfer files to a smartphone or tablet that can run the Nikon SnapBridge app. The appendix of this book provides details. Unfortunately, the wireless options depend on the app, which means that if you want to download files to a computer rather than a smart device, you have to go another route. You have two options:

>> **Connect the camera to the computer via a USB cable.** The cable you need is supplied in the camera box. After making sure that your battery is fully charged (you don't want the camera to lose power during the file transfer), turn the camera off. Connect the smaller of the two plugs on the cable to the USB port labeled in Figure 10-13, connect the other end to an empty USB port on your computer, and turn the camera back on.

>> **Use a memory card reader.** A card reader, if you're unfamiliar, is a small device that attaches to your computer (or, in some cases, is built into the computer). When you put a camera memory card into the reader, your computer recognizes the card as another drive on the system, and you can then access the files on the card.

WARNING

Not all card readers work with the newest or highest-capacity SD cards. So if you're shopping for a reader, make sure that it's compatible with your memory cards.

After you connect your camera or put a card in the card reader, you can use whatever photo software you prefer to transfer photos to your computer. If you don't yet have a program for handling this task, give Nikon ViewNX-i a try. (It's free, after all.) The program has a built-in utility, Nikon Transfer 2, that makes the download process easy. Follow these steps:

USB port

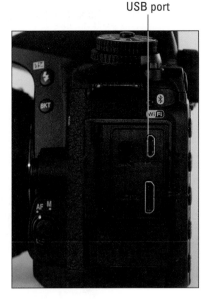

FIGURE 10-13:
You can connect your camera to your computer via the supplied USB cable.

1. **Launch Nikon Transfer 2 if it isn't already open.**

 Depending on how you install ViewNX-i and the computer preferences you establish, the Nikon Transfer 2 window may appear automatically when you insert a memory card into your card reader or attach the camera via USB cable. Figure 10-14 offers a look at the program window. (Although my figures show the Windows version of the program, these steps work for the Mac version as well.)

 If the program doesn't launch automatically, start ViewNX-i, open the File menu, and choose Launch Transfer.

2. **Display the Source tab, as shown in Figure 10-14, to view your pictures.**

 Don't see any tabs? Click the Options triangle (refer to Figure 10-14) to display them. Then click the Source tab. The icon representing your camera or card should be selected. In the figure, the icon shows Removable Disk F, which is the name my computer assigned to my card reader.

 Thumbnails of the images on the card appear in the bottom half of the dialog box. If you don't see them, click the Thumbnails triangle (again, refer to Figure 10-14) to open the thumbnails area.

3. **Select the files that you want to download.**

 Click a thumbnail to highlight it and then click the box underneath to mark the file for downloading. These tricks speed up the process:

 - *Select protected files only.* If you used the in-camera function to protect pictures, select just those images by clicking the Select Protected icon, labeled in Figure 10-14.

 - *Select all files.* Click the Select All icon, also labeled in the figure.

Click to hide/display thumbnails

Click to hide/display tabs

Select Protected

Select All

FIGURE 10-14:
Nikon Transfer
2 is a file-
transfer tool
built into Nikon
ViewNX-i.

4. **Click the Primary Destination tab to display options for handling the file transfer, as shown in Figure 10-15.**

 The most important setting on this tab is Primary Destination Folder, which determines where the program puts your transferred files. I highlighted this option in the figure. Open the drop-down list and choose the folder on your computer's hard drive (or external drive) where you want to put the pictures.

 Other options on this tab enable you to specify how pictures should be organized inside the primary destination folder and to rename files during the transfer.

5. **Click the Backup Destination tab (labeled in Figure 10-15) to transfer copies of the files to a second location.**

 TIP

 Options on this tab enable you to download copies of photos to your primary drive and to a backup drive in one step — a great archival timesaver. Select the Backup Files box and then specify where you want the backup files to go.

Choose location for downloaded files

Click tab to choose backup storage location

6. **Click the Preferences tab to set other transfer options.**

 Pay special attention to these settings:

 - *Transfer New Files Only:* Choose this option to avoid downloading images that you already transferred.

WARNING

 - *Delete Original Files after Transfer:* **Turn off this option.** Otherwise, your pictures are erased from your memory card when the transfer is complete. Always make sure the pictures made it to the computer before you delete them from your memory card.

TIP

 - *Open Destination Folder with the Following Application after Transfer:* You can tell the program to immediately open your photo program after the transfer is complete. Choose ViewNX-i to view and organize your photos using that program. To choose another program, open the drop-down list, choose Browse, and select the program from the dialog box that appears. Click OK after doing so.

TIP

DRAG-AND-DROP FILE TRANSFER

As an alternative to using a photo program to download files, you can use Windows Explorer or the Mac Finder to drag and drop files from your memory card to your computer, just as you copy files from a CD, DVD, or flash drive onto your computer. If you connect the camera's SD card through a card reader, the computer sees the card as just another drive on the system. Windows Explorer also shows the camera as a storage device when you connect the camera directly to the computer. (With some versions of the Mac OS, including the most recent ones, the Finder doesn't recognize cameras in this way.)

Be careful to copy, and not move, the image files when you drag and drop. That way, the images remain on the memory card as a backup if something goes awry during the transfer process.

7. **Click the Start Transfer button.**

 After you click the button, the Process bar in the lower-left corner of the program window indicates how the transfer is progressing. What happens when the transfer completes depends on the choices you made in Step 6. If you selected Nikon ViewNX-i as the photo program, it opens and displays the folder that contains your just-downloaded images.

Processing Raw (NEF) Files

Chapter 2 introduces you to the Raw file format. The advantage of capturing Raw files — NEF files on Nikon cameras — is that you make the decisions about how to translate the original picture data into an actual photograph. You take this step by using a software tool known as a *Raw converter.* To process your NEF files, you have the following free options:

>> **Use the in-camera processing feature.** From the Retouch menu, you can process Raw images right in the camera. You can specify only limited image attributes, and you can save the processed files only in the JPEG format, but still, having this option is a nice feature.

>> **Process and convert in Capture NX-D.** For more control over how your raw data is translated into an image, use this option. Not only do you get access to tools not found on the camera, but you can save the adjusted files in either the JPEG or TIFF format. You also have the advantage of evaluating your photos on a larger screen than the one on your camera.

TECHNICAL STUFF

TIFF stands for Tagged Image File Format and has long been the standard format for images destined for professional publication. I recommend saving your converted Raw files in this format because it does a better job than JPEG of holding onto your original image data. As explained in Chapter 2, JPEG compresses the file, meaning that it does away with what it considers "unnecessary" data.

Of course, you can use any third-party Raw-processing tool you prefer, such as the one provided with Adobe Photoshop and Adobe Lightroom. Just don't pay for a third-party tool until you've tried Capture NX-D — the fact that it's free doesn't mean that it isn't a good program. Whatever program you use, you may need to download a software update to enable the program to work with your D7500 files. (For Nikon Capture NX-D, you need version 1.4.5.)

Processing Raw images in the camera

Follow these steps to create a JPEG version of a Raw file right in the camera:

1. **Press the Playback button to switch to playback mode.**

2. **Display the picture you want to process in the single-image view.**

 If necessary, you can shift from Thumbnail view to single-image view by pressing OK. Press OK twice to go from Calendar view to single-image view.

3. **Press the *i* button to display the Playback mode version of the *i*-button menu.**

4. **Choose Retouch and then select NEF (RAW) Processing.**

 You see a screen similar to the one on the left in Figure 10-16, which is the first of two pages of options you can select for processing your file. Use the Multi Selector to scroll to the second page, shown on the right in the figure, or drag your finger down the scroll bar on the right edge of the screen.

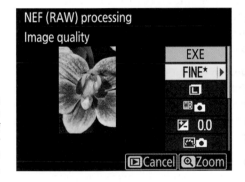 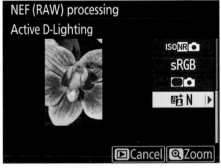

FIGURE 10-16: You get two pages of options for processing a Raw file.

5. **Set the conversion options.**

 Along the right side of the screen, you see a column offering the available adjustments you can apply to the Raw file. The following list identifies each setting, starting with the first option on the left screen in Figure 10-16 and continuing through the settings shown in the right screen:

 - *EXE:* Although this option tops the list of settings, it's actually the last one to choose. Select it to create the JPEG copy of your Raw file after you work your way though all the other settings.

 - *Image Quality:* Choose Fine to retain maximum picture quality. See the Chapter 2 section related to the JPEG format for details on this option.

 - *Image Size:* Chapter 2 explains this one, too. Choose Large to retain all the original image pixels.

- *White Balance:* If you're not happy with the color rendition of your subject, experiment with each setting to see which one you like best. Check out Chapter 6 for details about White Balance.

- *Exposure Compensation:* With this option, which I cover in Chapter 4, you can adjust image brightness. When using this feature for Raw conversion, you're limited to a range of –2.0 and +2.0; when shooting, you can choose from settings ranging from –5.0 to +5.0. Raise the value for a brighter image; lower it for a darker shot. The camera updates the preview to indicate how your setting will affect the picture.

- *Picture Control:* This option, detailed in Chapter 6, affects color saturation, contrast, and image sharpness. As with the White Balance and Exposure Compensation settings, the screen updates to show you the effect of the selected Picture Control.

- *High ISO Noise Reduction:* If your picture looks *noisy* — that is, marred by a speckled look — enabling this feature may improve the picture. See Chapter 4 for an explanation of ISO and noise.

- *Color Space:* This setting determines whether the camera uses the default color space, sRGB, or the larger Adobe RGB color space when converting your photo. Stick with sRGB until you digest the Chapter 6 sidebar that details this option.

- *Vignette Control:* Does your picture appear unnaturally dark in the corners? This flaw, called *vignetting,* can sometimes be eliminated or at least diminished by applying the Vignette Control feature. Chapter 4 has more information.

- *Active D-Lighting:* To brighten the darkest part of your picture without also brightening the lightest areas, try adjusting this setting. See Chapter 4 to understand more about how this feature works. You can set the level of adjustment to High, Normal, or Low; to darken shadows, try the Off setting.

QUAL

At any time, you can magnify the image by pressing and holding the Zoom In button or by tapping the Zoom icon at the bottom of the screen. Release the button or tap the icon again to return to the normal display.

6. **Select EXE on the first conversion screen.**

The camera records a JPEG copy of your Raw file and displays the copy in the monitor. The camera assigns the next available file number to the image, so the number of the original and the number of the processed JPEG don't match. You also see the Retouch symbol (the box with a paintbrush) just as you do when applying any Retouch menu feature.

TIP

You can also access the Raw processing tool through the normal menu-display route: Press the Menu button, display the Retouch menu, and then choose NEF (RAW) Processing. The camera displays thumbnails of Raw images; select the image you want to process and then tap the OK symbol or press the OK button to move forward. Everything else works as just described.

Processing Raw files in Capture NX-D

Figure 10-17 offers a look at Capture NX-D, one of the free programs you can download from the Nikon website. When you first open the program, it won't look like what you see in the figure; I customized the window layout to show before and after views of my photo and to display the panel of Raw conversion tools along the right side of the window. You can customize these and other aspects of the program window through options on the View and Window menus.

I have room only for brief of explanations of the Raw-processing tools, but the following pointers get you started in the right direction:

TIP

>> **Select the Raw file.** After opening Capture NX-D, click the thumbnail of the image you want to process. (If you don't see any thumbnails, open the View menu and select the Thumbnail option.)

>> If you're viewing images in Nikon ViewNX-i, you can ship the Raw file directly to Capture NX-D. Select the photo, open the File menu, and then choose Open in Capture NX-D.

>> **Display before and after views of your photo.** To arrange your original side-by-side with the edited version, open the View menu and select Compare Before and After Images.

>> **Display the Edit panel, labeled in Figure 10-17.** Controls for adjusting your Raw image appear in the Edit panel along the right side of the window. If you don't see the panel, open the Window menu and choose Edit.

>> **Use the tools in the Edit panel to adjust your photo.** You have to do a little work to uncover all the available options. See the icons along the left and bottom edges of the top pane of the Edit panel? Click those icons to display related tools. (Pause your cursor momentarily over an icon to display a text label that tells you what the symbol represents.) Use the scroll bar on the right side of the window to scroll the display to reveal more settings if needed.

>> **To remove all adjustments you made, click the symbol labeled *Undo all changes* in the figure.** You also can select Recorded Settings from the drop-down list near the top of the Edit panel to restore the settings that were in force when you took the picture.

Edit panel Convert Files

Undo all changes

FIGURE 10-17:
Capture NX-D
offers a large
assortment
of tools for
finalizing the
look of your
Raw images.

>> **When you finish adjusting the image, click the Convert Files icon, labeled in Figure 10-17.** Or open the File menu and choose Convert Files. You then see the dialog box shown in Figure 10-18. Set the File Format option (upper-right corner of the dialog box) to 8-bit TIFF. If you choose 16-bit TIFF, you may not be able to add the photo to documents or presentations or even open the file in other photo-editing programs.

The rest of the options work as they do when you save files in most Mac or Windows programs: Specify where you want to store the file, give the file a name, and then click Start.

TIP

One neat thing about working with Raw images is that you can easily create as many variations of the photo as you want. For example, you might choose one set of options when processing your Raw file as a color image and then a differ-ent set to create a black-and-white version of the photo. Just be sure to give each processed file a unique name so you don't overwrite the first TIFF file you create with your second version.

FIGURE 10-18:
To retain the
best picture
quality, select
TIFF as the
file format for
your processed
Raw files.

You can find more details on Raw processing and other NX-D features in the program's instruction manual, which is available online. To find out how to get to the manual, see the sidebar "Getting help with the Nikon software," earlier in this chapter.

Preparing Pictures for Online Sharing

Have you ever received an email containing a photo so large that you can't view the whole thing without scrolling the email window? This occurs because monitors can display only a limited number of pixels. The exact number depends on the screen resolution, but suffice it to say, today's cameras produce photos with pixel counts in excess of what monitors can handle.

Thankfully, newer email programs incorporate features that automatically shrink the photo display to a viewable size. That doesn't change the fact that a large photo file means longer downloading times, though — and if recipients choose to hold onto the picture, a big storage hit on their hard drives.

Sending a high-resolution photo *is* the thing to do if you want the recipient to be able to generate a good print. But for simple onscreen viewing, I suggest limiting your photos to fewer than 1,000 pixels on the longest side of the image so that people who use older email programs can see the entire picture (or nearly all of it) without scrolling the display.

This size recommendation means that even if you shoot at your camera's lowest Image Size setting (2784 x 1856), you wind up with more pixels than you need for onscreen viewing. Some new email programs have a photo-upload feature that creates a temporary low-res version for you, but if not, creating your own copy is easy. If you're posting to an online photo-sharing site, you may be able to upload all your original pixels, though many sites have resolution limits.

REMEMBER

In addition to resizing high-resolution images, check their file types. If the photos are in the Raw (NEF) or TIFF format, you need to create a JPEG copy for online use. Web browsers and e-mail programs can't display Raw or TIFF files.

You can tackle both bits of prep in ViewNX-i or by using the Resize option in your camera. The next sections explain both methods.

Prepping photos using ViewNX-i

For pictures stored on your computer, you can create small JPEG copies for online sharing using Nikon ViewNX-i. First, click the image thumbnail to select it. Next, open the File menu and choose Convert Files in the dialog box that appears, set things up as follows:

>> **Select JPEG as the file type:** Make your selection from the File Format drop-down list.

>> **Set the picture-quality level:** Use the Quality slider to set the picture quality, which is controlled by how much JPEG compression is applied when the file is saved. For best quality, drag the slider all the way to the right, but remember the trade-off: As you raise the quality, less compression occurs, which results in a larger file size. See Chapter 2 for more information.

>> **Set the image size (number of pixels):** To resize the photo, select the Change Image Size check box and then enter a value (in pixels) for the longest dimension of the photo. The program automatically fills in the other value.

>> **Select the next three check boxes and click the Remove button:** The boxes are located under the Change Image Size option. After you select a box, you see two buttons: Add and Remove. Choose Remove to eliminate unnecessary camera metadata, which reduces the size of the file you're creating.

>> **Tell the program where you want to store the reduced-size file and how you want to name the file:** Use the options in the Save In area of the Convert Files dialog box to handle this bit of business.

WARNING

If you're resizing a JPEG original, be sure to give the small version a new name to avoid overwriting the original.

After working your way through the dialog box options, click the Convert button to create the small-size JPEG version of your original.

Resizing pictures in the camera

TIP

The in-camera resizing tool, found on the Retouch menu, works on both JPEG and Raw images. With both types of files, your resized copy is saved in the JPEG format. You can get the job done in two ways:

>> **Resize a single photo:** Set the camera to Playback mode, display the photo in single-image view (or select it in Thumbnail or Calendar view), and press the *i* button. On the screen that appears, select Retouch to display the Retouch menu, shown on the left in Figure 10-19.

FIGURE 10-19: Use the Resize option to create a low-resolution version of your picture.

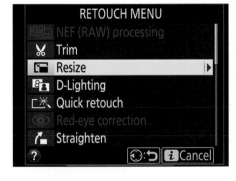
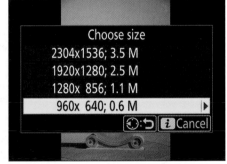

Select Resize to display possible image sizes (see the right side of Figure 10-19). The first value shows the pixel dimensions of the small copy; the second, the total number of pixels, measured in megapixels. Note that the available sizes depend on the size of your original and whether you captured the photo using the DX (whole sensor) Image Area setting or the 1.3 crop setting.

After you select a size, the camera asks permission to create the resized copy; answer in the affirmative to go forward.

>> **Resize a batch of photos:** Press the Menu button to access the regular menu system. Display the Retouch menu and choose Resize. Select Choose Size to set the pixel count of the small images. Then choose Select Image(s) to display thumbnails of your photos, as shown in Figure 10-20.

Select the image you want to resize. Then tap Set (bottom of screen) or press the Zoom Out button to tag the file with a Resize symbol, labeled in the figure. Select the next photo, rinse, and repeat. After tagging all the photos, tap OK or press the OK button to display the go-ahead screen. Then select Yes to create your small copies.

In both cases, the camera duplicates the selected images and *downsamples* (eliminates pixels from) the copies to achieve the size you specified. The small copies are saved in the JPEG file format, using the same Image Quality setting (Fine, Normal, or Basic) as the original. Raw originals are saved as JPEG Fine images.

Small-size copies appear during playback marked by a Resize symbol next to the file size, as shown in Figure 10-21. Next to the symbol, you see the resolution (pixel count) of the resized image. You also see the standard Retouch symbol, which appears anytime you alter a photo via a Retouch menu option. The camera assigns the next available filename to the file; you can view the filename in the default Playback display mode, as shown in Figure 10-21.

Resize symbol

FIGURE 10-20:
After selecting a photo, press the Multi Selector up or down or tap the Set symbol to tag the file for resizing.

Retouch symbol

Filename of resized image Resize symbol

FIGURE 10-21:
The Resize icon indicates a small-size copy.

4

The Part of Tens

Create custom exposure modes (U1 and U2) and a custom menu.

Add text comments and copyright notices to camera metadata (hidden file data).

Use Retouch menu tools to straighten tilting horizon lines, crop to a better composition, correct exposure and color problems, and more.

Create special effects by using the Effects exposure mode or by applying Retouch menu effects tools.

Customize the functions of certain buttons and dials.

Get started using Nikon SnapBridge to connect your camera to a smartphone or other smart device.

IN THIS CHAPTER

» Creating your own exposure
 modes and menu

» Adding copyright data and hidden
 comments

» Using your own folder and
 filenames

» Changing the behavior of some
 buttons and dials

» Adjusting automatic camera
 shutdown

Chapter **11**

Ten More Ways to Customize Your Camera

As you've no doubt deduced, Nikon is eager to let you customize almost every aspect of the camera's operation. This chapter discusses customization options not considered in earlier chapters, including ways to create custom exposure modes and menus, embed a copyright notice or other text information in your picture files, and even tweak the function of buttons and other controls.

Creating Custom Exposure Modes

After you gain some experience, you'll find that you rely on certain picture-taking settings for specific types of photos. For example, you might prefer one set of options when shooting landscapes and another for shooting portraits. If you routinely spend a lot of time adjusting options for different scenes, here's a way to make life easier: You can store two sets of options as custom exposure modes, represented on the Mode dial by U1 and U2 (for User 1 and 2), as shown in Figure 11-1.

Setting up your custom exposure modes is easy:

1. **Set the Mode dial to P, S, A, or M.**

The mode determines what picture settings you can control, and thus what options you can store as part of your custom exposure mode. For example, in A mode, you control the aperture setting; in S mode, you control shutter speed. Chapter 4 provides details.

2. **Select the settings you want to store.**

Custom user modes

FIGURE 11-1:
You can create two custom exposure modes: U1 and U2.

In A mode, for example, select the initial f-stop that you want the camera to use. In S mode, select the initial shutter speed. Also choose settings such as Image Quality, Image Size, Exposure Compensation, Flash Compensation, Flash mode, White Balance, Focus and AF-area modes, and so on.

Note that the following settings aren't stored: Storage Folder, Image Area, Manage Picture Control, Multiple Exposure, Remote Control Mode (ML-L3), Interval Timer Shooting, Time-Lapse Photography, Optical VR, and Manual Focus Ring in AF Mode.

3. **Display the Setup menu and choose Save User Settings, as shown on the left in Figure 11-2.**

You see the screen shown on the right in the figure.

4. **Select one of the user modes (U1 or U2) to store your settings.**

5. **Tap Save Settings (or highlight it and press the OK button).**

FIGURE 11-2:
Choose Save User Settings to store current camera settings as custom exposure mode U1 or U2.

Now when you turn the Mode dial to the custom mode you created, the camera immediately recalls the settings you stored. You can still adjust any settings — you don't have to stick with your default f-stop or shutter speed, for example. You can return to the stored settings at any time by rotating the Mode dial to another setting and then back to your custom mode. To return all U1 or U2 stored settings to the camera defaults, choose Reset User Settings on the Setup menu.

TIP

Don't confuse these menu settings with the Save/Load Settings option on the Setup menu. That feature stores camera settings in a data file on the installed memory card. You can later insert the memory card and choose Save/Load Settings to load the stored settings. The feature is helpful in situations where multiple photographers share a camera; it enables each user to easily return to a particular camera setup.

Creating Your Own Menu

In addition to creating custom exposure modes, you can build your own menu that holds up to 20 options. The idea is to put all your favorite options in one place so that you don't have to rummage through multiple menus to get to them. For example, Figure 11-3 shows the first page of a custom menu I created, which contains options from the Custom Settings menu, Playback menu, Photo Shooting menu, and Setup menu. Follow these steps to create your menu:

FIGURE 11-3:
Use the My Menu feature to gather frequently used options into one menu.

1. **Choose the My Menu icon to display the screen shown on the left in Figure 11-4.**

 I labeled the icon in the figure. Remember, though, that My Menu shares a slot in the list of menu icons with the Recent Settings menu. To toggle between the two, select Choose Tab from either menu.

2. **Choose Add Items.**

 A list of other camera menus (absent the Recent Settings menu) appears, as shown on the right in Figure 11-4.

3. **Choose a menu that contains an option you want to add to your custom menu.**

 You then see a list of all settings on the selected menu.

My Menu icon

FIGURE 11-4:
Display the My
Menu screen,
choose Add
Items, and
then select
a menu that
contains an
option you
want to put on
the menu.

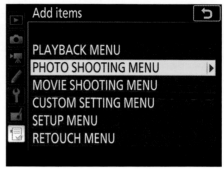

4. **To add an item, tap it or use the Multi Selector to highlight it and then press the OK button.**

The camera displays the Choose Position screen, showing the menu item you just added. On this screen, you can set the order of each item as you add it. Ignore that possibility for now; it's better to add all items to your menu and then reorder them as explained at the end of these steps.

5. **Press the OK button or tap the return arrow at the top of the screen to return to the My Menu screen.**

The item you just added appears at the top of the screen.

6. **Repeat Steps 2–5 to add more items to your menu.**

REMEMBER

A few items can't be added to a custom menu. A box with a slash through it appears next to those items. A check mark means that the item is already on your menu.

After creating your menu, you can edit it as follows:

>> **Change the order of menu options.** When the My Menu screen is displayed, scroll past the menu items you added and look for the Rank Items option, highlighted on the left in Figure 11-5. Select that option to display the screen shown on the right in the figure. Use the touchscreen or the Multi Selector and OK button to shuffle the list:

- *Touchscreen:* Tap an item to select it and then tap the position where you want the item to go.

- *Multi Selector:* Highlight the item you want to move and then press the OK button. Press the Multi Selector up/down to choose the new list position and press OK again.

When you're happy with the menu order, tap the exit arrow or press the Multi Selector left to return to the My Menu screen.

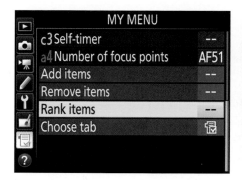

FIGURE 11-5: Choose Rank Items to change the order of menu items.

>> **Remove menu items.** Choose Remove Items, located just above the Rank Items option (refer to the left screen in Figure 11-5). You see a list of current menu items, with an empty box next to each item. To remove an item, check its box by tapping the box or by using the Multi Selector to highlight the item and then pressing the Multi Selector right. After tagging items, press or tap OK. A confirmation screen appears; select OK.

Adding Hidden Comments and Copyright Notices

Through the Image Comment feature, you can add hidden comments to your picture files. Suppose, for example, that you're on vacation and visiting a different destination every day. You can annotate all the pictures you take on a particular outing with the name of the location. Similarly, the Copyright Information feature enables you to tag files with your name and other copyright data.

REMEMBER

The text doesn't appear on the photo itself; instead, it's stored with other *metadata* (hidden data, such as shutter speed, date and time, and so on). You can view metadata during playback in the Shooting Data display mode (see Chapter 9) or along with other metadata in Nikon ViewNX-i and Capture NX-D (see Chapter 10).

Enable both options via the Setup menu, as follows:

>> **Image Comment:** Choose this option to display the screen shown on the left in Figure 11-6. Select Input Comment to display the keyboard screen shown in Figure 11-7, and use the following methods to enter a comment, which can be up to 36 characters long:

 • *Enter a character into the text box:* Tap a character in the keyboard or use the Multi Selector to highlight a character and press OK or tap OK Input.

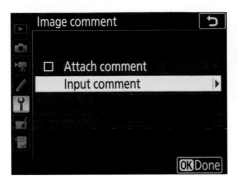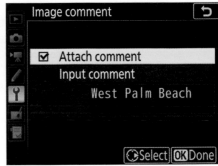

You can store a text comment up to 36 characters long in the file metadata.

TIP

QUAL

To cycle from the keyboard shown in the figure to screens that contain uppercase characters and symbols, select the Aa& key. Select the empty box to the left of that key to enter a space. I labeled both keys in Figure 11-7.

• *Move the cursor in the text box:* Tap the cursor arrows or press and hold the Zoom Out button as you press the Multi Selector in the direction you want to shift the cursor. Release the button to return to the keyboard section of the screen.

• *Delete a letter:* Move the cursor under the letter in the text box and then tap the Delete symbol or press the Delete button.

Tap to move cursor in text box

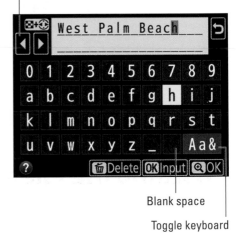

Blank space

Toggle keyboard

FIGURE 11-7:
This keyboard appears for all options that require you to enter text or numbers.

After entering your comment, tap the rightmost OK symbol (the one marked with a magnifying glass) or press the Zoom In button to display the screen shown on the right in Figure 11-6. Your comment appears underneath the Input Comment line. You're not done, however: You need to place a check mark in the Attach Comment box, as shown in the figure. To toggle the check mark on and off, tap the box or highlight Attach Comment and press the Multi Selector right. Press the OK button or tap OK Done to exit to the Setup menu.

>> **Copyright Information:** Choose this Setup menu option to enter copyright data. The left screen in Figure 11-8 offers a look. The drill for entering copyright information is the same as just described except that you can enter two items: Artist and Copyright. The maximum character count for Artist is 36; for Copyright, 54.

296 PART 4 The Part of Tens

After entering text, turn on the Attach Copyright Information option by selecting its box, as shown on the right in the figure. Finally, press the OK button or tap OK Done.

REMEMBER

Your comment or copyright information is added to any new pictures or movies you shoot. To disable either feature, revisit the menu option, remove the check mark from the Attach box, and press or tap OK. When the box is unchecked, the word Off appears next to the item on the Setup menu, as shown on the left in Figure 11-8.

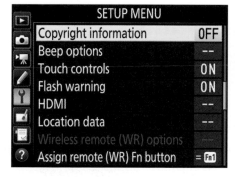
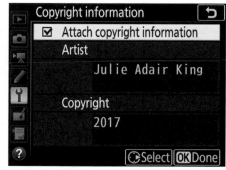

FIGURE 11-8:
Add copyright information through this Setup menu option.

Customizing Filenames

Normally, picture filenames begin with the characters DSC_, for photos captured in the sRGB color space, or _DSC, for images that use the Adobe RGB color space. (Chapter 6 explains color spaces.) Movie files are always captured in the sRGB space, so their filenames always begin with DSC_. You have the option of replacing the letters DSC with your own characters for both movies and stills. For example, you could replace DSC with TIM before you take pictures of your brother Tim and then change the prefix to SUE before you shoot Sue's wedding.

You customize filenames separately for still photos and movies:

>> **Customizing filenames for still images:** Open the Photo Shooting menu and choose File Naming, as shown on the left in Figure 11-9. The next screen, shown on the right in the figure, shows the current naming structure. Select File Naming to display the standard text-entry keyboard. (Refer to Figure 11-7.) Use the techniques listed in the preceding section to replace DSC with your chosen characters.

>> **Customizing filenames for movies:** Open the Movie Shooting menu and select File Naming to access the keyboard screen.

FIGURE 11-9:
You can
customize
the first three
characters of
filenames.

Customizing Folder Names

By default, your camera stores picture and movie files in a folder named 100D7500. Folders have a limit of 999 files; when you exceed that number or the last photo in that folder has the file number 9999, the camera creates a new folder, assigning the next available folder number.

If you choose, you can create a new folder or folders at any time. For example, perhaps you use your camera both for business and personal use. To keep your images separate, you can set up one folder numbered 200D7500 for work images and use the regular 100D7500 folder for personal photos. If that's not enough customization for you, you also can replace the first five characters of the folder name, changing D7500 to something like JULIE, for example.

To take advantage of either option, open the Photo Shooting menu and select Storage Folder, as shown on the left in Figure 11-10. You see the screen on the right in the figure. Adjust the folder prefix or create a new folder as follows:

>> **Replace the 5-character prefix:** Choose Rename to display a keyboard screen; enter the new prefix by using the techniques outlined earlier in this chapter.

FIGURE 11-10:
You can create
new folders
or change the
default
folder-name
prefix (D7500).

 To easily restore the default prefix (D7500), display the keyboard screen and then press and hold the Delete button for a few seconds.

>> **Create a new folder:** Choose Select Folder by Number, as shown on the left in Figure 11-11, to display the options shown on the right. The camera automatically chooses the next available folder number. For example, if the current number is 100, the selected number for the new folder is 101, as shown in the figure.

FIGURE 11-11:
Use this option
to create a
new folder
or to select a
different folder
to hold the
next images
or movies
you shoot.

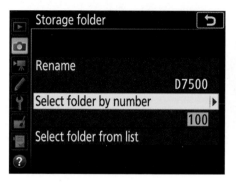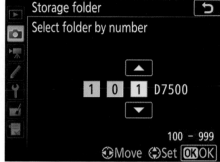

To select a different number, tap one of the value boxes or press the Multi Selector right or left to highlight it. Change the value by tapping the triangles above and below the box or by pressing the Multi Selector up/down. If you select a folder number that already exists, a folder icon appears to the left of the value boxes.

After setting the folder number, tap OK or press the OK button. The camera creates the folder and selects it as the current storage folder.

REMEMBER

Each time you shoot, verify that the folder you want to use is shown for the Storage Folder option. If not, select that option and then choose Select Folder by Number to enter the folder number or choose Select Folder from List to pick from a list of all available folders. A half-full folder icon to the left of the folder number shows that the folder contains images but has room for more. A full icon means the folder is stuffed to its capacity (999 images) or contains a picture with the file number 9999. Either way, you can't put any more pictures in that folder.

Changing the Purpose of the OK Button

You can customize the role that the OK button plays during shooting, playback, and Live View mode through the aptly named OK Button option, found in the Controls section of the Custom Setting menu and shown on the left in Figure 11-12.

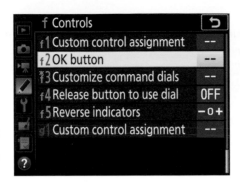
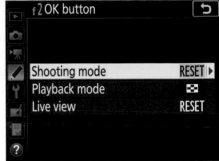

FIGURE 11-12:
You can
change the
role the OK
button plays
during
shooting,
during
playback, and
in Live View
mode.

After you choose the option, work your way through the following settings, shown on the right in the figure:

>> **Shooting mode:** Choose from these options:

- *RESET (Select Center Focus Point):* At this setting, which is the default, the button selects the center autofocus point. Chapter 5 explains the process of choosing an autofocus point.

- *Highlight Active Focus Point:* Pressing OK highlights the active focus point in the viewfinder — which you also can accomplish by pressing the shutter button halfway.

- *None:* This setting disables the OK button during shooting.

>> **Playback mode:** For movie files, pressing OK always begins movie playback. For photo playback, choose from these options:

- *Thumbnail On/Off:* This setting is the default; pressing OK toggles between the Thumbnail and single-image displays.

- *View Histograms:* If you're a histogram fan, this option may be for you: You can press OK to display a larger histogram than you can view in the normal playback modes.

- *Zoom On/Off:* Normally, you magnify an image by pressing the Zoom In button. But if you select this option, you can press OK to toggle between single-image or Thumbnail view to a magnified view of your photo, with the zoomed view centered on the active focus point. After highlighting the option, press the Multi Selector right to select the initial magnification level.

See Chapter 9 for details on these and other playback functions.

>> **Live View mode:** For Live View mode, you have these options:

- *RESET (Select Center Focus Point):* This one works as it does during viewfinder shooting: Pressing OK selects the center focus point. It's the default setting.

- *Zoom On/Off:* Normally, you press the Zoom In button to magnify the Live View display. But if you choose this setting, you can also use the OK button for that purpose. Before leaving the selection screen, press the Multi Selector right to choose the initial magnification level that you want the camera to use when you press OK during Live View shooting.

- *None:* The OK button plays no role during Live View.

Customizing the Command Dials

Through the Customize Command Dials option, found in the Controls section of the Custom Setting menu and shown on the left in Figure 11-13, you can modify how the command dials behave, as follows:

>> **Reverse Rotation:** This setting determines which direction you spin the dials when adjusting shutter speed, f-stop, and Exposure Compensation values. Normally, rotating the dial to the right raises the value; rotating to the left lowers it. To switch things up, choose Reverse Rotation, as shown on the right in the figure, to display a screen that enables you to set the behavior of the dials separately for shutter and aperture adjustment and for the Exposure Compensation setting. To "turn on" reverse orientation, tap the option to place a check mark in the adjacent box. (Or highlight the option and press the Multi Selector right.) Remove the check mark to return to the default dial-rotation setup.

>> **Change Main/Sub:** This option determines which dial you use to adjust aperture and shutter speed and to change the Focus mode and AF-Area mode. To choose the aperture and shutter speed operation, select Exposure Setting and select one of these options:

- *Off:* This setting is the default. The Main command dial adjusts shutter speed, and the Sub-command dial controls aperture.

- *On (Mode A):* Sets the Main command dial to adjust f-stop in the A exposure mode.

- *On:* Reverses dial functions for S, A, and M exposure modes. The Sub-command dial changes shutter speed in the M and S modes, and the Main command dial changes f-stop in A and M modes. (Select this option to totally mess with another D7500 user who borrows your camera.)

For autofocus settings, the default setup is to use the Main command dial to change the Focus mode and the Sub-command dial to choose the AF-area mode. (You press the AF-mode button on the left side of the camera while rotating the dials.) To reverse the dial arrangement, choose Autofocus Setting and set that option to On.

>> **Menus and Playback:** Change from the default setting, Off, to On to use the command dials for these functions:

- *Playback:* Use the Main command dial to scroll through pictures. Rotate the Sub-command dial to jump forward or backward multiple frames according to preferences set through the Sub-dial frame advance option, described momentarily.

- *Menu navigation:* Rotate the Main command dial to scroll a menu page up and down. Rotate the Sub-command dial right to display the submenu for the selected item; rotate left to jump to the previous menu.

If you choose *On (Image Review Excluded),* things work the same way as with On except that the command dials don't work during the image-review period. (That feature, if enabled via the Playback menu, displays a photo for a few seconds after you shoot it.)

>> **Sub-dial frame advance:** If you set the Menus and Playback option to On, use this setting to specify whether you want to jump 10 frames, 50 frames, or to the next folder when you spin the Sub-command dial. You can also set the dial to advance to the next protected file, the next still image, or the next movie.

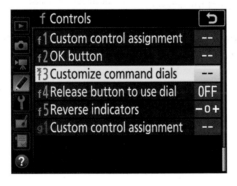
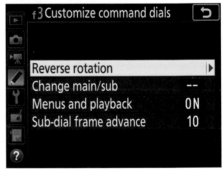

FIGURE 11-13: You can customize the behavior of the command dials.

TIP

Normally, an operation that involves both a camera button and a command dial requires you to hold down the button while spinning the dial. If you find it cumbersome to press the button while rotating the dial, locate the Release Button to Use Dial setting, found in the Controls section of the Custom Settings menu, and change the setting to On. You then use a different technique to adjust settings that involve a button and command dial: Press the button, release it, rotate the associated command dial, and then press the button again to deactivate the option. I dislike this option because it's easy to forget that final button press and end up adjusting that still-active setting when you think you're using the command dial for some other purpose.

Assigning New Tasks to a Few Buttons

Through the Custom Control Assignment menu option, you can specify what action you want the camera to take when you press the Fn1, Fn2, and AE-L/AF-L buttons during still photography. You also can choose what happens when you press any of those buttons, the BKT button, or the movie-record button while rotating the Main command dial.

To set things up, display the Custom Settings menu, choose Controls, and then select Custom Control Assignment, as shown in Figure 11-14. During view-finder photography, you also can choose the option from the *i*-button menu.

Either way, you see the screen shown on the left in Figure 11-15. Don't panic — it's not as complicated as it seems. Here's what you need to know:

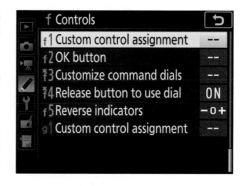

FIGURE 11-14:
Select Custom Control Assignment to begin the button customization process.

>> **Checking the current settings:** The table on the right side of the screen shows the current button and button-plus-dial assignments. The semi-circle with arrow symbol represents the Main command dial; Off means that no job is assigned. Notice that two buttons, BKT and the Movie-record button, can only be assigned a task that includes the Main command dial. (Pressing the BKT button by itself always brings up autobracketing settings, and pressing the Movie-record button by itself starts and stops recording.)

One button or button + dial combo is highlighted in yellow. In the figure, the Fn1 button is highlighted, for example. A text label naming the button and its assignment appears in the upper-left corner of the screen to help you decode the symbols. Additionally, the yellow circle in the camera graphic shows the location of the selected button. Use the Multi Selector to highlight a different button or button + dial combo.

>> **Changing a function:** To establish a different function for a button or button + dial combo, tap its symbol in the table (or highlight it and press the OK button). The camera displays a list of possible jobs you can assign. For example, the right side of Figure 11-15 shows settings for the Fn1 button.

Not sure what a setting does? On screens that display the question mark symbol, tap the symbol or press the Help button to display an information screen. The camera's user guide offers additional details on the available settings.

When you're satisfied with all your function assignments, return to the left screen in Figure 11-15. Then press the Menu button or tap Done to lock in your choices and exit the screen.

FIGURE 11-15: Select the button you want to customize (left) and then choose the function you want it to perform (right).

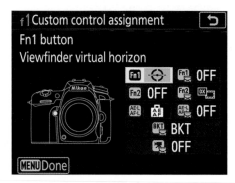 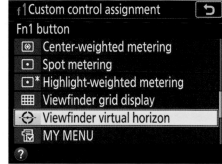

You also can customize four buttons — Fn1, Fn2, AE-L/AE-F, and the shutter button — for movie recording. To explore these options, open the Custom Setting menu, choose Movie, and select Custom Control Assignment. You then see the setup screen. Although you get fewer customization options for movie recording than for still photography, setting the button functions works as just described. The next section offers details about setting the function of the shutter button during movie recording.

Modifying the Role of the Shutter Button

Getting a headache considering all the ways you can customize buttons and dials? Me, too. Remember, you *wanted* an advanced camera. The good news is that only one more button, the shutter button, requires discussion. You can set the button to perform the following functions:

>> **Lock exposure.** Normally, pressing the shutter button halfway initiates autofocusing and exposure metering, but the camera adjusts exposure settings up to the time you take the picture.

To set the button to lock exposure and focus, open the Custom Setting menu, choose Timers/AE Lock, and choose Shutter-Release Button AE-L. Choose from two settings: ON (half press) locks exposure when you press the button halfway. ON (burst mode) enables this shutter-button feature only when you use one of the Continuous Release modes.

>> **Use the shutter button to start/stop movie recording.** By default, pressing the button during movie recording ends the recording and captures a still photograph. You can instead choose to use the button to start and stop movie recording. To make this change, choose Custom Control Assignment from the Movie section of the Custom Setting menu. Select the Shutter Button option and then change the setting from Take Photos to Record Movies.

If you take this step, press the shutter button halfway to fire up the Live View display when the camera is in Movie mode. Release the button and press halfway again to autofocus. Press the button all the way down to start recording; press again to stop recording.

Adjusting Automatic Shutdown Timing

To save battery power, your camera automatically shuts off the exposure meter, viewfinder display, and monitor after a period of inactivity. You can specify how long you want the camera to wait before taking this step through the following options, both found on the Timers/AE Lock portion of the Custom Setting menu:

>> **Standby Timer:** Controls the exposure meter and viewfinder display shutoff.

>> **Monitor Off Delay:** Determines monitor shutoff for picture playback, menu displays, the Information display, Live View display, and Image Review.

Chapter **12**

Ten Features to Explore on a Rainy Day

Consider this chapter the literary equivalent of the end of an infomercial — the part where the host exclaims, "But wait! There's more!" Features covered here aren't the sort that drive people to choose one camera over another, and they may come in handy only on certain occasions. Still, they're included at no extra charge, so check 'em out when you have a few spare moments.

If this chapter is your first foray into the book, note that I don't include basic operation details, such as how to display and navigate menus here. Check out Chapter 1 for those fundamentals if you need help.

Investigating the Retouch Menu

Through the Retouch menu, you can do simple photo editing in the camera. It's a no-risk proposition: The camera doesn't alter your original file; it makes a copy and applies changes to the copy only. Here are the basics you need to know to get started:

» **Accessing retouching tools:** You can take two routes:

- *Retouch menu:* Display the Retouch menu, shown on the left in Figure 12-1. (More tools await on the menu's second and third pages.) Select a tool and

press OK to display image thumbnails, as shown on the right in the figure. Select the image you want to edit by tapping it or by using the Multi Selector to move the yellow box over it. Then tap the OK symbol or press the OK button to display options related to the chosen retouching tool.

FIGURE 12-1:
After selecting a Retouch menu option (left), select the photo you want to edit (right).

- *Playback **i**-button menu:* In Playback mode, select the photo you want to alter, press the **i** button, and choose Retouch to display the Retouch menu over your photo. Select a tool and press OK to access the tool settings.

 You can't use the **i**-button menu to access one tool, Image Overlay. See "Two roads to a multi-image exposure," later in this chapter, for details about this feature.

- >> **Determining which files can be edited:** If the camera can't apply the selected tool, it displays an X over the thumbnail, as shown on the right in Figure 12-1, or dims or hides the tool on the Retouch menu. A file or tool may be off-limits for these reasons:

 - *The tool isn't relevant to the current file.* For example, the Straighten tool I selected doesn't work on movie files, so the X appears over the movie file in the figure. (Movie files are indicated by a dotted border.) In fact, the only Retouch menu option available for movies is Edit Movie. And if you took a portrait without using flash, the Red-Eye Reduction tool isn't available — the camera is smart enough to know that you won't need it.

 - *You previously applied a tool that prevents further editing.* You can apply multiple tools to the same original, but you need to be careful in what order you use them because some tools produce a file that can't be

altered. After you use the Trim tool to crop your image, for example, you can't do anything else to the cropped version. A Retouch symbol, shown on the right in Figure 12-1, indicates an edited file. (I mention tools that prevent further adjustments as I detail them in this chapter.)

» **Adjusting tool settings:** After you select certain tools, you see a preview of your image along with options that enable you to adjust the tool effect. You can find details on settings available for the Resize and NEF (Raw Processing) tools in Chapter 10; Chapter 8 discusses the Edit Movie options. In this chapter, I explain options for other tools that are especially useful, complicated, or both.

QUAL

» **Get a bigger preview:** If the Zoom symbol appears at the bottom of a screen, press the Zoom In button or tap the Zoom symbol to magnify the image. Release the button or tap the exit arrow in the top-right corner of the screen to exit the magnified view.

» **Saving the edited copy:** Unless I specify otherwise, tap the OK Save symbol at the bottom of an editing screen or press the OK button to finalize edits and save the edited copy. The file is saved in the JPEG format, using the same Image Quality setting as the original. If you began with a Raw image, the JPEG version is saved using the Fine setting. (Again, Image Overlay is the exception: It combines two Raw files to create a new Raw file.)

The retouched image is assigned the next available file number. Make note of the number so that you can find the image later.

TIP

» **Compare the original and retouched image:** Put the camera in playback mode and display the original or retouched image. Then press the *i* button, choose Retouch, and select Side-by-Side Comparison, as shown in Figure 12-2. (You can't get to this feature via the standard Retouch menu; you must use the Playback mode version of the *i*-button menu.)

FIGURE 12-2:
The Side-by-Side Comparison option is available only when you display the Retouch menu through the *i*-button menu.

A screen similar to the one shown in Figure 12-3 appears, with your original on the left and the edited version on the right. A text label indicates the tool used to create the edited version.

The yellow box indicates the selected image. Select the other image by using the Multi Selector. You can then tap Zoom or press the Zoom In button to study the selected image at a larger size. Release the button or tap the exit arrow to return to the side-by-side view.

When the retouched version is selected, you can also use these tricks:

- If you applied more than one tool to the picture, press the Multi Selector right and left to display thumbnails that show how each tool affected the image.

- If you created multiple edited copies of the photo, press the Multi Selector up and down to scroll through them.

To return to normal playback, select the image you want to display (the original or the altered version). Then press the Playback button.

FIGURE 12-3:
The left image is your original; the right, the retouched version.

Straightening Crooked and Distorted Photos

The following Retouch menu tools enable you to level a tilting horizon line, eliminate lens distortion, and correct perspective.

» **Leveling the horizon (Straighten tool):** Despite my best efforts, my landscape and architectural photos rarely feature a level horizon line. I don't understand why I can't "shoot straight." All I know is that I'm glad that I can use the Straighten tool to rotate the picture to level.

After you select the Straighten tool, an alignment grid appears over your photo, as shown in Figure 12-4. The yellow marker under the scale at the bottom of the screen shows the direction and amount of rotation. To move the marker, drag left or right on the scale or press the Multi Selector right or left. You can achieve a maximum rotation of 5 degrees.

FIGURE 12-4:
The Straighten tool offers a quick and easy way to fix a tilted horizon line.

» **Removing barrel and pincushion distortion (Distortion Control tool):**
Certain lenses create *barrel distortion,* in which objects at the center of a
picture appear to be magnified and pushed outward — as if you wrapped the
photo around the outside of a barrel. *Pincushion distortion* produces the
opposite result, making center objects appear smaller and farther away.

Your camera offers two anti-distortion features. The Auto Distortion Control
option on the Photo Shooting menu is designed to correct distortion as the
picture is recorded to the memory card; the Distortion Control tool on the
Retouch menu is available for post-capture editing.

The Retouch menu version provides two settings:

- *Auto:* This option, like the Auto Distortion Control feature on the Photo
 Shooting menu, is available for certain lenses. If the camera recognizes your
 lens, it attempts to correct distortion based on its knowledge of the lens.

- *Manual:* If the Auto option is dimmed or you prefer to do the correction on your
 own, select Manual. A scale indicating the degree and direction of the correction
 appears under the photo. Use the Multi Selector to move the yellow marker
 along the scale until you remove as much distortion as possible.

» **Correcting convergence (Perspective Control tool):** When you photograph
a tall building and tilt the camera upward to fit it all into the frame, an effect
known as *convergence* occurs, causing vertical structures to tilt toward the
center of the frame. Buildings sometimes even appear to be falling away from
you, as shown in the left image in Figure 12-5. If the lens is tilting down,
vertical structures lean outward, and the building appears to be falling toward
you. Either way, try applying the Perspective Control tool. I used the tool to
produce the right image in Figure 12-6.

After you select the tool, you see a grid over your photo and a horizontal and
vertical scale at the bottom and left edges of the screen. Drag left or right on the
bottom scale (or press the Multi Selector left and right) to move the out-of-
whack structure horizontally. Drag up and down on the vertical scale or press
the Multi Selector up and down to rotate the object toward or away from you.

| Original | After Perspective Control applied |

FIGURE 12-5:
The original
photo
exhibited
convergence
(left); applying
the Perspec-
tive Control
filter corrected
the problem
(right).

WARNING

One important detail about these tools: In order for the camera to perform this magic, it actually distorts the original, tugging the corners this way and that to get things in proper alignment. This distortion produces an irregularly shaped image, which then must be cropped and enlarged or reduced to create a copy that has the same pixel dimensions as the original. That's why the After photo in Figure 12-5 contains slightly less subject matter than the original. (The same cropping occurs if you make these changes in a photo editor.) Framing your originals a little loosely ensures that you don't lose important parts of the image due to the adjustment.

Manipulating Exposure and Color

Chapters 4 and 6 explain picture-taking settings that affect exposure and color. Of course, it's best to nail down these characteristics as you shoot, but if things go awry, you can make minor modifications through these Retouch tools:

>> **D-Lighting:** Chapter 4 explains Active D-Lighting, an exposure setting which brightens too-dark shadows in a way that leaves highlight details intact. You can apply a similar adjustment to an existing photo by choosing D-Lighting from the Retouch menu. I used this tool on the photo in Figure 12-6, where strong back-lighting left the balloon underexposed in the original image. After you choose the option, an Effect setting appears; adjust the setting to specify the strength of the adjustment. I used the maximum Effect level for the balloon image.

Original image　　　　　　　　D-Lighting, High

FIGURE 12-6:
The D-Lighting tool brightens shadows without affecting highlights.

WARNING

You can't apply this tool to pictures taken using the Monochrome Picture Control. Nor does D-Lighting work on pictures to which you previously applied the Quick Retouch tool, explained next, or Monochrome tool, detailed later.

>> **Quick Retouch:** This filter increases contrast and color saturation and, if your subject is backlit, also applies a D-Lighting adjustment to restore some shadow detail that otherwise might be lost. As with D-Lighting, you can choose from three levels of Quick Retouch correction. And the same restrictions apply: You can't apply the filter to monochrome images or to pictures that you adjusted via D-Lighting.

>> **Red-Eye Correction:** For flash portraits marred by red-eye, give this tool a whirl, which replaces the red pixels with more suitably colored ones.

>> **Filter Effects:** This Retouch menu option gives you access to tools designed to mimic traditional lens filters. The first two are color-manipulation filters, which work like so:

- *Skylight filter:* Reduces the amount of blue to create a subtle warming effect.

- *Warm filter:* Produces a warming effect that's just a bit stronger than the Skylight filter.

After you choose either tool, the camera displays a preview of your photo with the effect applied. Both tools produce minimal color shift, and neither enables you to adjust the strength of the effect. And to answer your question, no, you can't apply the filter several times in a row to produce a stronger effect.

The other two filters on the Filter Effects submenu, Cross Screen and Soft, are special-effects filters. I describe both later in this chapter.

>> **Monochrome:** Choose this tool to create a black-and-white, sepia, or cyanotype (blue and white) copy of color photo. For the sepia and cyanotype tools, you can adjust the intensity of the tint by pressing the Multi Selector up and down.

After creating your monochrome image, you can't apply the D-Lighting, Quick Retouch, and Soft tools to it. Obviously, color adjustments such as the Warm and Skylight filter are also no longer available. So if you want to apply any of those tools to your image, use them before the Monochrome tool.

Cropping Your Photo

To *crop* a photo means to trim away some of its perimeter. Cropping can often improve an image, as illustrated by Figure 12-7. When shooting this scene, I couldn't get close enough to fill the frame with the ducks, as shown on the left. So I cropped the image after the fact to achieve the composition on the right.

FIGURE 12-7: Cropping creates a better composition and eliminates background clutter.

WARNING

The Trim tool enables you to crop right in the camera. However, always make this your *last* editing step because you can't alter the cropped version using any other Retouch menu tools.

After you select Trim from the Retouch menu, you see the screen shown in Figure 12-8. The yellow box represents the crop frame, which you can adjust as follows:

>> **Set the crop aspect ratio.** You can crop to one of five aspect ratios: 3:2, 4:3, 5:4, 1:1, and 16:9. The current aspect ratio appears in the upper-right corner of the screen. To cycle through the other settings, rotate the Main command dial.

>> **Adjust the crop frame size.** For each aspect ratio, you can choose from a variety of crop sizes, which depend on the size of the original. Sizes are stated in pixels, with the current size displayed in the upper-left corner of the screen.

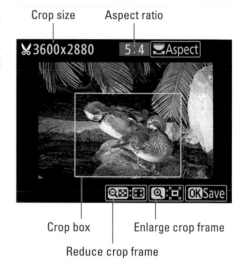

Crop size Aspect ratio

Crop box Enlarge crop frame

Reduce crop frame

FIGURE 12-8: The yellow box indicates the cropping frame.

Use these techniques to change the crop-frame size:

● *Shrink the cropping frame.* Tap the Reduce symbol, labeled in the figure, or press and release the Zoom Out button. Each tap or button press further reduces the crop size.

● *Enlarge the cropping frame.* Tap the Enlarge symbol, also labeled in Figure 12-8, or press the Zoom In button.

QUAL

If you're cropping in advance of printing the image, remember that to generate a good print, you need about 300 pixels per linear inch of the print — 1200 x 1800 pixels for a 4 x 6 print, for example. So keep an eye on the pixel count shown in the upper-left corner of the screen as you set the size of the crop frame.

>> **Reposition the cropping frame.** Press the Multi Selector up, down, right, or left. Or just drag the frame around on the screen.

When you view cropped images in Playback mode, a scissors symbol appears in the lower-right corner of the frame. You also see the Retouch symbol that shows up on every edited photo.

Three Ways to Play with Special Effects

In addition to practical photo-correction tools, the Retouch menu offers some special-effects tools. You also can add effects as you shoot by using the Effects exposure mode. The next three sections explain these two features plus one additional special effect that you can achieve through the Photo Shooting menu or Retouch menu.

Applying Retouch menu effects

For after-the-shot effects, try these Retouch menu options:

>> **Fisheye:** Apply this tool to distort the image so that it appears to have been taken with a fisheye lens.

>> **Cross Screen:** This tool adds a starburst effect to the brightest part of the image. To access it, choose the Filter Effects option on the Retouch menu.

>> **Soft:** Also accessed via the Filter Effects option, the Soft filter blurs your photo to give it a dreamy, watercolor-like look.

>> **Color Outline:** Select this option from the Retouch menu to turn your photo into a black-and-white line drawing. (And please don't ask me why this filter isn't called Black-and-White Outline.)

>> **Photo Illustration:** This effect produces a cross between a photo and a bold, color drawing.

>> **Color Sketch:** This filter creates an image similar to a drawing done in colored pencils.

>> **Miniature Effect:** Have you ever seen an architect's small-scale models of planned developments? The Miniature Effect filter attempts to create a photographic equivalent by applying a strong blur to all but one portion of an image. When you apply the filter, you indicate the area you want to keep in focus by moving a yellow frame over that part of the photo. Figure 12-9 offers an example. The left photo is the original; the right shows the result of keeping focus sharp in the part of the street occupied by the cars.

Original

Miniature Effect filter

FIGURE 12-9: The Miniature Effect filter throws all but a small portion of a scene into very soft focus.

TIP

The Miniature Effect filter works best if you shoot your subject from a high angle — otherwise, you don't get the miniaturization result.

>> **Selective Color:** This effect *desaturates* (removes color from) parts of a photo while leaving specific colors intact. For example, in an image of a red rose against a green background, you might desaturate the background and leave only the rose petals in color.

TIP

This tool is not only less than intuitive to use, but also makes it difficult to precisely adjust only specific parts of the image. Have fun experimenting, but realize that to create this effect successfully, you need to do the job in a photo-editing program that enables you to select the parts of the photo you want to change.

>> **Painting:** The last special effect on the Retouch menu, this one produces a vividly colored, loosely rendered version of your photo.

Shooting in Effects mode

When you set the Mode dial to Effects, as shown in Figure 12-10, you can apply special effects while shooting.

For still photos, I prefer to capture my originals sans effect and then work from the Retouch menu to alter them. That way, I wind up with one normal image and one with the effect applied, just in case I decide that I prefer the unaltered photo to the effects version. Shooting in Effects mode also brings up another problem: To create the effects, the camera puts most picture-taking controls, such as White Balance and Metering mode, off-limits. For most effects, you also must choose one of the JPEG Image Quality settings; Raw shooting is unavailable except when you choose the Silhouette, High Key, or Low Key effects. (See Chapter 2 to explore the issue of JPEG versus Raw.)

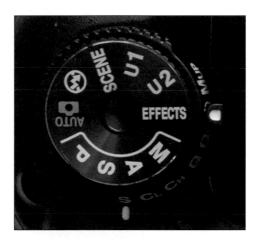

FIGURE 12-10:
Effects mode lets you apply special effects to movies and still photos.

However, Effects mode does offer some artistic filters not available on the Retouch menu. In addition, it enables you to add effects to movies, which isn't possible from the Retouch menu. So even though I suspect that you won't find a use for Effects mode very often, I'd be remiss if I didn't spend a little time discussing it.

TIP

The best way to take advantage of Effects mode is to turn on Live View. You have to use Live View to shoot movies anyway, but it's beneficial for still photography, too. Several effects offer settings you can tweak to alter the result, and you can get to those settings only in Live View mode. Live View also enables you to preview the selected effect.

To shoot stills, move the Live View switch to the position shown in Figure 12-11. For movie recording, set the switch to the movie-camera symbol. Then press the Live View (LV) button to engage Live View.

As soon as you set the Mode dial to Effects and engage Live View, an icon representing the currently selected effect appears in the upper-left corner of the display, as shown in Figure 12-11. To choose a different effect, rotate the Main command dial. A ribbon containing icons representing each effect appears near the top of the screen, as shown on the left in Figure 12-12. To scroll through the available effects, rotate the Command dial. The preview updates each time you scroll to a new setting.

If an effect offers tools for altering the final look of the image, you see an OK Set symbol near the bottom of the frame, as shown in the figure.

Effects mode symbol

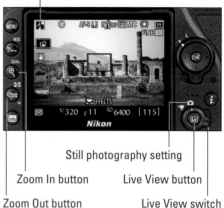

Still photography setting

Zoom In button Live View button

Zoom Out button Live View switch

FIGURE 12-11:
Set the camera to Live View mode to access Effects mode adjustments or to apply effects when recording movies.

FIGURE 12-12:
Rotate the Main command dial to scroll through available effects (left); the OK Set symbol tells you that you can adjust the impact of the effect (right).

When you find an effect you like, press the shutter button halfway and release it to return to shooting mode. If an effect offers adjustments, tap the OK Set symbol or press the OK button to display a screen containing the adjustment controls. For example, the Photo Illustration effect offers the single control shown on the right in Figure 12-12. As you change the setting, the preview updates to show how the new setting affects the image. Usually, you adjust options by moving a marker along a bar like the one shown in the figure. Press the Multi Selector right to make that happen. You can also tap the bar to place the marker at the spot you tap.

After making your adjustments, tap OK Done or press OK to return to the live preview. (If you see the OK Set sign on the preview, you can tap it at any time to readjust the effect settings.)

Now for a review of the various effects:

>> **Night Vision:** Use this setting in low-light situations to produce a grainy, black-and-white image.

>> **Super Vivid:** Choose this setting for hypersaturated, super-contrasty images.

>> **Pop:** One step less intense than Super Vivid, this mode amps up saturation only.

>> **Photo Illustration:** This setting produces a bright, poster-like effect.

Autofocusing is not available during movie recording in this mode. Additionally, the resulting movie looks more like a slide show made up of still images than a standard movie.

>> **Toy Camera Effect:** This mode creates a photo or movie that looks like it was shot by a toy camera — specifically, the type of toy camera that produces images that have a vignette effect (corners of the scene appear darker than the rest of the image). In Live View mode, you can adjust two options: Vividness, which affects color intensity; and Vignetting, which controls the amount of vignetting.

>> **Miniature Effect:** This one is a duplicate of the one on the Retouch menu; refer to Figure 12-9 for an example of the result. Again, the filter works by blurring all but a small portion of the scene, which you specify by positioning the red focus frame that appears in Live View mode.

To set up this effect, press OK or tap the OK icon to display horizontal markings that indicate the width of the sharp-focus region. Use the Multi Selector or touchscreen controls at the bottom of the screen to adjust the width and position of the in-focus region. When you achieve the look you want, press or tap OK again.

A few limitations apply: Flash is disabled, as is the AF-assist lamp. If you use the Continuous Release mode, the frames per second rate is reduced. When autofocusing, you can't use any AF-area mode except Single-point. (Chapter 4 discusses this autofocus option.)

For movies, sound recording is disabled, autofocus is disabled during recording, and movies play back at high speed. (The high-speed playback means a movie that contains about 45 minutes of footage is compressed into a 3-minute clip, for example.)

>> **Selective Color:** Like the Selective Color filter on the Retouch menu, this effect enables you to desaturate (turn black and white) all but a few colors. And as with the Retouch menu filter, the Effects mode version is complex to use — even more so, in fact — and doesn't give you enough control to precisely

desaturate just the colors you want to alter. If I were you, I wouldn't waste my time; instead, shoot the photo in a regular exposure mode and then create the effect in a photo-editing program that offers tools that make it easier to control which part of your photo is affected by the desaturation.

>> **Silhouette:** Choosing this setting ensures that backlit subjects will be captured as dark silhouettes against a bright background. To help ensure that the subject is dark, flash is disabled.

>> **High Key:** A *high key* photo is dominated by white or very light areas, such as a white china cup resting on a white doily in front of a sunny window. This setting is designed to produce a good exposure for this type of scene, which the camera otherwise tends to underexpose in response to all the high brightness values. Flash is disabled.

>> **Low Key:** The opposite of a high key photo, a low key photo is dominated by shadows. Use this mode to prevent the camera from brightening the scene too much and thereby losing the dark and dramatic nature of the image. Flash is disabled.

After selecting an effect and setting any adjustments available for the effect, you can exit Live View to take the picture using the viewfinder if you prefer. To record a movie, remain in Live View mode and press the red movie-record button on top of the camera to stop and start recording.

Two roads to a multi-image exposure

Two camera features combine multiple photographs into one:

>> **Multiple Exposure (Photo Shooting menu):** With this option, you can combine your next 2-10 shots. After you enable the option and take your shots, the camera merges them into one file. The Multiple Exposure option is available only when you shoot in the P, S, A, or M exposure modes and isn't available in Live View mode at all.

>> **Image Overlay (Retouch menu):** This option, available only through the regular Retouch menu (and not the Playback version of the *i*-button menu), enables you to merge two existing Raw images to create a third Raw image. I used this option to combine a photo of a werewolf friend, shown on the left in Figure 12-13, with a nighttime garden scene, shown in the center. The result is the ghostly image shown on the right. Oooh, scary!

FIGURE 12-13:
Image Overlay
merges two
Raw (NEF)
photos
into one.

On the surface, both options sound cool. The problem is that you can't control the opacity or positioning of the images in the combined photo. For example, my overlay picture would have been more successful if I could move the werewolf to the left in the combined image so that he and the lantern aren't blended. And I'd also prefer to keep the background of image 2 at full opacity in the overlay image rather than getting a 50/50 mix of that background and the one in image 1, which creates a fuzzy-looking background.

However, there is one useful effect that you can create with either option: a "two views" composite like the one in Figure 12-14. For this image, I used Image Overlay to combine the front and rear views of the antique match striker into the composite scene.

FIGURE 12-14:
If you want
each subject to
appear solid,
use a black
background
and position
the subjects so
that they don't
overlap.

REMEMBER

For this trick to work, the background in both images must be the same solid color (black seems to be best), and you must compose each photo so that the subjects don't overlap in the combined image, as shown here.

I don't recommend using Image Overlay or Multiple Exposure for serious photo compositing. Instead, do this work in your photo-editing software, where you have more control over the blend. In the interest of reserving space for features that I think you will find much more useful, I leave you to explore these two features on your own. The camera manual offers details on both options.

Creating a Dust Reference File

If you notice spots appearing in the same place on every photo, even after you have cleaned your lens, they're likely caused by dust that made its way onto the camera's image sensor. The best remedy is to take your camera to a qualified technician for sensor cleaning, but until you have time to do that, the Image Dust Off Ref Photo option on the Setup menu may be helpful.

Here's how it works: You shoot a picture of a blank piece of paper, the idea being that only the dust spots will show up in the resulting image. You then load that image into Nikon Capture NX-D, one of the Nikon programs I introduce in Chapter 9. From the reference image, the program creates a file noting the position of the dust spots. When you open a photo in Capture NX-D, you enable the program's Image Dust Off tool, which applies some corrective magic to the dust spots, consulting the reference file to know where those spots are located.

Unfortunately, the tool works only on photos that you shoot in the Raw format and isn't always successful. Still, it's worth trying. For details, see the camera instruction manual.

Connecting Your Camera to an HDTV

Your camera is equipped with a feature that enables you to connect it to an HDMI television or monitor so that when you set the camera to playback mode, you can view your pictures on a large screen. If the camera is in Live View mode, the preview appears on the TV.

To connect the two devices, you need a Type C mini-pin HD cable. Nikon doesn't make its own cable, so just look for a quality third-party version. Next, set HD preferences by opening the Setup menu and choosing HDMI. You're offered these options:

>> **Output Resolution:** By default, the camera decides the proper HD video resolution to send to the TV after you connect the two devices. But you can also choose a specific resolution through this option.

>> **Advanced:** Choose this option to reveal the following settings, which control a few more aspects of how the camera feeds the video signal to the TV.

- *Output Range* and *Output Display Size:* Leave these two settings at their defaults unless your TV manual suggests otherwise. The Output Range setting controls the range of brightness levels in the video picture; the

Output Display Size option determines whether the camera slightly reduces the dimensions of the display to ensure that everything is visible on your monitor.

- *Live View On-screen Display:* Turn this option on to display the data that normally appears on the camera monitor during Live View shooting.

- *Dual Monitor:* Enable this option to view the display both on the camera monitor and the HD screen.

After you select the necessary Setup menu options, turn off the camera, and look for the HDMI-out port on the left side of the camera, as shown in Figure 12-15.

At this point, I need to rely on you (or your favorite media tech person) to figure out where to connect the other end of the HD cable. You may need to connect it directly to the TV or to another HD-input device that's part of your system. You may also need to change certain input settings on your TV or other HD device. When everything's good to go, turn on your camera to send the signal to the TV set. Control playback using the on-camera controls. The only exception is that when you play movies, you must use the TV's remote control to adjust sound volume.

HDMI-out port

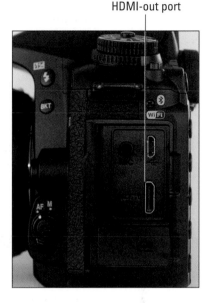

FIGURE 12-15:
The HDMI-out port is located here.

Creating a Digital Slide Show

The Slide Show feature automatically displays photos and movies one by one.

REMEMBER

Which files are included in the show depend on the setting of the Playback Folder option on the Playback menu. Additionally, any pictures that you hid through the Hide Image function do not appear. Chapter 9 explains more about choosing which folders you want to view; Chapter 10 details the Hide Image feature.

Follow these steps to present a slide show:

1. **Display the Playback menu and select Slide Show, as shown on the left in Figure 12-16.**

 You see the screen shown on the right in the figure.

FIGURE 12-16:
Choose Slide
Show to set
up automatic
playback of
pictures and
movies.

2. **Set the Image Type option, set the Frame Interval Option, and press OK.**

 Select Image Type to specify whether you want the show to include photographs and movies, photos only, or movies only. The Frame Interval option determines how long each image will be displayed. (Movies always play in their entirety.)

3. **To begin playing the show, select Start.**

 To pause the show, press OK; to resume playback, choose Restart. To exit the show before it ends, press the Playback button.

 When the show ends, you're given the option to restart the show, adjust the frame interval, or exit to the Playback menu.

Intro to Nikon SnapBridge

Your D7500 enables you to connect your camera wirelessly to a smartphone or tablet. After establishing the connection, you upload photos to the device, making it easy to then share them via social media. You also can use your smart device as a wireless remote control.

To enjoy these features, you must install the Nikon SnapBridge app on your smart device. The app is free, but is available only for devices that run recent versions of the Android OS (operating system) or Apple iOS. Visit Google Play for Android apps; go the App Store for iOS apps. The current OS requirements appear on the download page for that app.

Your smart device also must offer Bluetooth low-energy (BLE), a special Bluetooth feature that minimizes the battery power required to handle wireless data transmission. (Look for Bluetooth version 4.0 or later.)

I can't provide detailed instructions for using SnapBridge because things vary depending on your device and its operating system. In addition, when Nikon issues updates to the app — which it is likely to do as it introduces new cameras that offer SnapBridge support — some aspects of the app itself may change. As I write this, the most current versions of the SnapBridge app are 1.3.1.3 for Android and Version 1.3.0 for iOS.

That said, this appendix provides you with some general guidance in taking advantage of SnapBridge. For additional help, including tutorials that explain setup steps and features, point your web browser to www.snapbridge.nikon.com.

What Can I Do with SnapBridge?

Here are the most useful functions that SnapBridge offers:

>> **Transfer photos and movies from the camera to your smart device for viewing or uploading to the Internet.** You can transfer full-resolution

images or smaller versions that are 2MB in size (which is plenty large for online sharing). In either case, the camera sends copies of your images; your originals remain on your memory card. Unfortunately, this feature doesn't work with photos that you capture in the RAW (NEF) file format.

>> **Use your smart device as a wireless remote control.** When the camera and device are connected, the device's screen becomes an extension of the camera's Live View display. You can set focus, view a few camera settings, and then tap a button on the device to trigger the camera's shutter release.

>> **Ship photos to Nikon Image Space.** Your D7500 purchase entitles you to a free account at Nikon Image Space, an online photo storage and sharing site. After registering for an account at the site (www.nikonimagespace.com), you can use SnapBridge to upload transferred files to your Image Space gallery. You also can connect to the website via your computer and upload photos from your hard drive or other storage device.

If you use Image Space, you may want to download its standalone app, also free and available for iOS and Android devices. The app enables you to view, organize, and share your Image Space files.

>> **Add credits and other text information to photos that you transfer to the device.** You can add a copyright notice, the location and date and time, a logo, or certain bits of shooting data (shutter speed, ISO, and so on). This data is attached only to the transferred images.

TIP

You also can use options on the camera's Setup menu to tag files with comments and copyright notices. Going that route adds the data to all new photos you shoot. See Chapter 10 to find out more.

Reviewing Basic Connection Steps

After you open the SnapBridge app, the features are the same, although laid out on the screen a little differently. (The last section of this chapter takes you on a tour of the app.) The process of connecting your camera to your device is a different story altogether, with specific steps depending on your device, whether it uses the iOS or Android operating system (OS), and which version of that OS it uses. So consider the following steps just a generic overview of the process and consult the SnapBridge help site and the camera manual for help if you need it.

1. **On your smart device, enable Bluetooth and Wi-Fi.**

 Usually, you accomplish both steps through the device's Settings screen.

2. **Display the camera's Setup menu and scroll to the page shown on the left in Figure A-1.**

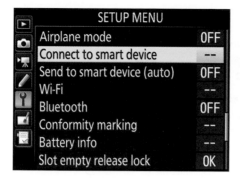

FIGURE A-1:
Choose
Connect to
Smart Device
from the Setup
menu to begin
the connection
process.

3. **Set the Airplane Mode option to Off.**

Turning on Airplane Mode disables the camera's wireless features.

4. **Choose Connect to Smart Device.**

5. **Choose Start.**

You see a welcome screen, followed quickly by a screen that tells you to use SnapBridge to connect to your smart device. Press the OK button or tap OK. The screen shown in Figure A-2 appears, prompting you to start SmartBridge on your device. Don't take that step until you see this screen, or the two devices may have trouble finding each other.

FIGURE A-2:
Wait until you see this screen to start SnapBridge on your device.

6. **Open SnapBridge on your smart device.**

The device searches for your camera and then displays the camera name on the app screen. When prompted, tap the camera name.

7. **Wait for a pairing request to appear.**

When the app is ready to connect your camera and smart device, you see a pairing request on the device. On the camera, you see the screen shown in Figure A-3. It displays an authorization code, which should match the one showing on your device. If the codes don't match,

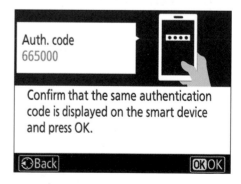

FIGURE A-3:
After confirming that the code shown on the camera matches the one on your device, choose OK on the camera and on the device.

your device may be trying to connect to another nearby D7500. The odds of that happening aren't great, but you can tap the Back button or press the Multi Selector left to exit the connection screen on the camera if it does.

8. **If the pairing codes match, give both devices the go-ahead.**

 On the camera, press the OK button or tap OK at the bottom of the display. Also answer in the affirmative on the device.

If all went well, the camera displays the screen shown in Figure A-4, telling you that the two devices are linked. If this is the first time you've connected them, the camera presents two more screens, one asking whether you want to download location data from the smart device and one asking whether you want to sync the camera clock with the one on the smart device. (You can adjust these options later.)

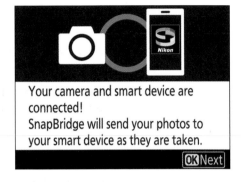

FIGURE A-4:
When you see this screen, tap OK or press the OK button.

Keep in mind that these steps just establish a Bluetooth connection, which enables the camera to talk to SnapBridge. To use certain SnapBridge features, you have to also establish a Wi-Fi connection. Nikon seems to have done a good job of making that process fairly automatic; see the next section for information about the Wi-Fi option on the camera that sets up that part of the connection.

One last word about the connection process: In my experience, the camera-connection process isn't always reliable, and it's difficult to sort out where the issue lies. My best advice is to uninstall the app, reinstall it, and start fresh. If you previously connected but can't seem to reconnect, another fix that sometimes works is to visit your device's Bluetooth and Wi-Fi connection settings, locate the camera name, and then choose Forget This Device (the specific name of that option may be slightly different depending on your device's operating system).

Reviewing Camera Options

To customize the way that the camera interacts with your smart device, open the Setup menu and make your way through the following options:

>> **Location Data:** Look for this option on the screen that comes just before the one shown on the left in Figure A-1. When Location Data is enabled,

SnapBridge sends the device's GPS coordinates to the camera. That information is added as *metadata* (hidden text data) to pictures or movies you record. The data is added as long as the devices are connected and for two hours after you break the connection. Keep in mind that in order for this feature to work, you must enable location services on your smart device.

You can view a picture's location data in some camera playback modes (see Chapter 9) and in programs and apps that can read metadata.

>> **Airplane Mode:** Set this option to On to disable wireless transmission from the camera, as you might when, say, on an airplane. The feature is disabled by default.

If you use Eye-Fi memory cards, turning on Airplane mode also shuts down wireless transmission from the cards.

>> **Connect to Smart Device:** Choose this setting to start the process of connecting your camera to your phone or tablet. The preceding section spells out the steps involved.

One option I didn't cover: If you want to set up a password to ensure that no one else can connect to your camera, select this menu option and then choose Password Protection. You then have to enter that password on your smart device to connect to the camera.

>> **Send to Smart Device (Auto):** Select On if you want the camera to automatically send all new photos you shoot to your smart device. Turn the feature off if you prefer to select specific pictures to send to the device. See the next section for information on how to tag pictures for transfer.

>> **Wi-Fi:** When you use certain SnapBridge features, including using the smart device as a remote control, the camera establishes a *peer-to-peer* Wi-Fi connection between the devices. That simply means that the two devices talk to each other via a private Wi-Fi network that is provided by the camera. When you use these functions, you're prompted to select the camera network on your smart device. You then have to enter a password on the smart device; by default, the password is NIKOND7500.

If you're a networking guru and want to alter the password or otherwise change how the Wi-Fi connection is established, first turn off the camera's Bluetooth transmission via the Bluetooth option on the Setup menu. Then select Wi-Fi, choose Network Settings, and dig in. To view the settings that are currently in force, choose Current Settings. And after your "helpful" techy friend fiddles with settings so much that you can't connect via Wi-Fi any more, choose Reset Connection Settings.

>> **Bluetooth:** Choose this option to turn Bluetooth functionality on or off, to see a list of devices currently paired with the camera, and to choose whether you want the connection to remain on even after you turn off the camera.

Selecting Specific Photos for Transfer

While viewing photos in SnapBridge, you can use options built into the app to select files that you want to transfer to the device. You also can tag photos for transfer before connecting your camera to the device. I prefer that option because I don't have to have both devices powered up during the process.

Here's how to take advantage of in-camera tagging:

>> **Select a batch of photos for transfer:** To tag multiple photos at a time, open the Playback menu and choose Select to Send to Smart Device, as shown on the left in Figure A-5. On the next screen, choose Select Image(s), as shown on the right in the figure. You then see thumbnails of your files, as shown in Figure A-6.

FIGURE A-5: To select multiple files for transfer, select these Playback menu options.

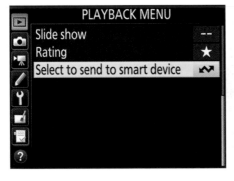

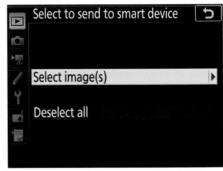

Select the first photo you want to transfer by tapping its thumbnail or by using the Multi Selector to move the yellow selection box over it. Then tap Set or press the Zoom Out button. The transfer symbol appears with that photo's thumbnail, as shown in the figure. Keep selecting and tagging the rest of the photos you want to transfer. To remove the tag from a photo, tap Set or press the Zoom Out button again. When you finish tagging all photos, tap OK or press the OK button. To remove the transfer tag from all photos, choose the menu option again but

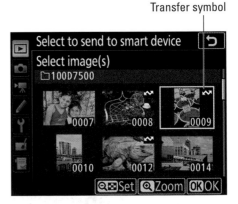

FIGURE A-6: Highlight a thumbnail and then tap Set or press the Zoom Out button to tag it for transfer.

select Deselect All instead of Select Image(s) when you get to the right screen in Figure A-5.

» **Tag a single photo for transfer:** Put the camera in Playback mode, display the photo, and press the *i* button to display the playback version of the *i* button menu, shown on the left in Figure A-7. Choose Select to Send to Smart Device/Deselect. The menu disappears and you see the transfer symbol on the playback screen, as shown on the right in the figure. If you change your mind, choose the menu option again to remove the tag.

Transfer symbol

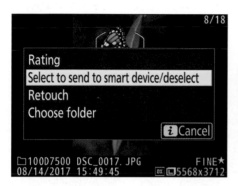

FIGURE A-7: During playback, you can tag the currently displayed image through the *i* button menu.

Taking a Look at SnapBridge Functions

Now for the fun part: Reviewing the actual functions you can enjoy when you connect the camera to your smartphone or other smart device.

Figure A-8 shows the home screen of the app in its iOS incarnation (left screen in the figure) and its Android flavor (right screen). Features are divided among four tabs: Connect, Gallery, Camera, and Other, all described briefly in the upcoming sections. To display a tab, tap its name or symbol. On an iOS device, the tab symbols are at the bottom of the screen; on an Android device, the icons are near the top of the screen. From this point forward, figures show the iOS versions of the screens, but those screens appear the same on an Android device except for a few design differences specific to the device operating system.

Connect tab

Options on this tab relate to establishing the connection to the camera. At the top of the screen, you see a symbol representing your camera, when connected. If you

turn on the Auto Link option, as shown in Figure A-8, you can access the following settings:

» **Auto download:** Choose this option to set the size of the transferred files — 2MP (megapixels) or the original size. You also can enable or disable automatic upload to your Nikon Image Space account on this screen.

» **Upload Location and Synchronize Clock:** Turn these features on if you want to embed the device's location data and time/date information to new pictures or movies you shoot with the camera. You also have to enable the Location Data option on the camera for this data transfer to occur.

Gallery tab Other tab

Connect tab Camera tab

Tap to switch tabs

FIGURE A-8: Here's a look at the SnapBridge home screen on an iOS device (left) and an Android device (right).

If you turn on Auto Link and Auto Download, the device starts transferring photos immediately, either copying all photos on your memory card or those you selected by tagging them in the camera. However, this is not your only avenue to downloading images to the device; you also can select photos and start a transfer via the Camera tab, explained a block or two from here.

Gallery tab

Display the Gallery tab, as shown in Figure A-9, to view thumbnails of images stored on your device as well as those you transferred from the camera. Use standard smartphone picture-viewing gestures — swipe to scroll through your photos, pinch out to magnify the display, and so on.

Camera tab

Through this tab, featured in Figure A-10, you can access two features:

>> **Use the device as a camera remote control.**
This feature applies to still photography only and works via a Wi-Fi connection. Before making that connection, set the camera to P, S, A, or M exposure mode and select the picture settings you want to use. Also turn off Live View, if it's engaged. Then return to the SnapBridge screen and choose Remote Photography, as shown on the left in Figure A-10. When the app finds your camera, it prompts you to open your device's Wi-Fi settings and select the camera as your Wi-Fi source. You need to enter the camera's network password; by default, it's NIKOND7500.

FIGURE A-9:
After connecting to the camera, open the Gallery tab to view image thumbnails.

REMEMBER

When the connection is made, you see the screen shown on the right in the figure with a live view of the scene in front of the camera lens. You also see some shooting data, such as the shutter speed and f-stop. A focus box appears on the preview; tap your subject to place the focus box over it and set focus. The focus box turns green when focus is achieved. Tap the Settings icon to choose a few more options, including whether you want the pictures to be transferred to the smart device immediately after you shoot them. Keep the Live View option on the Settings page enabled; otherwise, you can't see the live preview on the device screen.

To take a picture, tap the shutter-button icon, labeled in the figure. The picture is saved to the SnapBridge gallery. A thumbnail of the photo appears under the live preview. Tap the thumbnail to see the images at a larger size and access icons that enable you to share or delete the image.

WARNING

Don't turn the camera off or choose another tab in the SnapBridge app between shots; either action breaks the Wi-Fi link and you have to go through the connection process all over again.

Tap to launch remote-control feature

 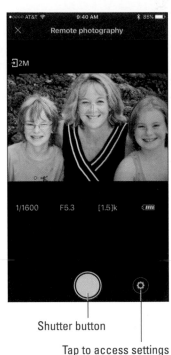

FIGURE A-10:
You can use your smart device as a wireless remote control.

Shutter button

Tap to access settings

>> **Download selected pictures from the camera memory card.** If you didn't set up automatic download and you didn't tag pictures in the camera for transfer, choose the Download Selected Pictures option (left screen in Figure A-10). You see thumbnails of your pictures. Tap Select and then tap each image or movie file you want to transfer. Next, choose the download size and then OK.

You can transfer movie files *only* via a Wi-Fi connection. If the camera isn't connected to the device via Wi-Fi, movie files won't appear in the list of files you can transfer.

Other tab

Display the Other tab to access a few more app options. The two most useful are:

>> **Add Credits:** Choose this option to embed copyright data and other information into your picture files.

>> **Info/Settings:** Tap this option and then tap Instructions to launch your web browser and access the SnapBridge Help site.

Index

About the Author

Julie Adair King is the author of many books about digital photography and imaging, including the bestselling *Digital Photography For Dummies.* Her most recent titles include a series of *For Dummies* guides to popular digital SLR cameras, including the *Nikon D3400, D5600, D7200,* and *D600.* Other works include *Digital Photography Before & After Makeovers, Digital Photo Projects For Dummies,* and *Shoot Like a Pro!: Digital Photography Techniques.* A native of Ohio and graduate of Purdue University, she resides in West Palm Beach, Florida.

Author's Acknowledgments

I am deeply grateful for the chance to work with a wonderful publishing team, which includes Rebecca Senninger, Steve Hayes, and Mary Corder, to name just a few. I am also indebted to technical editor Theano Nikitas, without whose insights and expertise this book would not have been the same.

Publisher's Acknowledgments

Executive Editor: Steven Hayes

Project Editor: Rebecca Senninger

Technical Editor: Theano Nikitas

Sr. Editorial Assistant: Cherie Case

Production Editor: Siddique Shaik

Cover Image: Julie Adair King